THE LITHIC GARDEN

THE
LITHIC GARDEN

*Nature and the Transformation of the
Medieval Church*

Mailan S. Doquang

OXFORD
UNIVERSITY PRESS

Oxford University Press is a department of the University of Oxford. It furthers
the University's objective of excellence in research, scholarship, and education
by publishing worldwide. Oxford is a registered trade mark of Oxford University
Press in the UK and certain other countries.

Published in the United States of America by Oxford University Press
198 Madison Avenue, New York, NY 10016, United States of America.

CIP data is on file at the Library of Congress
ISBN 978–0–19–063179–6

1 3 5 7 9 8 6 4 2

Printed by Sheridan Books, Inc., United States of America

To Don

Contents

Acknowledgments *ix*

List of Abbreviations *xi*

Introduction **1**

Nature 8

Meaning 17

Ornament 18

The Chapters 20

1. The Foliate Frieze as Architectonic Framing Device **23**

The Sacred Frame 23

The Frieze at Amiens Cathedral: An Exemplar 27

Interior Friezes 35

Exterior Friezes 40

Foliate Borders in Other Media 59

Cluny III and the Proliferation of Architectonic Foliate Friezes 62

Conclusion 71

2. Paradise Found **73**

The Earthly Paradise 75

The Celestial Paradise 77

The Architecture of Paradise 80

Loci of the Divine 89

The Tree of Life 94

The *Hortus Conclusus* 97

Garden and Sepulcher 102

Beyond Paradise 106

Conclusion 108

3. The True Vine 113

Christ and the Vine: The Textual Tradition 115

The Figural and the Vegetal on Church Portals 117

The True Vine Inside and Outside Amiens Cathedral 125

A Genealogy of Christ 139

Contextualizing the Vine 150

Conclusion 153

4. The Golden Vine 157

The Temple of Jerusalem 159

The Temple as Model 161

The Temple Vine: The Textual Sources 163

The Dome of the Rock as Temple 165

Byzantine Precedents 171

Islamic Parallels 177

The Foliate Frieze as Golden Vine 179

Conclusion 185

The Garden: An Afterword 189

Notes 193

Bibliography 217

Index 249

Acknowledgments

FIRST AND FOREMOST, I WOULD LIKE TO THANK MARVIN TRACHTENBERG, my adviser, mentor, and friend. It is safe to say that this project would not have come to fruition without Marvin's continued support and patient guidance. I owe a debt of gratitude to Cecily Hilsdale for her wise council on all aspects of my career. I am grateful to Michael T. Davis for his insightful feedback on my work over the years. I thank Finbarr Barry Flood, whose research on the Great Mosque of Damascus was a source of inspiration for this book. I extend my thanks to Jacqueline Jung for her close reading of the manuscript and for her invaluable input. I would also like to thank Meredith Cohen and Stefaan Van Liefferinge for their encouragement, their advice, and the pleasure of their company in Paris and New York.

I drafted this manuscript in its entirety between 2012 and 2014 while I was a postdoctoral fellow and lecturer at McGill University. I am grateful to the Social Sciences and Humanities Research Council of Canada for its generous support of my work during this period and for providing me with the extraordinary opportunity to return to my alma mater. I thank Angela Vanhaelen, chair of the Department of Art History and Communication Studies while I was a fellow at McGill, for the time, resources, and space to pursue this project. My thanks also go to Cathleen Fleck for providing me with a platform to present my work in its early stages at the 101st Annual Conference of the College Art Association in 2013. I benefited immensely from discussions with my fellow presenters at CAA: Bianca Kühnel, Neta Bodner, Gillian Elliott, and Pamela Berger. I am also grateful to Jacqueline Jung for including me in her session at the 51st International Congress on Medieval Studies at Kalamazoo in 2016, which allowed me to present more mature versions of my ideas and receive much needed feedback.

I am indebted to the many friends, colleagues, and institutions who helped me during the research, writing, and publication processes. I thank Sarah Pirovitz at Oxford University Press for her dedication and professionalism. For their assistance during production, I thank Abigail Johnson, Denise Phillip Grant, Timothy DeWerff, and the dedicated staff at Newgen Knowledge Works. I am grateful to my two anonymous readers, whose constructive comments improved the manuscript immeasurably. I am thankful to the Manhattan Research Library Initiative for granting me access to the extensive research collections of New York City. For the beautiful photographs, thank you, Prisca Brülisauer, Nathalie Collin, Marek Dospěl and

Elizabeth Dospĕl Williams, Gauthier Gillmann, Bojana Krsmanović, Francesca Leoni, Marci Lewis, Gabriel Rodriguez, Gerald Raab, Maria Smit, Jonathan Smith, Amy Taylor, Marvin Trachtenberg, Jacqueline van der Kort, Jennifer Udell, and the staff at the Bibliothèque nationale de France. For their advice, support, and generosity, I extend my thanks to Leigh Binford, Nancy Churchill, Giles Constable, Kate Crehan, Richard Etlin, Heather Horton, Dorothy Ko, Kathryn Smith, Kristine Tanton, Erik Thunø, Saadia Toor, and Caroline Walker Bynum. I am grateful to Beatrice Radden Keefe for her encouragement and staunch optimism. A special thanks to Anne Hrychuk Kontokosta for keeping me on track early in the research process, and to Jennifer Udell and Daniel Newsome for fifteen years of friendship. My heartfelt thanks go to my entire support system in France, especially to Chloé Enkaoua, Stéphane Berneuil, and Eve Boccara Zion, who helped make Paris my home away from home.

This book would not have been possible without the unconditional support of my family. My deepest gratitude goes to my parents Kim and Christiane, my brother Doan, my sister Kimchi, and the Selby, Strasser, and Wolever families. Last but not least, I thank my husband, Don, whose confidence, encouragement, and love saw me through this project.

Abbreviations

AN	Archives nationales, France
BM Dijon	Bibliothèque municipale de Dijon
BnF	Bibliothèque nationale de France
CCCM	Corpus Christianorum, Continuatio Mediaevalis
CCSL	Corpus Christianorum, Series Latina
CEM	Centre d'études médiévales
CNRS	Centre national de la recherche scientifique
CSEL	Corpus Scriptorum Ecclesiasticorum Latinorum
CUER MA	Centre universitaire d'études et de recherches médiévales d'Aix
DOP	Dumbarton Oaks Papers
JRS	*Journal of Roman Studies*
JSAH	*Journal of the Society of Architectural Historians*
JWCI	*Journal of the Warburg and Courtauld Institutes*
MGH AA	Monumenta Germaniae Historica, Auctores antiquissimi
PG	Patrologiae Graecae
PL	Patrologiae Latinae
PMLA	Publications of the Modern Language Association of America
PPTS	Palestine Pilgrims' Text Society
RMN	Réunion des musées nationaux
SBO	Sancti Bernardi Opera
SPCK	Society for Promoting Christian Knowledge

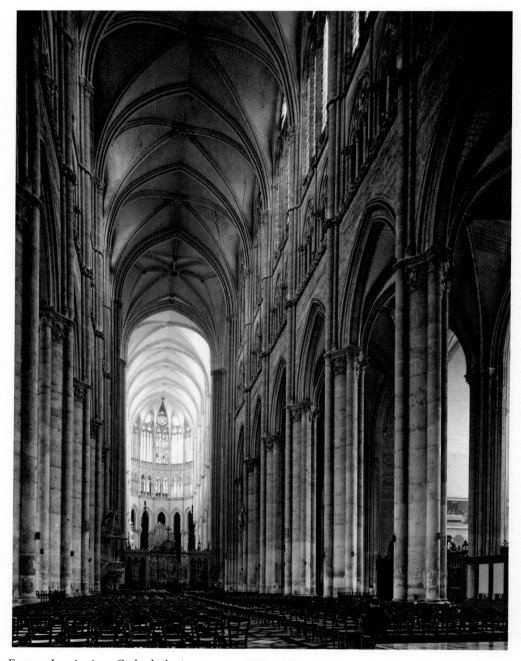

FIGURE I.1 Amiens Cathedral, view to east, 1220–1269

Photo: © Mapping Gothic France, Media Center for Art History, The Trustees of Columbia University, Department of Art History and Archaeology

Introduction

THIS BOOK ORIGINATED IN 2006 DURING A VISIT TO THE LARGEST MEDIEVAL building in France, the thirteenth-century cathedral of Amiens nestled in the old quarter of what is now the capital of the northern region of Hauts-de-France. I did not anticipate that the experience, considered routine for a medievalist, would initiate a fundamental shift in my conception of the architecture of the high and late Middle Ages. What caught my eye upon entering the cathedral was the monumental foliate frieze running around the entire nave, transept, and choir of the building (figs. I.1, I.2). Although scholars have often noted that the frieze marks the midpoint of the elevation and underlines the clean proportions of the building, I was struck not just by its position, but also by its size and, more important, its form. The frieze's fleshy leaves, bulbous fruit bunches, and serpentine tendrils were so exquisitely and energetically carved that, as I ran through comparanda in my mind's eye, it seemed more and more to become one of the most impressive pieces of sculpture of the Middle Ages (figs. I.3, I.4).

I encountered the frieze often after this initial visit, on site and in publications, noting each time its virtuosity and immense size, but its significance eluded me until the winter of 2012, when the pivotal idea of this book began to crystallize. The time, energy, and expense devoted to creating this enormous sculpture suggested that it was a key part of the interior ensemble. I came to realize that the frieze was not simply an extravagant embellishment, devoid of meaning and purpose, but rather, a semantically charged component that was of demonstrable importance to the cathedral's medieval builders and users. In addition to interconnecting sacred spaces and gesturing to the omnipresent world of agriculture (in particular viticulture), the frieze would have encapsulated and promoted a set of interrelated core aspects of the Christian faith for its medieval viewers. It seemed at once to evoke the viridity of the paradisiacal garden, Christ as the true vine, the Eucharistic wine and ritual, and the golden vine that dressed the Temple of Jerusalem, originally built by the wise king Solomon. From the very center of its walls, these distinct but figuratively and literally entwined paradisiacal, messianic, Eucharistic, and Solomonic associations would have resonated throughout a building already pervaded with symbolic significance.[1]

Given that architectonic motifs in medieval churches are rarely (if ever) entirely unique, I began to look for foliate friezes in other buildings. The ambition and artistry of the Amiens frieze in any case suggested that its makers had extensive experience with such components, either directly or indirectly. I discovered that although there are no interior vegetal friezes at the cathedrals of Chartres and Reims, two nearby structures the builders at Amiens emulated and aimed to surpass, the motif does appear in dozens of Romanesque and Gothic churches in areas as diverse as Burgundy, Champagne, Picardy, Normandy, the Île-de-France, and the Loire from the turn of the twelfth century onward (figs. I.5–I.8).[2] Closely related foliate bands are also ubiquitous outside

1

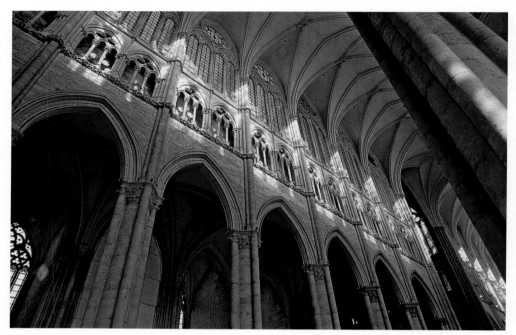

FIGURE I.2 Amiens Cathedral, nave

Photo: author

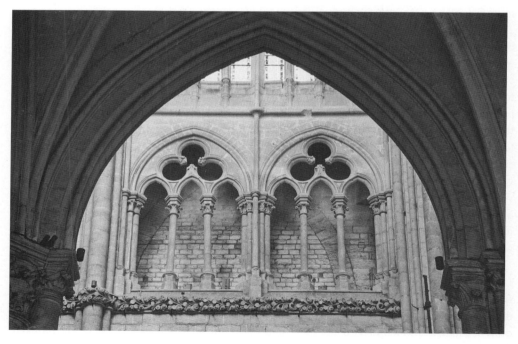

FIGURE I.3 Amiens Cathedral, nave triforium

Photo: author

FIGURE I.4 Amiens Cathedral, nave frieze

Photo: author

FIGURE I.5 Saint-Rémi, Reims, detail
of choir elevation, begun 1160–1170

Photo: author

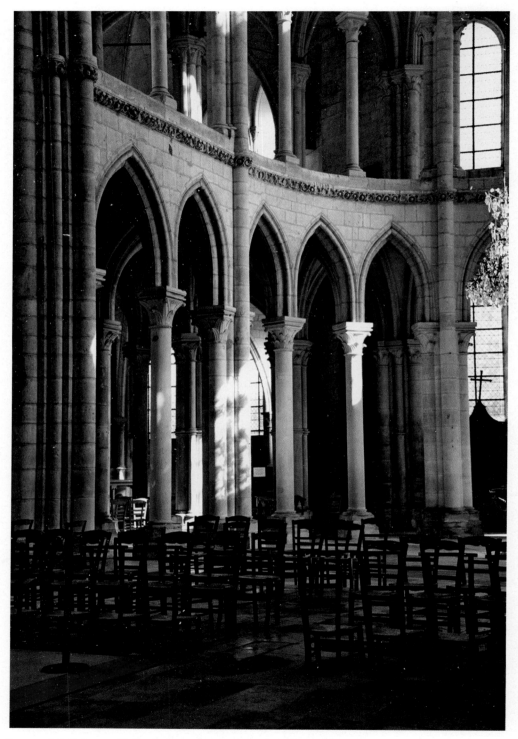

FIGURE I.6 Soissons Cathedral, south transept, ca. 1176–1190
Photo: author

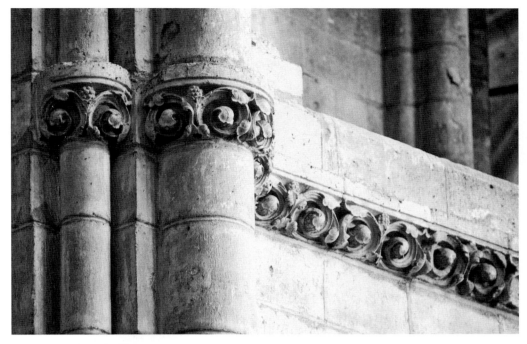

FIGURE I.7 Detail of I.6

Photo: author

FIGURE I.8 Notre-Dame, Poissy, nave frieze (upper), fifteenth century

Photo: author

FIGURE I.9 Reims Cathedral, west façade, south portal, jamb, thirteenth century
Photo: author

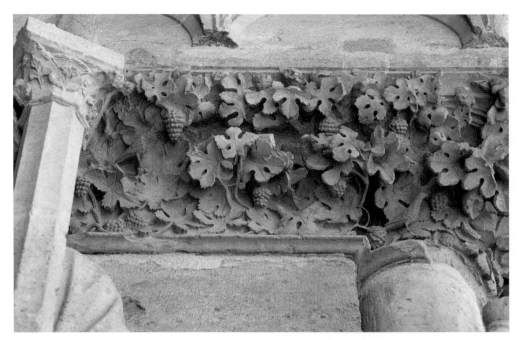

Figure I.10 Detail of I.9
Photo: author

churches, especially in portal zones (figs. I.9, I.10). The frieze at Amiens Cathedral is just one example—albeit extraordinary—of what is in fact a common element in the architecture of high and late medieval France, with the fertile wine-growing region of Burgundy serving as an incubator for the trend. Thus, in my research, what began with curiosity regarding a single High Gothic frieze became an expansive study of the functions and resonances of a widespread architectonic device in French church design from the early twelfth to the fifteenth century, with an emphasis on its introduction and initial development. To be clear, it is not that other foliate elements in sacred contexts were unable to provoke responses from viewers, but, as I seek to demonstrate throughout this study, foliate friezes operated multidirectionally, overlaying sacred and mundane connotations in innovative and often unique ways. Furthermore, my focus on the signifying potential of the friezes is in no way incompatible with recent work stressing the medieval aesthetic experience and the role of medieval art in eliciting visceral reactions, nor are my geographic boundaries meant to suggest that foliate friezes were a uniquely French phenomenon.[3] Indeed, although friezes made an early appearance in the architecture of medieval France, one finds similar examples in other parts of Europe, notably on church façades in Italy, Spain, and Germany.

This book is the first to focus on foliate friezes and their varied functions. Foliate friezes occasionally appear in general studies of vegetal sculpture (alongside column capitals, vault bosses, corbels, and other elements), as well as in monographs on particular buildings.[4] As a distinct class of objects, however, the organic bands festooning the churches of France remain conspicuously absent from our otherwise rich histories of medieval architecture, despite generations of rigorous scholarship. In addition, treatments of foliate friezes have primarily addressed formal issues. For example, emphasizing sources, transmission, and dating, Denise Jalabert charted the stylistic development of monumental flora in France, slotting vegetal bands and other botanical components into three formalist categories: *généralisée* (twelfth century), *naturaliste* (thirteenth century),

and *réaliste* (late fourteenth and early fifteenth centuries).[5] Wilhelm Schlink and Dany Sandron stressed some of the same issues, albeit more pointedly, in their treatments of the friezes at the cathedrals of Langres and Amiens, the former scholar relating the example at Langres to carvings in Dijon and the latter presenting the Amiens band as a stylistically enriched version of its possible models at the church of Saint-Rémi at Reims and the cathedral of Soissons (see figs. I.4–I.7).[6] What these three representative publications reveal is that, when they are at all noted, foliate friezes tend to be discussed in anachronistic terms, with scholars emphasizing taxonomy and stylistic progress, in addition to using the friezes as diagnostic dating instruments.[7]

Whereas scholars of medieval architecture have generally studied foliate friezes using nineteenth- and early-twentieth-century analytical tools, this book offers a new perspective by seeking to interpret the friezes through the system of values and practices of the temporally and culturally distant Middle Ages. It considers foliate friezes in relation to a series of factors: historical circumstances, the habitus of their makers and viewers, the liturgy, their location in and on buildings, adjacent figural and vegetal sculptures, and contemporary objects in different media.[8] The only comparable analysis is Stephen Murray's treatment of the frieze at Amiens Cathedral, which initially appeared in his 1996 monograph on the building.[9] Murray presented the Amiens frieze within the context of the annual feast commemorating the invention of the relics of Saint Firmin, which was closely associated with ideas of organic growth. His interpretation is unique in that it stresses the evocative ability of a foliate frieze, but it focuses on a single example and posits a solitary meaning.[10] By contrast, this study takes a more expansive view by treating foliate friezes as a distinctive group of objects and by emphasizing their multi-pronged, mutable meanings, both sacred and mundane. This broad, contextual method brings us closer to understanding the responses friezes might have engendered in beholders whose daily experiences revolved around agricultural endeavors and whose imaginary was filled with paradisiacal visions and aspirations.

NATURE

The ability of foliate friezes to convey meanings depended entirely upon the receptivity of their experiencing subjects to depictions of vegetal forms. An enabling factor in this regard was the primarily agrarian lifestyle of Western Europeans during the Middle Ages. The natural environment was an inescapable part of the medieval lifeworld, and its destructive and life-sustaining powers were viewed with deep ambivalence.[11] On the one hand, the vast majority of Europe's population were peasants whose days were given to agricultural labor, with crop production and animal husbandry persisting as primary generators of income even as towns, trade, and industry rose to greater prominence.[12] On the other hand, this predominantly agrarian society was subject to the unpredictability and at times catastrophic effects of the elements, with floods threatening to destroy houses, ruin crops, and drown animals, and droughts and early frosts endangering harvests. The seasons, agricultural labor, and the rising and setting sun dictated the rhythm of medieval life, with time, which was imprecisely measured by modern standards, following what anthropologists have described as an "ecological" pattern rather than adhering to its current abstract structure.[13]

The pervasiveness of themes associated with the land and agricultural work in the cultural output of the Middle Ages attests to the centrality of nature in its tamed and wild states in the life space of medieval subjects. For instance, depictions of the labors of the months are ubiquitous across a wide range of media, including mosaic, sculpture, stained glass, and manuscript illumination.[14] These images overwhelmingly focus on human activities set outdoors, most of which

were essential for survival. Peasants are shown chopping wood, pruning trees, and digging in fields (February, March); training vines and scything (April, May); mowing hay, shearing sheep, and cutting corn (June, July); threshing, harvesting, and treading grapes (August, September); sowing, plowing, and thrashing for acorns (October, November); and slaughtering and roasting pigs (December, January) (fig. I.11).[15] Contrasting with these manual tasks of the peasantry are the hawking scenes of the month of May, which convey the importance of the natural world to nobles, who owned and lived almost entirely off the land and for whom hunting was a common pastime. The themes of land, labor, and leisure in medieval calendars, which have been interpreted as both expressing and reinforcing class structures, also feature in agricultural treatises of the period, such as the *Rules for Household and Estate Management* by Robert Grosseteste (d. 1253), *Husbandry* by Walter of Henley (d. ca. 1300), and the *Liber ruralium commodorum* of Pietro de' Crescenzi (d. 1321).[16] These themes coexisted with other, equally significant aspects of nature, such as its links to fecundity, procreation, and romantic love in cosmological and chivalric texts, and its medicinal and scientific functions.[17] Setting aside these wide-ranging associations, the images and texts mentioned above point to the vital place of the vegetal world in medieval life. This centrality helped shape the ways in which medieval viewers saw and understood depictions of foliage in sacred contexts, their distinct cultural habitus prompting them to "read" and react to the motifs in ways that can now be reconstructed only with difficulty.

The development of the foliate frieze in the architecture of the twelfth century marked an important shift in the constitution of the medieval church by drawing plant life into sanctified space to a degree rarely seen in earlier periods. The main binary here is not between church and nature (the latter belonging to the *ordo creationis* in the Middle Ages), but rather, between the ritually consecrated and the unconsecrated.[18] Of course, real and fictive botanical elements appeared in churches before this time. Living plants were used in the liturgy and as church adornments from the Early Christian period onward, notably in baptism and marriage ceremonies, and during the Holy Week liturgy.[19] The medieval practice of carving column capitals with acanthus leaves, moreover, was carried over uninterrupted from antiquity, though at times in a highly abstract manner.[20] Vegetation was sometimes also shown in early medieval church mosaics and frescoes, most frequently in apses. However, depictions of organic motifs, when present, were usually subordinate to figural representations and geometric forms (the latter often of antique origin), such as cylindrical column shafts, triangular pediments, rectangular entablatures, and semicircular arcades, windows, apses, and half-domes (fig. I.12). The permutations that occurred in French architecture in the early twelfth century were subtle, but had far-reaching effects. Vegetation became an increasingly important presence within the social space of the church, featuring more noticeably in sacred buildings alongside geometric elements and depictions of human figures. Although foliage in this period generally remained secondary to non-vegetal motifs, the rendering of foliated components in the three-dimensional medium of sculpture (which was brightly painted), rather than in mosaic or fresco, lent the organic a greater saliency than ever before in the history of Western medieval architecture. Vegetal friezes and other sculpted flora altered the bipartite matrix of abstract and figural elements that had dominated French church design, destabilizing the balance between the two conventional components by placing them in more prominent dialogue with the organic.

The growing emphasis on sculpted vegetation in French churches coincided roughly with what Marie-Dominique Chenu and others (recently Steven Epstein) described as the twelfth-century "discovery of nature" in medieval thought and literature, a phenomenon best exemplified by the philosophical writings of William of Conches (d. 1154), Bernard Silvestris (d.

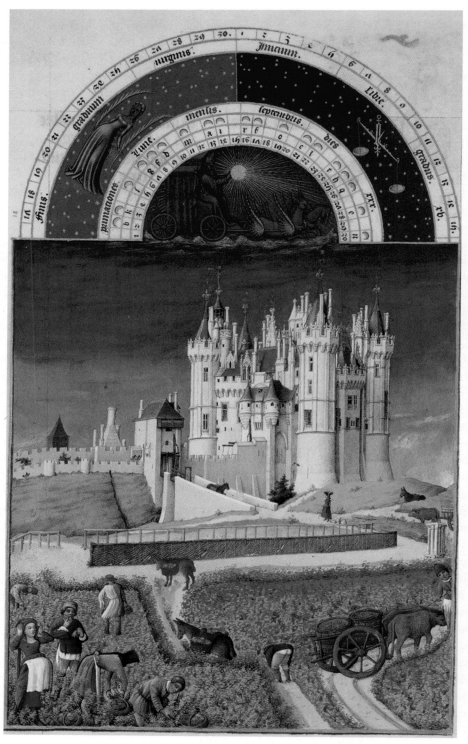

FIGURE I.11 Limbourg Brothers, *September (Grape Harvest), Très Riches Heures du Duc de Berry*, 1411–1416, Chantilly, Musée Condé, Ms. 65, fol. 9v

Photo: R.-G. Ojéda

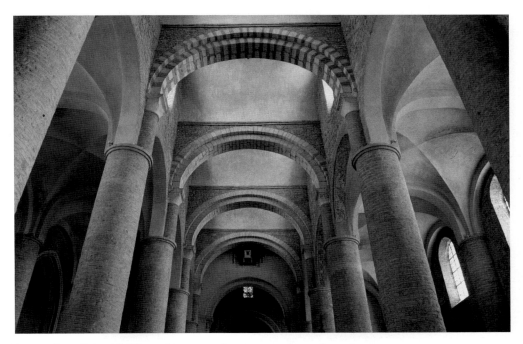

FIGURE I.12 Saint-Philibert, Tournus, view to east, eleventh century
Photo: author

1178), and Alan of Lille (d. ca. 1202).[21] What Chenu was referring to in this still-influential essay of 1952 was not the poetic or artistic appreciation of local flora and fauna, but rather, an intellectual-historical process that gave rise to an awareness of the visible world as an entity worthy of direct and rigorous confrontation. Chenu was preoccupied with naturalism in various forms of representation, most relevantly sculpture, which he saw as the counterbalance to more abstract representational modes. Although scholars have refined Chenu's thesis and even refuted some of his claims, what I take from his study is his recognition of the new importance accorded to the physical environment in the twelfth century.[22] The phenomenal world may not have served as a conduit to the divine, as Chenu boldly asserted, but it certainly made the divine more knowable through its familiarity.

Jumping to the other end of the chronological span of this study, natural forms are most abundant in the so-called *Astwerk* (literally "branch-work") of the late Middle Ages, in which supports, arches, vaults, and façades are subsumed beneath layers of ornamentation, much of it organic.[23] Some late medieval builders went so far as to substitute outright conventional architectural members, such as columns, piers, and ribs, with forms inspired by nature (fig. I.13). A salient feature of this architecture is the spreading of vegetal forms beyond the confines of the architectonic components they adorn to adjacent elements, resulting in the merging of parts. The copious use of organic imagery is most common in Germanic buildings of the late fifteenth and sixteenth centuries, but examples also appear in earlier and contemporary structures in France and Spain (fig. I.14).[24]

The wealth of vegetal carvings in Late Gothic *Astwerk* relative to earlier periods is undeniable; however, I wish to draw attention to two relevant correlations. First, there exists a parallel

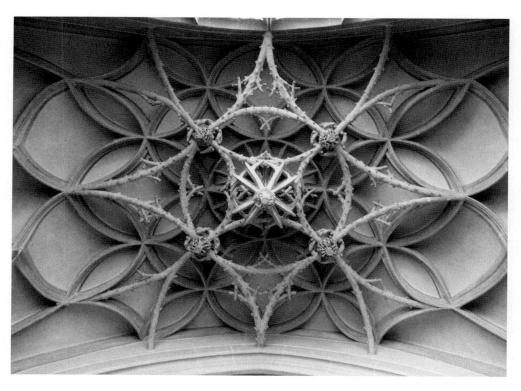

FIGURE I.13 Church of Our Lady, Ingolstadt, chapel vault, 1510–1520

Photo: Christa Syrer

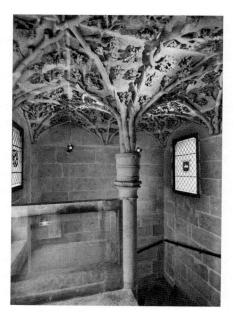

FIGURE I.14 Tour Jean-sans-Peur,
Paris, early fifteenth century

Photo: author

between the emergence of *Astwerk* in French court art in the fourteenth century and the initial proliferation of monumental flora in French churches at the turn of the twelfth century.[25] In both cases, organic motifs play a more meaningful role in architectural design than they had previously, shifts contemporary viewers could not have failed to notice. Another point of comparison is the fluid treatment of foliated members with respect to bordering components. Although vegetation in high medieval churches typically respects the physical limits of the architectonic elements it inhabits without impinging on adjoining fields (unlike Late Gothic *Astwerk*), there are many exceptions to this tendency. This is most striking in the treatment of column capitals, where foliage often encroaches on neighboring zones, obscuring the normative structural relationship between capital (load) and shaft (support) (see figs. I.9, I.10, I.15, and I.16). Without minimizing the achievements of late medieval builders, then, it is fair to make the following assertions: first, the greater role accorded to plant motifs in twelfth-century church design compared to earlier buildings is analogous to the increased use of vegetal ornamentation in *Astwerk*; second, the breaching of boundaries with foliage in high medieval churches echoes the structural slippages caused by botanical forms in late medieval buildings, the difference being one of degree, not of kind.[26] Such continuities in the conception and uses of sculpted foliage in architectural contexts over the *longue durée* justify the chronological breadth of my project and its rejection of conventional style-based periods.

Writers have linked Gothic architecture to the natural world since at least the sixteenth century, specifically to forests. This analogy, which manifested itself in visual media in the eighteenth and nineteenth centuries, bears superficial resemblance to my interpretation of medieval flora and therefore invites comment (fig. I.17). The first mention of the well-known forest theory of the origins of Gothic architecture comes from a report for an unnamed pope, possibly Leo X (d. 1521), which some have ascribed to Raphael (d. 1520). The author claimed not only that the pointed arch of the *maniera tedesca* was structurally and visually inferior to its round counterpart, but also that its form derived from the primitive building practice of tying together the branches of living trees.[27] Early Romantics perpetuated this theory, albeit in more positive and often nationalistic terms, by associating Gothic buildings metaphorically with forests. Johann Wolfgang von Goethe (d. 1832) likened Strasbourg Cathedral to a giant tree with "thousands of branches, twigs, and leaves."[28] François-Réné de Châteaubriand (d. 1848) also related the Gothic church to the woods in his *Génie du Christianisme*: "[T]he coolness of the vaults, the darkness of the sanctuary, the shadowy aisles, the secret passages, the low doors, all recall in the Gothic church the labyrinths of the forests."[29] The ineffable qualities of "religious awe, the mysteries, and divinity" further affirmed the Gothic church/forest metaphor for Châteaubriand.[30] Friedrich von Schlegel (d. 1829) also employed the forest metaphor, equating the towers, buttresses, pinnacles, and vaults of the Gothic church with spiky trees and forest overgrowth.[31] Romantic writers ascribed the "organic qualities" of Gothic churches to the German affinity for nature, which ostensibly reflected the ancestral practice of worshipping in forests.

Architectural historians have sought to invalidate the forest theory by addressing structural, geometric, technical, visual, and contextual issues surrounding the development of Gothic architecture in the twelfth century.[32] Although Paul Crossley characterized the theory as "nonsense" (following Paul Frankl, who rejected it as "time-worn"), he recognized the applicability of the forest analogy to the architecture of the late Middle Ages, especially to *Astwerk* in southern Germany.[33] According to Crossley, the interior of the Late Gothic church was suggestive of "the limitless and impenetrable spaces of the forest," and its profuse vegetal ornamentation

FIGURE I.15 Saint-Germain-des-Prés, Virgin Chapel portal, Paris, ca. 1245–1255, Paris, Musée national du Moyen Âge (Cl.18986)

Photo: author

FIGURE I.16 Detail of I.15

transformed "the whole interior into leafy latticeworks, resembling gardens, arbours and forests" (see fig. I.13).[34] It is the second of Crossley's observations that speaks most directly to my project. In contrast to Romantic writers, who generally emphasized the metaphorical link between forests and Gothic churches, my study of architectural foliage and its evocative potential addresses both the metaphoric and the literal.

This book is about images of vegetation, but it does not hinge on their naturalistic representation or on what might be called the "reality effect" (depictions that contain enough details to identify the plant species, but that are not, strictly speaking, mimetic). The naturalistic impulse in the artistic output of the thirteenth century and its relationship to translations of Aristotelian natural philosophy have long preoccupied historians of medieval art.[35] Closely related is the question of direct observation, whereby artists translated their visual experiences directly into pictorial form rather than working from exemplars. My aim is not to revisit these well-studied and long-vexed issues, but instead to attend to the representational symbolism of monumental flora, bracketing questions of style. Of central importance is the subject of intention (what artists wanted to do, or rather, what they were tasked with doing) and the question of skill (what artists were capable of accomplishing at any given moment). The reception and legibility of the images, which were often viewed from a distance, are also part of the equation. In many cases, particularly in the thirteenth century, sculptures appear to represent regional flora, the most pertinent being the grapevine, which was cultivated in France throughout the Middle Ages and was thus widely accessible to artists. The crucial point, however, is not whether sculptors worked directly from nature or even the level of verisimilitude they achieved, but rather, how the representations, naturalistically rendered or not, would have been perceived by medieval viewers in light of their sacral display contexts, liturgical actions, and adjacent figural and vegetal imagery.

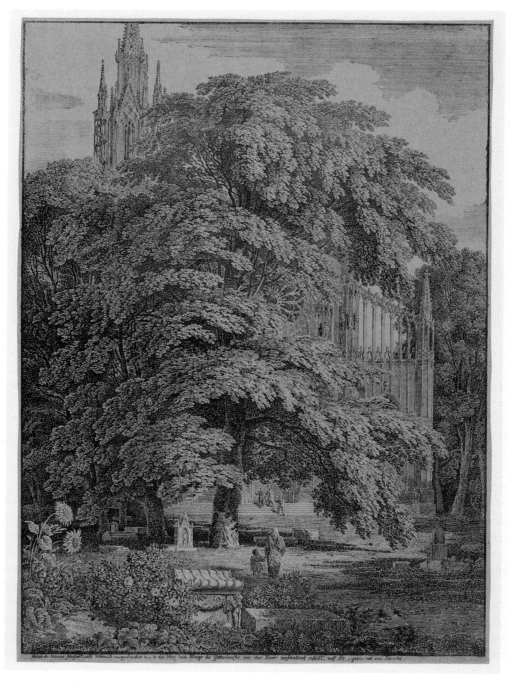

FIGURE I.17 Karl Friedrich Schinkel, *Gothic Church Hidden by a Tree*, 1810

Photo: The Metropolitan Museum of Art, The Elisha Whittelsey Collection, The Elisha Whittelsey Fund, 2004 (2004.21)

MEANING

The symbolism of churches features prominently in the historiography of medieval architecture. This branch of scholarship typically draws on medieval literary sources that attach meanings to architectural components.[36] For instance, bishop Eusebius of Caesarea (d. 339) likened the twelve columns in the apse of the church of the Holy Sepulcher in Jerusalem to the twelve apostles, a comparison repeated by abbot Suger (d. 1151) in his often-cited description of the abbey church of Saint-Denis.[37] The symbolism of sacred buildings is detailed most fully in the frequently copied and broadly disseminated *Rationale divinorum officiorum* of bishop William Durandus of Mende (d. 1296), which touches on many aspects of church design, including walls, towers, windows, doors, and piers. According to Durandus, these five elements signify (respectively) the doctrine of the four evangelists and the four cardinal virtues, preachers and prelates, holy scriptures, Christ, and the bishops and doctors of the Church.[38]

An important distinction needs to be made here. What I am proposing is not a return to the rigid iconographic interpretations typical of early- and mid-twentieth-century architectural discourse, a trend exemplified by the work of Günter Bandmann.[39] Crossley more than a quarter of a century ago called attention to the limitations of this method, in which forms are understood to bear intrinsic and seemingly immutable meanings and patronal intentions reign supreme.[40] He promoted a more flexible approach to the material, rightly claiming that architectural forms did not convey univocal meanings, but were instead capable of supporting "a variety of symbolic attributes."[41] As Crossley observed, Richard Krautheimer not only provided the theoretical basis for such multivalence in his generative article of 1942, "Introduction to an 'Iconography of Mediaeval Architecture,'" but he also put this theory into practice in his study of Carolingian architecture.[42] According to Krautheimer, the meanings attached to architectural forms were not unitary or fixed, but unstable, contested, and changing, such that centrally planned baptisteries, with their typological connections to Roman mausolea and baths, could simultaneously connote mystical death, resurrection, regeneration, and spiritual cleansing.[43] Krautheimer referred to this polysemy as "multi-think" in the postscript to the reprinted version of the article of 1969.[44] His conceptual apparatus, which maintains its methodological currency, provides an enabling framework for my multilayered interpretation of the foliate friezes in medieval churches.[45]

My approach to foliate friezes builds on a series of key publications by German art historians active in the 1960s: Karl Oettinger's "Laube, Garten, und Wald: Zu einer Theorie der süddeutschen Sakralkunst 1470–1520" (1962), Margot Braun-Reichenbacher's *Das Ast- und Laubwerk: Entwicklung, Merkmale, und Bedeutung einer spätgotischen Ornamentform* (1966), and Joachim Büchner, "Ast- Laub- und Masswerkgewölbe der endenden Spätgotik: Zum Verhältnis von Architektur, dekorativer Malerei, und Bauplastik" (1967).[46] These studies focus exclusively on the *Astwerk* of the Late Gothic period, but their contentions about the symbolic functions of vegetal motifs in sacred contexts bear on earlier monuments. Oettinger presented monumental flora in relation to botanical imagery in other visual media and literature, convincingly arguing that organic motifs from around 1500 were evocative of the heavenly garden and the *hortus conclusus,* the garden of the spouse of the Song of Songs, which was understood to be an emblem of the Virgin Mary. Büchner accepted Oettinger's thesis, but emphasized that pure organic forms were unusual in the medium of architecture. Braun-Reichenbacher interpreted organic motifs in Late Gothic churches in similar terms, asserting that the metaphor of the

paradisiacal garden displaced that of the heavenly city, which was dominant in the preceding centuries.

Crossley and Ethan Matt Kavaler provided more nuanced interpretations of vegetal ornamentation in Late Gothic buildings, arguing that the plethora of botanical forms and soaring arboreal vaults may have called to mind the dark aspects of nature (specifically sin and sexuality), in addition to the luxuriousness of the divine garden.[47] To support their claims, both scholars cited the work of Götz Fehr, who associated Late Gothic foliage with the forbidding images of the Danube school, in which forests are presented as sites of both good and evil.[48] Crossley and Kavaler make compelling arguments about the unruly foliage of the late Middle Ages. What is most relevant for my purposes, however, is not the specifics of their interpretations, but rather, their openness to the semantic potential of foliage in architectural contexts and, more important, their belief that organic motifs could signify broadly, which strongly recalls Krautheimer's concept of "multi-think."

Paul Binski approached foliage in a comparably supple way in his study of the discursive associations of the vegetal forms at the thirteenth-century cathedrals of Lincoln and Ely.[49] He suggested that the two crocket piers in the transept of Lincoln Cathedral may simultaneously have referenced Aaron's rod, which sprouted buds and almonds (Numbers 17:8), and the blossoming Church (Israel) described in Isaiah 27:6 and 35:1. His interpretation of the foliage in the choir of Ely Cathedral was more site-specific. According to Binski, the budding marble shafts of the triforium and foliated corbels in the spandrels of the main arcade relate to Saint Etheldreda, the royal foundress and abbess of Ely, whose hagiography "provides a coherent and specific context for the artistic rehearsal of ideas of growth, flourishing and incorruptible virtue."[50] My emphasis on the signifying capacity of foliate friezes is of a piece with Binski's flexible approach to the foliage at Lincoln and Ely. However, he analyzes different types of foliated architectonic members as a group, whereas my study centers on a particular component—the foliate frieze—and its singular associations.

My theory about the evocative capacity of foliate friezes came into sharper focus through my engagement with the work of Finbarr Barry Flood on the now-lost *karma* (vine) of the eighth-century Great Mosque of Damascus.[51] It was Flood who initially suggested a possible link between the frieze at Amiens Cathedral and the golden vine of Solomon's Temple, a biblical archetype he maintained informed the design of the Islamic Dome of the Rock (a building often conflated with the Temple), the Byzantine churches of Hagia Sophia and Saint-Polyeuktos, and the Umayyad mosque in Damascus.[52] Equally pertinent is Flood's discussion of the Damascene *karma*'s influence on Mamluk monuments of the thirteenth and fourteenth centuries.[53] His research informed my project on two levels: first by extending the possible associations of French foliate friezes to include the Solomonic, a connotation that applies specifically to friezes rather than to vegetal components more generally; and second by providing a parallel for the appropriation and transfer of a highly charged foliate motif from a revered prototype to later buildings.

ORNAMENT

I encountered two deeply engrained dichotomies pertaining to monumental foliage while preparing this book: the contrast between the ornamental and the structural and between the ornamental and the meaningful (the latter raising a third and related polarity—the freedom versus the non-freedom of the medieval craftsman in designing sculptural programs). Ornament has conventionally been defined as "motifs and themes used . . . without being essential to structure and

serviceability . . . [but] for the purpose of embellishment."[54] What became clear early in the course of my research (and what numerous scholars had already recognized) is that such binary constructions are by and large problematic and hinder rather than enable the study of non-figural motifs in medieval art and architecture. In a penetrating article published in 1998, for instance, Anne-Marie Sankovitch located the origins of the structure/ornament polarity in nineteenth-century architectural discourse and elucidated the ways in which this mode of description continues to color scholarship on premodern buildings. She stressed the impossibility of untangling ornament from structure, all the while affirming the existence of both, though not in the traditional oppositional manner.[55] Oleg Grabar examined the second binary pair primarily from the perspective of Islamic art and architecture in his influential *The Mediation of Ornament* of 1992, defining ornament both as an aesthetic element designed to provide pleasure and as a semantic object capable of evoking meaning, both of which bear directly on my project.[56] Scholars in varied fields have adopted Grabar's approach, including Thomas E. A. Dale, David Castriota, and Cynthia Robinson, who specialize in Western medieval, ancient Roman, and Mudéjar art respectively.[57]

Despite the ever-growing body of scholarship on ornament, the notion that foliate motifs serve no functions beyond the decorative (a thesis forcefully advanced by Owen Jones in *The Grammar of Ornament*) has never quite been put to rest.[58] William Travis, for example, compared the foliate capitals in the choir of Autun Cathedral to the black squares of a crossword puzzle, effectively reducing them to meaningless background elements interspersed amid the more important (historiated) capitals, which reference identifiable texts.[59] Travis' analogy is consistent with the writings of Ernst Kitzinger, who cautioned against mining the abstract patterns typical of Insular art for meanings and advocated imposing "very strict limits" on such approaches to guard against "wild and reckless interpretations."[60] Indeed, one of the challenges of studying ornamental motifs is that their complex polyvalence cannot be unlocked using conventional iconographic methods due to the absence of texts to which the forms can be anchored with certainty. The lack of textual evidence explicitly addressing the resonances of foliate friezes in architectural settings, however, in no way means that they were devoid of significance.

Equally germane to my project is the manner in which Grabar broadened the discussion of ornament beyond issues of meaning versus non-meaning by presenting it as a mediator between the viewer and the physical object. For him, ornament plays an intermediary role that is historically specific. Meaning, therefore, resides not within ornamental motifs themselves; rather, it is generated through encounters between ornamental forms and their viewers. The notion that ornament could forge connections between the viewer and the viewed was taken up by Kirk Ambrose, whose investigation of the capitals at the church of La Madeleine at Vézelay considered "how the physical disposition of foliate forms might have played a role in a monk's articulation of meaning as he moved through the space of the nave."[61]

Although these studies are informative in their own right, they are also valuable indicators of the surge in interest in ornament across different fields over the last twenty-five years. The English translation in 1992 of Alois Riegl's *Stilfragen: Grundlegungen zu einer Geschichte der Ornamentik*, an 1893 account of the transformation of select ornamental motifs over time, is another useful measure of this change, as are the studies of Jean-Claude Bonne, Paul Crowther, Lambert Schneider, Barbara Grünbaum, Jean Charles Depaule, James Trilling, Ethan Matt Kavaler, and others representing virtually every area of art history.[62] The shift in the scholarship is all the more evident when one considers Ernst Gombrich's authoritative survey of European ornament, *The Sense of Order: A Study in the Psychology of Decorative Art* of 1979 (a pendant to his earlier *Art and Illusion*), in which the work of Riegl figures prominently.[63] At the time of its publication, Gombrich's book was not only unmatched in scope, but it was also the first since the advent of modernism and the ensuing purge of all things

ornamental to engage at length with theories of ornamentation. Although Gombrich's psychologi-
cal approach to ornament is distant from my own, my discussion of the interrelation of the vegetal
frame (*ornamentum*) and the figural center (*imago*) draws on his analysis.

The overarching aim of this book is to demonstrate that vegetal friezes were integral and inte-
grating parts of the architectural ensemble, not to be dismissed as mere decoration or epiphenom-
ena. To this end, I adopted a synthetic approach to the buildings, examining the formal and semantic
relationships between interior friezes and exterior foliage, the vegetal and the figural, the frame
and the center, and monumental foliage and the liturgy. In addition to employing conventional
art-historical methods, this study draws on the disciplines of history, literature, musicology, sociol-
ogy, and anthropology. This book does not pretend to uncover all the potential functions of foliate
friezes in church settings, nor is it the final word on their complex webs of meaning. Rather, the
themes brought to the fore represent essential aspects of the friezes and the buildings they adorn, in
addition to serving as a point of departure for further explorations of a vast and richly layered topic.

THE CHAPTERS

This book consists of four interrelated chapters, each focusing on different aspects of foliate
friezes and their functions in sacred settings. Chapter 1 begins with a discussion of frame-field
relations, presenting foliate friezes as key parts of the consecrated architectural envelope with
ties to the unconsecrated natural environment. Next, it attends to visual, tectonic, and spatial
issues. Using the vegetal band at Amiens Cathedral as an exemplar, I outline the role of foliate
friezes as delineators of sacred space. I then orient readers to the large corpus of friezes in France
by surveying examples of interior and exterior friezes from different periods and regions. This
is followed by a discussion of related foliate sculptures, namely the ubiquitous organic bands
articulating church portals. The aim of this section is not to provide a comprehensive, chrono-
logical overview of foliate friezes and their stylistic development, but rather, to familiarize read-
ers with a class of objects whose lasting appeal in part lay in its versatility. After a brief survey of
foliate borders in non-architectural contexts, which speaks to the issue of shared practice across
media, the chapter concludes by considering the possible role of the abbey church of Cluny III
in the inception and spread of the foliate frieze phenomenon.

Chapter 2 focuses on the paradisiacal connotations of foliate friezes and other organic
sculptures by drawing on allegorical interpretations of the Late Gothic church as God's bower.
Relying on textual and visual evidence, I address not only the allegorical but also the formal
connections between church structures and the earthly and celestial paradise, arguing that all
three were understood in the Middle Ages as *loci* of divine presence, a function comparable to
the Ark of the Covenant, the portable Tabernacle of Exodus, and the Holy of Holies of the Jewish
Temple. Next I consider the relationship between the friezes and the Tree of Life, the *hortus
conclusus*, and the Garden of Joseph of Arimathea (the location of Christ's rock-cut tomb and
Resurrection), all of which present the garden not as a memory of an unstained and divinely
created past, but as a projection into an eschatological future. The chapter ends with an account
of the possible negative connotations of foliage in churches, which relate to the Fall of humanity
and the Expulsion of Adam and Eve from the Garden of Eden.

Chapter 3 shifts the emphasis to the messianic and Eucharistic aspects of foliate friezes, many
of which depict grapevines or plant forms that were likely interpreted as such. Christ's words to

his disciples recorded in John 15:1 serve as the foundation for this interpretation: "I am the true vine and my Father is the husbandman." This passage is the basis for the identification of the vine and its fruit with Christ, a notion that found visual expression in a variety of artistic media from the Early Christian period onward. Beyond linking foliate friezes to Christ, the main contribution of this chapter is the connections it makes between the vegetal and the figural, on the one hand, and between interior and exterior designs, on the other hand. I demonstrate that the botanical friezes articulating the borders of church portals not only thematically complemented (and at times amplified) central/figural scenes, but also functioned as signposts for the foliage inside buildings. In other words, exterior designs modulated the visitor's experience of interior spaces. Thus, this chapter sheds new light on the dynamic interaction between sculpture, architecture, and the viewer, while also illuminating and complicating interconnections of edge and center, exterior and interior, and form and liturgy, links activated by the experiencing subject as he or she paused before portal imagery, crossed church thresholds, and circulated through interior spaces.

Chapter 4 posits a relationship between foliate friezes and the monumental golden vine of Solomon's Temple in Jerusalem. The Temple vine, which is described by the Romano-Jewish historian Flavius Josephus (d. 100) in *Antiquities of the Jews* and *Jewish Wars*, two texts that circulated widely in the medieval West, was an arresting feature of the entrance to the *hekhal*, or sanctuary. I argue that French builders drew on textual descriptions of the Temple vine, in addition to the golden vines inside the Umayyad Dome of the Rock, an overtly Solomonic building believed to occupy the site of the Temple. The historical context reinforces the Temple vine/foliate frieze connection. The proliferation of foliate friezes in France coincided with a crucial period in East-West relations: the Crusades, which afforded visitors from the Latin world unprecedented access to the Dome of the Rock and its glittering vines. By addressing the transfer of a distinctive architectonic element from Jerusalem to France, this chapter provides a novel perspective on intercultural artistic exchange in the Middle Ages, while also explicating the appearance and spread of a particularly resonant motif in the religious architecture of medieval France.

In his biography of the Cistercian reformer Bernard of Clairvaux (d. 1153), William of Saint-Thierry (d. 1148) wrote of the central place of the natural environment in the life of his illustrious predecessor:

> Even to this day he [Bernard] will claim that it was by praying and meditating in the woods and fields that he discovered the deep meaning of Holy Writ. And he will jokingly say to his friends that it was only the oaks and beeches who were his masters in this subject.[64]

Bernard's letter of around 1125 to the Englishman Henry Murdach addresses the joys of monastic life and echoes this statement:

> Trust my experience: one learns more between the trees of the forests than in books. The trees and rocks will teach you a wisdom you will not hear from your teachers. Or do you expect to suck honey from stone and oil from the hardest rock?[65]

William and Bernard's remarks attest to the medieval belief in the capacity of the vegetal world to aid in revealing spiritual truths. What follows is an account of how the mutually informative relationship between natural forms and the Word was inscribed and perceived in the stones of the French church.

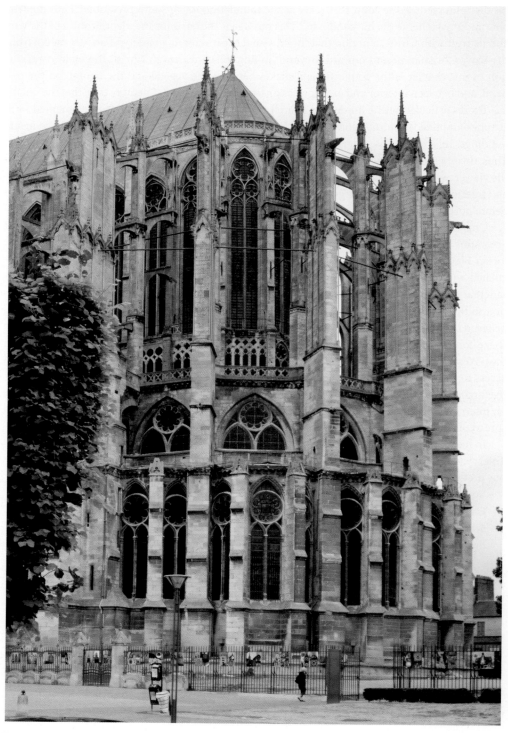

FIGURE 1.1 Beauvais Cathedral, choir, begun ca. 1225

Photo: author

The Foliate Frieze as Architectonic Framing Device

THE CHURCH EXTERIOR ENCLOSES SACRED SPACE LIKE A PICTURE FRAME separating the field of representation from its immediate environment. In the same way that a painting creates a world that ends at its edges, the architectonic frame of the medieval church divides sacred space from the surrounding landscape, standing out "like a figure on a ground."[1] The foliate friezes introduced into French church design at the turn of the twelfth century are broadly implicated in defining the limits of the sacred due to their placement on the borders of buildings. Alongside other elements forming the interior and exterior faces of the architectural envelope (that is to say, either side of the frame), such as luminescent stained glass windows and prismatic flying buttresses, the friezes articulate sanctified space and help define its visual character.[2]

THE SACRED FRAME

In art history and aesthetic theory, the frame is understood to give form and an ontological presence to space, which "otherwise threatens to dissolve in aporia," to borrow the words of D. N. Rodowick.[3] To clarify, I am not referring to the "law of the frame" in which the figure conforms to the shape of its architectural setting, a familiar concept for medievalists put forth by Henri Focillon and developed by his student and son-in-law, Jurgis Baltrušaitis.[4] Rather, what interests me is the dual role of the architectural frame as a delineator and indicator of the sacred. All buildings by definition have boundaries, but the exterior walls of medieval churches were designed both to communicate their sacred character and to set them apart from their surroundings, which consisted (for urban churches) of densely packed domestic and civic structures set along narrow streets, as well as small ecclesiastical buildings, such as oratories, baptisteries, and chapels. Flying buttresses, for instance, were generally reserved for monumental religious buildings and so likely functioned as visual indices of the sacred for medieval audiences. Similarly, architectural gigantism, which was closely but not exclusively associated with clerical construction projects, communicated to beholders the status of churches as sacred places invested with special

privileges (fig. 1.1). Even small rural churches stood out in the midst of agrarian buildings and the natural landscape because of their quality and durability (fig. 1.2). Beyond these distinguishing features, it was the symbolic vocabulary of the medieval church—its *koine*—which could include a cruciform plan, chapels, and sculptural decoration, that signaled to viewers the exceptional character of the spaces within, often from great distances. These visual signs of distinction worked in tandem with non-visual indicators of status, such as the reverberations of liturgical chant, the metallic clanging of bells, and the acrid smell of burnt incense, all of which confirmed and reasserted the sanctity of the spaces. These multisensory cues served to hierarchize space, such that the numinous, ethereal spaces of the church both contrasted with and were constitutively defined by the profane exterior world.[5]

Theories of frame-field relations in the figurative arts serve as productive touchstones for my interpretation of the role of architectural ornament in demarcating and evincing the sacred. In his expansive study of European ornament, for example, Ernst Gombrich remarked that the pictorial frame could perform a wide range of functions, such as directing the viewer's attention, setting off, labeling, and even celebrating, all of which it achieves primarily through ornamentation. He argued that the profusion and repetition of ornamental motifs blur the periphery, resulting in a heightened awareness of the center. For Gombrich, the frame did not simply delimit, but it also helped define the center, to which it is inextricably linked: "Without a frame there can be no center. The richer the elements of the frame, the more the center will gain in dignity. We are not meant to examine them individually."[6] Gombrich made these observations in relation to the ornate eighteenth-century frame enclosing Raphael's *Madonna della Sedia* (ca. 1513–1514) (fig. 1.3). His comments, however, are equally applicable to architecture, which demands the concurrent treatment

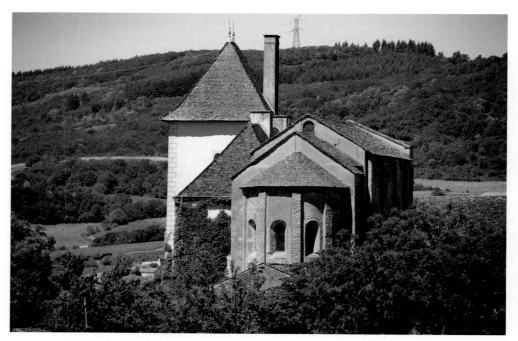

FIGURE 1.2 Cluniac chapel, Berzé-la-Ville, eleventh century
Photo: author

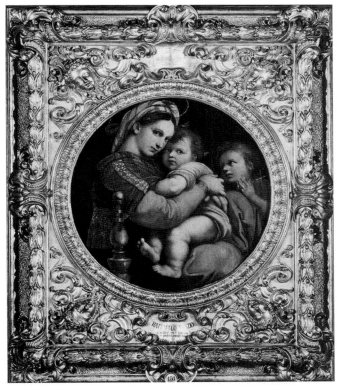

FIGURE 1.3 Raphael, *Madonna della Sedia*, ca. 1513–1514,
Florence, Palazzo Pitti

Photo: Jennifer Udell

of solids/exterior shell and voids/interior space (in other words, of frame and center). A similar
case can be made for church portals, where foliate and abstract ornamentation often frames fig-
ural imagery (see figs. I.9, I.10). The ordered repetition of limited, yet flexible sets of forms allows
architectonic members to captivate, set off, and label as effectively as a pictorial frame, while the
materials, craftsmanship, and spatial and surface effects of the architecture stimulate the senses.

The outer limits of the church delineated, with the permanence of stone, space made sacred
during the ephemeral consecration rite, a ceremony that can be traced to the eighth century.[7]
Consecration bestowed certain privileges on spaces and integrated them into a network of places
broadly understood to be sacred. Medieval sources, such as *De sacramentis* by the scholar-monk
Hugh of Saint-Victor (d. 1141) and the *Rationale divinorum officiorum* of Durandus (d. 1296),
reveal that the consecration rite had three main phases.[8] The first involved separating the build-
ing from its physical setting with two encircling processions by the bishop, and then a third
procession by the bishop, clergy, and congregation. The second saw to the purification and forti-
fication of the ritually cleansed space and altar with aspersions of hyssop, holy water, and blessed
salt. The third, which focused on protecting the building, included the interment of relics and
the anointment of the altar and the walls of the church. The ceremony ended with the celebration
of Mass. In addition to differentiating the interior from the exterior by sacralizing the former,
this multipronged ritual transformed the stones of the church themselves, making them sacred

in perpetuity, even in the event of damage.[9] Consequently, after consecration, the materials used to construct a church could be reused to build or repair another church, but not a lay structure.[10] Through the consecration rite, then, the stone bands of foliage articulating the boundaries of churches were not simply made to delineate the sacred, but they also became sacred themselves.

The hierurgy of stone appears in abbot Suger's *De Consecratione*, a key source for modern interpretations of twelfth-century French architecture.[11] In his description of the reconstruction of the west front (1130/35–1140) and choir (1140–1144) of Saint-Denis, Suger endorsed the destruction of parts of the old church to make room for the new project, yet he also proclaimed his esteem for the existing building: "Deliberating under God's inspiration, we choose—in view of that blessing which, by the church and by the extension of [Christ's] own hand—*to respect the very stones, sacred as they are, as though they were relics*."[12] In addition to justifying the radical design of the new building, its extravagance, and its cost, three factors that should not be underestimated in the context of the contemporary monastic reform movement spearheaded by Bernard of Clairvaux, Suger was defending the demolition of a building whose stones had been sanctified at the moment of its consecration.[13] According to Suger, the sacred stones of Saint-Denis were held together not by mortar, but by divine intervention: "Jesus Christ Himself being the chief cornerstone which joins one wall to the other, in Whom all building—*whether spiritual or material*—groweth unto one holy temple in the Lord."[14] This passage paraphrases Ephesians 2:19–21, but Suger augmented the biblical text in two critical ways: first, he attributed a role to Christ in bonding the walls; second, he specified that this joining was a material as well as a spiritual phenomenon.[15] Setting aside the question of Suger's agenda, which has been subject to much debate, these passages point to the transformation of the physical fabric of the church (achieved through divine assistance and consecration), resulting in the sacralization not just of the space of the church, but also of the individual stones enveloping it. It has been suggested that references to the transitory act of consecration were sometimes incised directly into medieval churches. At the thirteenth-century cathedral of Reims, for example, statues of Christ and angels process in perpetuity around the choir, their actions and liturgical implements seemingly alluding to the evanescent dedication ritual (fig. 1.4).[16]

As constituent features of the architectural frame, the foliate friezes encircling French churches and their portals interact with the consecrated buildings of which they are part and with the unsanctified realm of nature beyond their limits.[17] The friezes contribute to the splendor of church structures. Moreover, their incorporation into the sacred fabric is congruent with the Christian worldview formulated in biblical and cosmological texts, which presents the entire world, including vegetation, as the product of God's creation. To be clear, the "nature" one encounters in the representational space of the medieval church is tamed or cultivated and would have been broadly understood as such by France's predominantly agrarian population. Although many foliate friezes are naturalistically carved, under no circumstances are they (or any foliate sculptures) unmediated reflections of the plant world in its natural state, a point lucidly made by Nikolaus Pevsner in his evocative study of the foliage inside the thirteenth-century chapter house at Southwell Minster.[18] Pevsner claimed that the sculptors at Southwell were inspired by the flora of the English countryside (a claim difficult to verify given the changes to Europe's plant population over the centuries), but he also recognized that the vegetal forms were highly regularized and uniform in scale. This idealized naturalism led Pevsner to characterize the leaves of Southwell as a balance between style and nature.[19] Indeed, the contrast between the irregularity and impermanence of organic matter and the standardization and immutability of stone sculptures clearly differentiates real plants from their lithic counterparts. Such distinctions would not have been lost on medieval beholders and are well documented in the written

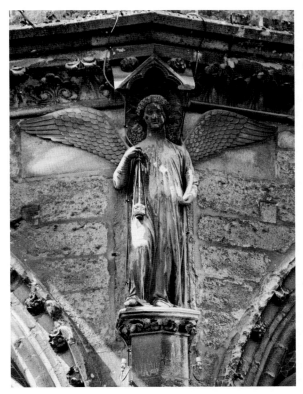

FIGURE 1.4 Reims Cathedral, choir angel
Photo: author

sources of the period. In the *Metrical Life of Saint Hugh* of ca. 1220–1230, for instance, Henry of Avranches distinguishes between the perishability of wood and the durability of stone in his description of the (re)construction of the vaults at the monastery at Witham.[20] Within sacred architectural contexts, impervious stone and flawless organic forms are highly suggestive of nature in its uncorrupt, prelapsarian state, as well as its living (and hence decaying) equivalent, a key binary for understanding the monumental flora in and on churches.

THE FRIEZE AT AMIENS CATHEDRAL: AN EXEMPLAR

The foliate frieze was a ubiquitous and malleable device that connected sacred spaces to the natural environment, while also punctuating and interlinking particularly important sections of churches. Botanical friezes initially proliferated in France at the turn of the twelfth century in Burgundian churches directly associated with or located in proximity to the now-destroyed abbey church of Cluny III. I begin my analysis not with these modest early examples, but with the longest and most spectacular foliate band in France: the frieze at Amiens Cathedral (see figs. I.1–I.4). I selected this frieze as my exemplar not simply because of its size and remarkable formal qualities, but also

because it adorns one of the best-studied buildings of the Middle Ages. Scholarship on the cathedral of Amiens dates back to the nineteenth century and the building continues to receive critical attention. Notable monographs on the cathedral are those of Antoine Gilbert, Jean Baron, Georges Durand, Louise Lefrançois-Pillion, Alain Erlande-Brandenburg, Stephen Murray, Anne Egger, and Dany Sandron.[21] Conventionally held up as a key monument in the process toward greater height and more daring voids, and as the culmination of the highly lauded Chartrain series, the cathedral also features in general surveys of Gothic architecture and in more focused investigations of the High Gothic.[22] Furthermore, its three architects, whose names were preserved in the labyrinth inlaid in the nave pavement (destroyed in 1825), geometric matrix, daring buttressing system, streamlined *piliers cantonnés*, figural sculptures, stained glass windows, and standardized lateral chapels have all been the subject of specialized studies.[23] One would expect the foliate frieze, which stretches virtually uninterrupted for over 350 meters—a measurement surpassing the length of three football fields—to figure substantially in this vast corpus, but that is not the case.[24] With the exception of Murray, who interpreted the frieze through the lens of the yearly Saint Firmin festival at Amiens, scholars have focused on the frieze's style, which they have used alongside other evidence to establish the building sequence, identify the campaigns of each architect, and posit links between the cathedral and earlier models.[25] In brief, the frieze has not been treated as an object of study in its own right, nor has it been considered in relation to broader trends in twelfth- to fifteenth-century French architecture, two imbalances I seek to redress.

The frieze at Amiens Cathedral is a massive piece of sculpture comprising tangled leaves, stems, tendrils, and fruit bunches bordered by two narrow torus moldings (see fig. I.4). In addition to highlighting the main processional route inside the building, the frieze contributes to the visual logic and internal organization of the cathedral because of its location at the 21-meter mark, the precise midpoint of the elevation (fig. 1.5). The frieze serves the dual role of physically and symbolically dividing the nave wall into lower (terrestrial) and upper (celestial) zones, while also creating a visual bridge between the main arcade at the bottom of the elevation and the triforium, clerestory, and vaults above. It alternates between anchoring and bisecting the web of linear elements articulating the walls, acting as a stabilizing force for the vertical shafts rising from the bottom of the triforium, all the while contributing to the dynamism of the building by traveling over the responds that spring from the arcade piers to meet the high vaults (fig. 1.6). The frieze is one of only two horizontal elements to run continuously down the length of the nave, lending a strong longitudinal emphasis to a building otherwise characterized by an explosive vertical drive.[26] Unlike the anemic stringcourse ringing the cathedral directly beneath the clerestory windows, the foliate frieze is a highly detailed, plastic, and therefore eye-catching aspect of the elevation (see figs I.2 and I.3). Not only is the clerestory fillet a fraction of the height of the foliate band, but its curved form perfectly matches the slender colonnettes of the triforium, the mullions in the windows, and the vault responds. In short, it blends seamlessly into its surroundings, despite its horizontality. By contrast, the frieze is among the few foliated elements inside the cathedral, it stands at approximately 40 cm in height (a measurement roughly commensurate with the courses of stone below), and it projects emphatically from the plane of the wall. Although the current colorless windows are particularly conducive to viewing the frieze, stained glass would not have hindered its legibility, a point well made by the more or less contemporary cathedral of Metz, whose windows are filled with colored glass made between the thirteenth and twentieth century (fig. 1.7). A broad band of foliage set beneath a fictive curtain runs between the triforium and clerestory of Metz Cathedral.[27] Despite the relative darkness of the building, the ability of the human eye to adjust to extreme variations in light, a process known as adaptation in ocular physiology, makes the frieze a perfectly legible component of the elevation.[28]

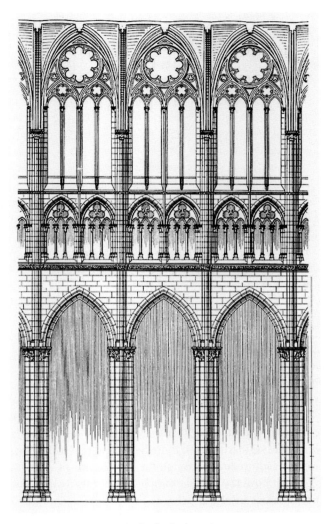

FIGURE 1.5 Amiens Cathedral, elevation
After Dehio and Bezold

The original polychromy of Amiens Cathedral would have made the frieze all the more striking for its medieval viewers. The cathedral's painted decoration was almost entirely effaced in the eighteenth century, but the bold hues discovered during the restoration of the west façade between 1992 and 1999 provide clues about the transformative impact of paint on the design and reveal that the frieze was part of a vibrantly colored ensemble featuring saturated reds, oranges, blues, greens, yellows, and importantly, gold.[29]

The extent and precise nature of the frieze's polychromy are impossible to determine with certainty due to losses, but important distinctions seem to obtain. The brownish-red pigments visible on the frieze, notably on the west side of the north transept, are probably red ochre and likely served as underpainting for other layers of color. These subsequent layers were almost certainly gold or green, the two most common colors for architectural flora in France from the mid-twelfth to the mid-fourteenth century.[30] It is possible that the frieze was originally painted

FigurE 1.6 Amiens Cathedral,
transept frieze
Photo: author

in a naturalistic hue as at the cathedral of Le Mans, where green pigments speckle the foliate band above the portal on the south side of the choir. However, gilding is an equally likely possibility given the extensive use of gold leaf on the exterior sculptures of the cathedral, namely on the central and south portals of the west façade and on the south transept door, aptly called the *portail de la Vierge Dorée* (portal of the Golden Virgin).[31] Indeed, portal sculptures seem to have been gilded with some regularity in high medieval France. Of the twenty-three buildings in Isabelle Pallot-Frossard's informative essay on the polychromy of French portals, more than half have traces of gold leaf.[32] All the gilded examples date to the twelfth and thirteenth centuries. Gilding was also pervasive inside churches in this period, a trend best exemplified by the Sainte-Chapelle of Paris, the resplendent royal chapel built under the patronage of king Louis IX (fig. 1.8). Though heavily restored, the chapel's painted scheme is based on medieval remains and incorporates lavish amounts of gold complemented by brilliant reds and blues.[33] The Sainte-Chapelle is particularly informative because it attests to an inclusive approach to gilding in the architecture of the Middle Ages, with gold decorating not only figural sculptures, but also vegetal motifs (fig. 1.9). The precious treatment of sculpted foliage, moreover, was not restricted to well-funded royal commissions like the Sainte-Chapelle. For example, the sheaths of wheat in the Cain and Abel capital in the nave of the cathedral of Chalon-sur-Saône (mid twelfth century) are enriched with gold leaf; the ivy and blossoming eglantine on two capitals from the dismantled jubé of Chartres Cathedral (1230–1240) have remnants of gold, green, and red paint; and a capital from the north transept façade of Notre-Dame of Paris (before 1258) is dressed with gold vine leaves set against a vibrant red background (fig. 1.10).[34] Although I have not come across any gilded organic friezes, the twelfth-century examples from Cluny III and Autun Cathedral have vestiges of yellow paint, which may have been intended to mimic gilding (fig. 1.11).[35]

Whether the foliate band at Amiens Cathedral was painted gold, yellow, green, or another hue, it would have stood out amid the other colors and forms inside the building. In his broad study of the interior polychromy of Gothic buildings, Jürgen Michler concluded that the walls

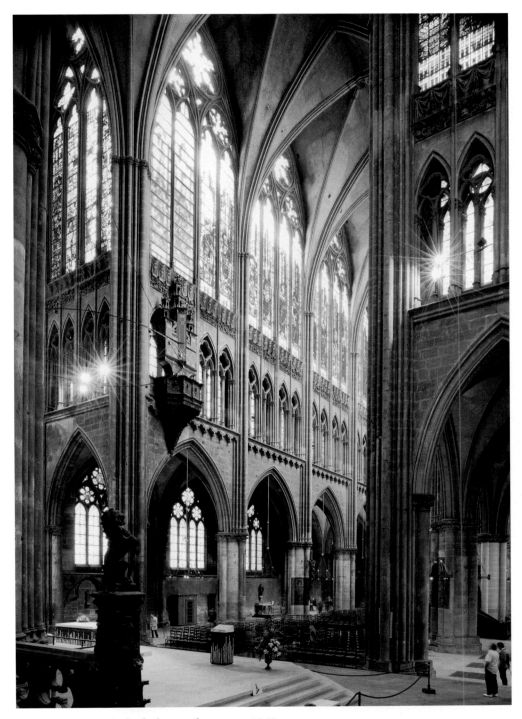

FIGURE 1.7 Metz Cathedral, nave, begun ca. 1245

Photo: © Mapping Gothic France, Media Center for Art History, The Trustees of Columbia University, Department of Art History and Archaeology

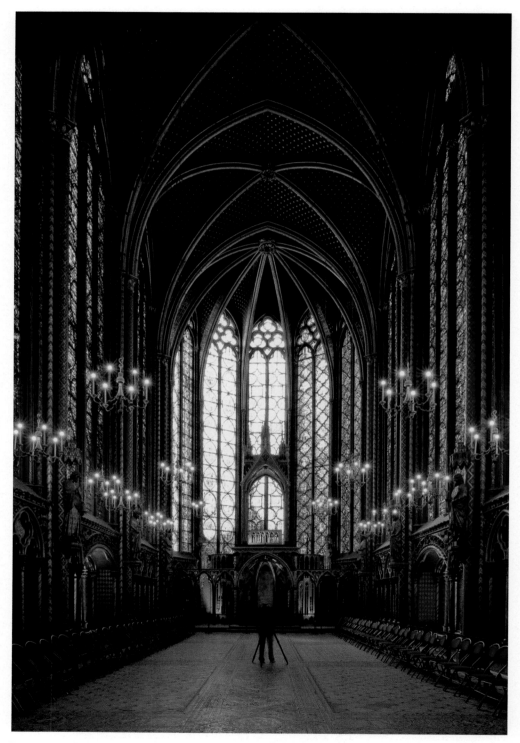

FIGURE 1.8 Sainte-Chapelle, Paris, upper chapel, 1239–1248

Photo: © Mapping Gothic France, Media Center for Art History, The Trustees of Columbia University, Department of Art History and Archaeology

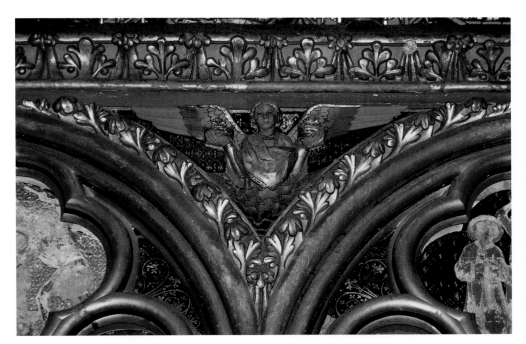

FIGURE 1.9 Detail of I.8

Photo: author

FIGURE 1.10 Notre-Dame, Paris, north transept capital, before 1258, Paris, Musée national du Moyen Âge (Cl. 23186)

Photo: author

FIGURE 1.11 Autun Cathedral, nave frieze, begun ca. 1120

Photo: author

of many French churches were painted a subdued shade of grey with white joints.[36] If this were the case at Amiens Cathedral, the neutral backdrop would have functioned as a foil for the vividly colored frieze. Even without its original paint, the frieze at Amiens remains a conspicuous feature of the cathedral due to its size and central position in the elevation. The frieze is all the more arresting because of the marked contrast between its pliable, organic appearance and the geometric and figural forms that characterize the rest of the interior (column capitals and vault bosses notwithstanding).[37] It is precisely the strict opposition to the abstract and figural that lends the frieze its forceful presence.

The foliate band at Amiens Cathedral lines the retrofaçade and travels continuously down the length of the nave, undulating over the bundled colonnettes that mark the limits of each bay. The fleshy, lobed leaves in this section of the building cannot be identified as belonging to a specific plant species, but the sinuous stems from which the leaves sprout are suggestive of vines and the bunches of round fruit that emerge from between the leaves unmistakably resemble grapes (see fig. I.4).[38] The sculptors carved the nave frieze with great care and technical precision, running masonry seams unobtrusively through vine stems rather than individual leaves and grape clusters.[39] Their dexterity is also apparent in the suppleness of the plant forms and the bold undercutting. The design of the frieze is self-replicating, with each segment corresponding to a single bay and comprising an almost identical series of horizontally oriented leaves interspersed with fruit and ending with a graceful, interlaced stem. The ordered complexity and exact repetition of motifs strongly suggest that the sculptors worked from templates, whereas the horizontality of the design gives the frieze a directional emphasis. Indeed, the frieze seems to sprout from the northwest corner of the retrofaçade, traveling counterclockwise around the building. Its journey is interrupted only in the area of the transept, where it leaps over the crossing piers and makes a series of sharp turns before wrapping

around the choir, where the faux realism of the nave foliage gives way to rigidly conventionalized leaf forms. Despite its stylization (particularly on the east end of the building), the frieze as a whole has a garland-like quality, lending the cathedral a festive appearance.[40]

INTERIOR FRIEZES

The audacious size of the foliate band at Amiens Cathedral and the skill with which it was carved are unparalleled, but the idea of framing sacred space with a botanical frieze is not unique, nor did it originate at this cathedral. Early examples in France appear in buildings in Burgundy and Champagne in the first half of the twelfth century. Over time, friezes proliferated in churches in Picardy, Normandy, the Loire, the Île-de-France, and throughout much of France. The friezes vary stylistically, with builders from different periods and places translating the motif into the current local idiom. Despite their stylistic differences, the friezes remain firmly linked conceptually by their role as articulators of sacred space and their roots in the natural world (loose as the latter may sometimes be).

Like the example at Amiens Cathedral, many friezes consist purely of organic forms, incorporating a variety of leaves, fruit, flowers, and stalks into their designs, alone or in combination. That having been said, it is not uncommon to see human figures, animals, birds, and fantastical creatures inhabiting or even cavorting amid the foliage. One finds a modest example inside the twelfth-century church of Notre-Dame-en-Vaux at Châlons-en-Champagne, where a carved human head lurks within the string of coiling leaves below the choir gallery (fig. 1.12). The head,

FIGURE 1.12 Notre-Dame-en-Vaux, Châlons-en-Champagne, choir frieze, second half of twelfth century

Photo: © Mapping Gothic France, Media Center for Art History, The Trustees of Columbia University, Department of Art History and Archaeology

which is about the same size as the flanking vegetal scrolls and mimics their curvilinear shape, is tucked unobtrusively beside a colonnette and can easily go unnoticed. Its discreet (and for the modern viewer enigmatic) presence stands in stark contrast with the prominent but badly damaged angels that bookend the fifteenth-century frieze in the north transept of Le Mans Cathedral (fig. 1.13). The angels hold shields carved with royal arms that seem to announce the sanctity of the French monarchy, an interpretation that accords with the patronage of the transept by king Charles VI (d. 1422).[41] As Michael Camille observed, however, border images, including sculptures in the upper reaches of buildings, are generally equivocal and resistant to simple interpretation.[42] The frieze at Le Mans Cathedral, for instance, contains figures whose meaning(s) are more opaque than the heraldry-bearing angels of the north transept, one of which strikes an acrobatic pose. The juxtaposition of a dove pecking at fruit (a traditional symbol of the Holy Spirit) with dragons regurgitating vine shoots in the fifteenth-century nave frieze at Notre-Dame in Poissy is similarly ambiguous, recalling the eclectic images that began to populate the margins of manuscripts across Europe in the thirteenth century (see fig. I.8).

Foliate friezes vary stylistically depending on their date and place of origin, and developed in tandem with other types of sculpted foliage, including column capitals, corbels, and vault bosses.[43] Early examples of foliate friezes are decidedly schematized, such as the ones at Saint-Rémi at Reims (begun 1160–1170) and the related church of Notre-Dame-en-Vaux at Châlons-en-Champagne (see figs. I.5 and 1.12).[44] These friezes are strictly regular and stiff, but their bourgeoning scrolls unambiguously ground them in nature. Some of the leaves even terminate in diminutive fruit clusters, details that would have been all the more apparent with the original paint. The severity and

FIGURE 1.13 Le Mans Cathedral, transept frieze, 1470s

Photo: © Mapping Gothic France, Media Center for Art History, The Trustees of Columbia University, Department of Art History and Archaeology

bulkiness of these foliate bands is at odds with the refined suppleness and detailed drill-work of the nearly contemporary rinceau wrapping rhythmically around the east end of Langres Cathedral (begun ca. 1160) (figs. 1.14, 1.15).[45] None of these early examples, however, portrays identifiable plant species, which is typical of twelfth-century foliate friezes. By contrast, foliate bands from later periods, such as the fifteenth-century frieze girding the transept of Le Mans Cathedral, tend to lie on the naturalistic end of the stylistic spectrum (fig. 1.16).[46] The verisimilitude of the alternate leaf arrangement, palmately lobed and serrated leaves, and bunches of round fruit reveal that the sculptors specifically had grapevines in mind when they carved this frieze. It bears repeating, however, that even naturalistic friezes stray from their real-world referents. Although the frieze at the cathedral of Le Mans is clearly identifiable as a grapevine, it was not rendered with scientific precision.[47] Furthermore, as Jean Givens observed, even foliage carved with exacting detail was not necessarily the product of direct observation.[48] Instead of the imperfect, jumbled forms one encounters outdoors, the vine frieze at Le Mans Cathedral looks overly manipulated, its uniform, unblemished leaves unfolding around the transept with the regularity of paper chain figures. Such friezes lend indeterminacy to the walls they adorn, belonging both to the exterior world of nature and to a preternatural realm in which nature is subsumed by artifice.

The foliate bands in French churches may be stylistically diverse, but their position inside buildings is remarkably predictable. The friezes consistently run below triforia, galleries, and clerestory windows, bisecting elevations horizontally and creating a symbolic bridge between the earthly sphere of the visitor below and the heavenly realm of God, Christ, and the saints above. Some buildings have a single interior frieze, like the cathedrals of Langres and Amiens, and the church of Notre-Dame at Moret-sur-Loing (second half of the thirteenth century), but often friezes appear at multiple levels, as at Saint-Rémi at Reims, Notre-Dame-en-Vaux at Châlons-en-Champagne, Notre-Dame-Saint-Laurent at Eu (begun ca. 1186), Saint-Jacques at Dieppe (thirteenth century), Notre-Dame at Poissy (fifteenth century), and Saint-Maclou in Rouen (begun 1436).[49] Some friezes ring churches entirely, while others are restricted to specific areas, most often, though not exclusively, to the east ends of buildings.

The last point raises the intriguing possibility that foliate friezes functioned as visual indicators of spatial hierarchies, and not just delineators of sacred space. The gendered separation of the nave into right (male) and left (female) sides was standard in the Latin church from Early Christian times, as evidenced by the fifth-century *Testamentum Domini*.[50] Many churches were also divided along east-west lines, a hierarchy most clearly expressed architecturally by variations in the relative heights of choirs and naves. It is the second of these divisions that is most germane to the study at hand. The rinceau at Langres Cathedral, for example, curves and swells around the space of the choir and the east side of the two transept bays immediately adjacent to the crossing (see figs. 1.14 and 1.15).[51] The frieze is conspicuously missing from the outer bays on the east side of the transept, the transept's terminal walls, the western side of the transept, and the entire nave. Put another way, the frieze only decorates the areas closest to the choir and high altar. That the cathedral of Langres was built from east to west without major interruption suggests that the embellishment of the sanctuary with a foliate band and its omission from the rest of the building was deliberate, rather than the product of a change in personnel or an unconsciously "evolving" style. The foliate frieze, then, seems to have been used strategically inside the cathedral to help mark the choir as a particularly important zone of sacrality. This reading of the frieze and its relationship to the building as a whole is of a piece with the theory of architectural decorum put forth by Dieter Kimpel and Robert Suckale in their survey of French Gothic architecture, whereby medieval designers relied

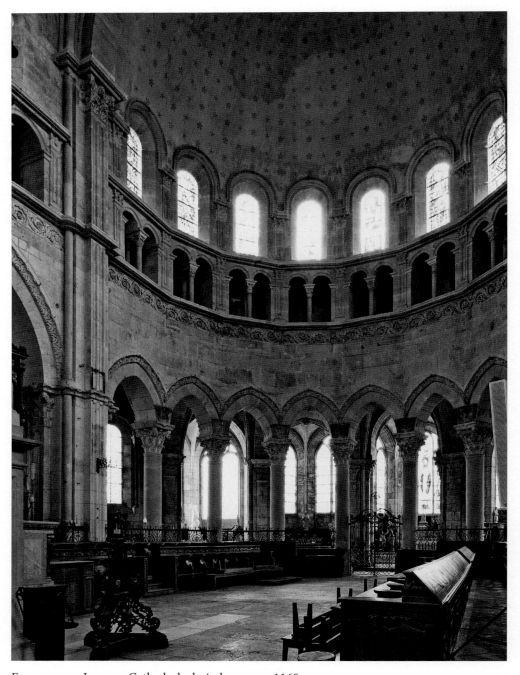

FIGURE 1.14 Langres Cathedral, choir, begun ca. 1160

Photo: © Mapping Gothic France, Media Center for Art History, The Trustees of Columbia University, Department of Art History and Archaeology

FIGURE 1.15 Detail of I.14

Photo: © Mapping Gothic France, Media Center for Art History, The Trustees of Columbia University, Department of Art History and Archaeology

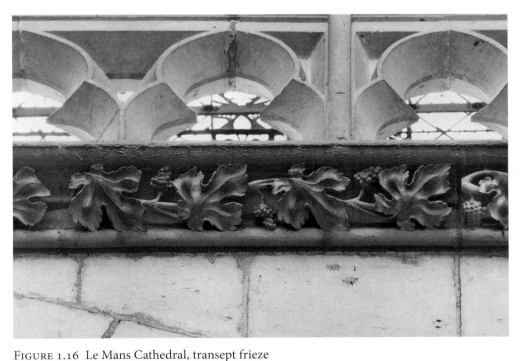

FIGURE 1.16 Le Mans Cathedral, transept frieze

Photo: © Mapping Gothic France, Media Center for Art History, The Trustees of Columbia University, Department of Art History and Archaeology

on formal devices to indicate gradations of sanctity inside churches, notably to convey the status of the choir as a prime location for relics and a focal point of worship.[52]

EXTERIOR FRIEZES

So far this chapter has focused exclusively on foliate friezes articulating the inner faces of the architectural frame, but vegetal bands were equally prominent outside churches. Exterior friezes adhere closely to their interior counterparts in formal and functional terms, and they proliferated at about the same time. They fall into two related types, the first consisting of friezes that surround churches entirely (or large sections of churches, such as choirs); the second comprising friezes framing church portals. In both cases, the bands of foliage are not simply ornamental, but also signal the exceptional character of the spaces they adorn.

The foliate friezes at the Premonstratensian church of Saint-Yved in Braine (ca. 1176–1208) fit squarely into the first category (fig. 1.17).[53] Two friezes demarcate the choir and the two

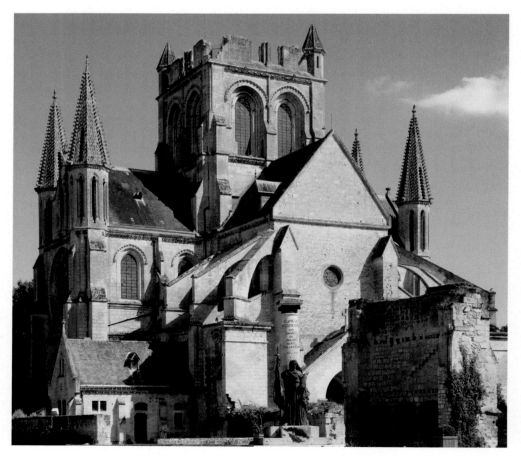

FIGURE 1.17 Saint-Yved, Braine, view from northwest, ca. 1176–1208
Photo: author

easternmost nave bays, one directly above the lower windows and the other below the eaves of the roof. Comparable friezes dress the transept façades and crossing tower above and below the windows (fig. 1.18). The west façade and four western nave bays were demolished between 1829 and 1848 during a series of restoration campaigns aimed at repairing damages caused during the French Revolution.[54] Given that the bands travel uninterruptedly around the rest of the building (bypassing only the buttresses), there is every reason to believe that the west end of the church also received foliate friezes. Even if the western bays were devoid of vegetal bands, however, this section of the building was not entirely devoid of organic decoration. A vine rinceau with miniature grape bunches identical to the upper frieze on the rest of the church fills the outer archivolt of the central portal, which was relocated to the retrofaçade in the nineteenth century to preserve what remains of its medieval paint (fig. 1.19).[55]

Pre-restoration engravings reveal that the foliate friezes at Saint-Yved maintain their original appearance, despite heavy-handed interventions in the nineteenth century.[56] The friezes include elegant palmettes on the apse; stiff palmettes on the chapels and lower transept; fleshy, fruit-bearing palmettes in the upper nave; and fluidly rendered rinceaux with tubular stems in the upper transept and nave aisles.[57] In addition to relieving the otherwise severe design, the exterior friezes at Saint-Yved, much like interior foliate bands in other churches, divide the building horizontally into upper/celestial and lower/terrestrial zones, as well as gesturing toward the unconsecrated vegetal realm beyond the sanctified limits of the church. It should be stressed that the natural world was not just an abstract, distant concept in the Middle Ages, but a central aspect of agrarian life. Equipping Saint-Yved with recognizable (though not mimetic) plant forms lent familiarity to the building, not just for peasants

Figure 1.18 Saint-Yved, Braine, transept frieze
Photo: author

and secular nobles, but also for the local clerical community whose wealth derived largely from land ownership.[58]

Foliate friezes similar in placement and function to those at Saint-Yved became common features of French church exteriors starting in the twelfth century. At Laon Cathedral (begun ca. 1150), bands of leaves encircle the cathedral at the eaves of the roof and above the gallery windows.[59] The five towers, two transept chapels, and four façades, including the south transept façade, which was remodeled in the early fourteenth century, also received foliate friezes, as did the various apertures (figs. 1.20, 1.21).[60] Like the examples at Saint-Yved, the friezes at the cathedral of Laon are stylistically heterogeneous, reflecting the protracted building process and the generations of sculptors involved in the project. The friezes range from rigid palmettes to interwoven rinceaux, two forms that find parallels at Saint-Yved. Comparable in function and position, if not style, are the ubiquitous rows of regularized foliage lining the exterior of many twelfth- and thirteenth-century churches. At Chartres Cathedral, for instance, two crocket friezes run around the main body of the building, their strong lines and rigid surface effects catching and holding the eye (fig. 1.22). As severe as they are, these friezes nonetheless belong to the vegetative world, a connection made all the more obvious when one compares them to the geometric stringcourses that dominated architectural design before moldings morphed into living forms. A case in point is the eleventh-century church of La Trinité at Caen, which contains a rich array of moldings carved with billets, zigzags, crenellations, and spiraling cables, but not a single botanical frieze (figs. 1.23, 1.24).

I have already touched on the second category of exterior foliate frieze in my discussion of Saint-Yved in Braine—the portal frieze, broadly defined to include any continuous band of foliage embellishing not just the portal proper, but the entire porch or entrance zone. As the

FIGURE 1.19 Saint-Yved, Braine, west portal

Photo: © Mapping Gothic France, Media Center for Art History, The Trustees of Columbia University, Department of Art History and Archaeology

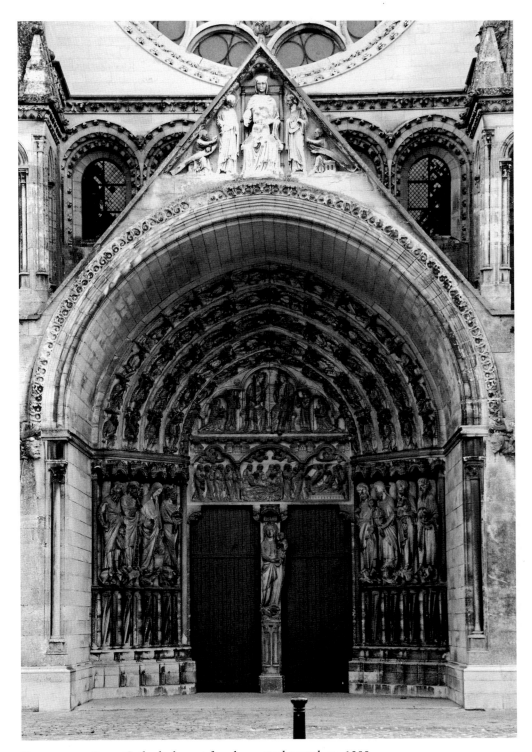

Figure 1.20 Laon Cathedral, west façade, central portal, ca. 1200
Photo: author

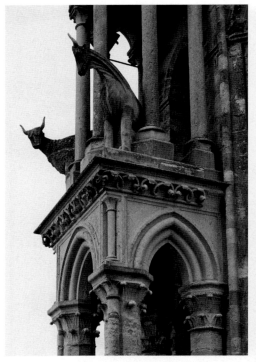

FIGURE 1.21 Laon Cathedral, west façade, north tower

Photo: author

FIGURE 1.22 Chartres Cathedral, nave buttress

Photo: author

primary transitive zone of the church, a well-established symbol of Christ, and a signifier of the path to salvation, the portal has long been recognized as an ideal place from which to communicate with visitors using images and texts.[61] Organic friezes came to frame the highly trafficked thresholds of churches, over time replacing abstract motifs with subjects inspired by nature, either directly or via artistic models. In combination with other elements, such as figural sculptures, inscriptions, and ordered assemblages of columns, portal vegetation draws the viewer's attention, while also indicating the special status of the spaces behind them.

Examples of portal friezes abound in the high and late medieval churches of France. In fact, rare is the church built between the twelfth and fifteenth century that does not incorporate bands of foliage somewhere in its entrance design. (Notable exceptions are the early churches of the Cistercians, whose austerity strictly limited their use of sculptural ornamentation.) The main portal of the cathedral of Autun is best known for its expansive figural program, but foliage also plays a role in the composition, adorning the second of three bands of archivolts (only two of which survive) (figs. 1.25, 1.26). The unfurling leaves and delicate buds sprouting from the helical stem impose order on the design by separating the narrative imagery in the lintel and tympanum, which depict the Last Judgment, from the non-narrative but still iconic sculptures of the outer archivolt, which represents the signs of the zodiac. (The division might also be read in sacred/secular terms given the close association of the zodiac with human labor.) A foliate band nearly identical to the one at Autun Cathedral veils the deep, concave molding framing the western doorway of the nearby and almost contemporary church of La Trinité at Anzy-le-Duc, enclosing representations of Christ, angels, and apocalypse elders (fig. 1.27).[62] Comparable

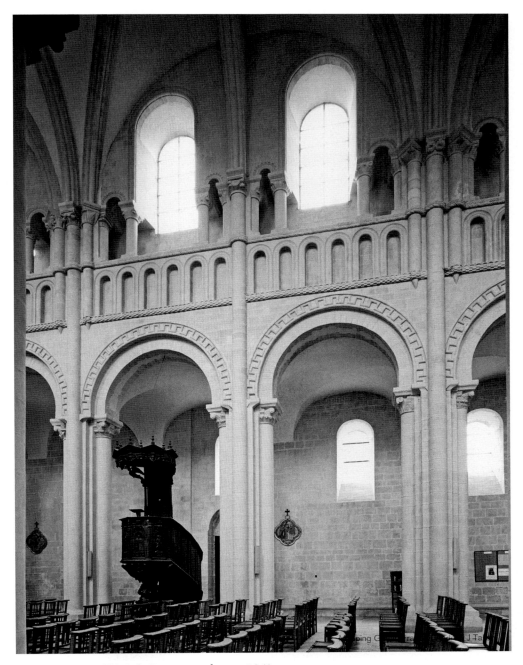

FIGURE 1.23 La Trinité, Caen, nave, begun 1062

Photo: © Mapping Gothic France, Media Center for Art History, The Trustees of Columbia University, Department of Art History and Archaeology

foliate bands ranging stylistically from generalized to naturalistic were prevalent in French portal design through the late Middle Ages and beyond (figs. 1.28, 1.29).

Church entrances emerged as critical points of focus for vegetal and figural ornamentation over the course of the twelfth century, with botanical forms typically occupying border zones. In

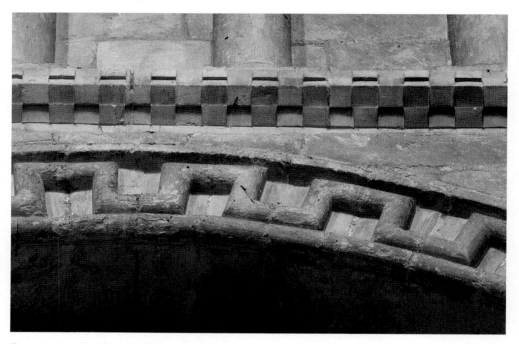

FIGURE 1.24 La Trinité, Caen, transept moldings

Photo: © Mapping Gothic France, Media Center for Art History, The Trustees of Columbia University, Department of Art History and Archaeology

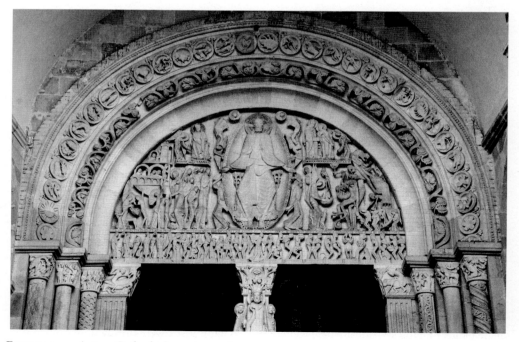

FIGURE 1.25 Autun Cathedral, west portal

Photo: author

FIGURE 1.26 Detail of 1.25

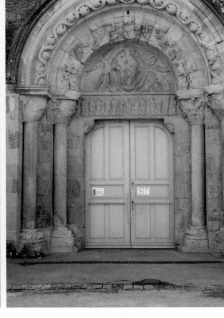

FIGURE 1.27 La Trinité, Anzy-le-Duc, west portal, early twelfth century

Photo: author

addition to decorating archivolts, organic imagery proliferated in doorjambs and lintels, creating strings of foliage around the entrances to churches. For example, the jamb columns of the Royal Portal of Chartres Cathedral are replete with plant forms winding around the slender shafts behind the statues of Old Testament kings and queens (figs. 1.30, 1.31). Vibeke Olson interpreted the animated figures, animals, birds, and mythical beasts populating the tangled vines in Neoplatonic terms, citing the sculptures as evidence of an interest in the natural world and humanity's position in the cosmos, which is represented in the façade's large, programmatic sculptures. Although Olson linked the column carvings to the scientific pursuits of scholars and theologians active at the school of Chartres in the twelfth century, she gave equal weight to their mundane connotations, suggesting that the familiarity of vines and foliage, animals, and agrarian labors would have prompted viewers from all social strata to contemplate their place within the macrocosm.[63] By engaging the terrestrial realm in the jambs (the visual field closest to the beholder), the designers of Chartres Cathedral mapped out a universal history encompassing biblical and historical events, sacred and secular figures, as well as the fallen world and the possibility of redemption. Comparable in placement (but not in style or precise inflection) are the classicizing rinceaux gracing the door posts of the so-called Valois Portal on the north transept of Saint-Denis (ca. 1165–1170), which are essentially foliate friezes rotated ninety degrees (fig. 1.32).[64] Closely related are the jambs of the central and north portals of the west façade of Notre-Dame at Mantes-la-Jolie (1160s) and the two lateral portals of the west façade of Rouen

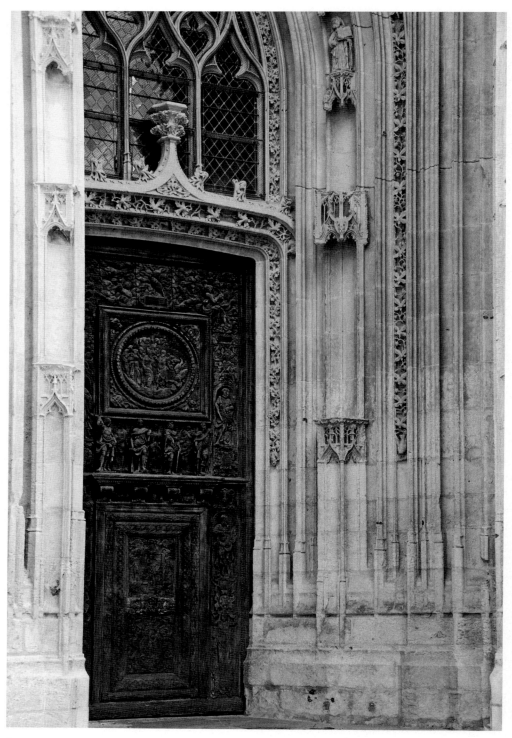

FIGURE 1.28 Saint-Maclou, Rouen, west porch, north portal, begun ca. 1436
Photo: author

FIGURE 1.29 Saint-Maclou, Rouen, west porch,
central portal frieze

Photo: author

Cathedral (1170s) (fig. 1.33). Among the most luxurious examples of foliated portals from the twelfth century, however, are the two doorways from the west façade of the church of Saint-Lazare at Avallon (ca. 1160), which feature a plethora of organic motifs, including interwoven grapevines, open flowers, acanthus leaves, and palmettes (figs. 1.34, 1.35).[65] The meticulously carved flora encases not only the embrasures and archivolts, but also the jamb pedestals, which are located precisely at eye level.

More conventional (that is, linear and horizontal) friezes appear above the central doorway of the west façade of Amiens Cathedral, whose visual program focuses on the Last Judgement (fig. 1.36). Two grapevines rich with mimetic details border the lintel depicting the rising and weighing of souls at the end of time (fig. 1.37).[66] I will consider the mutually reinforcing, semantic relationship between these vines (both of which retain traces of paint), the central imagery of the portal, the interior foliate frieze, and the liturgy in a later chapter. For the moment, I wish to set meaning aside to focus on a key spatiovisual issue: the integrating role of botanical images at Amiens. The frieze directly below the lintel is aligned with the foliate capitals of the major and minor jamb columns, continuing the strip of vegetation past the portal proper and across the shallow space of the porch (fig. 1.38). The bulbous lateral crockets of the jamb capitals are joined physically, giving them a frieze-like appearance and tying them conceptually to the lintel vines. Adeptly carved foliate panels set between

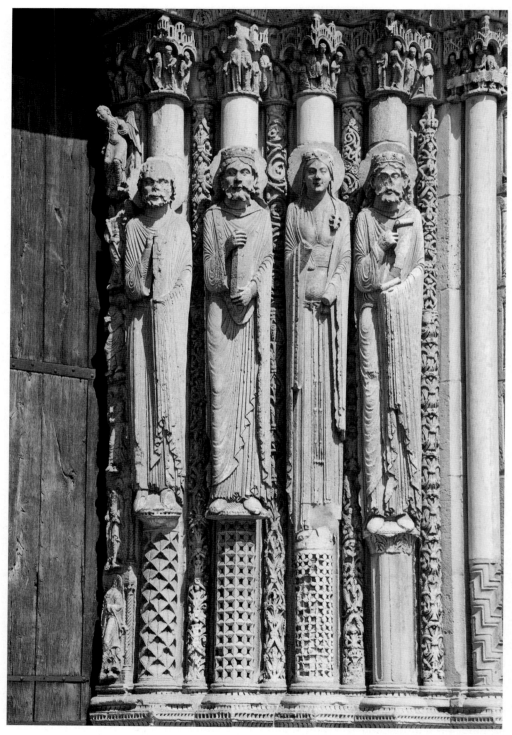

FIGURE 1.30 Chartres Cathedral, west façade, central portal, jamb, mid-twelfth century
Photo: author

FIGURE 1.31 Detail of 1.30

FIGURE 1.32 Saint-Denis, north transept portal, jamb, ca. 1165–1170

Photo: author

FIGURE 1.33 Rouen Cathedral, west façade, north portal, jamb, 1170s

Photo: author

FIGURE 1.34 Saint-Lazare, Avallon, west façade, south portal, mid-twelfth century

Photo: author

FIGURE 1.35 Detail of 1.34

the columns on the buttresses further extend the vegetal band (fig. 1.39). Echoing the ser-
pentine forms of the capital and lintel friezes are the entwined vines in the dado zone of the
portal, which join the twelve prophet quatrefoils on the buttresses flanking the central door
(fig. 1.40). Vine imagery also appears on the pedestal beneath the trumeau statue of the *Beau
Dieu*, or Beautiful God (fig. 1.41). The makers of the central portal then carried the organic
into the upper parts of the design with a depiction of a Jesse Tree in the seventh order of
archivolts (the second order from the exterior). A muscular branch shoots from the side
of the sleeping patriarch to support the royal ancestors of Christ (see fig. 1.39). The visual
consonance between this fruit-bearing grapevine and the others lends cohesiveness to the
doorway, unifying visually the dado, jambs, trumeau, lintel, and archivolts.

The liberal use of vine ornamentation around the central, Christocentric portal at Amiens
is as noteworthy as its absence from the lateral portals, which are devoted to Saint Firmin and
the Virgin Mary to the north and south respectively. These observations point out essential
aspects of the vegetation on the exterior of the cathedral: its measured use in relation to the fig-
ural imagery and, more pertinently within the context of this chapter, its function as a signpost
for the foliage inside the cathedral, namely the monumental frieze lining the nave. Importantly,
the central door lies on the same axis as the interior frieze, which itself marks the processional
path to the high altar, the site of the ritual reenactment of Christ's sacrifice with wine and bread
during Mass. The grapevines outside Amiens thus primed visitors both for the frieze inside the
building and the liturgical actions staged in the choir. In other words, the vine motifs at the

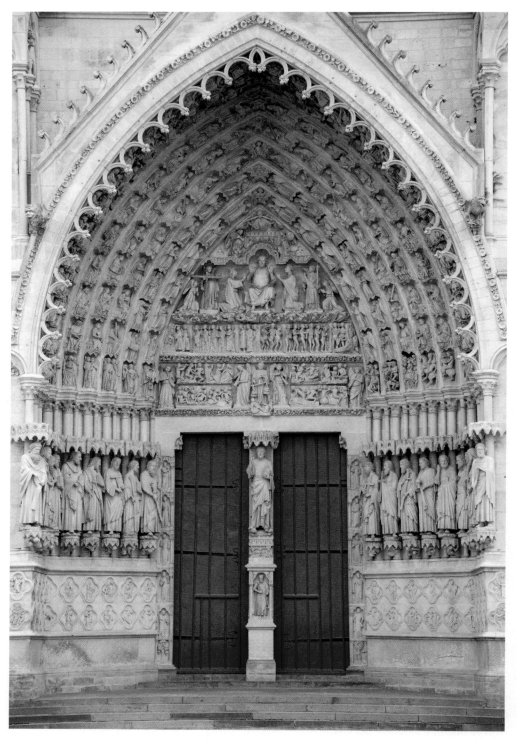

FIGURE 1.36 Amiens Cathedral, west façade, central portal
Photo: author

FIGURE 1.37 Amiens Cathedral, west façade, central portal, lintel

Photo: author

FIGURE 1.38 Amiens Cathedral, west façade, central portal

Photo: author

FIGURE 1.39 Amiens Cathedral, west façade, central portal, capital frieze

Photo: author

FIGURE 1.40 Amiens Cathedral, west façade, prophet quatrefoils

Photo: author

FIGURE 1.41 Amiens Cathedral, west façade, central portal, detail of trumeau
Photo: author

cathedral attest to the correlation not just of interior and exterior ornamentation, but also of the ornamental program and the liturgy.

Amiens Cathedral is not unique in its strategic and coordinated employment of natural imagery. The practice of using botanical motifs as architectonic framing devices on church façades and as harbingers for interior foliage was common throughout the Middle Ages. A compelling variant can be found at the cathedral of Reims, where the capitals of the jamb columns on the west façade are so dense with leaves that they invade the neighboring areas, forming lush bands of foliage immediately above the column statues (see figs. I.9 and I.10). Amid this thicket of living forms are small birds pecking at grapevines. The capital friezes at Reims Cathedral function as frames for the holy figures in the jambs alongside the carved drapery in the dado. (Like the fictive drapery below the foliate frieze at Metz Cathedral, the stone fabric at Reims evokes descriptions of the curtains, or *vela*, inside the Temple of Jerusalem and simulates the visual effects of the textiles suspended inside churches on special occasions, such as Lent.)[67] In addition to enclosing the jamb statues, the exterior foliage at Reims prepares viewers for the dazzling array of vegetation inside the building. Notable in this regard are the retrofaçade panels and arcade capitals, which are equipped with highly refined depictions of grapevines, oak leaves, wild roses, and other plants, including hybrid species that look real but do not actually exist in nature (fig. 1.42).[68] There is no foliate frieze inside the cathedral of Reims, but the syncopated rhythm of the large, exuberantly carved arcade capitals lends the building a longitudinal focus comparable to the frieze at Amiens, leading the eye to the sanctuary. A similar correspondence between exterior and interior occurs at the church of Saint-Maclou in Rouen, where the strings of foliage punctuating the jambs, lintels, archivolts, gables, balustrades, buttresses, and pinnacles of the west

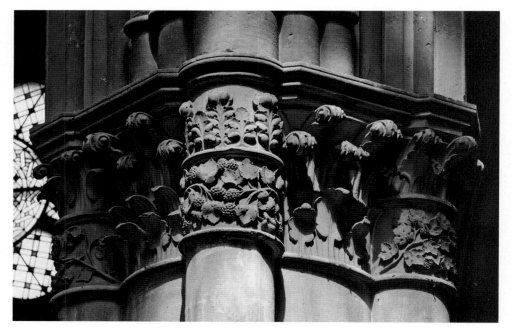

FIGURE 1.42 Reims Cathedral, nave capital

Photo: author

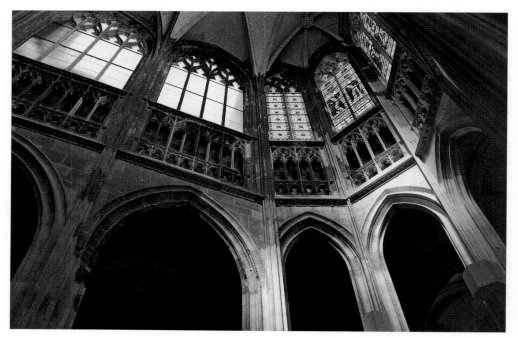

FIGURE 1.43 Saint-Maclou, Rouen, choir

Photo: author

porch anticipate the organic friezes at the triforium level inside the building (see figs. 1.28, 1.29, 1.43). Although there are clear stylistic and technical differences between the perforated west porch of Saint-Maclou and the twelfth- and thirteenth-century church façades described above, the buildings are tied conceptually by their use of foliage as framing and interconnecting devices.

FOLIATE BORDERS IN OTHER MEDIA

This chapter opened with a discussion of the frame as it pertains to architecture. This section addresses the treatment of borders in medieval art-historical scholarship more broadly, with the twofold aim of valorizing imagery inhabiting the edges and emphasizing the question of shared practice across artistic media. I am not concerned with studies devoted to classifying and deciphering the varied subjects that decorate the borders of medieval objects. Rather, I attend first to an enabling conceptual and linguistic shift in the study of the margins, and second to parallels between the integrating function of foliage in architecture and other media. The latter issue points to deeply ingrained habits of thought, perception, and practice relative to the vegetal frame in medieval visual culture.

Manuscripts serve as a logical point of departure for a discussion of border imagery. Illuminators often supplied text blocks, miniatures, and initials in manuscripts with ornamental edges, which vary compositionally and stylistically depending on when and where they were made. Blank sections of parchment surrounding texts and images might also be described as borders, as can texts themselves when they enclose illustrations. Starting in the thirteenth century, scribes began to extend and link the stems of initials to create borders around sections of pages.[69] Human figures, animals, and hybrids also appeared at the edges of manuscripts at this time, often merging with vegetal stalks to form frames around texts.[70] Over the course of the fourteenth century, elaborate borders incorporating foliage, figural scenes, animals, birds, and fanciful beasts proliferated in manuscripts across Europe and developed into regional types.[71] In France, wide margins filled with lace-like foliage became the norm around texts and illustrations alike, remaining common well into the fifteenth century (fig. 1.44). The diverse imagery at the edges of manuscripts (alongside scribbles and comments) has long been described as marginalia, a term scholars have also applied to border images in other media, including architecture.[72]

In a probing essay on the ideological functions of medieval art, Jonathan J. G. Alexander took issue with the use of the term "marginal" to characterize images on the borders of illuminated manuscripts. Additionally, he challenged the validity of the binary model of "center" and "periphery," urging scholars to do away with these value-laden categories and to replace the second with the term "frame."[73] At stake for Alexander was more than just semantics. In his view, this change in perception and language would allow border images to "assume a different importance and a different role, a dynamic interaction of meanings, both secular and religious, on different levels for a variety of viewers."[74] There are, of course, critical differences between frames in manuscripts and architectonic frames, notably the inability in many cases to take in the latter in their entirety without moving through space. Yet the shift proposed by Alexander remains germane to the study of architecture because it valorizes features of buildings that are all too often dismissed, including the foliated archivolts, lintels, and jambs framing church portals.

FIGURE 1.44 Limbourg Brothers, *Adoration of the Magi, Belles Heures of Jean de France*, Duc de Berry, fol. 54v, 1405–1408/09

Photo: The Metropolitan Museum of Art, The Cloisters Collection, 1954 (54.11a,b)

Equally relevant in the context of this chapter is the work of Jean-Claude Bonne, who stressed the role of ornament in establishing visual links between distinct sections of objects. His study of a Carolingian ivory binding at the Musée de Picardie in Amiens provides insights into the interconnection of border and center, and ornament and figure (fig. 1.45).[75] Bonne demonstrated that the organic motifs in the frame of the plaque relate formally to the three central scenes devoted to miracles from the life of Saint Rémi, an early bishop of Reims. The Corinthianesque capitals, foliated astragals, and fleuron bosses on the abaci of the four fictive columns in the upper register, which depicts Rémi resurrecting a young girl, recall the acanthus leaves dressing the border. Despite inconsistencies in scale, the columns seem to hold the upper part of the frame in place, mimicking the load-bearing function of columns supporting an entablature, and blurring the boundary between field and frame. With its central circle and almond-shaped petals, the inlaid rosette on the side of the altar in the second register, which shows Rémi prostrate before the altar and the hand of God filling holy ampules, relates closely to the inlaid patterns in the four corners of the binding. Further, the acanthus leaves and palmettes embellishing the arch in the bottom register portraying the baptism of king Clovis by Rémi join in formal terms the center and the frame, as well as the bottom and top of the plaque. Bonne's analysis points

FIGURE 1.45 Binding with scenes from the life of Saint Rémi, from Reims, late ninth century, Amiens, Musée de Picardie (M.P.992.4.5)

Photo: Cliché Com des images / Musée de Picardie

to the careful coordination of border and center in a non-architectural medium, in addition to conveying the vital role of ornament in guiding the beholder's encounter with the object. The prevalence of such ties between ornamental borders and central compositions in the cultural output of the Middle Ages led Bonne to characterize the relationships not simply as traditional practice, but as a phenomenon, which he termed "ornementalité."[76] In addition to providing an important parallel for my research on architecture, Bonne's discoveries attest to the strategic use of foliate ornament as far back as the Early Middle Ages.

CLUNY III AND THE PROLIFERATION OF ARCHITECTONIC FOLIATE FRIEZES

Having addressed the formal characteristics of foliate friezes; their location inside and outside buildings; their role in articulating, framing, hierarchizing, and integrating sacred spaces; and their relationships to other media, I turn now to the matter of their origins. The beginnings of the botanical frieze trend in medieval France are difficult to pinpoint due to the incomplete nature of the physical and documentary evidence. Early examples are clustered in the region of Burgundy, in buildings located close to Cluny III. Indeed, many of the earliest extant friezes are found in former Cluniac dependencies, raising the possibility that the church at Cluny helped diffuse or perhaps even spark the foliate frieze phenomenon in France in the medium of architecture.

The loss of material evidence incurred after the church at Cluny was secularized during the French Revolution complicates this hypothesis. The almost complete destruction of the building has clouded our understanding of its appearance and precise chronology of construction, making potential directions of influence impossible to determine with certainty.[77] However, the general consensus is that work unfolded from east to west beginning around 1088 under the patronage of abbot Hugh of Semur (d. 1109) and that the building process was protracted, with the dedication of the nave taking place only in 1130.[78] The crucial sections of the church for my purposes are the nave façade and narthex. Work on the façade unfolded between 1115 and 1130, a period that also saw the erection of the two easternmost bays of the narthex, which were vaulted by about 1170.[79] The western bays of the narthex may have been built around 1180–1185.[80] The narthex façade, the last part of the church to be constructed, was likely completed by about 1220.

The archaeological record, fragments in museum collections, graphic evidence, and comparisons with related buildings, such as the cathedral of Autun, the priory church at Paray-le-Monial (begun ca. 1120), and the priory church of Notre-Dame at La-Charité-sur-Loire (dedicated 1107), provide important information about the use of foliate ornament at Cluny III.[81] Pre-demolition drawings and engravings by Jean-Baptiste Lallemand and Pierre-Laurent Auvray reveal that the oldest sections of the building—that is, the choir, transept, and nave—lacked foliate friezes.[82] Organic forms nonetheless abounded in these early sections of the church (and in the adjacent monastic buildings), notably in the column capitals, many of which are of the Corinthian order.

Although the oldest parts of Cluny III did not have foliate friezes in the strict sense of the term, graphic sources (and a modern model of the church based on these sources) affirm that a vine-like pattern adorned the archivolts of the main arcade (fig. 1.46). A similar motif decorates the arcade of the church at Paray-le-Monial (often described as a "pocket edition" of Cluny III), the choir arcade of the cathedral of Chalon-sur-Saône (begun ca. 1090), the arcade

FIGURE 1.46 Model of Cluny III, Cluny, Musée d'art et d'archéologie, Palais Jean de Bourbon
Photo: author

in the narthex of the Cluniac church of La Madeleine at Vézelay (begun ca. 1120), and the outer archivolts of the west façade portal of the church of Saint-Hilaire in Semur-en-Brionnais (after 1164), all of which are located within about 225 km of Cluny (fig. 1.47).[83] Admittedly, the arcade vines in these churches are highly schematic, each consisting of two sinuous intersecting lines. Despite the rather extreme abstraction, the pattern departs sufficiently from the geometric designs typical of earlier buildings to warrant its identification as a vegetative element, possibly inspired by the classical rinceau (fig. 1.48). If this is indeed the case, then Cluny III presents an unusually early example of a sculpted vine circumscribing the interior of a medieval French church.

The relatively small conceptual step from stylized archivolt vine weaving around a space to encircling botanical frieze may have occurred at Cluny III itself. A frieze composed of open flowers alternating with animals, birds, and whimsical beasts inscribed within circles, remnants of which are preserved at the Musée d'art et d'archéologie in Cluny, lined the twelfth-century narthex of the church (fig. 1.49).[84] That this hybrid frieze was understood to be organic by its makers is apparent in the treatment of one of its segments, where the enclosing forms are not circles but serpentine vines complete with unfurling leaves (fig. 1.50). An anonymous drawing of the narthex at the Bibliothèque nationale de France shows that the frieze ran between the arcade and triforium, covered the vault responds, and framed the nave portal (fig. 1.51). Only two of the narthex's four walls appear in the drawing, but there is nothing to suggest that the frieze did not delineate the entire space. Although it depicts flowers and creatures, rather than just stalks, leaves, and fruit, the band's continuous journey around the space, combined with its position directly above the main arcade, connects it to later vegetal friezes, such as the example

FIGURE 1.47 Chalon-sur-Saône
Cathedral, detail of choir arcade,
begun ca. 1090

Photo: author

FIGURE 1.48 Mosaic: birds in rinceau, Princeton University Art Museum, Gift of the Committee for the Excavation of Antioch, y1965-227, 526–540

Photo: Princeton University Art Museum

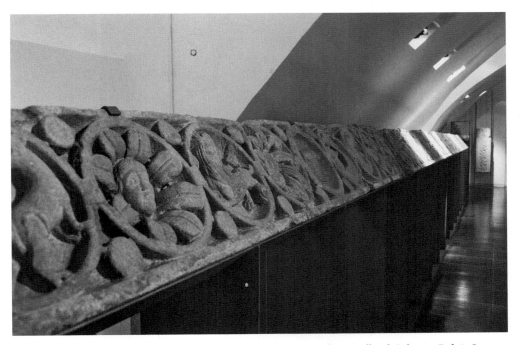

FIGURE 1.49 Narthex frieze from Cluny III, Cluny, Musée d'art et d'archéologie, Palais Jean de Bourbon, early twelfth century

Photo: author

FIGURE 1.50 Detail of 1.49

FIGURE 1.51 Narthex of Cluny III, late eighteenth century,
Paris, BnF, Est Ve 26p, fol. 197

Photo: BnF Paris

at Amiens Cathedral. In sum, although the narthex frieze at Cluny III differs morphologically from later organic bands, it is linked to these on a conceptual level by its basis in nature, its position inside the building, and its framing function.

It is possible that increased contact with Mediterranean lands, Byzantium, and the Levant through crusading, pilgrimage, and trade over the course of the eleventh and twelfth centuries spurred the introduction of the botanical frieze in the narthex of Cluny III. One finds remarkable foliate bands in similar positions in well-known buildings in Constantinople and Jerusalem, notably inside Hagia Sophia and the Dome of the Rock, both of which will be discussed in Chapter 4. Although C. Edson Armi cautioned against oversimplifying the question of artistic models at Cluny III, emphasizing the importance of local building traditions, he conceded that the masons at Cluny drew on a wide range of sources, synthesizing local, classical, northern French, and foreign forms and practices in the design of the church.[85] His proposal that highly revered Early Christian, Byzantine, and Carolingian buildings, such as San Simpliciano in Milan, San Giovanni Evangelista in Ravenna, and San Salvatore in Brescia, served as direct or indirect models for the stonework at Cluny III speaks to the possible role of distant prototypes in the church's design.[86] The ground plan of the building further ties Cluny to faraway places. Scholars have suggested that the church, which was dedicated to Saints Peter and Paul, the two principal saints of Rome, derived its five-vessel layout from the Constantinian church of Old Saint-Peter's in Rome.[87] According to legend, Peter himself appeared in a dream vision to Gunzo (a monk who had retired to Cluny) with measuring ropes to provide the dimensions and design of the church.[88] Textual sources further attest to links between Cluny and distant (specifically eastern) sites: Anastasius (d. 1085/86), a Cluniac monk and hermit who traveled to Cluny from Venice, seems to have had Greek connections; documents in the cartulary of Cluny indicate that the abbey made loans to pilgrims on their way to Jerusalem before the First Crusade; and some Crusaders became monks at Cluny upon their return from the Holy Land.[89] Eastern ties extended to the Cluniac liturgy, which presented the church as Jerusalem, a parallel repeated in a treatise by abbot Peter the Venerable of Cluny on miracles of a vision of Guy of Geneva.[90] Connections to the east also manifested themselves in the visual arts at the abbey. Eleventh-century Cluniac manuscripts and frescoes, for instance, reveal the direct influence of Byzantium, as well as Byzantine influence mediated through Italy.[91] As Giles Constable reminds us, moreover, Cluny held a unique position among European monasteries in that it headed a religious order with dependencies and interests all over the Christian world.[92] Eastern sources for the narthex frieze are plausible in light of Cluny's multipronged ties to distant places.

Given that Cluny III was highly regarded in its own time (Peter the Venerable admired the plan of the church, claiming it distinguished the building "from all others on the globe"),[93] and the impact the building had on twelfth-century church design, it follows that the head of the Cluniac order played a role in diffusing the botanical frieze motif.[94] Indeed, friezes similar to the narthex band of Cluny III are present in a number of buildings linked to the great church, giving the motif strong institutional connotations.[95] For example, a closely related frieze girds the nave of the Cluniac church of La Madeleine at Vézelay (figs. 1.52, 1.53).[96] The frieze consists entirely of rosettes, omitting the fantastical beasts of Cluny III. Despite this difference, the manner in which the circular frames enclose the flowers, as well as the frieze's uninterrupted circuit around the space and its location above the main arcade, recall the design and placement of the band in the narthex of Cluny III. Although the Vézelay frieze is unquestionably more uniform than its counterpart at Cluny, the flowers were treated in a comparably flexible manner, with variations in the number and orientation of the petals. (Some petals correspond to the cardinal

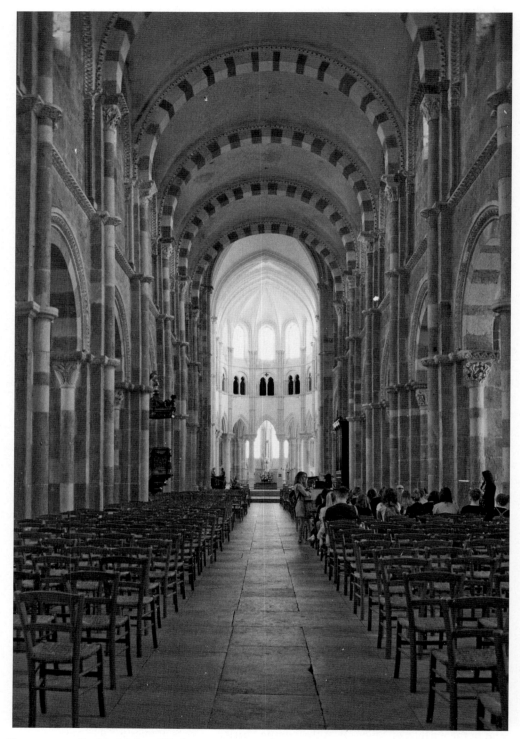

FIGURE 1.52 La Madeleine, Vézelay, view to east, begun ca. 1120
Photo: author

FIGURE 1.53 La Madeleine, Vézelay, nave frieze
Photo: author

points, while others are arranged diagonally; some flowers have four petals, while others only have two.)[97] A similar frieze adorns the interior of the cathedral of Autun, which rose at approximately the same time as the easternmost narthex bays of Cluny III (see fig. 1.11).[98] The frieze, which runs above the arcade in the nave and transept (the choir is later in date), consists of a string of open flowers, the same motif found in the narthex of Cluny III and at La Madeleine at Vézelay, but without the enclosing circles. An almost identical floreate frieze lines the choir of another Cluny-related building—the collegiate church of Notre-Dame at Beaune, whose eastern extremity was built in the mid-twelfth century (fig. 1.54).[99]

The foliate frieze in the choir of Langres Cathedral is closely associated with those inside the Cluny-related buildings listed above because of its placement between the main arcade and triforium and its role in establishing spatial order. Yet it deviates from the rest of the so-called Cluny school in a crucial way. Instead of rosettes, the frieze comprises stylized acanthus leaves carved in low relief, sections of which emerge from the mouths of half-length lions (see figs. 1.14, 1.15). The form of the band draws on the classical rinceau, a common motif in ancient art and architecture from the time of Alexander the Great onward (see fig. 1.48).[100] Indeed, the rinceau is one of many classicizing aspects of the cathedral's choir, the Corinthianesque capitals, fluted pilasters, and round arches of the triforium and clerestory numbering among the others. The inspiration behind these deeply historicizing features may have come from local monuments, such as the Roman gate at Langres, which contains all the formal components listed above, save the rinceau (fig. 1.55).[101] Other potential areas of influence include Burgundy and south-central France, which are replete with Roman ruins, some of which feature rinceaux. The examples known to me, however, are either restricted to portal zones or surround the exteriors of

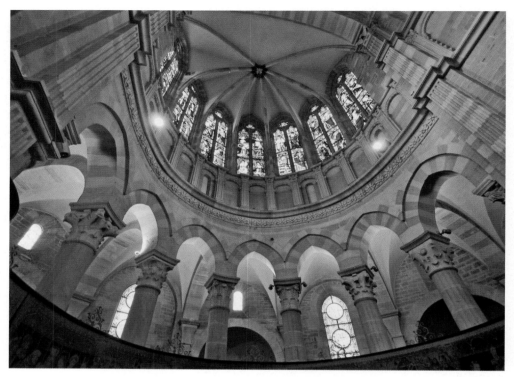

FIGURE 1.54 Notre-Dame, Beaune, choir, mid-twelfth century

Photo: Marvin Trachtenberg

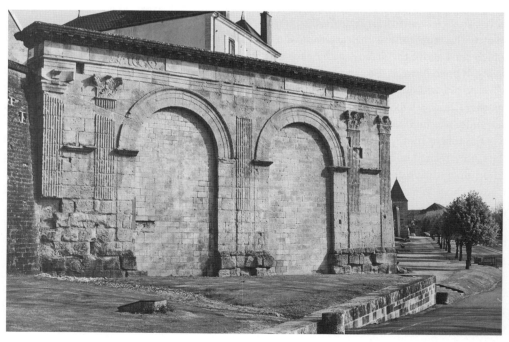

FIGURE 1.55 Roman gate, Langres, ca. 20 BCE

Photo: author

buildings. None encircle interior spaces in the manner of the foliate band at Langres Cathedral. For that, one must look further afield, notably to Byzantium and the Levant.

The main issue at hand is not the stylistic source of the Langres rinceau, which remains unclear, but its strong conceptual link to the floreate band at Cluny III. Given the proximity of the towns of Langres and Cluny (they are less than 200 km apart) and the many features the cathedral shares with the church, such as its distinctive tripartite elevation, complex pier design, and precocious combination of pointed and round arches, it is likely that the designers at Langres borrowed the botanical frieze motif directly from Cluny III or an associated building. Indeed, it well may be that Cluny and the churches within its orbit hold the key to understanding the growing trend toward interior organic friezes in France, with the initial stage of the formulation consistently including open flowers. Starting in the second half of the twelfth century in buildings such as the cathedrals of Langres and Soissons, and the churches of Saint-Rémi at Reims and Notre-Dame-en-Vaux at Châlons-en-Champagne, friezes became increasingly diverse. This diversity continued to grow over time, eventually encompassing the highly schematized, the pseudo-realistic, and everything in between (see figs. I.5–7, 1.12, 1.14, 1.15).

CONCLUSION

The medieval churches of France conveyed their sanctity to beholders in varied ways, heralding their importance through scale, typology, and ornamentation, as well as through the sights, sounds, and smells of the ritual acts staged within them. The foliate friezes that began to multiply inside and outside churches at the turn of the twelfth century helped signal the distinct status of the buildings they adorn. As integral parts of the architectural frame, the stone friezes became sacred at the moment of consecration, yet they remained inextricably linked to the non-sanctified world by their representational and at times seemingly mimetic relationship to nature. In a double gesture typical of monumental flora, the friezes deconstruct clear distinctions between the inside and outside, and the consecrated and unconsecrated, all the while participating in their production.

Early examples of organic friezes are clustered in the region of Burgundy, where agriculture and viticulture thrived as far back as antiquity and remain a vital part of the local economy and culture.[102] Although the precise role of Cluny III in initiating the foliate frieze phenomenon remains speculative due to the lack of documentation, what is exceedingly clear is that vegetal bands became progressively more common in buildings in its vicinity over the course of the twelfth century and, in different forms, remained a prominent part of church syntax throughout France for centuries. The friezes delimit, ornament, hierarchize, and interconnect spaces. Additionally, they participate in the visual differentiation of interior/consecrated and exterior/unconsecrated spaces, while also distinguishing sections of churches as particularly charged sites within the sacred whole. Foliate friezes, however, are more than simple architectonic devices, contributing not just to the form but also to the content of churches. No less than figural reliefs, statues of saints, and narrative and iconic stained glass windows, foliate friezes are contextually expressive objects that play a role in engendering responses from viewers. It is, therefore, to the multilayered and labile meanings of the friezes to which this study now turns.

FIGURE 2.1 Limbourg Brothers, *Expulsion of Adam and Eve from Paradise, Très Riches Heures du Duc de Berry*, 1411–1416, Chantilly, Musée Condé, Ms. 65, fol. 25v

Photo: IRHT-CNRS/Gilles Kagan

Paradise Found

THEOPHILUS' WELL-KNOWN TREATISE ON THE ARTS OF ABOUT 1125, *De diversis artibus*, contains one of the most evocative descriptions of church architecture from the Middle Ages. In the prologue to Book Three (the manual's final section), the author characterized the contemporary church interior as "the paradise of God, blossoming with various flowers, verdant with plants and leaves."[1] This striking description appears in a section of the text devoted entirely to techniques of metalwork and follows the discussion of stained glass in Book Two. Theophilus was not referring to botanical imagery on metal objects and in windows in this passage, but to polychrome works on the walls (*parietes*) and ceilings (*laquearia*) of churches. In fact, Theophilus singled out walls from all other sections of churches for their especially important role in signifying paradise: "If it [the eye] beholds the ceiling, they bloom like tapestries; if it considers the walls, there is the appearance of paradise; if it marks the abundance of light from the windows, it wonders at the inestimable beauty of the glass and the variety of the most costly work."[2]

Monumental foliage, such as the friezes described in the preceding chapter and other vegetal elements, numbers among the features that helped transform the medieval church into the paradisiacal garden described by Theophilus. These architectonic components worked in tandem with organic motifs in other media, as well as with adjacent figural sculptures and the liturgy, to forge and promote the connections between churches and paradise for medieval beholders. Although there is no question that nature covered a broad semantic field containing heterogeneous and unstable meanings in the Middle Ages, Theophilus' lyrical account of the church interior as a heavenly bower, which dates to around the same period as the initial proliferation of vegetal sculptures in sacred settings, presents a salient and largely unexplored interpretation of the high medieval church. His assertion therefore serves as a compelling point of departure for studying the multivalence and rich potentiality of foliated imagery in sacred contexts, some aspects of which apply specifically to organic friezes and others to sculpted flora more generally.

My reading of the high medieval church in paradisiacal terms builds on studies of Northern European *Astwerk* from the 1960s, notably those of Karl Oettinger, Margot Braun-Reichenbacher, and Joachim Büchner, who understood the vegetal architecture of the fifteenth and sixteenth centuries as an evocation of the sacred garden and enclosed arbor (see fig. I.13). Recent studies have downplayed these religious associations. For example, Ethan Matt Kavaler observed that organic forms were not necessarily inflected toward the sacred in the late Middle Ages. In lieu of religious symbolism, he stressed the reflexive role of foliated components in Late Gothic buildings, arguing that *Astwerk* dramatizes the tension between organic and nonorganic elements.[3] Paul Crossley also took issue with the mid-twentieth-century interpretation of *Astwerk*, critiquing its inability to

accommodate the polysemy of medieval symbolism.[4] Following François Bucher, he characterized the vegetal style as a reactionary phenomenon, positing that it constituted a response to the challenge of *all'antica* design in Italy, particularly to its theoretical justifications based on the writings of Vitruvius and expressed in the architectural treatises of Leon Battista Alberti, Filarete (Antonio di Pietro Averlino), and Francesco di Giorgio.[5] In contrast to Bucher, who emphasized the growing reliance on geometric techniques in Northern European architecture, Crossley suggested that German builders met the Italian challenge on its own terms by finding a theoretical justification for *Astwerk* with the same historical weight and intellectual clout as the Italian treatises.[6] According to Crossley, this legitimacy came from the writings of two ancient authors: Vitruvius, whose *De architectura* 2.1 situated the origins of architecture in primitive wooden huts; and Tacitus, whose *De Germania* described in favorable terms the worshipping practices of early Germanic tribes in forests and groves.[7] The former author validated the use of botanical subjects in architecture, whereas the latter gave the practice a historical and local resonance.

For all the ideological and social-historical dimensions these scholars have revealed in *Astwerk* designs, it is important not to lose sight of the symbolic aspects of church architecture, which were crucial for generations of Christian writers going as far back as Eusebius. And while it is true that *Astwerk* was a phenomenon that manifested itself across a broad spectrum of building types, including town halls and domestic structures, as well as churches, its use in secular architecture in no way negates its possible religious significance in sacred settings (see figs. I.13 and I.14). Organic forms were not explicitly coded, but could be read in a variety of ways depending on factors such as architectural context, class, gender, and the memories and expectations of the viewer.

This chapter reconsiders the connection between architectural flora and paradise. In contrast to mid-twentieth-century scholars, who focused on Germanic material from the late Middle Ages, my emphasis is on foliage in high medieval French churches. I approach the buildings as metaphors for paradise *with representational potential*. On the one hand, the churches functioned as symbols, with no necessary mimetic relationship to the paradisiacal garden. On the other hand, the churches were made in the image of paradise, their walls "blossoming with various flowers, verdant with plants and leaves," to repeat the words of Theophilus.

The coexistence I see between the metaphoric and literal senses of paradise relates superficially to the theories of Hans Sedlmayr, whose study of Gothic architecture of 1950, *Die Entstehung der Kathedrale*, outlines two modes of architectural representation: *Symbol* and *Abbild*. According to Sedlmayr, the Gothic church is not just the Heavenly Jerusalem in a figurative sense (*Symbol*), it is also a portrait or illustration (*Abbild*) of the heavenly city because it incorporates key visual aspects of the model into the representation.[8] Sedlmayr supported his claims using liturgical texts, notably the foundation-laying and consecration rites, which present the church in general and the sanctuary more specifically as the Heavenly Jerusalem.

Sedlmayr's book has provoked more vitriol than any other work on medieval architecture, particularly in English-language publications. In his encyclopedic study of Gothic architecture of 1960, Paul Frankl (a contemporary of Sedlmayr and one of his most ardent detractors) described *Die Entstehung der Kathedrale* as "disappointing and depressing for everyone who wants to increase his understanding of Gothic."[9] Sedlmayr's critical fortunes have not improved over time. In a 1998 essay, Wilhelm Schlink characterized the notion of the cathedral as a concrete representation of the heavenly city as "pure fiction" and "symptomatic of a special Austrian Catholic conservatism in the age of burgeoning National-Socialism."[10] Setting aside Sedlmayr's objectionable politics (he was a member of the National Socialist German Workers' Party) and his eccentric reading of

Gothic buildings (vaults are tethered to the ground by "aerial roots"), his two-pronged approach to architectural representation bears on the study of medieval churches. In my view, the problem lies not with Sedlmayr's underlying theory, but rather, in his rigid and totalizing application of it. According to Sedlmayr, *all* aspects of the Gothic church figuratively and literally represent the Heavenly Jerusalem, leaving little room for features that do not fit within the restrictive confines of this narrative or for the multitude of interpretive responses that such complex, large-scale buildings surely engendered in the Middle Ages. What I take from Sedlmayr's work, then, is his openness to the metaphorical *and* representational potential of architecture, an approach I apply to Romanesque and Gothic churches as it relates to medieval conceptions of the garden-paradise.

THE EARTHLY PARADISE

For medieval churchgoers familiar with the biblical Creation narrative, paradise was in the first place the Garden of Eden, the Vulgate Bible's *paradisum voluptatis* or garden of delights, which numbers among the most important gardens mentioned in scriptures (fig. 2.1). Briefly but tantalizingly described in the book of Genesis among other places, the garden planted by God in the East marked the introduction of plant life to the world.[11] The earthly garden was not only the first home of Adam and Eve, but also the hallowed site of the Creation where all things blossomed in accordance with God's command. Amid the lush vegetation were trees that were "fair to behold, and pleasant to eat," the Tree of Life, whose fruit imparted immortality, and the Tree of the Knowledge of Good and Evil, the fruit of which Adam and Eve were forbidden to eat.[12] A spring flowed through the garden and watered the thriving flora before branching off to form four riverheads.

Medieval writers conceptualized the Edenic garden in varied ways. For many thinkers, Eden was a real place that existed somewhere on earth, but that remained inaccessible and undiscoverable to humans. For example, in *De Genesi ad litteram*, Augustine of Hippo (d. 430) addressed the issue of the historical reality of the earthly paradise, concluding that Genesis was written with a "proper" rather than an allegorical meaning in view, that the Tree of Life was a real tree, and that the rivers running out of Eden were "true rivers, not just figurative expressions without a corresponding reality in the literal sense."[13] According to Augustine, Eden was "a delightful place shaded with fruit-bearing trees," which flourished by "the hidden work of God."[14] His views influenced later writers, such as Isidore of Seville (d. 636), who affirmed the historicity of Eden while also recognizing its mystical aspects in his *Etymologiae*, and the Venerable Bede (d. 736), who declared in his commentary on Genesis that although the location of Eden was unknown, it was certainly a place that "was and is on earth."[15] Other medieval thinkers, such Honorius of Autun (d. 1151), Peter Lombard (d. 1160), and Thomas Aquinas (d. 1274), voiced similar views in subsequent centuries.[16] Visual parallels to the literal understanding of Genesis in the textual tradition appear in *mappae mundi* of the period, which typically represent Eden as a physical place located at the edge of the world (fig. 2.2).[17]

Allegorical interpretations of Eden coexisted with the hermeneutic discourse outlined above, sometimes within a single text. An early example comes from the writings of the Alexandrine exegete Origen (d. 254), who posited that paradise was a spiritual rather than a corporeal place.[18] (Aquinas famously refuted Origen's theory in his *Scriptum super libros Sententiarum*.)[19] Robert Grosseteste (d. 1253) provided a more complex reading of Genesis in the *Hexaëmeron*, claiming to approach the material "according to the literal sense," before making "some remark on the allegorical and moral senses of it, that fit with faith and morals."[20] Even Nicholas of Lyre (d.

FIGURE 2.2 *Mappamundi*, Saint-Sever Beatus, before 1072, Paris, BnF, Ms. lat. 8878, fols. 45bisv–45ter

Photo: BnF, Paris

1349), known as one of the greatest literal commentators on Genesis of the later Middle Ages, offered a moral account of Eden in *Postilla moralis*, written as a supplement to *Postilla litteralis*.[21] Saint Ambrose (d. 397) laid the foundation for this duality in *De paradiso* by consistently seeking to transcend the literal view of paradise without denying its historical materiality. Ambrose described paradise as "a land of fertility—that is to say, a soul which is fertile—planted in Eden, that is, in a certain delightful or well-tilled land in which the soul finds pleasure."[22]

Scholars and theologians were not alone in their preoccupation with the earthly paradise. Alastair Minnis recently demonstrated that thinking on Eden was not restricted to the schools, but also manifested itself in secular texts and popular commentary (as well as in visual media). Grasping the complexities of the prelapsarian world may have eluded the average lay man and woman, but it afforded theologians, poets, and craftsmen "an extraordinary amount of creative space" as they sought to represent with words and images a key site in salvific history.[23] Depictions of Eden were standard in Genesis cycles across media, with organic forms ranging from minimalist landscapes to highly detailed settings with trees, plants, flowers, and fruit consistently serving as identifiers of place. A well-known example is the idyllic, fruit-bearing garden in the Fall and Expulsion miniature from the Limbourg Brothers' *Très Riches Heures du Duc de Berry* (1411–1416), beyond which are barren mountains and expansive seas (see fig. 2.1). Contemporary architectural forms feature prominently in this painting. The Fountain of Life at the center of the composition is shaped like an elaborate Gothic building complete with columns, vaults, openwork flyers, and crocketed pinnacles. The fiery angel on the right-hand side of the garden casts Adam and Eve out of the gates of paradise, whose acutely pointed gables and traceried buttresses mirror current trends in portal design. The question arises: if sacred

architecture informed depictions of Eden, might visual and textual conceptions of Eden in turn be reflected in churches? I will return to this question later in this chapter.

THE CELESTIAL PARADISE

The scriptures complicate the cultural-historical account of paradise outlined above. In addition to the terrestrial Garden of Eden, the Bible describes heaven—God's celestial home—in paradisiacal terms. The first chapter of Genesis recounts how God created the heavens, in which he placed the sun, moon, and stars.[24] Heaven was thus linked to the sky and the sphere beyond, in contrast to Eden, which was generally viewed as belonging to this earth. Heaven was also the otherworldly dwelling place of God and angels mentioned in dream visions, notably in Genesis 28:10–17, which recounts Jacob's dream of a ladder connecting heaven and earth. Further, it was the domain from which God could emerge and into which the privileged few might ascend, such as the prophet Elijah, who saw a chariot of fire and "went up by a whirlwind into heaven."[25]

In addition to serving as God's abode, heaven was widely understood within the Christian conception of the cosmos to be the eternal dwelling place of the just located at the top of a vertical matrix comprising heaven, earth, and hell, an essentially Greco-Roman construct that coexisted with an equally pervasive concentric model of the universe.[26] Christ *ascended* to heaven forty days after the Resurrection and Lucifer was *cast down* to hell at the beginning of time.[27] Ezekiel's prophetic vision of the New Jerusalem and Daniel's prophecy of the resurrection of the dead served as the basis for the development of the Christian notion of heaven as a place for the souls of the saved.[28] That this celestial realm and paradise are one and the same is made explicit in Luke's account of the Crucifixion, when Jesus promises the good thief: "Amen I say to thee, this day thou shalt be with me in paradise" (*in paradiso*).[29]

The use of the term "paradise" in relation to the celestial realm of God and the eternal place of the just testifies to its long-standing association and conflation with the Garden of Eden. The Vulgate refers to both the Garden of Eden and the visionary restored Eden as paradise (*paradiso*).[30] The etymology of the term bears on this discussion. The Old Persian term *apiri-daeza* referred to a walled orchard. The ancient Hebrews adopted the word in the form of *pardès* (literally "delights"), which appeared in the Septuagint, the Greek translation of the Hebrew Bible, as παράδεισος (*parádeisos*), meaning "enclosed park."[31] From a linguistic perspective, then, the celestial paradise is closely connected to its terrestrial garden counterpart.

The garden figuration of heaven coexisted with an equally important urban notion of paradise. The idea of the heavenly city gradually came into being in the centuries immediately following the time of Christ, becoming more focused after the sack of Jerusalem and the destruction of the Temple in the year 70.[32] The metaphor is pervasive, but the only New Testament book to describe it in detail is the Revelation of John:

> And he took me up in spirit to a great and high mountain: and he shewed me the holy city Jerusalem coming down out of heaven from God. Having the glory of God, and the light thereof was like to a precious stone, as to the jasper stone, even as crystal. And it had a wall great and high, having twelve gates, and in the gates twelve angels, and names written thereon, which are the names of the twelve tribes of the children of Israel. . . . And the city lieth in a foursquare, and the length

thereof is as great as the breadth: and he measured the city with the golden reed for twelve thou-
sand furlongs, and the length and the height and the breadth thereof are equal. And he measured
the wall thereof an hundred and forty-four cubits, the measure of a man, which is of an angel. And
the building of the wall thereof was of jasper stone: but the city itself pure gold, like to clear glass.
And the foundations of the wall of the city were adorned with all manner of precious stones.[33]

Dislocated in time and space, the heavenly metropolis of Revelation, which bears a close rela-
tionship to the Jewish concept of the city-Temple and symbolizes the new covenant between God
and humankind, was an enticing model whose impact on the art and architecture of the Middle
Ages has long been recognized.[34] Illuminated apocalypse manuscripts produced in Spain and
England in the thirteenth century contain remarkable examples of the celestial city, capturing in
miniature the glittering opulence and geometric perfection of John's vision (fig. 2.3).

FIGURE 2.3 *Heavenly Jerusalem, Trinity College Apocalypse*, ca. 1255–1260, Cambridge, Trinity
College, Ms. R.16.2, fol. 25v

Photo: The Master and Fellows of Trinity College Cambridge

Many medieval representations of the celestial paradise reference both the urban metaphor of Revelation and the bucolic Garden of Eden. Throughout the Middle Ages, images of heaven drew heavily on forms derived from the natural world, conflating the celestial and terrestrial paradise, while simultaneously casting Christ as the New Adam.[35] An outstanding example of this trend is Jacopo Torriti's apse mosaic at Santa Maria Maggiore in Rome (1287–1292), which depicts the coronation of the Virgin Mary by Christ in heaven (fig. 2.4).[36] The mosaic shows two great flowering vines issuing from the ends of a river, an unambiguous reference to the gushing spring of Eden. The swirling tendrils shelter a variety of animals and birds, with the peacock—a symbol of paradise—featuring prominently among the fauna. The weight given to the organic in the Santa Maria Maggiore mosaic is unusual, but its use of vegetal forms as shorthand for the celestial paradise is entirely conventional. A modest example can be found in the archivolts of the Last Judgment portal on the west façade of Amiens Cathedral, where a male and female figure representing the souls of the blessed hold birds and leafy branches, their attributes hinting at the paradisiacal setting (fig. 2.5). Vegetation also appears regularly in images of the celestial city, such as the luxurious Heavenly Jerusalem miniature in the Trinity College Apocalypse, which fuses the garden and urban conceptions of paradise (see fig. 2.3). The perfect geometry, twelve gates, and brilliant jewel-like tones adhere closely to John's description of the New Jerusalem, but the intertwined arboreal scrolls and river chock-full of fish at the center of the composition recall in terms of subject and placement the Tree of Life and running streams in the Garden of Eden, as well as the life-giving tree on the banks of the river of the celestial city of Revelation.[37] The delicate vegetal forms incised into the gold background of the central square further evoke the garden setting.

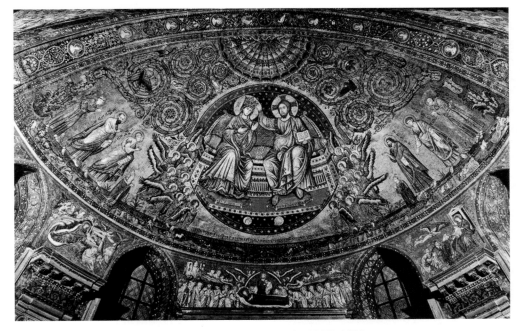

FIGURE 2.4 Santa Maria Maggiore, Rome, apse mosaic, 1287–1292

Photo: Public Domain

FIGURE 2.5 Amiens Cathedral, central portal, archivolt

Photo: author

THE ARCHITECTURE OF PARADISE

The interconnection of paradise and sacred architecture is well represented in medieval written sources. In his year-by-year account of the reconstruction of Canterbury Cathedral after a fire in 1174, for example, Gervase of Canterbury compared the displaced clerical community to "the children of Israel . . . ejected from the land of promise, yea, even from a paradise of delight" (*filii Israel occulto quidem sed justo Dei judicio de terra promissionis, immo de paradiso deliciarum ejecti*).[38] This passage speaks of the metaphorical link between Eden and the physical church, a site where the faithful had access to Christ, who was associated with the Tree of Life as early as the twelfth century. In the *Gemma anima*, Honorius of Autun made a similar but more expansive comparison, tying the whole of the monastic complex to the terrestrial and celestial paradise:

> Further the monastery bears the image of paradise, an even more secure paradise than Eden. The spring in this pleasant place is the baptismal font, the tree of life in this paradise is the body of the Lord. The various fruit-bearing trees are the different books of sacred scriptures [. . .] Furthermore monasteries foreshadow the heavenly paradise.
>
> *Porro claustrum praesefert paradisum, monasterium vero Eden securiorem locum paradisi. Fons in hoc loco voluptatis, est in monasterio fons baptismatis; lignum vitae in paradiso est: corpus Domini in monasterio. Diversae arbores fructiferae sunt diversi libri sacrae Scripturae [. . .] Porro monasteria praefert coelestem paradisum.*[39]

Related ideas are expressed in the writings of Peter Damian (d. 1072), Odo of Tournai (d. 1113), William of Malmesbury (d. 1143), Hugh of Fouilloy (d. ca. 1172), and Peter of Blois (d. 1203),

as well as in the twelfth-century *Historia Selebiensis Monasterii*, which describes the abbey at Selby in northern England as "a most pleasant place, planted with such a dense grove of trees and crowned with such an abundant and diverse river, as if it were an earthly paradise" (*locum amoenissimum tam frequenti nemore consitum, tam abundanti diversoque flumine coronatum, tanquam terrenum quendam Paradisum*).[40]

Additional ties between sacred architecture and paradise pertain to the church atrium, which was commonly designated "paradise" by medieval writers. Early usage of the word "paradise" as an architectural term seems to have applied only to the atrium of Old Saint-Peter's in Rome (fig. 2.6). A key text is an interpolation into the life of Pope Paul I (d. 767) from the *Liber Pontificalis*, a living document of collective authorship from the end of the eighth century. An early version of the biography from ca. 767 refers to the quadriporticus fronting the church as the atrium. However, a subsequent edition (produced before 792) adds that the oratory of Santa Maria ad Grada, which was located at the center of the eastern portico, was joined to the atrium "that is called paradise" (*quod vocatur Paradiso*).[41] The word was also used in a passage from the unfinished *History of the Lombards* of Paul the Deacon (before 800), which explains that Pope Donus (d. 678) repaved the "place called paradise in front of the basilica of the blessed Apostle Peter" (*locum qui Paradisus dictur ante basilicam beati apostoli Petri*).[42] The term surfaces yet again in a Roman sylloge, a collection of inscriptions of uncertain date now at the Vatican Library. Each passage has a topographical heading, including the epigraph of Pope John I (d. 526), which the text locates "in the paradise of Saint Peter" (*in paradiso beati Petri*).[43] The sylloge also contains an inscription from the atrium's central fountain, erected by Pope Simplicius (d. 483), which is situated "in paradise" (*in parad[iso]*).[44] By the ninth century, moreover, the word "paradise" consistently replaced atrium and quadriporticus as the designator of Saint-Peter's square in the *Liber Pontificalis*.

Although no medieval sources explain the meaning of the architectural term paradise, or why it was attached to the atrium of Saint-Peter's, some distinctions obtain. Ernst Schlee identified parallels between the atrium and the Garden of Eden, specifically its location to the east of the church and the fountain at its center.[45] By contrast, Giovanni Battista de Rossi posited that the term reflected the atrium's funerary function.[46] The reference, then, was to the celestial paradise where the souls of the saved awaited the final day of reckoning. Alternatively, Jean-Charles Picard suggested that the atrium was named for the monumental Apocalypse mosaic on the façade of the church.[47] These interpretations are not mutually exclusive, and it is possible that all three senses of paradise were entwined for medieval subjects, not just at Saint-Peter's, where the designation seems to have originated, but across much of Europe. Indeed, the use of the term "paradise" expanded over time and came to describe the forecourts of Carolingian and high medieval churches. The best known examples stem from the tenth-century Saint-Gall plan of an ideal monastery, which shows hemispherical courtyards labeled *paradisi* at both ends of the basilica, and the *Chronicon monasterii Casinensis* of ca. 1070, which refers to the atrium of abbot Desiderius' church at Montecassino as a place "which we call paradise following Roman custom" (*quod nos Romana consuetudine paradysum vocitamus*) (fig. 2.7).[48]

For modern viewers, the connection between architecture and paradise is perhaps most apparent in the cloister (from the Latin *claustrum*, meaning "lock"). This porticoed building type assumed its canonical form in the Carolingian period and bears a strong formal relationship to the atrium.[49] The Edenic garden was an important archetype for the cloister, which served as a place of contemplation, prayer, and study separate from the external world for celibate, Adam-like clerics.[50] This strictly clerical space comprises a quadrangular, open-air court called a garth that typically contained a fountain at its center and a variety of plants, alluding to the running

FIGURE 2.6 Martino Ferrabosco, *Plan of Old Saint-Peter's,* ca. 1620

Photo: The Metropolitan Museum of Art, Harris Brisbane Dick Fund, 1945 (45.82.2)

spring and thriving vegetation of paradise.[51] In France, cloisters were most common in monastic contexts. However, they could also be incorporated into episcopal precincts, as at Noyon, where a well-preserved thirteenth-century cloister walk still stands on the northwest side of the cathedral (fig. 2.8).[52] Members of both the regular and secular clergy were therefore well acquainted with this building type.

FIGURE 2.7 Saint-Gall plan, detail, ca. 820, St. Gallen, Stiftsbibliothek, Codex Sangallensis 1092

Photo: St. Gallen, Stiftsbibliothek

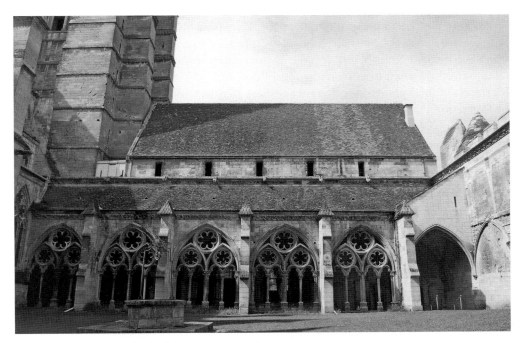

FIGURE 2.8 Noyon Cathedral Cloister, ca. 1240

Photo: author

The historical record reveals that parallels between the cloister and paradise existed from an early date. The author of the late-fourth-century *Historia monachorum* described the monastery of Abbot Isidore in Thebes as a walled complex with "watered gardens, and all the fruits and trees of paradise" (*horti irrigui, omnium quoque pomorum arborumque paradisi*).[53] According to the Augustinian canon Hugh of Fouilloy, the cloister symbolized the Heavenly Jerusalem,[54] an association on which Durandus elaborated in the *Rationale divinorum officiorum*:

> Furthermore, as the Church signifieth the Church Triumphant, so the cloister [*claustrum*] signifieth the celestial paradise, where there will be one and the same heart in filling the commands of God and loving Him: where all things will be possessed in common, because that of which one hath less, he will rejoice to see more abounding in another, for God shall be all in all.[55]

The cloister-paradise analogy persisted throughout the Middle Ages and later, such that Louis of Blois (d. 1566), abbot of the Benedictine abbey of Liessies in northern France, composed the following verses to adorn the gates that led to the gardens of his monastery:

> May the beauty of flowers and other creatures draw the heart to love and admire God, their creator.
> May the garden's beauty bring to mind the splendor of paradise.
> The birds sing the praise of God in heaven so that man may learn to praise Him in his heart.[56]

Sculptures participated in the paradisiacal construct of the medieval cloister. Although botanical, abstract, and figural forms generally coexisted on the large-scale reliefs and column capitals of the medieval cloister, vegetal forms became more dominant over the course of the twelfth century, reinforcing the links between the cloister and the garden-paradise. An instructive example is the late-twelfth- or early-thirteenth-century cloister of the former Benedictine monastery of Saint-Guilhem-le-Désert near Montpellier, which has been partially reconstructed at The Cloisters in New York City (fig. 2.9).[57] Some capitals and abaci reproduce ancient Roman leaf types with meticulously carved channels and deep drill holes, but others seem to portray the local flora, such as vines and hop plants (fig. 2.10). Regardless of their models, the diversity of these elegant sculptures echoes in general terms the vegetation that once grew within the garth, which itself reflected the *varietas* of God's Creation. Bolstering ideas of growth in this virtual garden are the column shafts and pilasters carved to resemble the bark of palm trees and scrolling foliage (fig. 2.11). The Edenic aspects of the design are further emphasized by the parallel rows of wavy lines on several of the column shafts, which recall the cascading paradisiacal spring described in Genesis (see fig. 2.9).

Central to my reading of the church in paradisiacal terms are its affinities with the cloister, which range from formal to metaphorical. From a strictly formal perspective, the arcades that connect the nave of a basilica (the prevalent church type in high and late medieval France) to its side aisles recall the arcades of the porticoes that surround the cloister's garth, usually on all four sides. In both cases, the alternating supports and voids create a staccato rhythm down the length of the structures, while the lateral spaces—the aisles and porticoes—function as ritual pathways and facilitate circulation. Moreover, foliage was used in a comparable manner in cloisters and churches, namely as a framing mechanism. At the Saint-Guilhem-le-Désert cloister, the foliate capitals together with the column shafts and arches serve to frame the space of the garth (see fig. 2.9). The term "vegetal frame," however, is more appropriate to continuous bands of foliage,

FIGURE 2.9 Saint-Guilhem-le-Désert Cloister, New York, Metropolitan Museum of Art, The Cloisters Collection, early thirteenth century

Photo: author

FIGURE 2.10 Detail of 2.9

Photo: author

FIGURE 2.11 Detail of 2.9
Photo: author

such as the remarkable frieze in the thirteenth-century cloister of Mont-Saint-Michel, where the botanical forms were lifted out of the capital zone and placed directly above the arches (figs. 2.12, 2.13).[58] Complete with twining tendrils and palmately lobed leaves, this lifelike vine winds gracefully and without interruption around the space of the cloister. The vine leaves and small grape clusters filling the spandrels of the arches add to the sumptuousness of the design and heighten the visual consonance between the architecture and the planted garth. Despite enclosing a non-consecrated space, the Mont-Saint-Michel cloister vine is comparable to the strings of foliage circumscribing church interiors by virtue of its general form and encircling function, a relationship made all the more compelling given the conception of both building types—cloister and church—in paradisiacal terms.

A wide range of written and epigraphic sources from the Middle Ages liken churches to paradise. Building on earlier scholarship, Laurence Hull Stookey examined the church consecration liturgy and determined that it emphasized the Heavenly Jerusalem as far back as the tenth century, in addition to referencing the gate of heaven (*porta caeli*).[59] A recurring antiphon in the vespers for the feast of the Dedication from the Common of the Dedication of a Church of the Roman Missal and Breviary borrows directly from Revelation 21: "All thy walls are precious stones, and the towers of Jerusalem shall be made of jewels" (*Lapides pretiosi omnes muri tui, et turres Jerusalem gemmis aedificabuntur*).[60] The Roman ritual also includes a hymn about Jerusalem, which mentions streets and walls of pure gold (*Plateae*

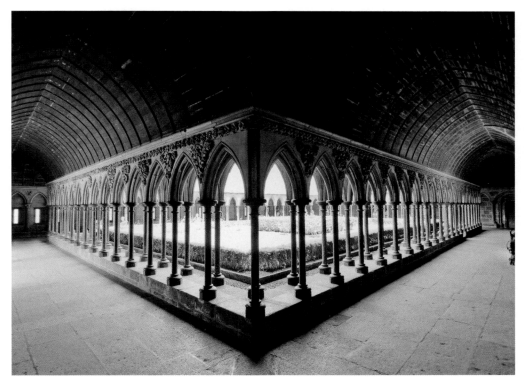

FIGURE 2.12 Mont-Saint-Michel Cloister, completed 1228

Photo: Marvin Trachtenberg

FIGURE 2.13 Detail of 2.12

Photo: Marvin Trachtenberg

et muri ejus, Ex auro purissimo).[61] Although Otto von Simson claimed that the twelfth and thirteenth centuries were "singularly preoccupied" with the symbolic significance of church architecture, Stookey's study revealed earlier roots to such formulations.[62] An inscription leading from the cloister to the church of the Apostles at Nola, recorded by Paulinus of Nola (d. 431), supports Stookey's findings, while also providing evidence of the close interconnection of cloister, church, and paradise: "Enter the celestial paths through pleasant lawns, Christians; it is also fitting that the entrance to this place is from fertile gardens. From here an exit into the sacred paradise is given to those who merit it" (*Caelestes intrate vias per amoena virecta, Christicolae; et laetis decet huc ingressus ab hortis, Unde sacrum meritis datur exitus in paradisum*).[63]

Over the last few decades, scholars have drawn attention to the parallels between church architecture and paradise. It has become commonplace, for instance, to interpret the radiant stained glass windows that became major features of Western European churches in the twelfth century as allusions to the gleaming gems dressing the walls of the celestial city.[64] Furthermore, architectural historians have suggested that the dimensions of the Heavenly Jerusalem as recorded in Revelation were reflected in critical measurements of some medieval churches, such as the cathedrals of Amiens and Beauvais (ca. 1225–1284). From pavement to keystone, the former measures approximately 144 Roman feet and the latter 144 royal feet, echoing the 144-cubit dimension given by John.[65] Similarly, the heavenly city's twelve gates and length of 12,000 furlongs find parallels in the 120-royal foot module used to lay out the church of Saint-Ouen in Rouen (begun 1318–1319).[66] The transfer of dimensions from a biblical text to actual structures is a testament to the status of the celestial paradise as an archetype for churches, and may suggest that meaning was inscribed into buildings at the outset of the construction process.

Depictions of the Garden of Eden in monumental media reinforce the notion of the church as an image of paradise. The story of the Creation and humankind's exile from Eden routinely appears in architectural sculpture and stained glass. In some buildings, images of Eden are juxtaposed with vegetal ornamentation, cementing the link between organic forms and this key biblical site. The central portal of the north porch of Chartres Cathedral is a striking example of this practice. Unfolding from east to west in the two outermost figural archivolts are eighteen pairs of images recounting the Creation and Fall.[67] Vegetation functions as a topographical marker in several scenes, locating them in the garden-paradise. Enclosing these two archivolts is a winding foliate frieze (fig. 2.14). Of importance here is not just the apposition of the Edenic episodes and the foliate band, but also their proximity, which diverges from the widely spaced archivolts of the rest of the porch, thereby strengthening the formal and semantic relationship between Eden and the vegetal frieze. Taken together, the figural and foliated archivolts at Chartres Cathedral seem to announce the status of the portal as the gateway to paradise.

An interdependence of figural and organic sculptures is also apparent on the western portal of the abbey church at Andlau, which dates to the mid-twelfth century (fig. 2.15). The portal is set within a deep, groin-vaulted porch and consists of four main parts: the tympanum depicts the *Traditio Legis* (probably reused from an earlier project), with Christ conferring a key on Saint Peter and a book on Saint Paul; the lintel recounts the Creation and Fall in five episodes; the outer doorjambs show pairs of abbey benefactors under superposed arches, some of whom are identified by inscriptions; and the inner doorjambs are carved with inhabited rinceaux held up by atlas figures.[68] Each section of the portal incorporates vegetal forms that interlink and

FIGURE 2.14 Chartres Cathedral, north transept, central portal, archivolts and gable, ca. 1210
Photo: author

enrich the narratives. The figures in the tympanum are flanked on the left by a barren tree and on the right by a tangled vine laden with grape bunches, which have been interpreted as the Tree of Knowledge and the Tree of Life (fig. 2.16).[69] Two schematized foliate friezes line the bottom of the tympanum, cutting across the lintel and jambs. Indicating the celestial landscape are three trees symmetrically disposed in the lintel. The first appears in the Creation of Eve scene on the left; the second is the Tree of Knowledge at the center of the composition, whose coiling serpent provides a visual parallel for the grapevine in the tympanum; and the third functions as a support for Adam and Eve after their expulsion from Eden on the right-hand side. The most important section of the design for my purposes is the foliage on either end of the lintel, which is not only congruent with the three trees in Creation and Fall scenes, but also sprouts directly from the interlaced rinceaux of the inner jambs, physically merging the two sections of the portal. Although all foliate sculptures have the capacity to evoke paradise, the form and composition of the Andlau portal leave little ambiguity about the role of foliate bands—in this case jamb rinceaux—as paradisiacal signifiers.[70]

LOCI OF THE DIVINE

A defining aspect of both the terrestrial and celestial paradise is their status as *loci* of divine presence. This function is made explicit in scriptures and in medieval visual and textual sources, which present Eden as a place where God walked among humans and heaven as God's celestial

FIGURE 2.15 Andlau Abbey, west portal, ca. 1140

Photo: © Ministère de la Culture/Médiathèque du Patrimoine, Dist. RMN-Grand Palais/Art Resource, NY

FIGURE 2.16 Detail of 2.15

abode.[71] The heavenly city described by Bernard of Cluny in the twelfth-century poem *De contemptu mundi*, one of the most significant medieval contributions to the literature on heaven, is both a place illuminated by God's golden light and the site where saints joyously fulfill their desire to encounter God, who "will be a sure sight for them."[72]

The role of Eden and heaven as places of divine presence connects these sacred locations to some of the most revered objects and monuments of the Judeo-Christian tradition. Foremost among these are the Ark of the Covenant (the golden receptacle for the stone tablets on which God inscribed the Ten Commandments); the portable Tabernacle that sheltered the Ark, a golden lampstand, and a table for showbread during the Israelites' journey through the wilderness to the Promised Land; and the Holy of Holies of the Jewish Temple in Jerusalem, which was the first permanent container for the Ark. The presence of God among his people manifested itself in all three vessels.[73]

More relevant to the issue at hand is the function of the Christian sanctuary as a place of divine presence. Like paradise, the church was broadly understood to be a dwelling place of God, a status affirmed in Ephesians 2:21–22 and reiterated in the liturgical hours for the feast of the dedication at many churches, including Saint-Denis: "How awesome is this place. Truly this is none other than the house of God and the gate of heaven" (*O quam metuendus est locus iste: vere non est hic aliud, nisi domus Dei et porta caeli*).[74] Within the sacred whole, the liturgical choir was singled out as a particularly important site of divine presence, a point verified in Chapter 19 of the Rule of Saint Benedict, the standard for Western medieval monasticism: "God is present everywhere [. . .] Let us be sure, however, without a moment's doubt, that his presence to us is never so strong as while we are celebrating the work of God [in the oratory]" (*Ubique credimus divinam esse praesentiam [. . .] maxime tamen hoc sine aliqua dubitatione credimus, cum ad opus divinum assistimus*).[75] The points of contact between churches and paradise outlined above, combined with Theophilus' description of the church as a blooming garden cited at the beginning of this chapter, provide vital evidence for the metaphorical and literal interpretation of the medieval church

as a heavenly arbor. Indeed, the foliage that seems to sprout miraculously from the walls of churches calls to mind a burgeoning garden. Combined with vegetal imagery in other media, sculpted organic forms create an aura of enticing growth evocative of the bounty of the paradisiacal garden.

Whether rendered in two or three dimensions, the blooming vegetation in the medieval churches of France was suggestive not only of divine plenitude, but also of divine creativity. By evoking the Garden of Eden, fictive flora alluded to God's role as the maker of all things at the start of time. Closely related is the conception of God as an architect, a cosmogenic metaphor rooted in the Timaean notion of the divine artificer and addressed by numerous Neoplatonic thinkers, such as William of Conches, Thierry of Chartres (d. ca. 1150), and Clarembald of Arras (d. ca. 1187). Aquinas clearly articulated this idea in the following century in his *Summa Theologiae*: "God, who is the first principle of all things, may be compared to things created as the architect is to things designed" (*ut artifex ad artificiata*).[76] Visual iterations of this concept are especially significant in light of their frequent inclusion of the compass, a tool and emblem of the medieval master mason (fig. 2.17).[77] For example, one finds a carefully rendered compass on the bottom of the tomb slab of Hugues Libergier (d. 1263), the builder of the now-destroyed church of Saint-Nicaise at Reims (fig. 2.18).[78] The analogy is clear: just as God designed the universe, master masons designed churches, which mirrored the perfection of God's creation not simply with their plumb walls and precisely squared stones, but also with their blossoming, Eden-like foliage.[79] The parallel between divine creation and human endeavor is well documented in the art and architecture of the Middle Ages, notably in the labors of the months, which are often portrayed on holy objects and buildings (see fig. I.11).

The power of God to create is inextricably linked to his ability to transform matter, offering yet another avenue for the interpretation of foliate elements in medieval churches. Within the Christian conception of the world, God alone could create and alter matter (as opposed to the Devil, who merely deceived the senses).[80] Daniel 4:31–33 recounts that God turned the Babylonian king Nebuchadnezzar into a wild beast for seven years for failing to acknowledge his authority. Comparable to this metamorphic feat is the apparent transmutation of nature in the medieval church from untamed organic matter susceptible to the depredations of time into immutable and regularized stone. Read inversely, the power might be seen to lie in the hands of the mason, whose job it was to transform the intractable (stone) into the seemingly pliable (vegetation). It is with these correlations in mind that we can interpret the writings of William of Conches, who echoed Calcidius' commentary on the *Timaeus* when he proclaimed: "It must be recognized that every work is the work of the Creator, or the work of nature, or the work of a human artisan imitating nature."[81] With varying degrees of verisimilitude, the organic forms in French churches approximate real vegetation, which itself reproduces the divinely created flora of Eden. These observations resonate with the characterization of God in the anonymous fourteenth-century mystical treatise *Theologia Deutsch*: "For He is the Substance of all things, and is in Himself unchangeable and immoveable, and changeth and moveth all things else."[82] The apparent transformation of matter inside churches—its alteration from inanimate to animate or vice versa—paralleled God's singular power to create and recreate.

FIGURE 2.17 *God as Architect*, ca. 1230–40, Vienna, Österreichische Nationalbibliothek, Codex Vindobonensis 2554, fol. 1v

Photo: Public Domain

FIGURE 2.18 Tomb of Hugues Libergier,
from Saint-Nicaise, Reims, ca. 1263

Photo: author

THE TREE OF LIFE

With the exception of the north porch of Chartres Cathedral and the west portal of the abbey church at Andlau, I have discussed the paradisiacal aspects of monumental flora in general, rather than focusing on specific types of foliated architectonic elements. There are, however, ways in which foliate friezes specifically participated in the paradisiacal figuration of the church, a function based on their vine-like characteristics, such as their distinctive leaf and fruit types, or their sinuosity (see, for example, figs. I.10, I.15, I.16, 1.16, 1.29, 1.35, and 1.37). Foliate bands could evoke the Tree of Life in the Garden of Eden, an association grounded in the notion of the Edenic tree as a vine and the garden itself as a vineyard in the Judeo-Christian tradition.[83] Although the textual and pictorial records reveal that the morphology of the life-generating tree was relatively elastic, with some sources describing it as an olive tree and others tying it to the palm (a symbol of the Resurrection), there were nevertheless strong currents from antiquity onward connecting the Edenic tree to the grapevine.[84] The first-century writings of Philo of Alexandria exemplify this link. Philo characterized the cosmic World Tree, which was associated with the Tree of Life in Jewish, Christian, and gnostic sources, as a giant vine with man-sized grapes.[85] (This description is congruous with Josephus' account of the monumental grapevine articulating the entrance to the Jewish Temple, a topic I shall return to in Chapter 4.)

Although the primary concern of this section is elucidating the relationship between foliate friezes and the paradisiacal tree in Christian contexts, it warrants mention that the identification of the Tree of Life as a vine had repercussion on the artistic output of Jews as well as Christians. For example, a full-page miniature in a Hebrew Bible from Provence (ca. 1300), now in a private

collection in New York, depicts the Tree of Life as a golden vine with scrolling tendrils supporting reddish-blue and white grapes.[86] Similarly, the graceful vine in the tympanum above the main entrance to the thirteenth-century Altneu synagogue in Prague has been interpreted as a representation of the Tree of Life (fig. 2.19).[87] This supple vine, which covers the entire surface of the tympanum and features a dozen grape clusters symbolizing the twelve tribes of Israel, emerges from a bifurcated stream reminiscent of the Edenic spring described in Genesis. The foliate capitals in the jambs repeat the vegetal forms of the tympanum, underscoring the paradisiacal aspects of the space.

In patristic and exegetical sources, the Tree of Life was often associated and even conflated with the cross of the Crucifixion, which some held was carved from the Edenic tree. In *Adversus Judaeos*, Tertullian (d. ca. 240) found that what had been lost through Adam was regained through the wood of Christ's cross.[88] Similarly, the *Lignum vitae* of Saint Bonaventure (d. 1274), one of the most important devotional texts on the Passion from the high Middle Ages, described the cross of the Crucifixion in arboreal terms with twelve branches "adorned with leaves, flowers, and fruits" springing from a trunk.[89] Other contributions on the topic appear in popular legends of the True Cross.

Representations of the cross of the Crucifixion as a living entity (*arbor vitae*), early examples of which can be found in Anglo-Saxon manuscripts and Carolingian ivories, were commonplace by the twelfth century. Related to this iconography is the depiction of the Tree of Life with or as a grapevine, a motif best exemplified by the shimmering apse mosaic in the early-thirteenth-century church of San Clemente in Rome (fig. 2.20).[90] An immense vine of Byzantine inspiration rises from an acanthus plant at the base of the cross and winds its way across the semi-dome, the spiraling branches occupying virtually every inch of the lustrous

FIGURE 2.19 Altneu Synagogue, Prague, portal, completed ca. 1270

Photo: Marek Dospěl

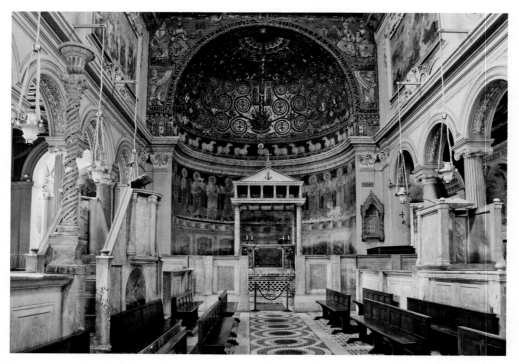

FIGURE 2.20 San Clemente, Rome, view to east, begun ca. 1099
Photo: author

surface. Interspersed between the shoots are paradisiacal motifs, including animals, birds, and baskets brimming with fruit. The imagery evokes the viridity and fruitfulness of Eden, whereas the gold background is suggestive of a spiritual realm. An inscription at the base of the half-dome reinforces for literate viewers the paradisiacal imagery above: "We will liken the Church of Christ to this vine from the wood of the Cross . . . which the [old] law makes wither but which the cross makes green" (*Ecclesiam Cristi viti similabimus isti de ligno crucis . . . quam lex arentem set crus facit esse virentem*).[91] The arresting opus sectile pavement coiling up the center of the nave loosely recalls the botanical forms and polychromy of the vine in the apse, thereby unifying the different sections of the building formally and conceptually as evocations of a garden-paradise.[92]

Although the book of Genesis situates the Tree of Life within the Garden of Eden, other biblical sources tie it to the Heavenly Jerusalem. Ezekiel, for instance, foretells of the planting on Judgment Day of life-giving trees on a river bank, whose leaves and fruit will never fall off or decay.[93] Revelation 22:2 provides a similar description: "On both sides of the river, was the tree of life, bearing twelve fruits, yielding its fruits every month, and the leaves of the tree were for the healing of the nations." The central concepts of Christian eschatology expressed in these authoritative texts speak to the potency of the vine-like motifs articulating the interior and exterior of French churches. Clerical authorities harnessed natural forms to convey fundamental truths of the faith and to promote a distinctly Christian worldview, employing in their churches undying leaves and everlasting fruit replete with potential meanings that reflected with their diversity both the inestimable bounty of paradise and the infinite power of God.

THE *HORTUS CONCLUSUS*

My sister, my spouse, is a garden enclosed [*hortus conclusus*], a garden enclosed, a fountain sealed up [*fons signatus*].

Thy plants are a paradise of pomegranates with the fruits of the orchard. Cypress with spikenard.

Spikenard and saffron, sweet cane and cinnamon, with all the trees of Libanus, myrrh and aloes with all the chief perfumes.

The fountain of gardens: the well of living waters, which run with a strong stream from Libanus. (Song of Sol. 4:12–15)

The enclosed garden of the Song of Songs, the "most frequently interpreted book of medieval Christianity" according to E. Ann Mather, offers a key point of reference for my reading of the foliage inside medieval churches and attests to the intertextual and intervisual aspects of monumental flora in sacred contexts.[94] Equipped with a fountain and full of fruit and spices, the *hortus conclusus* bears a striking resemblance to the paradisiacal gardens of Genesis and Revelation.[95] As the nearly one hundred extant medieval commentaries and homilies on the biblical poem reveal, however, the teeming garden was a referent with unstable meanings, serving at once as an emblem and title of the Virgin Mary, a symbol of Christ's human nature and Resurrection, and a stand-in for the Church.[96] The enclosed garden became a metaphor for Mary's closed womb and perpetual virginity, as well as her immaculate conception. Within this regained and reimagined Eden, Mary was presented as the New Eve, the unsullied vehicle of the incarnation and salvation, and as the enclosed garden itself. John of Damascus (d. ca. 749) succinctly expressed this idea in a sermon on the Assumption of the Virgin: "Thou art a spiritual Eden, holier and diviner than Eden of Old. That Eden was the abode of the mortal Adam, whilst the Lord came from heaven to dwell in thee."[97] Closely related is John's sermon in the second nocturne of Matins (fourth lesson) for the Assumption in the Roman breviary, which describes Mary as "the living garden, in which the condemnation was annulled, in which the tree of life was planted."[98]

The cult of the Virgin grew exponentially in Western Europe beginning in the second half of the eleventh century, as evidenced by the proliferation of treatises written about her, the creation of collections of her miracles, and liturgical innovations.[99] The Virgin came to be worshipped as the queen of heaven, the primary intercessor for the salvation of humankind, and the personification of the Church. Patristic writers, notably Augustine and Ambrose, paved the way for these developments by casting the Virgin as *typus ecclesiae*.[100] Autpert Ambrose (d. 784) and the Carolingian Mariologists contributed substantially to the cult of the Virgin by emphasizing her intercessory and mediating powers for individual believers.[101] In their view, the Virgin's unique maternal relationship to Christ elevated her above all other members of the Church, resulting in a closer bond between the Virgin and the Church than ever before. Twelfth-century exegetes, such as Rupert of Deutz, Honorius of Autun, Alan of Lille, and Bernard of Clairvaux, further promoted the cult by identifying Mary as the bride in the Song of Songs.[102] As Friedrich Ohly observed, earlier thinkers laid the groundwork for the Marian interpretation of the Song of Songs, but a commentary by Rupert from ca. 1110–1119 is the earliest systematic Marian exposition of the poem to have come down to us.[103] This innovative text treats the Song of Songs as a love poem between Christ and the Virgin, referring to the latter as a "closed garden" (*hortus conclusus*) and "sealed

fountain" (*fons signatus*).[104] By the twelfth century, then, firm links had been established between the Virgin and the garden, the Virgin and the Church, and, as discussed above, the paradisiacal garden and church architecture. The Virgin was herself closely associated to sacred buildings, a connection supported by her increasingly important presence on church portals as of the twelfth century and the proliferation of churches (re)dedicated in her name (see figs. 1.19 and 1.20).

Despite the wealth of associations between Mary and the Song of Songs in twelfth-century texts, the garden and fountain played a limited role in the Marian imagery of the period, gaining traction only in the late Middle Ages. The *hortus conclusus* became a common theme in visual media around 1400, with images of the Virgin Mary in a garden setting appearing in manuscripts, panel paintings, textiles, and other media, especially in Germany. Martin Schongauer's late-fifteenth-century *Virgin in the Rose Garden* from the Dominican church of Saint-Martin in Colmar is one of the most striking examples of a late medieval *hortus conclusus* (fig. 2.21).[105] Two angels wearing billowing garments crown the seated Virgin, who holds the infant Jesus in her arms. A wooden trellis covered with blossoming red roses serves as an elegant backdrop for the figures, bringing to mind a fragrant, living tapestry. A single white rose, a symbol of

FIGURE 2.21 Martin Schongauer, *Virgin in the Rose Garden*, Colmar, Church of Saint Martin, 1472
Photo: Public Domain

Mary's purity, and diminutive goldfinches, emblems of the Resurrection, also populate the garden. Variants of this subject include depictions of the Annunciation in an enclosed garden and combined scenes of the Annunciation, the Hunt for the Unicorn, and the Virgin and Unicorn in garden locales. The gardens in these images are invariably delineated with hedges, trellises, wattle fences, and elaborate architectonic barriers that function as frames for the scenes. The last often recall church structures. The doorway in the mid-fifteenth-century *Madonna and Child with Saints in the Enclosed Garden* from the circle of Robert Campin, for example, comprises a pointed arch, traceried pinnacles, and undulating crockets, all of which find parallels in contemporary church design (figs. 2.22, 2.23). Similarly, the two wall hangings behind the Virgin and Christ, whose vegetal patterns echo the "real" plants growing in the garden and sprouting from the top of the walls, recall the textiles suspended in churches on certain occasions.[106] Such connections help explain the relationships scholars have posited between images of the *hortus conclusus* and architectural *Astwerk*, some going so far as to characterize Late Gothic churches as literal representations of the heavenly garden.[107]

Most depictions of the Virgin in the *hortus conclusus* date to the late Middle Ages, but the back cover of the Bamberg Psalter of ca. 1220–1230 reveals the salience of the subject in Western European visual culture before this time (fig. 2.24).[108] The painted parchment cover, which is protected by a clear horn plate and enclosed by a silver vegetal frame, depicts the Virgin and Child

FIGURE 2.22 Follower of Robert Campin, *Madonna and Child with Saints in the Enclosed Garden*, Washington, DC, National Gallery of Art, ca. 1440–1460

Photo: Samuel H. Kress Collection (1959.9.3)

FIGURE 2.23 Detail of 2.22

seated on a rainbow within a mandorla, four medallions with busts of female saints, and four standing male figures and their attributes, each related typologically to the Incarnation: Ezekiel indicating a closed gate (bottom left), Aaron in priestly dress holding a flowering rod (upper left), Jesse with a leafy branch (upper right), and Solomon beside a fountain (bottom right). The image relevant to this discussion is that of the crowned Solomon, ostensibly the author of the Song of Songs, who gestures toward a circular fountain on a polygonal base, a clear reference to the *fons signatus* in the biblical poem. Although Solomon is set against a flat, gold background (like the rest of the figures), the three blossoming stems growing in pots at the base of the fountain unambiguously locate the scene in the *hortus conclusus*. These vegetal forms, as well as the flowering rod of Aaron and the branch of Jesse, interact formally and conceptually with the silver rinceau framing the composition, such that all the figures, including the Virgin and Child, might be said to inhabit if not a garden per se then certainly an otherworldly space demarcated by foliage.

It is impossible to determine why depictions of the Virgin in the *hortus conclusus* were so rare in the high Middle Ages, when exegetes first identified Mary as the bride of the Song of Songs. (Conversely, scholars have not determined exactly what spurred the creation of *hortus conclusus* images after 1400.)[109] The thirteenth-century Bamberg Psalter is the earliest extant object to tie Marian and Song of Song imagery. Yet the *hortus conclusus* remains highly relevant to the study of the visual culture of high medieval France, notably in the field of architecture. The increasing importance of Marian images on church façades and the growing practice of dedicating churches in her name beginning in the twelfth century not only coincided with the Virgin's identification as the bride of the Song of Songs, but also with the proliferation of monumental flora in sacred contexts. Given these convergences, it is possible that the foliated sculptures in and on churches brought to mind the *hortus conclusus* for knowledgeable medieval viewers. This is particularly true in cases where organic forms were juxtaposed with Marian imagery on buildings dedicated to the Virgin, as at the cathedrals of Chartres, Laon, and Paris (see fig. 1.20). These Early Gothic buildings may have been perceived as enclosed gardens, both figuratively and literally. A final observation about

FIGURE 2.24 Bamberg Psalter, back cover, ca. 1220–1230, Staatsbibliothek Bamberg, Msc. Bibl.48

Photo: Gerald Raab

the relationship between high medieval churches and the *hortus conclusus* pertains to the reception of vegetal forms over the *longue durée*.[110] Shifting the emphasis away from the synchronic (and from the notion of the object as a static bearer of a single, prescribed meaning) makes room for insights into the variable functions and associations of monumental foliage over time. This diachronic approach provides a larger semantic field for interpreting twelfth- and thirteenth-century vegetal sculptures, in addition to situating them within broad trends in medieval visual culture.

GARDEN AND SEPULCHER

The biblical Passion narrative describes two gardens—the Garden of Gethsemane at the foot of the Mount of Olives and the Garden of Joseph of Arimathea near Calvary. The gospels identify the former as the place where Jesus prayed with his disciples on the eve of the Crucifixion and the site of his betrayal by Judas. The latter, which is the focus of this section, was the location of Jesus' rock-cut tomb and Resurrection. Like the lush oasis of paradise and its counterpart in the Song of Songs, the Garden of Joseph of Arimathea bears on the study of botanical images in church contexts, adding to the complex nexus of meaning.

The Garden of Joseph of Arimathea plays a key role in the gospel of John, which relays an exchange between Jesus and Mary Magdalene at the tomb in the garden where Joseph, a secret disciple, and Nicodemus took Christ's body after the Crucifixion.[111] After encountering two angels, the weeping Mary saw Christ, whom she initially mistook for a gardener.[112] The ensuing exchange, during which Christ forbade Mary from touching him (*Noli me tangere*), was a common subject in art from the Early Christian period onward, with botanical forms typically functioning as visual indices of the setting (fig. 2.25). Representations of the *Noli me tangere*, especially those from the late Middle Ages, often show Christ holding a spade or a rake and donning gardener's clothing in accordance with John's account. Nowhere is Christ's role as the New Adam—the redeemer of humankind from the consequences of the Fall—more explicit than in this emotionally charged garden scene.

On a symbolic level, the garden that held Christ's tomb relates closely to the terrestrial and celestial paradise (with their life-generating trees), and by extension to the cross of the Crucifixion. The inclusion of vegetal imagery (specifically trees) in depictions of the *Noli me tangere* also reinforces the typological links between Mary Magdalene and Eve, a correlation first made in writings ascribed to Hippolytus of Rome (d. 235) and elaborated upon by numerous writers, including Ambrose, Augustine, Rabanus Maurus (d. 856), and Aquinas.[113] Mary and Eve are also conflated in the popular sermon, *On the Veneration of Saint Mary Magdalene*, attributed to Odo of Cluny (d. 942).[114] Equally relevant is the association of the Holy Sepulcher in the Garden of Joseph of Arimathea with the Tree of Knowledge in Eden, a parallel made by Petrus Chrysologus (d. 450), who compared the desire of the three Marys at Jesus' tomb to the desire engendered in Eve by the paradisiacal tree.[115] The Garden of Joseph of Arimathea hence had entwined meanings, all of which related to the cycle of salvation—to paradise, its loss, and its recovery. These meanings surely informed the *Noli me tangere* panel on the celebrated bronze doors of Bishop Bernward from the church of Saint-Michael in Hildesheim, where two fruit-bearing grapevines, symbols of Christ's redemptive sacrifice and paradise, serve as bookends for the scene (fig. 2.26).[116]

FIGURE 2.25 *Noli me tangere*, from Saint-Leonhard,
Lavanttal, Austria, New York, Metropolitan Museum of
Art, The Cloisters Collection (68.224.2), 1340–1350

Photo: author

Like all Holy Land sites linked to the Passion, the garden where Mary came upon the risen Christ was a prime pilgrimage destination that attracted increasing numbers of Western visitors after Jerusalem came under Christian rule in 1099. Indeed, an important objective of the Crusades was to seize control of the site of Jesus' tomb. Christian travelers to Jerusalem consistently expressed their desire to visit the Holy Sepulcher. In a description of the city composed soon after the Latin conquest, an Anglo-Saxon monk declared: "I am Saewulf. Though I am unworthy and sinful I was on my way to Jerusalem in order to pray at the Lord's Tomb."[117]

The place Saewulf encountered during his voyage from Britain bore little resemblance to the garden-tomb of scripture or to the fourth-century church of the Holy Sepulcher initially built on the site by Constantine the Great (d. 337). The latter consisted of two distinct but interconnected buildings: a five-aisled basilica fronted by a colonnaded atrium, which was separated from a rotunda by a second atrium (fig. 2.27).[118] It was the rotunda, called the Anastasis, that marked the location of Christ's rock-cut tomb. The church was altered and reconstructed numerous

FIGURE 2.26 *Noli me tangere*, bronze doors, church of Saint-Michael, Hildesheim, 1015

Photo: Foto Marburg/Art Resource, NY

1. Anastasis Rotunda
2. Tomb aedicula
3. Atrium
4. Calvary

FIGURE 2.27 Church of the Holy Sepulcher, Jerusalem, fourth century

After Corbo

times in subsequent periods, notably by Constantine Monomachus in the mid-eleventh century (after the destruction by the Fatimid caliph, Abu ʿAli al-Mansur al-Hakim), and then by the Crusaders in the mid-twelfth century.[119] The church took on its current double-ended form during the Crusades, the period most pertinent to this study. The Crusader-era church (dedicated in 1149) consisted of the Anastasis Rotunda, a domed transept, and a pilgrimage choir to the east that opened onto a large courtyard (fig. 2.28). The church proper was surrounded by dozens

1. Anastasis Rotunda
2. Tomb aedicula
3. Crusader choir
4. Calvary

FIGURE 2.28 Church of the Holy Sepulcher, Jerusalem, twelfth century
After Corbo

of subsidiary structures of varying shapes, sizes, and functions, forming a vast complex within the city walls of Jerusalem. In short, the site of Christ's tomb had been fundamentally altered by the twelfth century and the verdant Garden of Joseph of Arimathea had long disappeared.

With its monumental size and soaring dome, the Anastasis Rotunda was an appropriately imposing marker of Jesus' tomb. Lavish marbles and glimmering mosaics contributed to the building's magnificence. According to the German monk, Theodoric, who visited Jerusalem in 1172, the sepulcher itself was clad in "parian marble, gold and precious stones" and had three openings through which pilgrims could make physical contact with the tomb.[120] The ornate setting and costly materials were a far cry from the simple garden described in the Bible, yet the written record suggests that the garden remained central to conceptions of the site, with some pilgrims even describing their experiences in the Holy Land as though they were eyewitnesses to the Passion. Nicole Chareyron remarked that the Florentine monk Riccoldo da Monte di Croce seemed entirely unaware of the church's formal features and expensive adornments in his thirteenth-century account of his visit to the Holy Sepulcher, instead describing the area as it appeared in the time of Christ:

> We wanted to go to the sepulcher to seek out the Lord whom we had not found at Calvary, for he had been buried, and I, unhappy man, coming too late, said: "Let us seek him in the grave where he has been laid." . . . We followed the path by which the Marys had gone. . . . As we walked, we talked amongst ourselves, asking one another: "Who will roll back the stone for us?" . . . Turning round and round the sepulcher, we eagerly sought for the Lord but did not find him, when one of us cried out: "Surrexit Christus."[121]

The importance of the garden remains clear even in more conventional travelers' reports, which identify the Anastasis Rotunda rather than an imagined biblical setting as the location of the tomb of Christ. During his late-fourteenth-century visit to the church of the Holy Sepulcher, for instance, the French nobleman Ogier d'Anglure came across a round, flat stone, which he identified as "the place where Mary Magdalene mistook Our Lord for a gardener."[122] The biblical setting was made more immediate for visitors to the church prior to the renovations undertaken by the Crusaders in the mid-twelfth century. Textual sources from the first half of the twelfth century reveal that the area east of the rotunda was a garden or an open court.[123] According to the travel accounts of Theodoric and John of Würzburg (ca. 1165), visitors to the church after the Crusader-era alterations were offered a mosaic or painting of the *Noli me tangere* (now lost) in lieu of an actual garden.[124] Located above one of the portals of the south transept, the image almost certainly included vegetal motifs as an indicator of the original garden setting.[125]

The church of the Holy Sepulcher captured the imagination of travelers, patrons, and builders in Western Europe, who singled out the hallowed Anastasis Rotunda for reproduction in architecture, manuscript illumination, painting, and other media early in the building's history.[126] In light of the reception of the building and its critical place in the medieval imaginary, as well as the sustained currency of the Holy Sepulcher's original garden setting, foliate motifs in church contexts become particularly loaded. The vegetal forms could evoke crucial events from the Passion of Christ. By extension, they may have alluded to the church built to commemorate these events and to the city of Jerusalem itself. These associations ultimately circle back to the Edenic and celestial gardens discussed at the outset of this chapter, since paradise, the Heavenly Jerusalem, and the earthly city of Jerusalem were not just intimately connected, but oftentimes synonymous in art and thought from the time of Constantine onward.[127]

BEYOND PARADISE

The emphasis on multivalence in the semantic dimension of monumental flora demands attending to the possible negative connotations of organic motifs in church settings. Representations of natural forms in sacred contexts were complex, functioning as unstable referents that operated across varied and at times competing value systems. In other words, the dynamic interactions between medieval beholders and foliate motifs could produce meanings that were not just different but potentially contradictory.[128] The lines between the positive and negative facets of nature were porous and, as Paul Crossley and Ethan Matt Kavaler noted, the paradisiacal and forbidding could coexist in individual depictions of nature.[129]

The vegetation in churches speaks directly to the bucolic aspects of the Garden of Eden and to the original harmony that existed between God, humans, and the natural environment. By their very connection with Eden, however, organic forms may also have taken on sinister qualities for medieval viewers. As the site of the Creation and the Fall, two pivotal episodes in biblical history, the Garden of Eden presented a series of paradoxes: the earthly garden could simultaneously call to mind fecundity and eternal life and the violent expulsion of Adam and Eve, their suffering, and the inevitability of their deaths. Like the natural world itself, which has the power to sustain and extinguish human life, Eden was both a place of unfathomable beauty and the repugnant site of the rupture between man and woman, and humans and God. The

Enchiridion of Augustine attests to this duality by describing nature as flawed but not entirely evil and by contrasting the intrinsically imperfect goodness of nature with the supreme and immutable goodness of God.[130]

This ambivalence toward the natural environment manifested itself across medieval literary culture. The forest, for example, appears as an archetypical romance landscape in the writings of Chrétien de Troyes, in Tristan legends, and in *Sir Gawain and the Green Knight*, among other texts. Its associations include darkness, danger, and lawlessness, as well as themes of adventure, love, and spiritual vision.[131] By contrast, *Natura*, the mother of generation (*mater generationis*), is a central figure in the mid-twelfth-century *Cosmographia* of Bernard Silvestris, which links her directly to fertility: "Blood sent forth from the seat of the brain flows down to the loins bearing the image of the shining sperm. Artful Nature molds and shapes the fluid, that in conceiving it may reproduce the form of ancestors."[132] Similarly, in Alan of Lille's *De planctu naturae* (1160s), which was influenced by the *Cosmographia*, nature is God's substitute and vice-regent whose role is to ensure the continuation of species after the Creation, a responsibility she shares with Venus, Hymen, and Cupid:

> I stationed Venus, learned in the artisan's skill, on the outskirts of the Universe to be the subdelegate in charge of my work that she, under my will and command, with the active aid of Hymenaeus, her spouse, and Desire, her son, might exert herself in the reproduction of the varied animal-life of earth.[133]

In contrast to *Natura* in *De planctu*, for whom procreation is the aim of sex, the widely read *Roman de la Rose* of Guillaume de Lorris and Jean de Meun emphasizes the connections between nature, sexual desire, and pleasure, rather than reproduction.[134] As Alastair Minnis observed, the *Rose*'s impregnation received a mere four lines in the 21,782-line poem.[135] The poem is set within a walled garden, a common element in epic and chivalric literature that draws on the classical literary topos of the *locus amoenus* (pleasant place) and on the biblical *hortus conclusus*. Medieval theologians, such as Bonaventure and Aquinas, contributed to the topic by contrasting nature and reason, and by tying the former to instinct and sexuality.

Representations of organic forms in the visual arts were equally complex and polyvalent. Beyond referencing the paradisiacal, vegetal motifs were closely associated with human endeavor in depictions of the labors of the months and illustrated agricultural treatises (see fig. I.11). Vegetation was also linked to the leisure activities of the elite, as well as to medicine and sexuality in herbals and romances.[136] In addition, plant imagery often appeared alongside hybrids and fantastical creatures, which have alternately been described as decorative, didactic, humorous, and apotropaic.[137] Even the cloister garden, which was associated with paradise in numerous medieval texts, was not always cast in the positive terms described earlier in this chapter. The prior provincial of the Dominicans in Teutonia, Hermann von Minden (d. ca. 1299), for example, reminded the nuns of Saint-Lambert who sought his permission to "eat in the meadow near the infirmary" of the dangers lurking in their enclosure: "The first Adam disregarded the means of salvation and therefore was tempted in the garden; the second Adam was betrayed in a garden. . . . Who would protect you from the fiery ants, from the crawling spiders, from the biting fleas?"[138] In other words, even in explicitly (and exclusively) clerical settings like cloisters, the meanings of nature were varied and oftentimes ambiguous.

Such ambivalence is at the core of Hieronymus Bosch's famous triptych, the *Garden of Earthly Delights* (1503–1504), which illustrates God presenting Eve to Adam in the Garden

Figure 2.29 Hieronymus Bosch, *Garden of Earthly Delights*, Madrid, Museo del Prado (P02923), 1490–1500

Photo: Public Domain

of Eden in the left-hand panel, nude figures and whimsical creatures basking in sensory pleasures in the central panel, and a disquieting vision of the torments of hell in the panel on the right-hand side (fig. 2.29).[139] The fantastical setting in which the figures and animals interact is a curious amalgamation of expansive meadows planted with imaginary fruit-bearing trees, hybrid stone pavilions, and mysterious primordial pools. The Fountain of Life, a structure that incorporates botanic, geometric, and animal forms, is the dominant feature of the fantasy landscape in the Creation panel. Margot Braun-Reichenbacher and others have noted that the aberrant view of nature apparent in this triptych, which effectively dramatizes the world's divergence from the perfection of God's plan, is congruent with the paintings and prints of the Danube School.[140] This point is well illustrated by the sixteenth-century woodcut of Saint Stephen by Lucas Cranach, where menacing creatures entwined with gnarled tree branches frame the standing saint in what can properly be described as a nightmarish perversion of the idyllic garden of paradise (fig. 2.30).

CONCLUSION

Immense, awe-inspiring, and life-supporting, yet untamed, unpredictable, and potentially destructive, nature was manipulated and harnessed in medieval art and thought in seemingly infinite ways to convey wide-ranging and at times conflicting ideas. The viewers who encountered botanical forms in church settings belonged to diverse social groups and as such brought with them varying degrees of knowledge and vastly different sets of memories and expectations. Even in sacred contexts, then, medieval observers would not necessarily have interpreted the artificialized organic forms presented to them from the point of view of the Bible or exegesis.

Sanctus Stephanus prothomartyr.

FIGURE 2.30 Lucas Cranach, *Saint Stephen*, Amsterdam, Rijksmuseum (RP-P-2005-215-1), ca. 1495

Photo: Rijksmuseum, Amsterdam

Religious symbolism was not a foregone conclusion, but neither should it be dismissed out of hand. For the medieval churchgoer, foliate motifs could be sharply inflected toward the paradisiacal, not simply because of their location in sacred buildings, but also because they were read in light of the rituals and activities staged in the spaces. Chief among these were Masses, processions, liturgical plays, and sermons preached to lay men and women from elaborate pulpits and choir screens.[141] Organic forms were also interpreted in relation to the liturgical implements used in the spaces, and alongside the figural images on the walls and ceilings, in the windows, and articulating the portals of buildings. Indeed, it was the multisensory, experiential dimension of the medieval church *as an ensemble* that shaped the viewer's perception of monumental flora. Within the sanctified spaces of the church, nature was artfully deployed in the service of the Christian faith, offering the beholder a paradise located not in a distant, undisclosed part of the world or in the heavenly realm of the future, but, rather, one that could be accessed and experienced in all its splendor in the here and now.

FIGURE 3.1 Antioch Chalice, 500–550

Photo: The Metropolitan Museum of Art, The Cloisters Collection, 1950 (50.4)

THREE

The True Vine

I am the true vine, and my Father is the husbandman. (John 15:1)

THE JOHANNINE ASSOCIATION OF JESUS WITH THE GRAPEVINE HAD broad repercussions on the history of Christian art, but never was its impact more acute in the medium of architectural sculpture than in the high and late Middle Ages, when tectonic vine forms were given a more prominent place in the design of churches than ever before. The foliate friezes that began to proliferate in French churches at the turn of the twelfth century translated the Christocentric meanings of the vine as they developed in the textual tradition into a visual language accessible to a wide range of viewers. The pervasiveness of friezes depicting plants identifiable as grapevines attests to the symbolic potency of the motif in religious contexts and indicates the function of foliate bands as referents for Christ as the true vine (see, for example, figs. I.10, I.16, 1.16, 1.29, 1.35, and 2.13). Even in the absence of botanically accurate details allowing for their secure identification as grapevines, such as round fruit bunches and palmately lobed leaves alternately disposed along stalks, the friezes behave in a distinctly vine-like manner, trailing around buildings and their apertures like creepers winding around trellises. The distance from which many of the friezes were viewed in any case made the carving of minutiae unnecessary for their identification as grapevines.

Christ's discourse on the true vine as recorded in the gospel of John was rarely illustrated in the Middle Ages. The only two securely identified examples appear in the *Sacra Parallela* (a ninth-century compilation of biblical and homiletic texts ascribed to John of Damascus) and on a cruciform reliquary casket now in the Vatican Museums (also from the ninth century).[1] Yet a strong pictorial tradition existed throughout the Middle Ages associating Christ with the vine. An early example is the so-called Antioch Chalice, a sixth-century standing lamp once ambitiously identified as the Holy Grail (fig. 3.1).[2] This skillfully crafted object contains two images of a young Jesus surrounded by entwined, fruit-bearing rinceaux. On the opposite end of the chronological spectrum is a Late Gothic ivory diptych, whose two leaves portraying the Crucifixion and Lamentation are enclosed by organic subjects: grapevines articulate the upper and lower borders of the frames, while five-petal roses, emblems of Jesus' wounds and the Virgin Mary, fill the lateral edges (fig. 3.2).[3] What these disparate objects spanning the history of Christian art from the sixth to the fifteenth century speak to is a continuity of thought and practice vis-à-vis the allegory of Christ as the true vine.

FIGURE 3.2 Ivory diptych with Passion scenes, 1400–1450
Photo: The Metropolitan Museum of Art, Gift of J. Pierpont Morgan, 1917 (17.190.269)

In Chapter 1, I touched on Jean-Claude Bonne's research on the function of vegetal orna-
mentation in medieval art, specifically on its role as an interconnector of the center and frame
of small-scale objects, such as ivories. This chapter applies Bonne's syndetic approach to archi-
tectural sculpture to offer a new reading of the relationship between figural and vegetal motifs
in church settings, the former generally occupying a central place within a composition and the
latter usually functioning as a frame. Whereas Bonne focused primarily on formal connections
between center and border, I add a semantic layer to the discussion. In this regard, the chapter
draws on the work of Hélène Toubert on eleventh- and twelfth-century Italian wall paintings.[4]
Although Toubert was primarily concerned with the affinities between the paintings in medi-
eval Roman churches and the mural arts of antiquity, approaching the links between the two
from the perspective of the Gregorian reform, her attentiveness to the complex relationship
between field and frame informed my reading of foliate friezes. Toubert recognized that non-
iconic frames were integral to the decorative programs of churches and demonstrated that the
elements inhabiting the frame could reinforce and even amplify the narrative content. Engaging
Toubert's thesis, William Tronzo concluded that frames in medieval wall paintings could serve
to "define and explain or interpret the *figura* that they enclosed," becoming "prime places in vis-
ual imagery where the act of interpretation occurred."[5]

As a pervasive and enduring symbol of Christ, the grapevine serves as a productive lens
through which to examine the foliate friezes in the high and late medieval churches of France,
bringing into focus semantic facets distinct from those encountered in the preceding chapter.
Although this chapter is mainly concerned with the reconstruction and attribution of meaning,
it is important not to lose sight of the dimension of presence, or the impact of monumental
vegetation on the senses and bodies of medieval beholders.[6] Sculptures were not just bearers
of solemn, orthodox, and textually grounded meanings in the Middle Ages, but also sources of
delight, surprise, and wonder due to their craftsmanship, expense, and extravagance.[7] Following
a brief account of the development and reception of the true vine allegory in the written rec-
ord, this chapter provides visual evidence for the formal and semantic interdependence of the

center and frame, the iconic and vegetal, and the interior and exterior of churches in relation to architectural flora, the true vine allegory, and the Eucharistic rite. The dynamic interplay of façade imagery, interior sculptures, and the liturgy calls attention to the kinetic experience of the church visitor and demonstrates that the placement of vegetation at the margins of sacred buildings is in no way equivalent to marginal status.

CHRIST AND THE VINE: THE TEXTUAL TRADITION

The gospels laid the foundation for the transformation of the grapevine, a common artistic and literary motif in antiquity, into a preeminent Christian emblem. Following his self-identification as the vine in John 15:1, Jesus extended the allegory to encompass his followers, characterizing them as fruitful branches.[8] The parable of the workers in the vineyard recorded in Matthew 20:1–16 also links the vine and Christ. This parable, which underlines the unmerited grace of God toward humankind, compares the kingdom of heaven to a vineyard, stressing that all laborers who accept the invitation to work there will reap equal rewards, regardless of when they arrived. At the marriage at Cana, the first miracle of Jesus recorded in the gospel of John, Christ transformed six jugs of water into wine during the wedding feast.[9] Furthermore, a series of Old and New Testament passages tie Christ and the winepress. For example, Isaiah 63:3, which reads, "I have trodden the winepress alone," relates typologically to Revelation 19:15, which tells of the climactic return of Christ to establish his earthly kingdom: "And he treadeth the winepress of the fierceness of the wrath of God the Almighty." Finally, the vine relates to the Last Supper and its ritual reenactment during Mass as described in three of the four canonical gospels.[10] Representations of vines in Christian contexts, then, had Christocentric, Eucharistic, sacrificial, and salvific connotations, as did images of wheat, which were associated with the sacramental body of Christ.

The Church Fathers and early medieval exegetes commented and elaborated upon the biblical references to Christ and the vine, establishing the foundation for a virtually uninterrupted textual tradition that lasted through the late Middle Ages and beyond.[11] Although many of the texts differ in emphasis, they all express and strengthen the intimate connection between Christ and the vine. In *De patriarchis*, for instance, Ambrose compared Christ to a grapevine hanging on the cross, describing him as the vine clinging to the wood and the fruit from whose wounded side the water of baptism and blood of redemption flowed.[12] References to Christ as the vine also appear in the writings of Augustine, notably, in his commentary on the gospel of John, which provides a detailed analysis of the discourse on the true vine. Augustine distinguished between the earthly and true vines, stressed Christ's role as mediator and ecclesiological body, and linked Christ, the vine, and the faithful in a manner that recalls Old Testament parallels between the vine and the Israelites.[13] Gaudentius of Brescia (d. 410) also engaged the true vine allegory by comparing the cross of the Crucifixion with a winepress. The press extracted the wine of Christ's blood "drawn from the many grapes of the vineyard that he had planted," which fermented under its own power within those who received it with faithful hearts.[14] Gregory the Great (d. 604) expressed similar ideas, describing Christ both as the treader and trodden fruit of the vine.[15] Interest in the allegory of the true vine, moreover, was not restricted to medieval thinkers of the Western tradition in this early period. Clement of Alexandria (d. 215) equated wine from

the grapevine with the blood of the word, while Theophilus of Alexandria (d. 412) presented the true vine as an intoxicating antidote to grief in his sermon on the mystical supper.[16] Vineyard imagery also figures in the works of the fourth-century Syrian theologian Saint Ephrem, specifically in his hymns on the church.[17]

The true vine allegory continued to occupy scholars and theologians of varied backgrounds and institutional affiliations during the high and late Middle Ages. In *De miraculis*, composed between 1135 and 1156, Peter the Venerable described the monks of Cluny as the fruitful branches of the true vine.[18] The prolific Augustinian poet and composer of Latin hymns Adam of Saint-Victor (d. 1145), who served as subdeacon and precentor of Notre-Dame of Paris before entering the nearby monastery of Saint-Victor, ended an Easter sequence with a joyous proclamation of the regenerative powers of the true vine.[19] The Cistercian abbot Adam of Perseigne (d. 1221) equated wine with the blood that issued from the true vine, whereas Aquinas, a Dominican who studied at the University of Paris in the mid-thirteenth century, emphasized the true vine's intoxicating and fortifying aspects.[20] As Caroline Walker Bynum demonstrated, moreover, *sanguis Christi* became increasingly prominent in Christian devotion and practice, as well as in visions and art in northern Europe in the later Middle Ages.[21]

Among the most important medieval texts on the true vine is the *Vitis mystica* of ca. 1263, which is generally attributed to Bonaventure.[22] This key devotional text on the Passion not only reveals the author's knowledge of viticultural practices, but also draws parallels between the earthly and true vines:

> And first, the vine is generally planted in the earth, not sown, but transferred from its own parent vine: and this seems to me to have reference to the conception of Jesus. The vine springing from the parent vine is God begotten of God, Son of the Father, eternal and consubstantial with Him of whom He is begotten. But that He might bring forth more fruit, He was planted in the earth, that is, conceived in the Virgin Mary, being made what He was not, and yet abiding what He was. How blessed is this earth, which bringeth forth blessings to all nations! Truly blessed is she, who through the good gift of God brought forth so blessed fruit.[23]

In addition to comparing the planting of vines and the mystery of the Incarnation, the author of the *Vitis mystica* associated the act of pruning with events in the life of Christ, such as his circumcision (which referenced "pruning" in a corporeal sense).[24] Figurative aspects of pruning also made their way into the text, as did comparisons between the leaves of the vine and the words of Christ (Chapters 6–15) and the flowers of the vine and Christ's virtues (Chapters 16–17).[25]

Alongside the sources cited above, the *Vitus mystica* demonstrates the currency of the true vine allegory in the written tradition of medieval Europe. The texts produced in French intellectual circles in the twelfth and thirteenth centuries are particularly relevant for my purposes as they help to contextualize the reception of vine motifs in churches. These high medieval texts correspond temporally and geographically to a critical period in the proliferation of monumental flora in sacred buildings, including the emergence and spread of foliate friezes. Additionally, their authors belonged to the same broad social group as the fabric committees tasked with administering building projects, which included overseeing the financing, construction, and decoration of churches.

Although the primary producers and readers of Passion texts like the *Vitus mystica* were male clerics, thematically related works created specifically for women also circulated in the Middle Ages. These writings elucidate how some women may have responded to the vine motifs inside churches. Two notable examples are Aelred of Rievaulx's *De institutione inclusarum* (1160–1162), which the abbot wrote for his sister, and *De perfectione vitae ad sorores*, written by Bonaventure for Isabelle of

France (d. 1270), the sister of king Louis IX (d. 1270).[26] The former urges female recluses to contemplate and consume Christ's crucified body, including his blood, which is "changed into wine to gladden you."[27] The latter stresses the sacrifice of Christ, who gave "his most holy body to eat and his most precious blood to drink."[28] Such texts provide insights into the knowledge and memories some women may have brought to viewing Passion imagery, including portrayals of vines.

As Miri Rubin observed, the Eucharistic symbolic system was a multivalent one whose potential meanings were tempered based on gender, region, and other factors, often in unpredictable ways.[29] Just as the Mass itself was semantically stratified, so too were its symbols. The Eucharist could represent community or individualistic ideas and experiences related to sacrifice and salvation (as well as other possible meanings). Analogously, vine motifs in sacred settings could bring to mind Christ, the sacrament of the Mass, the Eucharistic wine, food, and more broadly life, death, and the salvation of humankind through the sacrifice of Christ. Vines might also have been construed as symbols of Christ sheltering his church and clergy. The long history of conceptualizing the church altar as the cross of the Crucifixion, which began in the patristic period, strengthened the connections between the sacrificial blood of Christ, wine, the Mass, and depictions of grapevines.[30]

THE FIGURAL AND THE VEGETAL
ON CHURCH PORTALS

By the twelfth century, visitors and passersby often encountered sculptures of Christ on the portals of French churches. These images may have included Christ as an infant on the Virgin's lap, enclosed within a mandorla in majesty, enthroned as the stern judge at the end of time, or crowned as the king of heaven with his mother, the queen, by his side. In this section, I argue that representations of Christ on the entrances to churches, along with other Christocentric images, colored the medieval spectator's understanding of vegetal friezes, especially when the two were placed in proximity.

Such is the case at the cathedral of Chartres, where Christocentric themes play out in the figural and botanical sculptures of the north transept.[31] In the preceding chapter, I read the foliate frieze on the north porch of the cathedral in relation to the two outer orders of archivolts articulating the central aperture, which show the Creation and Fall in thirty-six paired scenes (see fig. 2.14). I posited that this foliate band worked in tandem with the adjacent archivolts to evoke the paradisiacal garden. In this section, I broaden the discussion by considering the frieze together with the imagery on the portal proper, arguing that the carved figures and vegetation interact in pointed, Christocentric ways. The example of Chartres Cathedral not only demonstrates the semantic malleability of organic forms in sacred architecture, but also suggests that their meanings could be modulated by nearby figural sculptures.

The lintel and tympanum of the north transept's central portal depict the Death, Assumption, and Coronation of the Virgin Mary, while the archivolts portray angels, prophets, and a Jesse Tree (figs. 3.3, 3.4). Closer to the viewer is the trumeau statue of Saint Anne holding the infant Virgin, who serves as the link between the Old and New Testament figures in the jambs. The column statues are organized typologically across the space of the door. The Old Testament priest Melchizedek holding a censer and chalice on the far left is juxtaposed on the far right with Saint Peter, the first priest of the New Testament and the foundation stone of the Church (see figs. 3.3 and 3.5). Next on the left is Abraham offering the bound Isaac to God, an episode that anticipates God's sacrifice of his son for the salvation of humankind. To drive the point home, Abraham is

Figure 3.3 Chartres Cathedral, north transept, central portal
Photo: author

FIGURE 3.4 Detail of 3.3

Photo: author

FIGURE 3.5 Detail of 3.3

Photo: author

paired on the right-hand side of the portal with John the Baptist holding a disk inscribed with the sacrificial lamb of God. Moses with the tablets of the Old Law on the left is connected on the right to the infant Jesus, a symbol of the New Law, in the arms of Simeon, who foretold Christ's sacrifice at the altar of the Temple of Jerusalem. Beside Moses is the prophet Samuel preparing to slaughter a lamb. The torqued column shafts on which the jamb figures stand are adorned at the top and bottom with plant forms, as are the interior surfaces of the canopies suspended above their heads, including the one above Saint Anne and the Virgin in the trumeau, which is covered with vine leaves. The stylized vine frieze running across the top of the porch complements and bolsters the themes of sacrifice, salvation, and priesthood addressed below (and most overtly in the figure of Melchizedek with his chalice), at once alluding to Christ as the true vine, the sacramental wine, and the Eucharistic rite, a priestly privilege and duty. A similar consonance between vegetal and figural forms is apparent at the top of the portal, where the foliate frieze seems to support the majestic image of Christ enthroned in the gable (see fig. 2.14).

The mutually reinforcing relationship between the organic and the iconic on the north transept is neither unique nor new to Chartres Cathedral. This is borne out by the building's west façade, which predates the north transept by at least fifty years.[32] The sculptures on all three portals have a Christological thrust, but the south portal is of particular interest within the context of this chapter because of its overt sacrificial and Eucharistic content. Three images of Christ appear on the vertical axis of the doorway (fig. 3.6). He is shown as a newborn infant in the Nativity in the lower lintel, standing on an altar in the Presentation in the Temple in the upper lintel, and enthroned on his mother's lap in the tympanum. Margot Fassler stressed the "powerful liturgical resonances" of the south portal sculptures, first by comparing the arrangement of the figures in the Presentation scene to a liturgical procession, and second by reading the figure of Christ on the

FIGURE 3.6 Chartres Cathedral, west façade, south portal
Photo: author

altar, which resembles "an ancient piece of liturgical furniture," as a direct correlation between his blood and the Eucharistic wine.[33] Fassler also understood the Nativity in liturgical terms, likening the swaddled child in the manger to "a loaf of bread in a basket."[34] The images in the tympanum underscore the liturgical themes rendered below. The Throne of Wisdom is aligned with Christ on the altar and in the manger. In this way, the portal visually and conceptually links the Church and the Temple (the former represented by the Virgin and the latter synecdochically by the altar), as well as the body of Christ and the Eucharistic wine and bread. Equally relevant is Fassler's interpretation of the angels flanking the Throne of Wisdom, whose swinging censers parallel the liturgical actions that took place at the altar inside the cathedral, specifically the censing of the gospel book at the start of Mass and the sacramental wine and bread during the sacrifice.[35]

Although the iconography of the south portal is more complex than my rapid sketch might suggest (incorporating portrayals of the Liberal Arts and addressing a variety of themes, including royal and Mariological ones), there is no denying its focus on sacrifice and the liturgy, topics that find parallels in the introit and tropes of the feast of the Purification, one of three major annual processions at Chartres Cathedral.[36] The vegetal sculptures on the portal, which are carved with striking attention to detail, complement the figural program and the liturgy. As Vibeke Olson observed, the vine is the most common motif on the sixteen colonnettes in the west façade jambs (see figs. 1.30 and 1.31).[37] Populating the vines are labors of the months and signs of the zodiac, noblewomen reading and sewing, masters instructing their pupils, musicians, acrobats, nude figures, and an array of real and fantastical creatures. All form part of the secular realm and, as such, serve not just as a point of reference for lay viewers of different social standing, but also as a point of entry into the broader program.[38] The colonnette vines, which also belong to a familiar sphere, are near eye level, making them all the more accessible to beholders approaching the cathedral from the west. The tenor of the vegetal motifs shifts as the viewer's gaze moves up the façade. Whereas the natural forms on the colonnettes at the bottom of the southern portal are associated with the secular activities of the laity, those above the door take on Christological and Eucharistic connotations by virtue of their juxtaposition with the figural sculptures in the lintels and tympanum. Prominent among these is the heavily restored vegetal frieze in the outer archivolt, which is composed of leaves, stalks, and fruit harboring human heads.

A comparable interplay of vegetal and iconic sculptures can be found on many church façades, though the redemptive and Eucharistic tone is not always as obvious or emphatic as the examples from Chartres Cathedral. As I stressed earlier in this book, some botanical friezes are highly stylized and cannot be securely identified as grapevines, particularly those from the twelfth century. At Autun Cathedral and La Trinité at Anzy-le-Duc, for instance, unrecognizable plants with fleshy leaves sprouting from serpentine stocks fill the portals' archivolts (see figs. 1.25–1.27). The vegetation decorating the north portal of the church of Notre-Dame at Mantes-la-Jolie (1170s) is also schematized, consisting of two regularized scrolls emerging from vases in the doorposts and clusters of fruit nestled amid linear, unfurling leaves in the outer archivolt (fig. 3.7).[39] Despite the abstraction, it is possible that visitors associated the organic bands at all three sites with the grapevine given their proximity to sculptures addressing Christological subjects. These include Last Judgment scenes at Autun Cathedral, Christ in Majesty at La Trinité in Anzy-le-Duc, and the Three Marys at the Tomb and Christ Enthroned in the lintel and tympanum at the church in Mantes-la-Jolie.

The stylization of these three examples stands in sharp contrast to many later foliate bands, which are immediately recognizable as grapevines. Notable in this regard are the graceful vines framing the portal of the now-destroyed Virgin Chapel of Saint-Germain-des-Prés,

FIGURE 3.7 Notre-Dame, Mantes-la-Jolie, west
façade, north portal, ca. 1170

Photo: © Mapping Gothic France, Media Center for Art
History, The Trustees of Columbia University, Department
of Art History and Archaeology

remains of which are currently on display at the Musée national du Moyen Âge in Paris
(see figs. I.15 and I.16).[40] Alongside ivy, maple, and fig leaves, the vines rise from the base
of the embrasures, cover the jamb capitals, and weave around the archivolts to surround the
glazed tympanum (lost in 1802). The lintel is also adorned with foliage, namely polylobed
and ribbed leaves, as is the trumeau, which is dressed with two strings of ivy. Although the
iconography of the tympanum window is unknown, the trumeau once held a statue of the
Virgin and Child. The portal vines framing the trumeau would have resonated with this lost
image of Christ.

The mid-thirteenth century portal from the Benedictine abbey church at Moutiers-Saint-
Jean, now in the Cloisters Collection, also attests to the interconnection of the vegetal and fig-
ural in the architecture of medieval France (figs. 3.8 and 3.9). Although the figural sculptures are
heavily damaged, testifying to the portal's tumultuous history, the organic motifs are remarkably
well preserved.[41] The tympanum is carved with a Coronation scene, with Christ crowning the
Virgin with one hand and holding a disk in the other. The royal pair is seated beneath a foli-
ated trilobed arch and flanked by two attending angels, each bearing a candlestick. A trampled
dragon and adder are visible beneath the broad folds of Christ's garments. The rest of the sculp-
tures consist of six kneeling angels in the archivolt, two column statues of kings in the jambs

FIGURE 3.8 Moutiers-Saint-Jean portal, ca. 1250

Photo: The Metropolitan Museum of Art, The Cloisters Collection, 1932 (32.147)

(probably David and Solomon), and eight superposed Old and New Testament figures in the embrasure niches.

A naturalistic grapevine lines the trilobed arch and the bottom edge of the tympanum of the Moutiers-Saint-Jean portal, enclosing the Coronation scene entirely in foliage. Arches were often included as shorthand for the palace of heaven in medieval depictions of the Coronation

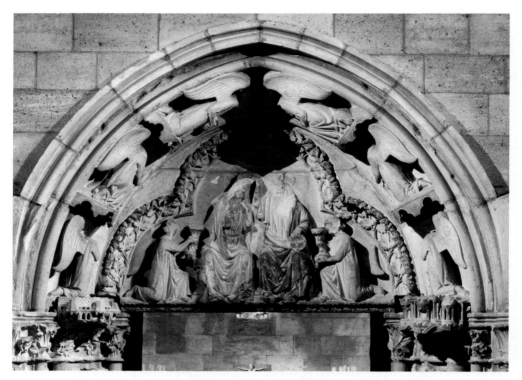

FIGURE 3.9 Detail of 3.8

of the Virgin. As William Forsyth observed, the Moutiers-Saint-Jean portal is unusual in that it uses vine ornamentation to transform the heavenly palace into a leafy arbor, an Edenic refer- ence that presents Christ and Mary as the New Adam and Eve.[42] In addition to this paradisiacal gesture, several aspects of the program can be understood from a Eucharistic perspective: the botanically accurate grapevine on the arch and the pseudo-naturalistic vines on the jamb capitals allude to the sacramental wine; the inscribed disk in Christ's left hand resembles a Eucharistic wafer; and the angels in the tympanum and archivolt hold implements of the Mass, such as candles and censers.[43] The small figures in the jamb niches further promote the Christological and Eucharistic message of the portal. Among them is Melchizedek at an altar that probably once supported a chalice, Elijah with the raven that brought him bread (a refer- ence to the host), Abraham sacrificing Isaac, and the priest Simeon with the Christ Child in the Temple. The salvific meanings of the sculptures would not have been lost on the monastery's clerics, the principal users of this portal, which originally connected the church to the main cloister. The Moutiers-Saint-Jean doorway, alongside the portal from Saint-Germain-des-Prés, is illustrative of the strategic use of organic and figural motifs in the architectural sculpture of thirteenth-century France. More important, reading backwards from these two portals opens new ways of thinking about the schematized foliate bands of earlier generations, which occupy comparable positions and are juxtaposed with similar figural images (see, for example, figs. 1.19, 1.20, and 3.6). This interpretation suggests that giving visual enunciation to the allegory of the true vine with iconic and vegetal sculptures was standard practice in French architecture as early as the twelfth century.

THE TRUE VINE INSIDE AND OUTSIDE AMIENS CATHEDRAL

In Chapter 1, I described the ways in which builders employed foliate motifs to link in spatio-visual terms various parts of Amiens Cathedral. In this section, I demonstrate that the organic and the figural were carefully calibrated at the cathedral to stress Christocentric and Eucharistic themes. In contrast to the immediately preceding discussion, which focused exclusively on church portals, here I take both exterior and interior designs into account, in addition to functionality. This approach draws on recent work by Paul Crossley, who interpreted the cathedral of Chartres in relation to rhetoric and memory, arguing that the building was "best viewed as a performed aesthetic experience."[44] Crossley identified *ductus*, or movement and direction via repetition, as a key aspect of Chartres Cathedral, arguing that the images visitors encountered outside reflected the themes and imagery they experienced inside the building. Further, he stressed that memory was a cognitive process that involved not just recollection, but also categorizing and rethinking, such that different sections of the building were sequentially connected and could interact with less static and even ephemeral elements like the liturgy. Attentiveness to foliate decoration reveals that persuasion and memory were as important to the experience and design of Amiens Cathedral as Crossley has shown them to be at Chartres.

The meticulously carved grapevines on the west façade of the cathedral of Amiens function as glosses to the figural imagery (see figs. 1.36 and 3.10). I have already drawn attention to the two lintel friezes of the Last Judgment portal at the center of the façade, which are clearly identifiable as grapevines by their naturalistically rendered cordate leaves and spherical fruit clusters

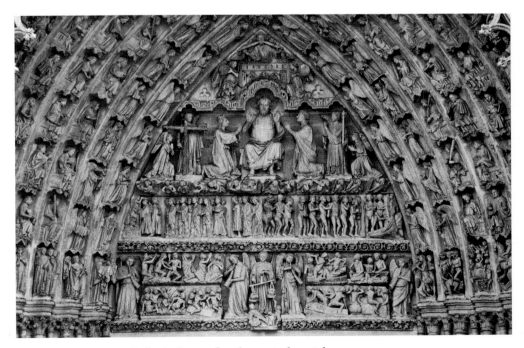

FIGURE 3.10 Amiens Cathedral, west façade, central portal

Photo: author

(see figs. 1.37 and 3.11). The friezes are eye-catching aspects of the façade, not simply because they decorate the central portal, but also because their organic forms stand in stark contrast to a design otherwise dominated by figural sculptures. The tangled vines enclose a turbulent scene of the dead rising from their graves at the end of time, some clasping their hands in supplication, others grasping their heads in bewilderment. The archangel Michael weighing the souls of the dead occupies the middle of the composition, while four flanking angels blare their trumpets to herald the impending moment of reckoning.

The paired grapevines framing the lintel operate in conjunction with three representations of Christ, which serve as the thematic and visual foci of the central portal. Closest to the viewer in the trumeau is the *Beau Dieu*, an over life-size statue of the resurrected Christ treading on two beasts with a book in his left hand and his right hand raised in a blessing gesture (fig. 3.12).[45] He stands beneath an architectonic canopy, whose apse-like shape, prismatic chapels, traceried lancets, and angled piers recall the design of the cathedral's choir. Beneath him is a defensive-looking structure complete with battlements and arrow slits, which rests atop grape bunches suspended from an elegantly coiled vine whose five leaves are emblematic of Christ's wounds (see fig. 1.41). Christ appears a second time in the tympanum as a frontal, hieratic figure sitting in judgment beneath an elaborate canopy (see fig. 3.10). He is flanked by two kneeling intercessors, the Virgin Mary on the left and John the Evangelist on the right, as well as angels holding the instruments of the Passion. The third portrayal of Christ, located in the apex of the tympanum, consists of an apocalyptic figure with swords issuing from his mouth. Two kneeling angels holding a sun and moon appear on either side.

FIGURE 3.11 Amiens Cathedral, west façade, central portal, detail of lintel frieze
Photo: author

FIGURE 3.12 Amiens Cathedral, west façade, central portal, trumeau
Photo: author

Wilhelm Schlink demonstrated that the west façade's vast sculptural program hinges on the three depictions of Christ on the main vertical axis of the central portal.[46] He addressed the relationship between these images (especially the *Beau Dieu*) and two biblical texts. The trodden beasts beneath the feet of the *Beau Dieu* allude to Psalm 90:11–13: "For he hath given his angels charge over thee; to keep thee in all thy ways. In their hands they shall bear thee up: lest thou dash thy foot against a stone. Thou shalt walk upon the asp and the basilisk: and thou shalt trample under foot the lion and the dragon." The second text, Matthew 4:6, describes the temptation of Christ and refers directly to Psalm 90: "If thou be the Son of God, cast thyself down, for it is written: That he hath given his angels charge over thee, and in their hands shall they bear thee up, lest perhaps thou dash thy foot against a stone." Schlink argued that the façade sculptures present Christ as an exemplum, whose triumph over sin served as an object lesson for visitors to the cathedral. The sculptures of the central portal thus offered viewers a path to salvation through the abandonment of vice and the emulation of Christ's virtues, which are represented in the dado quatrefoils flanking the central door. Leaving aside the other potential meanings and nuances of the sculptures (of which there are many), Schlink's analysis highlights the recursive structure of the portal program and rightly places Christ at its nexus. The presence of three images of Christ on the longitudinal axis of the cathedral—that is, in alignment with the high altar inside the liturgical choir and the Masses celebrated therein—attests to the complex but perceptible relationship between imagery, space, and ritual activated by the beholder's movement and sensory interactions with the building.

The inclusion of grapevines at multiple levels of the central portal bolsters the iconography of the figural sculptures. Indeed, the presence of vines directly above and below the *Beau Dieu* augments the Christocentrism of the design by referencing the allegory of the true vine. The same can be said of the prophet quatrefoils in the dado of the buttress piers beside the central door. Not coincidentally, these quatrefoils (and only these) are connected physically by interlaced, fruit-bearing plants (see fig. 1.40). Organic motifs also appear inside the quatrefoils, notably, in the Micah relief on the left-hand side of the portal, which depicts a meandering vine and two figures exchanging grapes and figs (fig. 3.13).[47] The relief relates to Micah 4:4: "And every man shall sit under his vine, and under his fig tree, and there shall be none to make them afraid: for the mouth of the Lord of hosts hath spoken." The vine in the quatrefoil also alludes to Micah's prophesy of the coming of the messiah from Bethlehem (cited in the gospel of Matthew), bringing it in line thematically with the rest of the vine imagery on the portal.[48]

It is not just the presence of the grapevine on the central portal that speaks to its measured use as an emblem of Christ at Amiens, but also its absence from the two lateral portals. This is particularly significant in light of the other potential meanings botanical forms carried at the cathedral. Foremost among these is their connection to Saint Firmin (d. ca. 303), the first bishop of Amiens and a highly revered local saint.[49] The relics of Saint Firmin numbered among the cathedral's most treasured relics and were carried in procession inside the building, in the claustral precinct, and throughout the town on the annual feast of the Ascension, as well as during relic quests aimed at raising funds for building works.[50] According to legend, bishop Sauve (d. 625) miraculously discovered the misplaced relics of Saint Firmin on a winter day.[51] The bishop reportedly fasted for three days and prayed for a sign from God to help locate the remains of the saint. On the fourth day, during the celebration of Mass, a ray of light directed the bishop to the spot where the relics were buried. Upon unearthing them, the frigid day became balmy,

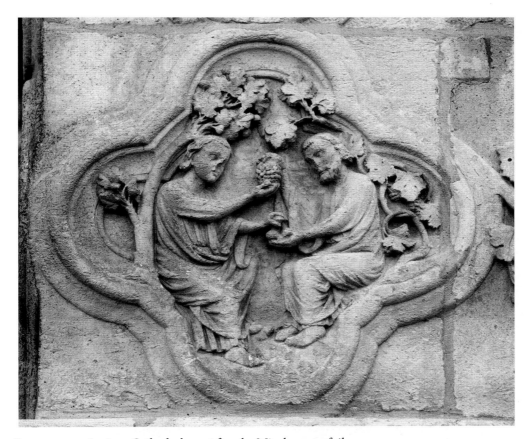

FIGURE 3.13 Amiens Cathedral, west façade, Micah quatrefoil
Photo: author

causing the snow to melt, flowers to bloom, and fruit to grow and ripen. The clerics at Amiens Cathedral celebrated this miracle yearly on January 12, the date of the invention of the relics of Saint Firmin, with the liturgy of the Green Man. On the day before the feast, an official dressed in green hailing from the nearby church of Saint-Firmin-en-Castillon distributed foliate crowns to the cathedral clergy.

The north portal of Amiens Cathedral illustrates bishop Sauve's discovery of the relics of Saint Firmin and the events that occurred in the aftermath of the miracle (fig. 3.14).[52] A looming Saint Firmin with miter and crozier greets visitors from the trumeau with a blessing gesture. The multi-tiered, perforated structure at the center of the lintel serves a dual function, at once forming a canopy over the saint in the trumeau and also alluding to his golden, bejeweled reliquary chasse, which was housed inside the cathedral, directly behind the high altar (fig. 3.15).[53] Flanking the canopy-shrine in the lintel are six seated bishops holding croziers (emblems of their priestly duties), books (symbols of their role as teachers), and staffs (representative of their administrative responsibilities). The invention of the relics of Saint Firmin appears in the lower register of the tympanum (fig. 3.16). A spiraling ray of light bisects the central group of figures, guiding bishop Sauve to the location of the relics. With a shovel in hand, the mitered bishop stands over the remarkably well preserved corpse of the saint as the

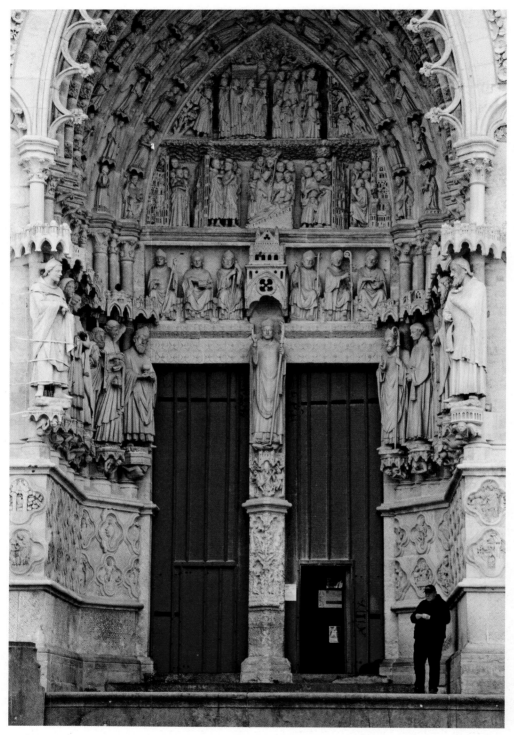

FIGURE 3.14 Amiens Cathedral, west façade, north portal

Photo: author

FIGURE 3.15 Amiens Cathedral, west façade, north portal, lintel

Photo: author

FIGURE 3.16 Amiens Cathedral, west façade, north portal, tympanum

Photo: author

inhabitants of the nearby towns of Thérouanne, Noyon, Cambrai, and Beauvais, indicated by highly detailed walls, bear witness to the miracle. The upper register of the tympanum shows the translation of the relics of Saint Firmin to Amiens (fig. 3.17). Leading the procession on the right are clerics and altar boys holding a jeweled book and an arm reliquary. Behind them, six figures carry a traceried chasse with poles on their shoulders as censing angels flutter above. Children perched in trees greet the procession at the city gates on the far right, an overt reference to Christ's triumphant entry into Jerusalem.[54] Trailing the procession is the legendary Green Man standing before a leafy tree, his burgeoning staff and headdress reminiscent of the foliate crowns given to the canons of Amiens Cathedral during the annual invention feast (fig. 3.18).[55]

Given that the theme of organic growth is central to the legend of Saint Firmin and the extensive use of foliage elsewhere on the building, one would expect to find an abundance of foliage on the north portal, but that is not the case. In fact, vegetation is largely restricted to the column capitals—a conventional place for it—and to the tympanum to indicate the wondrous change of seasons sparked by the discovery of the lost relics of Saint Firmin.[56] The vine friezes and motifs that pervade the central portal are nowhere to be found, nor do they appear on the south portal, which is dedicated to the Virgin Mary.

The absence of vine friezes from the north and south portals at Amiens, combined with their prolific use on the Judgment portal, intimates that the component was primarily a referent for Christ, rather than the local bishop saint. This interpretation has implications for the monumental foliate band inside the building (see figs. I.1 and I.2). The interior frieze lines the central vessel, but not the cathedral's side aisles. Simply put, it is on the same longitudinal axis as the exterior vines. In Chapter 1, I argued that the grapevines outside the cathedral visually prepared visitors for the natural imagery they encountered inside the building, namely the foliate

FIGURE 3.17 Amiens Cathedral, west façade, north portal, tympanum
Photo: author

Figure 3.18 Detail of 3.17
Photo: author

band beneath the triforium. I would now like to suggest that the Christocentric associations of the grapevine on the west façade were carried forward to the interior of the cathedral. In other words, the beholder's interactions with the figural and foliate sculptures on the central portal before entering the building informed his or her perception of the interior frieze, making it a prime emblem of Christ.[57]

Unlike the botanical forms on the central portal, which unmistakably represent grapevines, the nave frieze does not accurately portray a specific plant species (see figs. I.3 and I.4). And yet the interlaced stems marking the limits of each bay and clusters of round fruit are strongly suggestive of grapevines. It is possible that the 21-meter distance between the frieze and the viewer made the carving of mimetic details unnecessary to identify the foliate band as a grapevine. It is equally possible, however, that the sequential experience of the cathedral as the beholder moved through space resulted in the production and transmission of meaning. The juxtaposition of grapevines with images of Christ on the central portal lent the motif a decidedly Christocentric emphasis, and it is with this emphasis in mind that visitors encountered and interpreted the foliate frieze inside the building. The Christ-vine connection expressed on the west façade and carried into the nave via the foliate frieze was then restated in a multisensory but fleeting manner during the ritual performance of Mass at the high altar, which is itself aligned with the central door.

The screen that once stretched across the liturgical choir of Amiens Cathedral contributed to the iterative quality of the building. The Gothic screen was dismantled in the mid-eighteenth century, but scholars have reconstructed its general appearance using graphic and textual

evidence and sculptural fragments in museum collections.[58] The pictorial sources show that the screen was an arcaded and vaulted structure fronted by a staircase that spanned the width of the central vessel. A series of reliefs in niches embellished its western or nave-facing surface above the arcade. Although the iconography of the sculptures is unclear from the sources, texts and fragments, including a moving portrayal of the Betrayal and Arrest of Christ now at the Metropolitan Museum of Art, reveal that the program focused on the Passion, from the Entry into Jerusalem to the Descent into Limbo. Texts reveal that a depiction of the Last Judgment featuring an enthroned Christ capped the central aperture, which opened directly onto the liturgical choir. In keeping with the Christological and redemptive aspects of the figural sculptures was the organic frieze that ran across the top of the screen.[59] The precise design of this frieze is unclear from the sources, but, given the profusion of vines elsewhere on the building, it is entirely possible that it represented a grapevine. Hence the foliate frieze and Last Judgment relief from the dismantled choir screen may be understood as pendants to the figural and vegetal sculptures of the Judgment portal on the west façade, with the foliate frieze in the nave not only connecting the two ends of the building visually, but also taking on their Christocentric inflections. What the foliage at Amiens alerts us to, then, is the careful coordination of organic and figural imagery inside and outside the building, and a recursive structure, contingent upon the beholder's movement, that became increasingly apparent after crossing the cathedral's threshold.

The south transept of about 1260 supports my Christological reading of the botanical sculptures at Amiens Cathedral (fig. 3.19).[60] Unlike its austere northern counterpart, the south transept portal received a lavish decorative program, perhaps because it faced the claustral precinct and was used during ordinary (i.e., regular) and extraordinary (i.e., relic-quest) processions.[61] The plant forms are concentrated in the lower parts of the doorway. A tactile vine frieze springs from the top of the dado and frames the portal proper, while a second vine punctuates the bottom of the lintel (figs. 3.20, 3.21). The trumeau supporting the *Vierge Dorée* also received vine ornamentation, as did the dado zone, where grapevines dress the capitals of the blind arcade and the spaces in between, forming a continuous foliate band bordered by the abaci and astragals of the capitals and the moldings on the walls (fig. 3.22).

The botanical motifs on the south transept underscore the iconography of the figural sculptures. With the exception of the Virgin and Child in the trumeau and the column statues of angels and clerics, which may have been reused from an earlier project, the sculptures are devoted to events and miracles in the life of Saint Honoré, the seventh bishop of Amiens.[62] In spite of the emphasis on this local saint, the sacrifice of Christ on the cross and its ritualized reenactment in the Mass are at the core of the program. In the tympanum, aligned with the *Vierge Dorée* on the main vertical axis of the portal, are images of a covered altar supporting a chalice (bottom register) and Saint Honoré celebrating Mass while the hand of God blesses the sacrament (second register) (fig. 3.23). Occupying the apex of the tympanum is the crucified Christ flanked by the Virgin Mary, John the Evangelist, and two kneeling angels with censers, a scene that alludes to the censing of the gospel book and Eucharist during Mass.[63] The diminutive tympanum angels mirror the actions of the two life-size angels in the jambs, who swing their censers toward the infant Jesus in his mother's arms in the trumeau (see fig. 3.20). Beside the angels are ecclesiastical figures holding liturgical accoutrements, including chalices, books, and scrolls (fig. 3.24). The portal sculptures of the south transept therefore interlink Christ, the Eucharist, and the grapevine, while simultaneously calling attention to priestly privilege and power. The sculptures might also be said to serve a signaling function, preparing visitors for

FIGURE 3.19 Amiens Cathedral, south transept portal
Photo: author

FIGURE 3.20 Amiens Cathedral, south transept portal, trumeau

Photo: author

FIGURE 3.21 Amiens Cathedral, south transept portal, jamb frieze

Photo: author

FIGURE 3.22 Amiens Cathedral, south transept portal, dado

Photo: author

FIGURE 3.23 Amiens Cathedral, south transept portal

Photo: author

FIGURE 3.24 Amiens Cathedral, south transept portal, jamb
Photo: author

the rituals—the Mass—and the imagery—the nave frieze and choir screen sculptures—inside the building. Attending to the relationship between different sections of the cathedral (interior and exterior) and its varied sculptural components (botanical and figural), alongside the liturgy, brings to the fore the role of the building as an entity energized by moments of passage and linked by ritual and mnemonic practices.

A GENEALOGY OF CHRIST

Medieval craftsmen presented the royal lineage of Christ in a highly compressed manner using two main elements: crowned figures and organic forms. The latter thematically and visually ties the subject, known as the Jesse Tree, to the sculpted flora in medieval churches and thus invites comment. Scholars have traced representations of the Jesse Tree as far back as the eleventh century and have identified the twelfth and thirteenth centuries as a critical time in its development, a period that overlaps with the marked increase in fictive foliage in French architecture.[64] The iconography is based on the prophecy in Isaiah 11:1, which casts the Old Testament patriarch Jesse as the progenitor of a royal line that included renowned kings, such as David and Solomon, and ultimately led to the messiah. The passage reads: "And there shall come forth a rod out of the root of Jesse, and a flower shall rise up out of his root."[65] The Latin word *virga* (rod) was associated with *virgo* (virgin) from the third century onward, notably in the writings of Tertullian.[66] The conflation of the two terms was used to support the identification of the Virgin Mary and Christ as direct descendants of Jesse.[67]

This key prophecy of Isaiah tracing the lineage of Christ to the Davidic dynasty was portrayed in a literal manner across different visual media, starting with manuscripts. In early illustrations, the Virgin tends to dominate the tree.[68] An ink drawing from a twelfth-century copy of Jerome's *Explanatio in Isaiam* from the Cistercian monastery at Cîteaux is a noteworthy example (fig. 3.25). Graphically rendered in colored ink is an oversized Virgin supporting a nimbed dove on her halo and the Christ Child on her right arm. Gift-bearing angels flank the mother and child. The Virgin is tethered to the recumbent Jesse, drawn entirely in brown ink, by a thick vine springing from the loins of the patriarch. Divided by inches of blank space, color, and scale, the Old and New Testament figures seem to belong to separate domains, with Jesse in a position comparable to marginalia in later manuscripts.[69] The initial on the facing page shows Isaiah holding a long scroll with two Latin inscriptions (fig. 3.26). One is the passage describing the rod growing from the root of Jesse cited above; the other is the Incarnation prophecy from Isaiah 7:14: "A virgin shall conceive and bear a son." The foliage decorating the initial, as well as the extensive use of green pigments on the garments of Jesse, the Virgin, and Christ, underline the importance of the organic in depictions of the Jesse Tree.

Images of the Tree of Jesse were common in church settings, the best-known examples appearing in stained glass windows, but sculptors also engaged with the subject.[70] Although their approaches varied depending on the period and specific architectural context, vegetation consistently served as the supportive framework for the figures. Early examples can be found on thirteenth-century portals and reinforce the interconnections between sculpted foliage and Christ prevalent on church façades.

FIGURE 3.25 Jesse Tree, *Explanatio in Isaiam* by
Saint Jerome, Cîteaux, early twelfth century, BM
Dijon, Ms. 129, fol. 4v

Photo: BM Dijon

The Judgment portal at Amiens Cathedral once again serves as a compelling case study
(see fig. 1.36). Eight orders of archivolts frame the tympanum and lintel. The seventh band (the
second from the exterior) contains a series of superposed kings seated atop fruit-bearing grape-
vines (see fig. 1.39). Two sleeping male figures representing Jesse, each with his head resting on
one hand and a bowed stalk rising from his loins, appear at the springing of the archivolt on both
sides. Directly above Jesse on the right-hand side is a crowned figure playing the harp, probably
king David (fig. 3.27). Solomon holding a burgeoning scepter is his likely counterpart on the
left. The vertical arrangement of the kings, the organic scaffolding on which they rest, and the
sleeping figures at the bottom of the composition unambiguously identify the archivolt scene as
a Jesse Tree, despite the absence of the Virgin and Christ.

The Jesse Tree archivolt at Amiens Cathedral highlights the regal ancestry of Christ and
presents his forebears as essential agents in the history of salvation, reiterating the broad theme
of the façade. The figure of Solomon is especially important because of his status as the builder
of the first Temple of Jerusalem and his close association with the grapevine, two issues I will
address in the next chapter. Equally compelling, however, is the way in which the Jesse Tree
connects the upper parts of the central portal formally and semantically to the rest of the sculp-
tures. The vines on which the kings of Judea are perched interact visually with the other organic

FIGURE 3.26 Isaiah, *Explanatio in Isaiam* by Saint
Jerome, Cîteaux, early twelfth century, BM Dijon, Ms.
129, fol. 5r

Photo: BM Dijon

forms on the portal, namely, the grapevine beneath the *Beau Dieu*, the curling stems joining the prophet quatrefoils, and the two vegetal friezes framing the lintel (see figs. 1.36–1.41). Separated from the capital frieze only by abaci, the Jesse Tree echoes in formal terms the organic shapes of the band, which is itself aligned with the vine frieze below the lintel. Foliage thus provides formal and thematic continuity to all sections of the central portal—jambs, trumeau, lintel, and archivolts—heightening its Christocentrism.

The dialogue between the Jesse Tree and the adjacent vegetal and figural imagery at Amiens is typical of buildings of the period. The early-thirteenth-century sculptures on the west façade of Laon Cathedral strongly support this point, despite losses and heavy-handed restoration.[71] Christ and the Virgin Mary serve as the focal point of the design. The central portal portrays the Death, Assumption, and Coronation of the Virgin; the north portal depicts Incarnation scenes; and the south portal is devoted to the Last Judgment (see figs. 1.20 and 3.28).[72] The Jesse Tree adorns the archivolts of the Coronation portal. More expansive than its counterpart at Amiens, the Jesse Tree at Laon spreads across three of the five archivolts, each containing seated kings framed by vines that resemble living mandorlas (fig. 3.29). The sleeping Jesse appears at the bottom left of the fourth archivolt, a Y-shaped trunk emerging from his body and sprouting upward to support David, identifiable by his harp. Like the example at Amiens, the Jesse Tree at

FIGURE 3.27 Amiens Cathedral, west façade,
central portal, archivolt

Photo: author

FIGURE 3.28 Laon Cathedral, west façade, portals

Photo: author

Figure 3.29 Laon Cathedral, west façade, central portal, archivolts

Photo: author

Laon lacks representations of the Virgin and Christ at its apex. To complete the iconography, the viewer must look to the tympanum, where the enthroned pair presides as king and queen inside the palace of heaven, which is symbolically indicated by a trilobed arch. With its emphasis on Christ's royal roots, the Jesse Tree in the archivolts of Laon Cathedral not only fits thematically with the principal image of coronation on the central portal, but it also depends on this image to bring the narrative to its logical conclusion.

Designers employed a similar strategy on the roughly contemporary north transept of Chartres Cathedral, which repeats in stone a subject already represented in a twelfth-century stained glass window on the west façade.[73] The Jesse Tree occupies two of the five archivolts of the central door (exclusive of the four archivolts on the porch) (see fig. 3.3). Jesse is shown on the lower left-hand side of the fourth band, a bifurcated trunk shooting out from his body (fig. 3.30). Curvilinear stems trimmed with appliqué-like vine leaves enclose the crowned figures. One finds a comparable but abridged example of the Jesse Tree in the middle archivolt of the south portal on the west façade of Amiens Cathedral, repeating on a smaller scale the iconography of the central portal's seventh archivolt (fig. 3.31).[74] Like the archivolts at the cathedral of Laon, the Jesse Trees from the north porch of Chartres and the south portal of Amiens present the viewer with Coronation scenes in the tympana as substitutes for Christ and the Virgin in the voussoirs. More important, the Jesse Trees at all three cathedrals reiterate the connection between organic growth and Christ manifested in other figural and vegetal sculptures on the façades.

The Jesse Tree maintained its currency in the building projects of the late Middle Ages. However, the subject was generally allotted more space than in earlier periods, lending it greater visual and semantic weight. Pierre des Aubeaux's Jesse Tree at the cathedral of Rouen

FIGURE 3.30 Chartres Cathedral, north
transept, central portal, archivolts

Photo: author

FIGURE 3.31 Amiens Cathedral, west
façade, south portal, archivolts

Photo: author

(1508–1514), for instance, is not relegated to the archivolts at the margins of the portal as in earlier iterations of the subject, but instead fills the entire tympanum of the west façade's central door (fig. 3.32).[75] Jesse lies prone at the bottom of the relief, kings and prophets stand on the branches fanning out above him, and a portrayal of the Virgin and Child in a fiery mandorla crowns the composition. Bands of foliage of varying widths and design decorate the lintel and archivolts, framing the principal scene. Although the sleeping patriarch and budding stalk are conventional aspects of the Jesse Tree at Rouen Cathedral, the placement of kings and prophets on either side of the trunk as well as on its central axis, combined with the fact that they are standing rather than seated, are significant departures from the thirteenth-century examples discussed above.[76]

The expansive approach to the Jesse Tree at Rouen Cathedral not only accords with broad tendencies in late medieval architectural sculpture, which saw foliage play an increasingly important role in church design, but also with the widespread use of organic forms as visual tools to chart consanguinity and affinity.[77] Conceptualizing familial relations in botanical terms was commonplace in clerical circles and also among lay nobles, for whom ancestry was a prime source of wealth and power. The tree served as a device to visualize familial lines of descent in sacred and secular contexts and in diverse media. In addition to architectural sculpture, the Jesse Tree can be found in stained glass windows, wall paintings, manuscripts, and ivories. Similarly, although secular consanguinity trees are most pervasive in manuscripts, they also appear in monumental media. A remarkable example is the massive family tree that fills the tympanum of the north transept of Beauvais Cathedral (figs. 3.33, 3.34).[78] The tympanum is unfinished, but the lack of space allotted for a reclining figure at the bottom of the composition and the blank

FIGURE 3.32 Rouen Cathedral, west façade, central portal, tympanum, 1508–1514
Photo: author

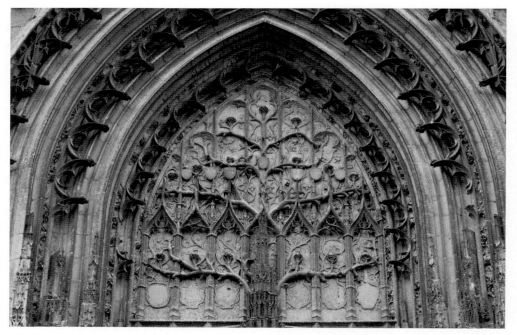

FIGURE 3.33 Beauvais Cathedral, north transept portal, tympanum, 1510
Photo: author

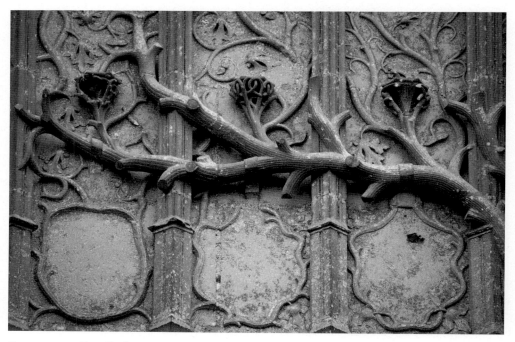

FIGURE 3.34 Detail of 3.33

escutcheons beneath each foliated pedestal suggest that it was made as a secular genealogical tree, rather than as a depiction of the royal ancestry of Christ. Crowned salamanders, the personal emblems of king François I of France, as well as the initial "F," appear in the jambs. These details point to the royal patronage of the façade and support the identification of the tympanum sculpture as a secular tree. In short, the extensive use of the tree as a tool to indicate lineage suggests that a wide range of viewers, both clerical and lay, were equipped to understand the Jesse Tree in its intended Christocentric manner.

Closely related thematically to the Jesse Tree is the so-called gallery of kings adorning the façades of several French cathedrals. Royal galleries comprise rows of crowned figures representing the kings of Judea standing side by side beneath architectonic frameworks. Their exact placement varies from building to building, ranging from the area directly above the portal zone (Notre-Dame of Paris), to the approximate center of the façade (Amiens Cathedral), to the crowning element of the design (the cathedrals of Reims and Chartres). Whatever their location, these over-life size statues showcase the royal ancestry of Christ to viewers below.[79]

The first known example of a gallery of kings comes from the cathedral of Paris, where twenty-eight statues of biblical monarchs stretch across the width of the façade (fig. 3.35). Once thought to represent French rulers, the sculptures were targeted by Revolutionary vandals.[80] The current statues date to the nineteenth century, but the heads of twenty-one of the original sculptures were discovered under the Banque française du commerce extérieur in 1977.[81] These fragments show that the kings were once brightly painted, with saturated pigments accentuating the figures' eyes, lips, cheeks, and crowns (fig. 3.36). Vibrant polychromy also characterized the gallery of kings at the cathedrals of Amiens and Reims, making the sculptures conspicuous features of the designs, even from ground level.

The statues of Old Testament kings on the façades of French cathedrals almost certainly resonated differently at each locale. At Reims Cathedral, the procession of kings in the gallery can hardly be divorced from the function of the building as the coronation church for French monarchs.[82] Similarly, the proximity of Notre-Dame of Paris to the royal palace complex on the Île-de-la-Cité and the tradition of royal patronage at the cathedral surely inflected the statues of kings in the gallery in political ways.[83] Messages of royal authority, however, coexisted with an ecclesiastical worldview that identified Christ as the descendent of these biblical figures, a relationship consistently depicted using botanical imagery. Monumental vegetation, when viewed in tandem with royal galleries, may be interpreted in light of these connections. Amiens Cathedral once again serves as an illustrative example (fig. 3.37). A foliate band consisting of winding stems and deeply undercut leaves runs directly beneath the gallery of kings (heavily restored by Violet-le-Duc). The frieze lacks the details necessary to identify the plant species decisively, but the affinities between it and the two friezes lining the lintel of the central portal strongly support its identification as a grapevine (see figs. 1.37 and 3.11). Given its placement below the royal forebears of Christ and its distance from the beholder, it is likely that the foliage beneath the gallery was understood to be a grapevine.[84] A similar case can be made for the strings of rigid, upright leaves below the royal galleries at the cathedrals of Paris and Reims. The artful juxtaposition of vegetal and figural sculptures associating Christ with the vine is therefore evident not just on church portals and choir screens, but also on the upper reaches of the façades, which were among the most public sections of the buildings.

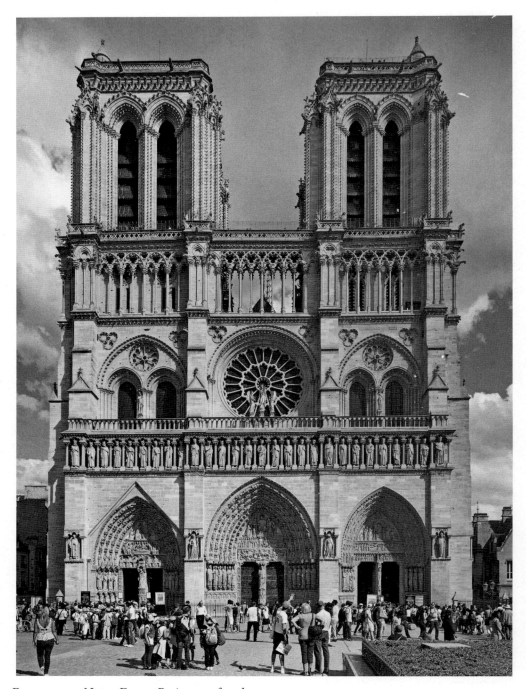

FIGURE 3.35 Notre-Dame, Paris, west façade

Photo: © Mapping Gothic France, Media Center for Art History, The Trustees of Columbia University, Department of Art History and Archaeology

FIGURE 3.36 Heads of kings from Notre-Dame, Paris, ca. 1230, Paris, Musée national du Moyen Âge (Cl. 22982–Cl 23003)

Photo: author

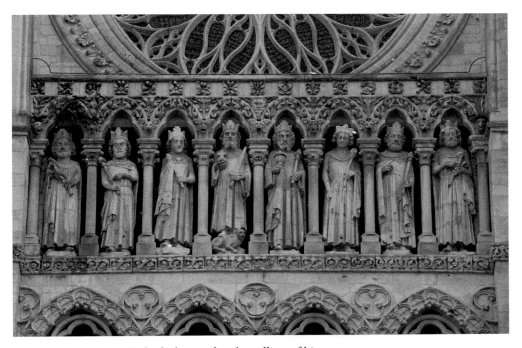

FIGURE 3.37 Amiens Cathedral, west façade, gallery of kings

Photo: author

CONTEXTUALIZING THE VINE

With the vine, Christians adopted an ancient motif that was at once formally malleable and symbolically loaded, whose scriptural origins lay in the postdiluvian age of Noah and whose cultivation dated back millennia.[85] An artistic ornament with roots stretching at least to the Hellenistic period, the scrolling vine accrued layers of meanings and served diverse functions centuries before the emergence of a distinctly Christian art.[86] The classical rinceau was then incorporated into the art and architecture of nascent Christianity, with craftsmen, builders, and patrons appropriating the motif and perpetuating many of its functions and meanings, while also giving it a new and distinctly Christian flavor (see fig. 3.1).

Ancient Greek and Roman builders made liberal use of the rinceau in sacred architecture, with living forms featuring prominently outside temples. Exemplary in this regard is the vine rinceau circumscribing the exterior of the Maison Carrée in Nîmes, a well-preserved Corinthian temple built under the aegis of Marcus Agrippa in 16 BCE (fig. 3.38). [87] The vine travels around the entablature, framing sacred space like the foliate friezes articulating medieval church exteriors. In addition to entablatures, ancient builders used organic patterns around the portals of temples. At the Temple of Bacchus at Baalbek (ca. 150), for example, recessed botanical friezes weave their way around the entrance to the cella, enclosing the door in a way that recalls the vegetal bands decorating the entrances to French churches.

An outstanding example of an organic frame in the architecture of antiquity is the Ara Pacis Augustae in Rome (13–9 BCE) (figs. 3.39, 3.40).[88] Vegetal scrolls and garlands depicting over fifty identifiable plant species, including grapevines, acanthus leaves, and ivy, cover the

FIGURE 3.38 Maison Carrée, Nîmes, capitals and entablature, 16 BCE
Photo: José Luiz Bernardes Ribeiro

FIGURE 3.39 Ara Pacis Augustae, Rome, 13–9 BCE
Photo: Manfred Hyde

FIGURE 3.40 Detail of 3.39
Photo: Miguel Hermoso Cuesta

lower zone of the monument's four enclosing walls, occupying more than half its surface. The pilasters flanking the two entrances and marking the corners of the structure also received foliate embellishment. Jaś Elsner argued that the Ara Pacis was, for all intents and purposes, a temple erected by the Roman senate to commemorate Augustus' successful military campaigns in Hispania and Gaul.[89] Though atypical in design, the monument was laid out in much the same way as a Roman *templum*, a plot of land reserved for religious use and ritually defined as a place for augury. The primary difference between the Ara Pacis and a typical Roman temple was the former's lack of an *aedes*, a separate room designated for a cult statue.

Botanical images on the sacred buildings of the Greco-Roman world were intensely productive and polyvalent, encompassing the political, economic, social, and religious spheres. Paul Zanker demonstrated that the foliate motifs on the Ara Pacis were part of a broad strategy aimed at conveying messages of vitality, abundance, and growth in a golden age ushered in by Augustus after a tumultuous and protracted civil war.[90] According to Zanker, portrayals of viridity in Augustan art and architecture cast Rome as a prosperous earthly paradise. Augustus' program of cultural renewal, which focused on saving Rome from self-destruction by restoring Republican ideals related to religion, custom, honor, and manly valor (*virtus*) brings the political dimensions of the Ara Pacis into sharp relief, whereas the importance of the grapevine, which stood alongside wheat and olives as the primary product of the agrarian economy of the ancient Mediterranean, highlights the new prosperity brought by Augustus.[91] The links between the vine and Dionysus, god of the grape harvest, wine and winemaking, and ritual madness and ecstasy are more broadly relevant.[92] The *Bibliotheca* of the Pseudo-Apollodorus from the first or second century credits Dionysus with discovering the grapevine.[93] Indeed, the god was so closely associated with the vine that representations of him often included grapes and wine as his identifying attributes (fig. 3.41).

The firmly established formal and semantic functions of the vine in antiquity had important repercussions for Christians, who took up the motif as a prime symbol of the new religion and perpetuated some of its meanings. Key in this regard are the parallels between Christ and Dionysus explored in detail by Friedrich Hölderlin in *Brot und Wein* (an elegy written in 1800) and examined more recently by Martin Hengel, Barry Powell, and Peter Wick, among others.[94] These scholars discussed the correspondences between Dionysus and Christ, the most relevant pertaining to resurrection. Dionysus was not just associated with wine and revelry, but also with rebirth through two different myths, each of which presented the god as twice born. (In one account, Dionysus was reborn from Zeus' thigh after being rescued from the dead Semele's womb; in another, Zeus recreated Dionysus after the Titans devoured all but his heart.) The continuities between pagan and Christian vine symbolism, then, encompassed the themes of regeneration and eternal life.

The functions of the vine in the Jewish tradition are equally important for understanding its nuances in Christian contexts. Beyond its prominence in Jewish life and ritual practice, the grapevine was a messianic symbol, an emblem of the people of Israel, and a reference to the fertility of the land.[95] The more than forty expressions associated with the vine in the Hebrew Bible and Talmudic literature attest to its centrality.[96] In Isaiah 5:7 and Hosea 9:10, for instance, the children of Israel are likened to vines and grapes, while the same passage from Isaiah describes God as the owner of the vineyard that is Israel. Deuteronomy 8:8 reveals that the grapevine is among the seven plant species with which Israel was blessed. A copious amount of wine is linked to prosperity in Genesis 49:11–12 and to well-being in Zechariah 3:10, whereas 1 Samuel 16:20 presents wine as an appropriate gift for royals. The parable of the vineyard in Isaiah 5:1–2 provides a description of viticulture, referencing the breaking and clearing of the ground,

FIGURE 3.41 Banded agate ring stone with young Bacchus, first century BCE–third century CE
Photo: The Metropolitan Museum of Art, Gift of John Taylor Johnston, 1881 (81.6.78)

the planting of vines, and the use of a winepress. As I will demonstrate in the following chapter, moreover, a key aspect of the grapevine in the Jewish tradition was its association with the Temple of Jerusalem, whose original builder, king Solomon, was a typological precursor of Christ.

CONCLUSION

The sculpted foliate friezes decorating medieval French churches embedded diverse messages directly into the sacred fabric of buildings. Although the meanings of vegetal motifs were far from stable in the Middle Ages, even in sacred settings, the frequency with which builders represented grapevines with a high level of accuracy, or plant forms that were likely interpreted

as grapevines, is a powerful reminder of the sway of the true vine allegory over the medieval imaginary. Given the biblical roots of the Christ-vine relationship and the conflations or juxtapositions of Christ with the vine permeating medieval textual and visual materials, including architectural sculpture, it is likely that at least some of the friezes in French churches were designed with Christocentric and Eucharistic meanings in mind. Of course, this does not negate other potential motives driving the production of these costly sculptures, including the desire to create rich, decorative effects that maximized the visual and sensual impact of sacred buildings.

Foliate friezes functioned as vehicles of communication capable of evoking meanings from densely trafficked sections of churches. The friezes might thus be compared to inscriptions, which appeared in similar places as early as the fourth century, namely above the portals of churches and inside choirs.[97] In contrast to inscriptions, however, foliate friezes were socially inclusive, demanding from the viewer only visual and cultural literacy, rather than an ability to read Latin verses. Additionally, the ubiquity of the true vine allegory in popular sermons and plays virtually guaranteed a familiarity with the concept on the part of lay men and women of different social classes.[98] With this in mind, it is possible to identify foliate friezes as integral and integrating parts of the medieval church, a perceptual shift that transforms a seemingly insignificant decorative device into the symbolic poster child for fundamental tenets of the Christian faith.

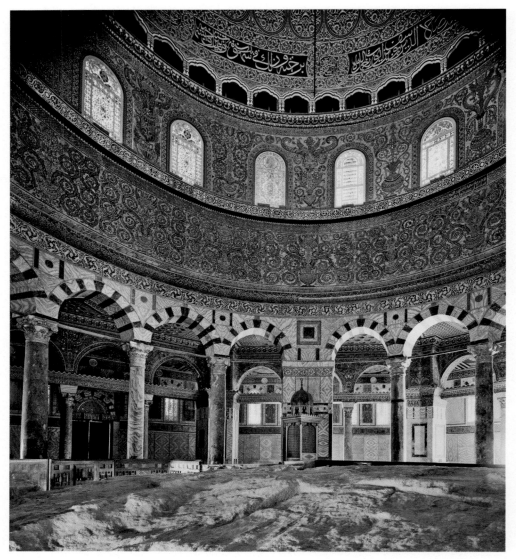

FIGURE 4.1 Dome of the Rock, Jerusalem, 691
Photo: Erich Lessing/Art Resource, NY

FOUR

The Golden Vine

SAINT QUODVULTDEUS, A FIFTH-CENTURY BISHOP OF CARTHAGE AND associate of Augustine, attests to the centrality of biblical archetypes early in the history of Christian architecture and to the inclusive manner in which such models were conceptualized: "If you have an affinity for building," he writes in *De gloria regnoque sanctorum*, "you have the creation of the world, the measurements of the Ark, the extent of the Tabernacle, the height of the Temple of Solomon, all aspects in earthly terms of the Church itself, which they all figure forth."[1] Church builders throughout the Middle Ages routinely drew on paradigmatic monuments to confer on their buildings spiritual and political authority. As Krautheimer observed almost seventy-five years ago, such borrowings might include the transfer of proportions and dimensions from model to copy, adopting the dedication of the prototype, or appropriating one or more of its salient features, which were generally interpreted in a flexible manner. Of these legitimating strategies, each of which was sufficient to convey the meaning(s) of the original according to Krautheimer, it is the fragmentation of the prototype into abstract, constituent parts, the "selective transfer" of these elements, and their "shuffling in the copy" that relates most directly to the study of foliate friezes.[2] The bands of foliage that appeared with increasing frequency in French churches around the time of the First Crusade bear a strong conceptual relationship to a key component of the Temple of Jerusalem: the golden vine articulating its entrance. As a synecdoche for the Temple, the potency of the golden vine for church builders in the Latin West lay in its capacity to link the present to a hallowed but geographically and temporally remote past, allowing churches not just to demonstrate, but also to enact the power of the archetype.[3]

Citations of the Temple vine served a wide range of functions in Christian contexts. In the simplest terms, the Temple was a dwelling place of God, a permanent replacement for the desert Tabernacle that came before it. Consequently, the Temple was synonymous with sacred space, such that references to the building, either formal or metaphorical, reinforced the special status churches acquired during consecration. The Temple was also a source of legitimacy, linking patrons and their churches to the sacrality of the divinely sanctioned building on the Temple Mount and its royal builder. As an emblem of the Old Law and God's covenant with the Jews, moreover, the Temple served as a powerful tool for the promotion of a supersessionistic Christian worldview. Accordingly, the parallel between the Temple/Old Law and the Church/ New Law had important ideological implications, not just presenting the Church as the legitimate heir and supplanter of the Temple, but also proclaiming the status of Christians as God's new chosen people.

No medieval texts identify the foliate friezes in French churches as the golden vine of the Temple of Jerusalem, but circumstantial evidence strongly supports this reading. First, although the Old Testament makes no mention of the golden vine, it *is* described in literary sources that circulated widely in French clerical circles in the Middle Ages: *The Antiquities of the Jews* and *Jewish Wars* of Josephus, and the Mishnah, the written compendium of Rabbinic Judaism's oral Torah. Second, patrons of architecture in the East and West from the Early Christian period onward were frequently cast as present-day Solomons and their churches were compared to the Temple, two practices that speak to the importance of the biblical king and his building as exemplars. Third, the function of the Temple vine as an architectonic framing device and delineator of sacred space, as well as its position at the threshold of the building, relates closely to the uses and placement of foliate friezes in French churches. Last, foliate friezes began to proliferate in France shortly after the conquest of Jerusalem and the ensuing surge in Latin travelers to and from the Levant, a period that also saw the transformation of the Temple platform into a locus of Christian worship and the incorporation of the buildings on the site into Western pilgrimage itineraries. The Temple had long been destroyed by the time the Crusaders took possession of Jerusalem in 1099. However, the seventh-century Umayyad building that stood in its place—the suitably "other" Dome of the Rock—was often identified as the Temple and thus became fodder for imagining and imaging the biblical building (figs. 4.1, 4.2). Importantly, two golden vines comparable in placement and function to the Temple vine described in textual sources and to French foliate friezes are prominent features of the design of the Dome of the Rock.

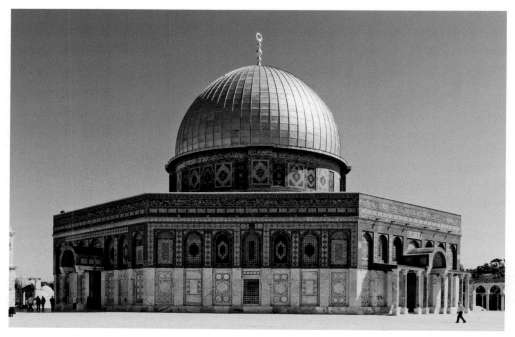

FIGURE 4.2 Dome of the Rock, Jerusalem

Photo: Ralf Roletschek

What I am proposing in this chapter is not a simple case of West borrowing from East. The period of confluence precipitated though by no means ushered in by the Crusades coincided in Western Europe with a sharp increase in the production of ambitious building works, a renewed interest in architectural sculpture, and profound societal changes of an economic, political, intellectual, and urbanistic nature. The foliate frieze emerged during this dynamic time as newly important in the religious architecture of France. As I stated in the preceding chapter, however, vine imagery (and in particular the vine frieze) was commonplace across broad geographic areas in antiquity, including parts of France. Furthermore, some friezes correspond more closely to textual descriptions of the Temple vine than to the vines in the Dome of the Rock. Encounters between West and East, prestigious exemplars near and far, and well-circulated texts surely factored into the revival, transmission, assimilation, and interpretation of foliate friezes. With the resurgence of the motif came new associations, key among which was the golden vine of the Jerusalem Temple, a building that had long fascinated church patrons.

Following an introduction to the Temple and a brief discussion of its status as an archetype, this chapter presents the textual sources for the golden vine. Next it considers the relationship between the Temple and the Dome of the Rock, the slippages enabling their conflation, and the golden vine friezes inside the latter. The two ensuing sections attend to vine friezes in select Byzantine and Islamic monuments. This is not intended as a comprehensive survey of vines in eastern contexts (an impossible task given the pervasiveness of the motif). Rather the emphasis is on examples that are demonstrably related to the Temple vine. Returning to the Latin West, the last sections focus on the transfer of the golden vine of Solomon's Temple through travel, texts, and oral reports, which produced extraordinary essays in monumental flora that became conspicuous features of church architecture throughout the French crownland.

THE TEMPLE OF JERUSALEM

The Old Testament recounts that king Solomon, Christ's royal forebear and typological precursor, built the Temple of the Lord on a threshing floor purchased by his father, king David, on the summit of the Temple Mount in Jerusalem, a site the Bible also calls Mount Moriah (fig. 4.3).[4] Solomon's Temple (begun ca. 959 BCE), also known as the First Temple, was the first permanent structure to house the Ark of the Covenant, a gem-encrusted, golden chest built by Bezalel and Oholiab under the command of Moses. The Ark contained the stone tablets on which God inscribed the Ten Commandments, as well as other holy objects.[5] The Temple replaced the Tabernacle, the sacred, portable sanctuary in which the Ark was stored during the Israelites' forty years of wandering in the desert following their exodus from Egypt.

The main scriptural sources for the architecture of Solomon's Temple are 1 Kings 6–7 and 2 Chronicles 3–4. Both describe the Temple as a rectangular structure with proportions of 3:1 (length to width) and 1:1.5 (width to height). It measured 60 cubits in length, 20 cubits in width, and 30 cubits in height. The interior space of the Temple was divided into three main parts with storage rooms lining its sides and rear.[6] A staircase led to the porch (called the *ulam*), whose portal was flanked by two bronze-cast pillars named Jachin and Booz, each measuring 18 cubits in height. A chord of 12 cubits wrapped around each pillar. Capitals measuring 5 cubits each dressed with interwoven chains, pomegranates, and lilies crowned these piers. Directly behind

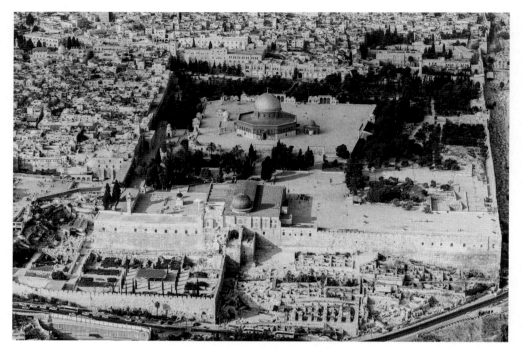

FIGURE 4.3 Temple Mount/Haram-al-Sharif, Jerusalem
Photo: Andrew Shiva

the porch stood the *hekhal* or Holy Place (also referred to as the Greater House), which contained the menorah, the table of showbread, and the golden altar of incense. The Ark of the Covenant lay beyond in the *Kodesh Hakodashim* or Holy of Holies (also called *debir* or Inner House), which was 20 cubits in length, breadth, and height. This most sacred section of the Temple, which was elevated and separated from the *hekhal* by stairs and blue, purple, and crimson veils (*vela*), also housed two monumental cherubim.[7] These gilded wood sculptures were set side by side so that their outstretched wings met at the center of the room and also touched the Temple walls. The interior walls of the Temple, the olivewood doors separating the *hekhal* from the Holy of Holies, and the main sanctuary doors were entirely overlaid with gold and adorned with reliefs depicting cherubim, palm trees, and open flowers. Projecting emphatically from the walls, these relief sculptures, called *anaglyfa* in the Vulgate, are key elements in what Paul Binksi described as a "Solomonic aesthetic" in his study of the fourteenth-century Lady Chapel at Ely, which is adorned with a rich array of foliate sculptures.[8] I will return to this aspect of the Temple and its relationship to the flora in French churches later in this chapter.

Solomon's Temple was the first of a series of sacred monuments to be built on the Temple Mount. Nebuchadnezzar II destroyed the original tenth-century building during the siege of Jerusalem of 587 BCE, making room for its replacement, the Second Temple (ca. 520 BCE), which was built shortly after the Babylonian captivity by Zerubbabel, the governor of the Persian province of Judah. King Herod the Great of Judea expanded the Temple in 19 BCE as part of a campaign to monumentalize the Temple Mount. It is Herod's Temple that appears in the New Testament and whose destruction Christ foretold.[9] This building was described in detail by Josephus in *Antiquities of the Jews* and *Jewish Wars* and in several tractates of the Mishnah, which was known

to Christian authorities in the West from the twelfth century onward.[10] Herod's Temple stood on the site until the first Jewish-Roman war, when the future emperor Titus and his army sacked Jerusalem, laying waste to most of the city and the Temple, an act understood by Christians as divine vengeance for the Crucifixion. Despite the efforts of Hadrian, who began reconstructing Jerusalem in 135, renaming the city Aelia Capitolina, and the building works of Constantine, the Temple Mount remained undeveloped, save an attempt to rebuild the Temple by the emperor Julian, which was aborted after the Galilee earthquake of 363.[11] The Temple lay in ruins for the remainder of the Byzantine period, presumably as an expression of the replacement of Judaism by Christianity and the fulfillment of Christ's prophecy.[12] This state of affairs persisted until the construction in 691 of the Dome of the Rock (or Qubbat al-Sakhra), the first monumental building of the Islamic religion. The Dome rose on the platform of the Temple Mount, renamed the Haram al-Sharif or Noble Sanctuary, under the patronage of the fifth Umayyad caliph, 'Abd al-Malik ibn Marwān (d. 703).[13]

THE TEMPLE AS MODEL

The Temple was a highly influential, but fluid architectural prototype throughout the Middle Ages. As Walter Cahn observed, the building "did not present a fixed image to be passively recorded"; rather, the Temple was a pliant model that acquired new characteristics over time, many of which were projected as Solomonic.[14] In medieval thought, the Temple was a malleable conflation of a number of buildings, both real and imaginary. Among these were the Jewish Temples of Solomon, Zerubbabel, and Herod mentioned above, the visionary Temple described by the prophet Ezekiel, and a number of extant buildings in Jerusalem, including the Dome of the Rock and the adjacent Aqsa Mosque (eighth century), both of which were converted for Christian use during the Crusades. The nearby church of the Holy Sepulcher, a powerful symbol of the New Covenant, was also associated and at times conflated with the Temple.[15]

Church patrons and their builders could imagine and image the Temple using real structures in Jerusalem and a variety of textual sources. Among the latter were biblical descriptions of Solomon's Temple and Ezekiel's visionary Temple, the writings of Josephus, the Mishnah, patristic texts, and exegetical analyses of the Temple by thinkers such as the Venerable Bede, Rabanus Maurus, Richard of Saint-Victor (d. 1173), Andrew of Saint-Victor (d. 1175), and Peter Comestor (d. 1178).[16] The written accounts of merchants, pilgrims, and Crusaders who journeyed to and from Jerusalem, as well as the unrecorded oral reports of travelers and depictions of the Temple on portable objects, may also have influenced architectural figurations of the Temple in the Latin West.[17]

As the First Temple of the Lord and the site of momentous biblical events, such as the Sacrifice of Isaac, Jacob's Dream of the Ladder, and the Presentation of Christ, the Temple of Jerusalem held an exalted position for medieval Christians.[18] The literary record attests to the elevated status of the building. Both Eusebius and Augustine understood the Temple of Solomon to be a prefiguration of the Church, a parallel repeated by later writers, including Durandus.[19] In his homilies on the gospels, Gregory the Great compared the Temple to the soul and the house of God.[20] Bede focused on typological associations between Solomon's Temple, the Church, and the heavenly *ecclesia*.[21] Other medieval writers, such as Isidore of Seville, Walafrid Strabo (d. 848), Rupert of Deutz, and Honorius of Autun, likened the Temple to the Church and the

mystical body of Christ.[22] Starting in the Carolingian period, exegetical writing on the Book of Revelation described the Heavenly Jerusalem in terms analogous to the Temple, the Ark of the Covenant, the Tabernacle, and the city of Jerusalem.[23] With its connotations of sacrality and perfect proportions, the divinely inspired Temple was both an ideal model for churches and a mirror of cosmic harmony.[24]

In light of the Temple's important and long-standing associations, it is unsurprising that equating church structures to the Temple, on the one hand, and patrons to Solomon, on the other hand, was a common rhetorical conceit throughout the Middle Ages.[25] Such correspondences between ancient and contemporary architectural endeavors and patrons appear in the written sources beginning in the fourth century. The first documented example stems from Eusebius' sermon for the consecration of the cathedral of Tyre, which likens Paulinus of Tyre (d. 388), the bishop responsible for constructing the building, to Solomon, Zerubbabel, and Bezalel. Eusebius opened his panegyric with a direct address to the bishop: "One might call you a new Beseleel, the architect of the divine tabernacle, or Solomon, king of a new and much better Jerusalem, or also a new Zerubbabel, who added a much greater glory than the former to the temple of God."[26] Eusebius drew parallels between the church of Paulinus in Tyre, the universal Church established by Christ, and the Temple of Jerusalem, stressing that the church was inextricably linked to and yet superseded the Temple. The church of Paulinus is no longer extant, but there is little chance that it bore a direct formal relationship to the Temple, the link instead being a metaphorical one of identity.[27] As Robert Ousterhout noted, Eusebius employed a similar rhetorical strategy to the one he developed at Tyre in his description of the church of the Holy Sepulcher, referring to the complex as the New Jerusalem and to the tomb of Christ as the Holy of Holies.[28] This well-crafted metaphor was taken up by later generations of writers. In a letter chronicling her travels to the Holy Land in the 380s, for instance, the Galician nun Egeria compared the consecration of the church of the Holy Sepulcher to the dedication of the Jewish Temple by Solomon.[29] Analogously, a twenty-line elegiac composed by Sidonius Apollinaris and inscribed into the walls of the church of Saint-Martin in Tours (consecrated in 470) likened the church to the Solomonic Temple.[30] Sixth-century writers also equated the Byzantine churches of Saint-Polyeuktos and Hagia Sophia in Constantinople, both of which will be discussed below, with Solomon's Temple. Even more striking, however, are the Old Testament associations of Charlemagne's Palatine Chapel at Aachen (begun ca. 792): the architect of the chapel, Odo of Metz (d. 814), was identified with king Hiram of Tyre, who contributed materials and manpower for the construction of the Temple; Alcuin (d. 804), a leading scholar at the Carolingian court, referred to the chapel as the "Temple of the most wise Solomon"; and Notker the Stammerer (d. 912), a scholar and poet at the monastery of Saint-Gall, claimed that the chapel was built "after the model of the most wise Solomon."[31]

Even more pertinent within the context of this study than the examples cited above are the Temple-church/Solomon-patron parallels in literary sources from high and late medieval France. In his twelfth-century account of the consecration of Saint-Denis, for example, Suger declared: "Solomon's riches could not have sufficed for his Temple any more than did ours for this work had not the same Author of the same work abundantly supplied His attendants."[32] In Suger's mind, his church was equivalent to the Temple, and God (the author) was to be credited for the actualization of both projects. Pope Urban IV similarly invoked Solomon's Temple in a letter dated 29 May 1262, which outlined his plans to build the eponymous church of Saint-Urbain at Troyes.[33] In addition to Solomon, the pope mentioned Gregory the Great and Gregory IX, thereby aligning himself with three illustrious predecessors who, like him, built sacred structures in their personal domains. Solomon also appears in a charter dated 12 December 1321

related to the disposition of funds for the construction of the church of Saint-Ouen in Rouen, which refers to the biblical king's construction of the Temple under God's command.[34] What these documents spanning the twelfth to the fourteenth centuries reveal is that Solomon and his Temple were potent and long-standing models for patrons of architecture in France. Although the texts make no mention of formal similarities between the churches and the Temple, it is clear that the Temple was a distinct and valued referent. Churches were conceived in the image of the Celestial Jerusalem, and the Celestial Jerusalem in turn was prefigured in the Solomonic Temple, making the Temple an ideal prototype for Christian sanctuaries. Particularly telling in this regard is the inscription that once adorned the main entrance to the now-destroyed abbey church of Notre-Dame des Moreaux at Champagné-Saint-Hilaire in western France (mid-twelfth century): VT: FVIT: INTROITVS: TEMPLI: S[AN]C[T]I: SALOMONIS (This entrance exists as the holy Temple of Solomon).[35]

The evocation of the Temple of Solomon in the liturgy further attests to the role of the building as an archetype of the Christian church. From the Carolingian period onward, the standard liturgical texts used in northern Europe for the church dedication rite and the annual feast commemorating the anniversary of the dedication were rife with Solomonic references.[36] For example, the description of Solomon's Temple in 2 Chronicles 6–8 was read annually during the octave of the dedication feast of the Latin rite at numerous churches, including the cathedral of Chartres.[37] The explicit references to David, Solomon, and the Ark of the Covenant made during the feast helped forge connections between past and present, and Temple and church. The Temple was not simply mentioned on these exceptional occasions, but on a regular basis during Mass. Across much of medieval Europe, the opening prayer of the Mass relied directly upon the concept of the church as the Temple, remade to be sure, but nonetheless linked to the model.[38]

THE TEMPLE VINE: THE TEXTUAL SOURCES

Of the different texts describing the Temple, Josephus' *Antiquities of the Jews* and *Jewish War* are particularly relevant to the study of monumental flora in sacred settings, as both confirm the existence of a Temple vine.[39] Latin translations of the texts, which were originally written in Greek (*Antiquities*) and possibly Aramaic (*Jewish War*), were broadly accessible to clerics in Western Europe throughout the Middle Ages.[40] In addition to being well represented in the writings of Carolingian scholars, an awareness of Josephus has been detected in the twelfth-century works of Peter Abelard, Hugh of Saint Victor, Peter Comestor, Richard of Saint-Victor, and Andrew of Saint-Victor.[41] Tellingly, these clerics formed part of the Parisian intelligentsia at a time when foliate friezes proliferated in France (and in the period during which Suger rebuilt Saint-Denis and compared himself to Solomon). The production of Josephus manuscripts not only increased dramatically between the twelfth and thirteenth centuries, but *Antiquities* became one of the most frequently cited texts of the period.[42] In it, Josephus describes the golden vine dressing the portal of the *hekhal* of Herod's Temple, which was the principal entrance to the building:

> The temple had doors also at the entrance, and lintels over them, of the same height with the temple itself. They were adorned with embroidered veils with flowers of purple, and pillars interwoven; and over these, but under the crown-work, was spread out a golden vine, with its branches hanging down from a great height, the largeness and fine workmanship of which was a surprising

sight to the spectators, to see what vast materials there were, and with what great skill the work-manship was done.[43]

The Temple vine also appears in Josephus' *Jewish War*:

> The entire house was divided into two parts within; it was only the first part of it that was open to our view. Its height extended all along to ninety cubits in height, and its length was fifty cubits, and its breadth twenty. But that gate which was at this end of the first part of the house was, as we have already observed, all over covered with gold, as was its whole wall about it; it had also golden vines above it, from which clusters of grapes hung as tall as a man's height.[44]

These passages reveal that the golden vine was a conspicuous feature of Herod's Temple because of its position at the threshold of the building, its size, the lavishness of its materials, and the artistry with which it was carved. The Mishnah Middot restates and elaborates upon these observations:

> There was a golden vine at the entrance to the *hekhal*, supported by poles and anyone who offered a donation of gold leaves, grapes, or clusters would hang them on the vine. Rabbi Eliezer ben Rabbi Zadok said: on one occasion, three hundred priests were commissioned to clear it.[45]

In addition to verifying the location, materials, and scale of the Temple vine (the sheer size of which required three hundred priests to clear it), this tractate of the Mishnah speaks to the mutability of the vine. That the faithful were driven to augment the vine with costly offerings of leaves, grapes, and fruit clusters crafted in gold is a direct reflection of its importance in its original architectural context.[46]

The three texts cited above describe the entrance to Herod's Temple, but Josephus also affirms that the golden vine existed in pre-Herodian times, adorning the Second Temple of Zerubbabel. This vine was sent to Damascus by Aristobulus II (r. 67–63 BCE), the Hasmonean ruler of Jerusalem, as a gift to the Roman general, Pompey the Great (d. 48 BCE), in an attempt to garner military and political support:

> A little afterward Pompey came to Damascus, and marched over Celesyria; at which time there came ambassadors to him from all Syria, and Egypt, and out of Judea also, for Aristobulus had sent him a great present, which was a golden vine of the value of five hundred talents. Now Strabo of Cappadocia mentions this present in these words: "There came also an embassage out of Egypt, and a crown of the value of four thousand pieces of gold; and out of Judea there came another, whether you call it a vine or a garden; they call the thing Terpole [τερπωλήν], the Delight. However, we ourselves saw that present reposited at Rome, in the temple of Jupiter Capitolinus, with this inscription, 'The gift of Alexander [Jannaeus], the king of the Jews [and Aristobulus' father].' It was valued at five hundred talents; and the report is, that Aristobulus, the governor of the Jews, sent it."[47]

The fact that the golden vine was deemed an appropriate diplomatic gift for a general of Pompey's standing, as well as its staggering value of 500 talents and its placement in the Temple of Jupiter Optimus Maximus on the Capitoline (one of Rome's oldest and most revered temples), speaks to its symbolic and monetary worth to Jews and Romans alike.

In his study of the lost *karma* (vine) inside the Great Mosque of Damascus, Finbarr Barry Flood hypothesized that the appearance of the golden vine in the Second and Herodian Temples relate to beliefs about the original Temple built on the site by Solomon.[48] He noted that although Old Testament descriptions of Solomon's Temple do not mention vine decoration, they do specify that the building was overlaid with gold (a descriptive detail reiterated by numerous Western medieval commentators) and that botanical forms were defining features of the building. 1 Kings 6 and 2 Chronicles 3 repeatedly mention the "pure gold" overlay of the interior of Solomon's Temple and both specify that the walls of the *hekhal* and of the Holy of Holies were carved with palm trees. 1 Kings 6:29–35 also reveals that ornamental buds and open flowers adorned the interior walls, and that the doors of the two chambers were carved with reliefs of palm trees and blooming flowers. In other words, biblical sources describe the Temple as a virtual garden whose fictive golden flora evoked the fulsome growth of paradise. Golden vegetation is also mentioned in Talmudic descriptions of Solomon's Temple, notably in the Mishnah Yoma: "When Solomon built the Sanctuary, he planted therein all sorts of precious golden trees, which brought forth fruit in their season."[49] Solomon's use of golden trees to beautify the Temple finds parallels in the Rabbinic belief that the gold decorating the Temple derived from the golden, fruit-bearing trees of paradise. Given that golden foliage was a prominent aspect of Solomon's Temple and the generally blurred distinctions between it and the Temples subsequently built on the site, it is likely that the golden vine of later Temple incarnations had a Solomonic timbre. In other words, the shimmering vine motif was closely associated with the First Temple built by Solomon, despite being more appropriate to the iconography of its successors.[50]

THE DOME OF THE ROCK AS TEMPLE

The gold-capped Dome of the Rock has dominated the center of the Temple platform since the late seventh century and stands today as an outstanding achievement of Islamic art and architecture (see figs. 4.1 and 4.2). No contemporary Umayyad texts describe the intended function of this unique building. However, it seems likely that 'Abd al-Malik had religious, political, and ideological aims in mind when he chose the highly charged Temple Mount as the location for this building.[51] The Dome of the Rock has historically served (and continues to function) as a pilgrimage destination, which may reflect its primary role as a replacement for Mecca in the time of 'Abd al-Malik, as Ignác Goldziher and others have suggested.[52] Its cylindrical core encased within two octagonal ambulatories shelters the rock believed to mark the place from which the prophet Muhammad ascended to heaven and received the doctrine of the new religion during the Night Journey from Mecca to Jerusalem.[53]

In her foundational study of medieval representations of the Temple, Carol Herselle Krinsky provided an overview of contemporary textual sources pertaining to the buildings on the Temple Mount. She remarked that eighth- and early-ninth-century visitors to Jerusalem were taciturn about the Dome of the Rock, a surprising revelation given the size, architectural distinctiveness, and hilltop location of the building. This may suggest that visitors did not hold the Dome of the Rock in particularly high regard at that time, or more plausibly, that they were barred from approaching the platform area.[54] By the mid-ninth century, however, the situation had changed drastically, at least for some travelers. During a visit to Jerusalem around 868, a Frankish monk named Bernard claimed he encountered "the Temple of Solomon where now the synagogue of

the Muslims is" (*Templum Salomonis habens sinagogam Sarracenrorum*).[55] Bernard's statement is undeniably muddled, but it is of critical importance because it is the first extant Western text to connect the Dome of the Rock to the Temple of Solomon. Not all visitors, though, were convinced of the Solomonic authorship of the Dome of the Rock. In his tenth-century *Annales*, for instance, Patriarch Eutychius of Alexandria (d. 940) proclaimed that the buildings on the Temple Mount were not of Jewish or Christian provenance, since Christians had left the site in ruins, as prophesied by Christ.[56] As Krinsky concluded, pre-Crusade sources present conflicting accounts of the origins of the Dome of the Rock, some associating it with the biblical Temple and others recognizing it as an Islamic monument of relatively recent construction.[57]

Scholars have observed that the predominantly symbolic images of the Temple of the pre-Crusading period increasingly co-existed with more specific representations of the building after the conquest of Jerusalem, when the Levant became more accessible to Western visitors.[58] Although there was a strong interest in the topography of Jerusalem on the part of pilgrims and other travelers before the Crusades, the capture of the Holy City in 1099 seems to have served as a catalyst for changes in Temple imagery. This occurred despite the fact that the Temple had long disappeared by the time the Crusaders took possession of Jerusalem. The Dome of the Rock became a prime model for depicting the Temple during the twelfth and thirteenth centuries, displacing the Anastasis Rotunda of the church of the Holy Sepulcher, on which representations of the Temple were commonly based until the ninth century, and nondescript renderings of centralized structures.[59] That is not to say, of course, that the church of the Holy Sepulcher was entirely abandoned as a stand-in for the Temple or that all depictions of the Temple were based on extant buildings, closely or not. Rather, the Dome of the Rock simply became a more prevalent model during the Latin occupation of the Levant, with Temple representations generally including the dome and distinctive octagonal ambulatory of the Umayyad building.[60]

The changes in pictorial representations of the Temple coincided with shifts in written descriptions of the Dome of the Rock. Much like the Florentines, who effaced the history of their Romanesque Baptistery in the fourteenth century by calling it an ancient Temple of Mars, the Dome of the Rock's history was conveniently "forgotten" and, alongside the adjacent Aqsa Mosque, the building was described as being of biblical origin with growing frequency over the course of the high Middle Ages.[61] Identifications of al-Aqsa were fluid, oscillating between the Temple of Solomon (*Templum Salomonis*), the Palace of Solomon (*Palatium Salomonis*), and the Porch of Solomon (*Porticum Salomonis*).[62] The building was also called the Temple of the Knights Templar after the Order began to use it as their headquarters in the twelfth century.[63] The substructures below the mosque were sometimes called Solomon's stables.[64] Similarly, many Christian travelers referred to the Dome of the Rock as the Temple of the Lord (*Templum Domini*), some going so far as to ascribe it to Solomon.[65] Some writers questioned the Solomonic authorship of the building, attributing its construction to Constantine's mother Helena, the Byzantine emperors Justinian and Heraclius, a Saracen chief named Omar, and the Emir of Memphis. However, most visitors claimed that it sheltered Jewish relics and associated the building with events that took place in the Temple of Herod, such as Christ's presentation to God, his disputation with doctors, and his expulsion of the moneychangers.[66] Despite inconsistencies in the textual sources, then, it is clear that the buildings on the Temple Mount were associated with the biblical Temple (of Solomon, Zerubbabel, and/or Herod). Visual evidence for such conflations appears in early maps of Jerusalem, such as the striking twelfth-century example from Saint-Omer, which refers to the Aqsa Mosque in the upper right quadrant of the walled city as the *Templum Salomonis* and to the Dome of the Rock immediately to the left as the *Templum Domini* (fig. 4.4).[67]

Figure 4.4 Map of Jerusalem, from Saint Omer, ca. 1170, The Hague, Koninklijke Bibliotheek, KB, 76 F 5, fol. 1r

Photo: Koninklijke Bibliotheek

The impact of recasting the Dome of the Rock as a biblical monument has been well documented in manuscript illuminations and seals of the Crusader era, but surprisingly, the potential influence of the building on French churches of the same period has yet to be addressed.[68] Scholars of French architecture have attended to the appropriation of Temple features as described in the literary sources, but not to the possible connections between churches and the Dome of the Rock. For example, Stefaan Van Liefferinge observed that the design of the choir of Notre-Dame of Paris (begun ca. 1163) reflects the Temple dimensions recorded in Peter Comestor's *Historia Scholastica*, a widely read biblical paraphrase from around 1173 that formed part of the core curriculum at the University of Paris and other schools.[69] Van Liefferinge determined that the height of the first level of the choir from the pavement to the keystones of the aisle vaults measures approximately 30 royal feet, the unit of measure used in Paris at the time of the cathedral's construction. The second level to the top of the tribune is also around 30 royal feet high, and the total height of the cathedral to the roof is close to 120 royal feet. Substituting royal feet for cubits, these dimensions correspond to those given by Peter Comestor, who presumably derived the 30-cubit module from Old Testament descriptions of the height of Solomon's Temple. This hypothesis is compatible with Michael T. Davis's interpretation of the fifteenth-century description of Notre-Dame by Guillebert de Metz.[70] Davis proposed that Guillebert provided the measurements of the cathedral in multiples of twenty in reference to the 20-cubit dimensions of the Holy of Holies of the temples of Solomon and Ezekiel.[71] Jacqueline Frank and William W. Clark also found correspondences between descriptions of the Temple and a twelfth-century French building: the abbey church of Saint-Denis. They contended that the twin towers of the west façade (one of which was dismantled after a failed restoration attempt in the nineteenth century), crenellations, and gilded bronze doors, as well as the tripartite division of the building into western nave, monk's choir, and eastern sanctuary, may have evoked the Temple as described in the Old Testament and Josephus (fig. 4.5).[72] They posited a link between these Solomonic traits and Suger's political ambitions for his abbey and for the Capetian monarchy, with which he had close ties. Similarly, Margot Fassler proposed that the ornately carved columns in the jambs of the west façade of Chartres Cathedral allude to biblical accounts of the Temple of Solomon, specifically to 1 Kings 6:29: "And all the walls of the temple round about he carved with divers figures and carvings" (see figs. 1.30 and 1.31).[73] The cathedrals of Amiens and Beauvais, the Sainte-Chapelle of Paris, and the abbey church of Saint-Ouen in Rouen also point to the importance of scriptural and exegetical sources in medieval French architecture. These buildings seem to incorporate the dimensions and proportions of the Heavenly Jerusalem, Noah's Ark, and Solomon's Palace.[74] The lure of biblically sanctioned models held equal sway over builders in other parts of Europe, notably those of Santo Stefano in Bologna (the city of Jerusalem), Würzburg Cathedral (Solomon's Temple), and the Lady Chapel at Ely (Solomon's House).[75]

The weight accorded to biblical archetypes in medieval architecture, combined with the function of the Dome of the Rock as a stand-in for the Temple in non-architectural visual media, raises the possibility that the Umayyad building, and not just literary descriptions of the Temple, served as a referent for church builders in the Latin West. Although there is no question that the rib-vaulted basilican churches of France differ markedly from the centrally planned Dome of the Rock, the buildings are closely connected by the foliate friezes articulating their interiors.

Two golden vine friezes encircle the Dome of the Rock. As Flood remarked, their inclusion in the decorative scheme of the building is consistent with Muslim beliefs about the embellishment of Solomon's Temple, namely, that after the Temple was constructed, two fruit trees of

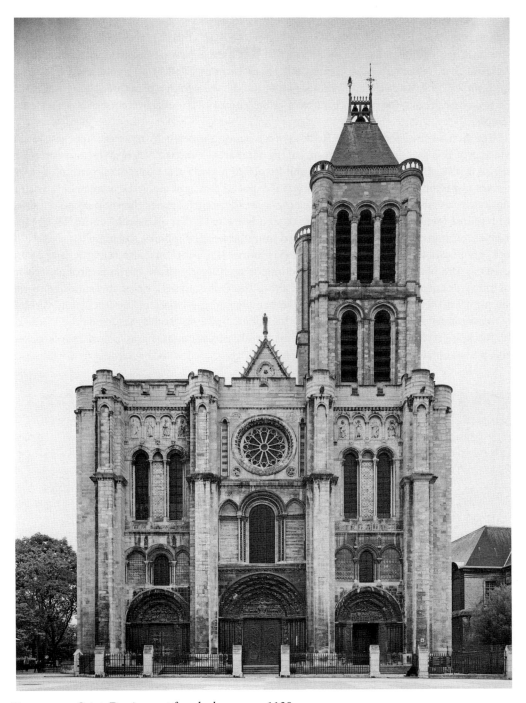

FIGURE 4.5 Saint-Denis, west façade, begun ca. 1130

Photo: © Mapping Gothic France, Media Center for Art History, The Trustees of Columbia University, Department of Art History and Archaeology

precious metals grew at the Gate of Mercy, one of the two doorways of the Golden Gate punc-turing the eastern wall of the Haram.[76] One tree bore leaves of silver and the other of gold. The Islamic preacher Abu Bakr al-Wāsitī (alive before 1019) and Ibn al-Murajjā (d. ca. 1030–1040), who authored a guide to Jerusalem, specify that the entire platform was inlaid with costly mate-rials and that Nebuchadnezzar cleared away eight wagons of silver and gold after destroying the Temple.[77] The Muslim tradition associating the site with golden plant life is congruent with the Jewish belief that the golden fruit trees of Solomon and paradise were used to decorate the Temple.

The first of the Dome of the Rock's golden vines, rendered in *repoussé*, appears on the gilded bronze plates under the tie beams of the outer arcade and the lintels of the four entrances (figs. 4.6, 4.7). The frieze's golden hue and its position above the portals conform to descrip-tions of the Temple vine.[78] The second frieze is a mosaic that runs along the interior of the drum supporting the dome, directly above the inner arcade, which frames the rock at the center of the building (see fig. 4.1). According to a description cited in the thirteenth century by Sibt ibn al-Jawzī, curtains were originally suspended from the arcade supports, shielding the area of the rock.[79] Only when the building was open to visitors were the curtains raised and the sacred core revealed. The placement of the vegetal mosaic frieze directly above curtains strongly recalls Josephus' description of the golden vine above the embroidered *vela* at the entrance to the Temple.[80] Further connections between the Temple and the Dome of the Rock are indicated by the composite nature of the friezes in the Islamic building. Both vines inside the Dome of the Rock are stylized bands fusing acanthus scrolls and pendulous grape clusters interposed with pomegranates. The last two plant species are associated with the Temple in 1 Kings 6, 2

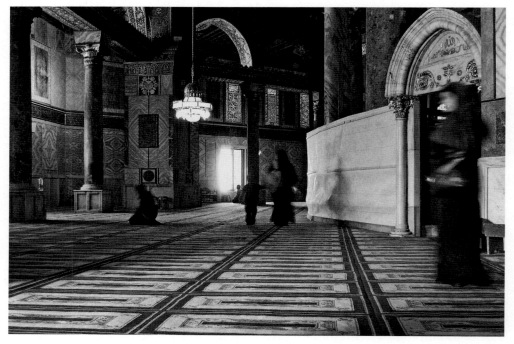

Figure 4.6　Dome of the Rock, Jerusalem
Photo: Emilio Bonfiglio/Manar al-Athar

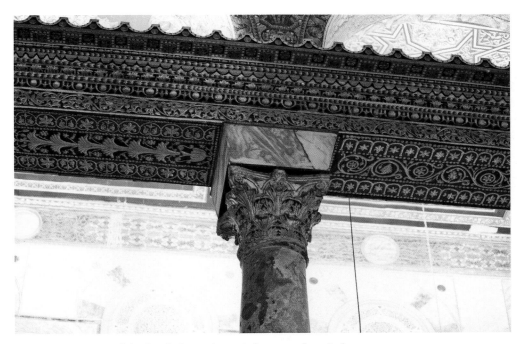

FIGURE 4.7 Dome of the Rock, Jerusalem, tie beam and capital

Photo: George Lewis/Manar al-Athar

Chronicles 3–4, and the writings of Josephus. The composite friezes of the Dome of the Rock also bear a striking resemblance to the hybrid vines typical of Jewish art and architecture from the Herodian era, which points to a formal as well as a conceptual connection to the Temple, an example of the regional art of the past par excellence.[81] These allusions to specific Temple attributes are concordant with the general connections between the Dome of the Rock and the Temple. As Priscilla Soucek observed, Islamic sources praise the Temple of Solomon for its lavish, symbolically charged decorations of jewels and whimsical trees, motifs that appear in the mosaics of the Dome of the Rock.[82]

BYZANTINE PRECEDENTS

'Abd al-Malik was not the first patron of architecture to draw on the Temple tradition through the use of gleaming vine ornamentation. Two buildings in Constantinople employ vine imagery to similar ends: Hagia Sophia and Saint-Polyeuktos (fig. 4.8). Of the two examples, the foliate band inside Hagia Sophia, built by order of the emperor Justinian between ca. 532 and 537, relates most directly to the vines inside the Dome of the Rock due to its golden color and framing function.[83] Most of the vine has been removed, but fragments, later restorations, and textual sources attest to its existence. A tangled, deeply undercut stucco vine appears today in the entablature between the mosaics and marble revetment of the side aisles (fig. 4.9). The aisle entablature is composed of six elements: a central vine, which occupies approximately half of the entablature's total height of 63 cm; four rows of pearl and ovate

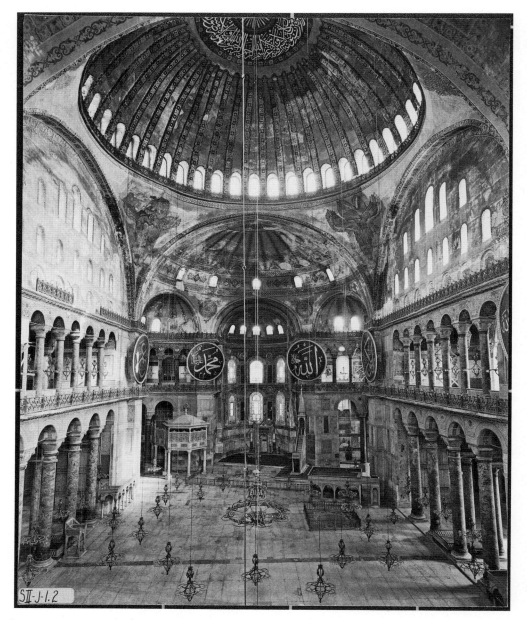

FIGURE 4.8 Hagia Sophia, Istanbul, 532–537

Photo: MS.BZ.004, The Byzantine Institute and Dumbarton Oaks Fieldwork Records and Papers, ca. late 1920s–2000s, Image Collections and Fieldwork Archives, Dumbarton Oaks, Trustees for Harvard University, Washington, D.C.

forms above and below; and an upper molding dressed with rigid leaves. Most of the entablature is modern, but Ernest S. W. Hawkins determined that its central section—the vine itself—was part of the original décor.[84]

The well-known kontakion of Paul the Silentiary, composed in 562 for the rededication of Hagia Sophia after the collapse of the dome during an earthquake four years earlier,

FIGURE 4.9 Hagia Sophia, Istanbul, south aisle, stucco vine

Photo: Hawkins, "Plaster and Stucco Cornices," fig. 1

corroborates Hawkins' conclusion and reveals that the vine was an important part of the original design:

> The twining vine with shoots like golden ringlets winds its curving path and weaves a spiral chain of clusters. It projects slightly forward so as to overshadow somewhat with its twisting wreaths the stone that is next to it. Such ornament surrounds the beauteous church.[85]

This laudatory hymn is of value not only because it confirms the existence of a golden vine inside Hagia Sophia in the sixth century, but also because it provides a frame of reference for the Solomonic interpretation of the vines inside the Dome of the Rock. Although the connections between the Temple of Solomon and Hagia Sophia have unquestionably grown over time, the evidence strongly suggests that these associations existed at the outset of construction. Paul's *kontakion*, for instance, echoes the praise of the Temple of Solomon in the Psalms before explicitly referring to the biblical building: "Whoever puts foot within the sacred fane, would live there for ever, and his eyes well with tears of joy. Thus by Divine counsel, while angels watched, was the temple built again."[86] The mid-sixth-century ekphrastic description of Hagia Sophia by Procopius also brings to mind the Temple by underscoring the building's "pure gold" ornamentation and by characterizing it as a place of divine presence:

> Whenever anyone enters to pray, he understands at once that it is not by human power and skill, but by God's will that this work has been so finely finished. His mind is lifted up to God and floats on air, feeling that God cannot be far away, but must especially love to dwell in this place, which He has chosen.[87]

Other aspects of Procopius' text, such as the emphasis on light, take on Solomonic resonances in view of these oblique references to the Temple. The interior of the church was not

"illuminated from without by the sun," rather, its radiance came into being from within, bathing the church with "an abundance of light."[88] As Ousterhout observed, the light inside the church may be an allusion to the presence of God inside the Temple, a theme repeated in the *Diegesis* of the ninth or tenth century. According to this collection of legends and miracles, Psalm 45:6, which reads, "God is in her midst, she shall not be moved," was stamped on the bricks of Hagia Sophia and may have been recited during the dedication of the church.[89] Moreover, Procopius' comparison of the variegated marble columns and revetment of Hagia Sophia to "a meadow with its flowers in full bloom" is consistent with the vegetal aesthetic of Solomon's Temple as described in the Bible. If, as presented in the literary sources, Hagia Sophia was the New Temple, then by extension Constantinople was the New Jerusalem.[90]

The connections between Hagia Sophia and the Temple in the written record are consonant with the proportions of the church. Georg Scheja proposed that the relative proportions of the building initially mirrored those of the Temple, described in the Old Testament as 3:1 and 1:1.5.[91] The length of the church including the narthex but excluding the exonarthex is approximately 300 feet, the width of the nave is 100 feet, and the total height of the building with its original dome was 150 feet. The connection to the Temple was such that upon seeing the church for the first time, Justinian ostensibly proclaimed, "Solomon, I have surpassed thee." Though often regarded as specious, references to Solomon's Temple in relation to Hagia Sophia in sixth-century sources lend weight to the remark. In *Hymn 54*, for example, Romanos the Melodist (d. ca. 556) juxtaposed the "magnificent Temple that the all-wise Solomon raised up, adorned, and embellished with infinite wealth" with Hagia Sophia, which was "brilliantly decorated" and "erected with such excellence that it imitated Heaven, the divine throne."[92] Corippus similarly compared the two buildings (albeit indirectly), ending the poem he wrote for the accession of Justin II in 566 with the authoritative statement: "Let the description of Solomon's Temple now be stilled."[93] Adding to the Solomonic current surrounding the church was the transfer of the Temple treasures taken by Titus during the first Jewish-Roman war from North Africa to Jerusalem in 532, at precisely the time Hagia Sophia was under construction. Procopius recounted the circumstances leading up to this event:

> And among these were the treasures of the Jews, which Titus, the son of Vespasian, together with certain others, had brought to Rome after the capture of Jerusalem. And one of the Jews, seeing these things, approached one of those known to the emperor and said: "These treasures I think it expedient to carry into the palace in Byzantium. Indeed, it is not possible for them to be elsewhere than in the place where Solomon, the king of the Jews, formerly placed them. For it is because of these that Gizeric captured the palace of the Romans, and that now the Roman army has captured that [of] the Vandals." When this had been brought to the ears of the Emperor, he became afraid and quickly sent everything to the sanctuaries of the Christians in Jerusalem.[94]

The links between Hagia Sophia and Jerusalem were reinforced over time by the former's growing collection of relics. Among the most hallowed were relics that were once stored inside the Temple or closely associated with it: the Ark of the Covenant, the tablets of the Law, the rod of Moses, Elijah's robe, the horn used to anoint David, and the trumpets of Joshua from Jericho.[95] The direct and indirect ties of Hagia Sophia to the Temple, many of which are contemporary with the construction of the church, provide the context for the Solomonic interpretation of the golden vine frieze encircling the building.

Equally emphatic references to the Temple of Solomon were made in the now-destroyed church of Saint-Polyeuktos (ca. 524–527), a precursor to Hagia Sophia.[96] Built under the patronage of Anicia Juliana (d. 527), a Byzantine princess and political rival of Justinian, Saint-Polyeuktos was the largest church in Constantinople until the reconstruction of Hagia Sophia. Although the building was abandoned and fell into disrepair in the eleventh century, many of its sculptures and architectonic elements were subsequently reused as spolia, first by Byzantines and later by Crusaders.[97] The principal remnants of the church are its foundations, the so-called *Pilastri Acritani* (two imposing monolithic piers now in the Piazzetta in front of the south portal of San Marco in Venice), and fragments of marble niches and capitals, many of which were excavated in the 1960s.[98] Some details of the design are unclear, notably whether or not the church was domed.[99] The scale of the project and its ostentatious use of marble, however, are indicative of the wealth of the patron and also hint at the visual impact of the building on the topography of sixth-century Constantinople.

The fragmentary state of Saint-Polyeuktos presents challenges to historians of medieval architecture, but the church is essential for my purposes because it provides the immediate context for the Solomonic interpretation of the vines inside Hagia Sophia. The two buildings share a number of traits, the most relevant being their bold display of vine ornaments, which seem to be associated with the golden vine of the Temple of Solomon.[100] Meandering vines with naturalistically rendered grape clusters and leaves fill the spandrels of the building's marble niches, the *Pilastri Acritani*, and several capitals (fig. 4.10). Like the friezes inside the Dome of the

FIGURE 4.10 Saint-Polyeuktos, Istanbul, niche, ca. 524–527, Istanbul Archaeological Museum
Photo: Public Domain

Rock, many of the vines at Saint-Polyeuktos are hybrids that combine heavy grape bunches and pomegranates, two fruit types mentioned in Old Testament descriptions of Solomon's Temple.[101] The palms and rosettes inside the church, notably on the cornices and capitals, further link the building to the Temple (fig. 4.11). The organic motifs at Saint-Polyeuktos take on a distinctly Solomonic cadence in light of the laudatory epigram once inscribed on the walls of the building. The seventy-six-line poem compares Anicia Juliana to past emperors who financed the construction of monumental buildings. The poem also credits the princess with having "surpassed the wisdom of the renowned Solomon, raising a Temple to receive God."[102] The Temple inflections apparent in the pictorial and epigraphic sources are of a piece with the dimensions of the church and with the unit of measure used to design it, which relate to descriptions of Solomon's Temple in 1 Kings 6:20 and the visionary Temple in Ezekiel 42:2–3. As Martin Harrison demonstrated, Saint-Polyeuktos measured approximately 100 royal cubits in both length and width, echoing the dimensions of the visionary Temple, inclusive of its platform.[103] Furthermore, he estimated that the internal dimensions of the church sanctuary were 20 royal cubits square, which corresponds exactly to the measurements of the Holy of Holies recorded in 1 Kings 6:20 and Ezekiel 41:4.

Investing a church with Solomonic meanings was both a religious and political act in sixth-century Byzantium. On the one hand, Justinian and Anicia Juliana's "New Temples" in Constantinople advanced the idea of the city as the New Jerusalem and instilled in their builders the moral and spiritual authority of a divinely sanctioned king. On the other hand, according to Gilbert Dagron, the Old Testament "had the same normative role in the political sphere as the New Testament in the moral sphere."[104] The typological connections between Byzantine and Old Testament rulers were such that contemporary emperors were regularly presented in Davidic or Solomonic terms as leaders of the new chosen people.[105] The broadly accessible *Life of St. Sylvester*, for instance, reports that Helena urged Constantine to "enter into possession of the

FIGURE 4.11 Saint-Polyeuktos, Istanbul, capital, ca. 524–527, Istanbul Archaeological Museum

Photo: Public Domain

basileia of David and the infinitely wise Solomon" so as to stand among them as agents of God.[106] Moreover, imperial panegyrics frequently referenced the virtues of David, while royal patrons of architecture were often compared to Solomon.[107] Byzantine builders drew on this sacred, royal legacy in varied and inclusionary ways, such that the Solomonic, Temple, and Jerusalemite connotations of their churches collided with other associations, such as the Heavenly Jerusalem and the Throne of God, to create richly polyvalent spaces whose meanings could "vibrate" within viewers, to borrow the words of the ninth-century theologian Johannes Scotus Erigena.[108]

ISLAMIC PARALLELS

Finbarr Barry Flood observed that the use of golden vine ornamentation as a framing mechanism was commonplace in Islamic architecture, particularly during the Mamluk period (1250–1517), when builders looked to Umayyad prototypes when designing their buildings.[109] Such models and copies, while seemingly tangential to my study, provide compelling parallels for the transfer of the golden vine from the Dome of the Rock to French churches. Foremost among the models for Mamluk builders was the Great Mosque of Damascus built by al-Walīd ibn ʿAbd al-Malik (d. 715), the immediate successor of ʿAbd al-Malik ibn Marwān, the patron of the Dome of the Rock. Flood demonstrated that the Damascene mosque influenced architecture in Egypt and the Levant from the mid-thirteenth to the mid-fourteenth century.

Although the interior ornamentation of the Great Mosque was almost entirely destroyed by fire in the late nineteenth century, some of its features have been reconstructed using visual and literary evidence. Of pivotal importance for my purposes is Flood's work on the *karma* that encircled the interior of the mosque. Sources reveal that the vine frieze was a conspicuous part of the decorative program. Citing earlier texts, the twelfth-century *Taʾrīkh madīnat dimashq* of Ibn ʿAsakir (d. 1176), the earliest source on the *karma*, reports that the vine cost an astronomical 70,000 dinars, a figure equal to one-eighth of the total cost of the building.[110] As Flood noted, the accuracy of this statement is less important than what it reveals about twelfth-century conceptions of the vine, namely that by this time, the sum was thought to be well within the realm of possibility.[111] The materials and size of the vine help explain its princely cost. Several fourteenth- and fifteenth-century sources assert that the *karma* was made of gold, while the chronicle of Muhammad ibn Muhammad ibn Saṣrā of 1389–1397 specifies that it was embellished with precious gems, including sapphires, carnelians, and pearls.[112] A pre-fire photograph shows that the frieze was approximately 60 cm wide (almost twice the width of the stucco frieze at Hagia Sophia) and that it ran above the marble paneling of the *qibla* or prayer wall directly below the mosaic zone (fig. 4.12).[113] Henri Saladin, who visited the building in 1879 before the interior was gutted by fire, described the band as "a golden rinceaux frieze of white marble set against a dark marble background."[114] Relying on a series of historic photographs, Flood convincingly argued that the band was not restricted to the southern (*qibla*) wall, as scholars had previously maintained, but that it ran around the entire building.[115]

The Damascene *karma* was a larger and more prominent part of the interior decoration of the mosque than the two golden vines inside the Dome of the Rock, yet there are clear affinities between the friezes. Like its counterparts in Jerusalem, the Damascus band was composite in form, consisting of acanthus scrolls coiling around single vine leaves, pendent grape bunches, and pomegranates. The frieze in Damascus rested on a series of engaged colonnettes, recalling

FIGURE 4.12 Great Mosque of Damascus, qibla wall before 1893

Photo: Oxford, Ashmolean Museum, Creswell Archive (EA.CA.715)

the placement of the mosaic vine above the freestanding columns supporting the arcade of the Dome of the Rock (see fig. 4.1). Further, textiles were suspended directly below the friezes in both locales.[116]

Although a frieze similar to the one in Damascus adorned the *qibla* wall of the Mosque of the Prophet in Medina, which was rebuilt by al-Walīd between 706 and 710, it was the *karma* of the Great Mosque of Damascus that captivated the attention of medieval writers and builders.[117] Literary sources from the twelfth century onward mention the vine, and copies appear in Mamluk monuments in Damascus and beyond. Exemplary in this regard are the two friezes that decorate the walls of the tomb of the Mamluk sultan Baybars I (d. 1277), which was completed in 1281 by his successor, sultan al-Mansur Sayf al-Dīn Qalāwūn. These narrow bands were modeled on the nearby vine inside the Umayyad mosque. Their position between the marble dado and the band of mosaics, as well as their gilding and scrolling form enclosing hanging grape clusters, relate closely to the *karma* inside the Great Mosque.[118] Qalāwūn was also responsible for adding a vine frieze to the *māristān* (hospital) of Nur al-Din in Damascus (1283) and for the marble band that appears on his tomb in Cairo (1295), whose octagonal form is evocative of the Dome of the Rock.[119] The Cairo tomb, which mimics the two-dimensionality and scrolling format of the Damascus *karma*, is especially interesting because it successfully references two key monuments—the Dome of the Rock and the Great Mosque—by borrowing a limited number of defining features from each building. Although the evidence is admittedly incomplete, what remains suggests that composite vine friezes were not features of Islamic buildings in the five hundred-plus years dividing the completion of the Great Mosque of Damascus and the construction of the Mamluk structures mentioned above.[120] The lure of the Damascene vine for thirteenth-century Mamluk builders, then, provides an important point of reference for this

study. Just as the Mamluks emulated the Umayyad practice of encircling monuments with vine friezes centuries after the fact, so too did French builders, who appropriated the golden vine motif from descriptions of the Temple and from the Temple itself (in the guise of the Dome of the Rock) starting in the twelfth century. That the Umayyad vines influenced architecture in both the East and West is not only indicative of their salience in their original settings, but it also speaks to their visual, semantic, and ideological appeal to builders of different faiths, across great distances, and over protracted periods of time.

THE FOLIATE FRIEZE AS GOLDEN VINE

The stone bands of foliage encircling French church interiors bear a strong conceptual relationship to the golden vines inside the Dome of the Rock, Hagia Sophia, the Great Mosque of Damascus, and other buildings, despite obvious material and stylistic disparities. Like their Islamic and Byzantine counterparts, which circumscribe spaces deemed special or holy, the friezes function as frames for the sacred, adorning the walls dividing the consecrated from the unconsecrated. Beyond their role as architectonic framing devices, the friezes in Islamic, Byzantine, and Western medieval buildings bridge the gap between exterior and interior by virtue of their basis in the vegetal realm. As I stressed earlier in this study, however, the friezes are not unmediated, unproblematic reflections of the natural world. Some are creative amalgamations of recognizable plants, whereas others comprise schematized leaves and fruit that are suggestive of organic forms, rather than mimetic representations of any real world referent. Indeed, even the most naturalistically rendered friezes are too symmetrical and regularized—their unblemished leaves too perfect—to be characterized as accurate depictions of plants.[121] Yet the vegetal friezes of France, including the almost true-to-life vine at the cathedral of Le Mans, the stylized frieze inside Amiens Cathedral, and the schematic bands in numerous twelfth-century churches, are not merely oblique allusions to grapevines (see figs. I.4–I.7, and 1.16). Given their architectural and socio-cultural contexts, and the nearby figural imagery, it is virtually impossible to read them as *anything but grapevines*.

Due to the vagaries of time, restorations, and aggressive cleaning campaigns, it is not possible to determine whether the friezes in French churches were consistently gilded in the manner of the Byzantine and Islamic examples discussed above. As I suggested in Chapter 1, it is possible that the brownish-red pigments on the frieze inside Amiens Cathedral served as underpainting for gilding or yellow pigments. This would correspond with the band of flowers inside Autun Cathedral, which occupies a similar position, serves a comparable encircling function, and bears traces of reddish brown and yellow paint (see fig. 1.11).[122] Red and yellow pigments were also discovered on the related frieze surrounding the narthex of Cluny III, which seems to have been set against a backdrop of white painted stones, making it a noticeable feature of the interior.[123] In light of the generous use of gold leaf on the portals of the west façade and south transept of Amiens Cathedral, it is possible that the interior frieze, or perhaps just sections of it, were originally gilded. To reiterate a point made earlier in this study, gold was routinely used to punctuate architectural sculptures in medieval France. In addition to Amiens Cathedral, remnants of gold leaf have been found on the portals of the cathedrals of Angers, Bourges, Paris, Reims, Rouen, and Senlis, the abbey church in Charlieu, the former priory church in Mimizan,

Notre-Dame-du-Port in Clermont-Ferrand, Notre-Dame-la-Grande in Poitiers, and Saint-Ayoul in Provins, all of which date to the twelfth and thirteenth centuries.[124] Foliate sculptures with traces of gilding from the twelfth to the fifteenth centuries reveal that despite its cost, gold was not simply reserved for depictions of holy figures (see figs. 1.8–1.10). Indeed, gold was such an integral part of church decoration that it became the target of Bernard of Clairvaux's ire: "O vanity of vanities, yet no more vain than insane! The church is resplendent in her walls and wanting in her poor. She dresses her stones in gold and lets her sons go naked."[125]

The placement of textiles directly below the friezes presents another point of contact between French churches and the Dome of the Rock, in addition to conforming to the description of the Temple by Josephus. As noted above, the curtains that screened the sacred core of the Dome of the Rock from the inner ambulatory were affixed to the arcade supports, hanging beneath the golden vine at the base of the dome's drum (see fig. 4.1). Textiles with large-scale representations of saints' lives hung in comparable positions in French churches in the Middle Ages, adorning the backs of choir stalls on high feast days. Although all extant medieval choir tapestries date to the fifteenth and early sixteenth centuries, documents suggest that such objects existed early in the history of church architecture.[126] Their juxtaposition with foliate bands would have been reminiscent of the entrance to the Temple, whose "embroidered veils with flowers of purple" stretched below the golden vine.[127] Evidence that some foliate friezes were conceived with textiles in mind can be found at the cathedral of Metz, where a fictive curtain stretches above the broad vegetal band between the triforium and clerestory, reversing the arrangement of *vela* and golden vine in the biblical temple (see fig. 1.7). The capital friezes and sculpted dado curtains framing the jamb statues at Reims Cathedral may also have been interpreted in these terms (see figs. I.9 and I.10).

Whereas interior friezes are comparable to the golden vines inside the Dome of the Rock, portal friezes adhere more closely to written descriptions of the Temple vine. Josephus and the Mishnah Middot unambiguously located the golden vine at the threshold of the Temple, specifying that it hung over the main entrance to the building, which was flanked by two interwoven pillars. Given their placement and form, it is possible that the foliate friezes that began to proliferate in the lintels and archivolts of church portals at the turn of the twelfth century were interpreted as the Temple vine (see figs. 1.25–1.27, 1.37). Jacqueline Frank and William W. Clark made a similar but more limited assertion by proposing that the twined garlands framing the royal figures in the Jesse Tree in the outermost archivolt of the central portal of Saint-Denis reference the golden vine (figs. 4.13, 4.14).[128] Supporting this thesis is the general availability of Josephus' *Antiquities* and *Jewish Wars* in the vicinity of Paris at the time Saint-Denis was under construction. Although neither text is listed in the surviving inventories of the library at Saint-Denis, the former was copied at the abbey in the ninth century and sent to Reichenau before traveling to Saint-Gall and other places, which points to a gap in the historical record, rather than a deficit in the abbey's extensive book collection.[129] To build on Frank and Clark's proposal, one might interpret the spiraling motifs decorating the jamb columns at Saint-Denis and other churches as allusions to the bronze, interwoven Temple pillars, Jachin and Booz, which are described (but not always named) in widely available texts, such as 1 Kings 7, 2 Chronicles 3, Josephus' *Antiquities*, Bede's *De templo Salomonis liber*, and Rabunus' *De universo* (fig. 4.15).[130] This interpretation does not exclude other possible readings, such John Onians's insistence that the jamb columns at Saint-Denis symbolized prophets.[131] The Solomonic traits of the portal, however, were boldly underscored by the column-statues of Old Testament royals that originally dominated the jambs, king Solomon almost certainly being foremost among these (fig. 4.16).[132]

FIGURE 4.13 Saint-Denis, west façade, central portal

Photo: author

FIGURE 4.14 Detail of 4.13

Photo: author

FIGURE 4.15 Saint-Denis, west
façade, jamb column, ca. 1130, Paris,
Musée national du Moyen Âge (RF
452–453)

Photo: author

FIGURE 4.16 Antoine Benoist, jamb statue from central portal of Saint-Denis, before 1729, from Bernard de Montfaucon, *Monuments de la monarchie française*, Paris, BnF, Ms. fr. 15634, fol. 35

Photo: BnF, Paris

The torqued columns flanking the south door of the church of Saint-Lazare at Avallon are especially arresting references to the Temple of Solomon, in particular the braided column on the right side of the portal, which strongly recalls the interwoven Temple pillars and their mesh-like capitals (see figs. 1.34, 1.35, and 4.17).[133] The fact that the twisted shafts at Saint-Lazare are monolithic may be significant in this context. Unlike columns made of coursed masonry, which might be described as composite, monoliths have a physical integrity that is comparable to bronze-cast objects, such as the Temple pillars. The expressive ability of the columns thus extends to technique as well as form. Helical and knotted columns similar to those at Saint-Lazare were common features of church portals and are generally understood to be Solomonic. Supporting this interpretation is a pair of knotted columns from the west façade of Würzburg Cathedral, whose abaci are inscribed IACHIM and BOOZ, a direct reference to the pillars flank-ing the entrance to Solomon's Temple (fig. 4.18).[134] The serpentine columns at Saint-Lazare at Avallon work in tandem with other facets of the design to lend the church a distinct Solomonic flavor. In general terms, the sheer density of ornamentation calls to mind the rich *anaglyfa* of the Temple. The forms of the carvings are more specifically Solomonic: the palmettes and rosettes in the first, third, and fourth order of archivolts relate to biblical descriptions of the flora adorning the walls and door of the Temple, whereas the entwined vines and copious grape clusters in the embrasures, jambs, and second and fifth archivolts allude to the golden vine. That the sumptuous carvings at churches like Saint-Lazare may have been perceived in Solomonic terms is confirmed by the writings of the Italian liturgist Sicard of Cremona (d. 1215), who proclaimed: "Lord, I have loved the decoration of your house and the dwelling place of your

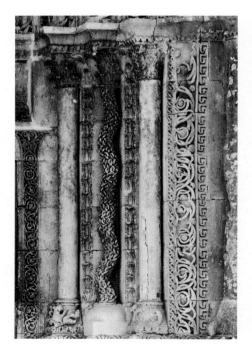

FIGURE 4.17 Saint-Lazare, Avallon, west façade, south portal, jamb

Photo: author

FIGURE 4.18 Würzburg Cathedral, columns, ca. 1230

Photo: author

glory. Churches are decorated with reliefs, pictures and sculptures in the round, which follow the example of the Tabernacle of Moses and the Temple of Solomon."[135]

CONCLUSION

Secular and clerical builders in the East and West drew on the legacy of king Solomon and his Temple in varied ways and to different ends. Referencing the golden vine was just one of many tactics patrons used to forge connections between themselves, the buildings they commissioned, and one of the most revered biblical archetypes of the Middle Ages. The overt, deliberate, and multi-pronged fashioning of Saint-Polyeuktos and Hagia Sophia in Solomonic terms accords with their status as imperial foundations and served to advance the royal pretensions of their patrons, whereas the Solomonic aspects of the Dome of the Rock presented the building as the legitimate successor and supplanter of the Temple originally located on the site. All three buildings laid ideological claims to the Temple and the Solomonic legacy, in part by incorporating golden vine friezes or vine ornamentation into their designs. The friezes that appeared in Mamluk buildings starting in the thirteenth century, which reflect the influence of the *karma* that once girded the Great Mosque of Damascus, seem to have had similar associations. More important, the transmission of the Damascene frieze to Mamluk architecture offers an instructive parallel for the transfer of the Dome of the Rock's vines to France, where the ideologically charged Temple was an equally attractive model, both formally and semantically. Incorporating the Temple vine into French church design bridged the spatio-temporal gap between biblical archetype and contemporary copy, mapping the past onto the present. For patrons associated with the French monarchy, such as abbot Suger of Saint-Denis, the Temple was a sharply politicized prototype, much as it was for the Byzantine and Muslim builders discussed above. In the case of Suger, allusions to the golden vine helped convey and reinforce connections between the abbey, the Capetian monarchy, and the biblical and royal past. More broadly, the golden vine linked churches to the first permanent house of God and served as a prime source of legitimacy, all the while proclaiming in visual terms the triumph of the True and New Temple.

Leaving portal friezes aside for a moment, there are compelling conceptual links between the foliate friezes inside French churches and the golden vines inside the Dome of the Rock. However, with the exception of the rinceau encircling the east end of Langres Cathedral, whose elegant acanthus leaves strongly recall the arcade vine of the Dome of the Rock, the friezes depart morphologically from their Umayyad precursors, reflecting instead the stylistic currents of their particular regions and periods (see figs. 1.14, 1.15, and 4.1). In all cases, though, the friezes delineate the realm of the sacred, marking the threshold between consecrated and unconsecrated spaces. In other words, French builders appropriated the functionality and resonances of the golden vine, all the while translating it into a familiar formal language. Under no circumstances are the resulting copies stylistically accurate reflections of their prototypes. More often than not, the affinities between model and copy are, to use the words of Krautheimer, "rather vague to the modern eye."[136]

The frieze from the narthex of Cluny III is a case in point. At first glance, the string of alternating flowers and fanciful creatures might seem discordant with the two composite friezes encircling the Dome of the Rock (see figs. 1.49–1.51). Yet the Cluniac band's continuous journey around the space, alongside its position directly above the main arcade and its yellow hue, firmly

connect it to the Jerusalemite model. The precise morphology of the two friezes, however, complicates any attempt at direct correlation. The blooming flowers at Cluny III evoke not the Islamic building, but the description of Solomon's temple in 1 Kings 6, which makes multiple references to reliefs of open flowers inside the building. The same can be said of the floral bands at Autun Cathedral, La Madeleine at Vézelay, and Notre-Dame of Beaune (see figs. 1.11 and 1.52–1.54). In short, the increased accessibility of the Dome of the Rock and its glittering vines during the Crusades may have driven the spread of interior foliate friezes in France, but their early form relates more closely to Old Testament descriptions of the Temple. As I argued above, the open flowers may also reflect descriptions of the Temple in the works of Josephus and the Mishnah.

Earlier in this study, I proposed that Cluny III played a role in the spread of foliate friezes in France. The inclusion of a vegetal frieze in the narthex, an unusual feature when work began on this part of the church in the early twelfth century, is consistent with the climate of experimentation at the abbey, which is also evidenced by the building's novel combination of pointed and round arches, gigantism, and precocious treatment of light.[137] Although rinceaux can be found on Roman monuments in the area, the Cluniac band seems to have been something other than the revival of a long-accessible ancient architectural component. This is borne out by the form of the frieze, which alludes to the open flowers of Solomon's Temple, by its color, which relates to the golden vines described in Josephus and the Mishnah and decorating the Dome of the Rock, and by its position and framing function, which further connect it to the Islamic Dome. Equally pertinent are the close ties between the abbey and the Levant, and the church's reliance on diverse (including distant) architectural sources. Further support for this hypothesis comes from eleventh- and twelfth-century Cluniac customaries, which refer to the narthex—the location of the frieze at Cluny III—as Galilee, the site where Christ began his ministry and appeared after his Resurrection.[138] The conception of the narthex in scriptural terms attests to the currency of biblical archetypes in Cluniac churches, lending weight to my Solomonic reading of the frieze at Cluny III and the churches within its orbit.

Historical circumstances, such as the Latin occupation of Jerusalem from 1099 to 1187 and the associated travels to and from the Holy Land, granted Western Europeans unprecedented access to some of the greatest monuments in Byzantium and the Levant. Notable among these were Hagia Sophia and the Dome of the Rock, two buildings that were well known to twelfth-century travelers and in which golden vines figure prominently.[139] Not coincidentally, the proliferation of foliate friezes in France corresponds with the increased East-West interactions that came with the Crusades. Transmission of the golden vine motif may also have occurred through the circulation of texts, notably Josephus and the Mishnah, as well as pilgrims' reports, such as the 1217 example by Master Thietmar, which mentions the Dome of the Rock's "admirable decorations."[140] It is also possible that the oral accounts of travelers played a part in disseminating the golden vine, as indicated by Suger's reference to "wonderful and incredible reports" from "very many truthful men" about the "superior ornaments of Hagia Sophia and other churches."[141] Former Christian prisoners of war retained as masons for Islamic architectural projects present another, albeit less likely, means of transmission.[142] Although many of these masons undoubtedly died in captivity, those who were exchanged or ransomed had direct knowledge of building practices in Islamic contexts and might have served as conduits for the spread of artistic ideas.[143] Since knowledge of the Temple on the part of patrons, masons, and viewers was generally indirect (mediated by texts, or more plausibly received secondhand through verbal communications), it is likely that the lack of formal affinities between the friezes inside the Dome of the Rock and those inside French churches went entirely unnoticed.

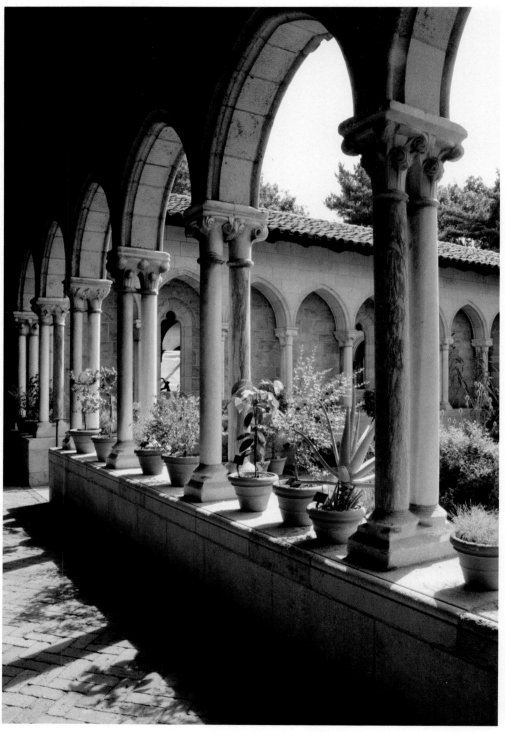

FIGURE A.1 Bonnefont Cloister, New York, Metropolitan Museum of Art, The Cloisters
Collection, late thirteenth–early fourteenth century (25.120.531–1052)

Photo: author

The Garden

AN AFTERWORD

NATURE WAS AN ESSENTIAL PART OF MEDIEVAL LIFE AND, IN ITS TAMED form, a key aspect of the medieval church. Throughout this study, I have focused on a single vegetal component—the foliate frieze—and its complex functions within church structures. Plant forms were not, however, confined to the physical fabric of buildings, nor was the relationship between the church, the garden, the vineyard, and the Temple strictly allegorical. In addition to architectonic flora and allegory, the written record attests to the use of real plants in the medieval church, which not only heightened the presence of the organic in sacred architectural contexts, but also engaged different sensory modalities.[1]

The tenth-century Romano-Germanic Pontifical, which served as the basis for the new Pontificals of the twelfth century, describes the extensive use of living vegetation in the Holy Week liturgy. The text offers no fewer than twelve prayers for blessing tree branches on Palm Sunday to commemorate the triumphal entry of Jesus into Jerusalem.[2] It was customary to start the Palm Sunday rite at a church outside city walls. The *Obsequiale Brixinense*, a fifteenth-century liturgical manuscript from Brixen in northern Italy, specifies that this was done in evocation of "the children [who] went outside the fortifications to meet the Lord coming from Bethany."[3] Palm and olive branches were placed at this location in reference to the palm fronds strewn before Christ in scriptural accounts of the entry into Jerusalem and the olive branch carried by the dove to Noah's Ark after the flood. When these plant species were unavailable, as was generally the case in non-Mediterranean regions, clerics used branches from other trees, including flowering branches.

Botanical imagery in the branch-blessing prayers recited on Palm Sunday engaged directly with these organic liturgical props:

> Almighty eternal God, Flower of the world, Fragrance of goodness, and Origin of those being born [. . .] who also made the devout multitude go forth with palm branches and mystical praises to meet him coming to Jerusalem on this day [. . .] celebrating these same [mysteries] through repeated seasons with senses purified in the truth of the confession of his name, bring you worthy homage, that flourishing with pious deeds as though with a variety of flowers, having put aside the burden of the flesh, we may be worthy to come with the fragrance of good works to the same your Son our Lord in the heavenly Jerusalem.[4]

The prayer refers openly to the celestial paradise, but the weight given to organic growth and the olfactory sense is also evocative of the Edenic garden (the sweet-smelling flower that is God, the pious deeds that are like flowers, the perfume of good works). As James Monti observed, this emphasis on vegetation in all likelihood relates to the mystical identification of Palm Sunday with the first day of the Creation, an association that appears in the writings of Honorius of Autun, who credited the sun, which was created by God on the first day, for the blossoming flowers and lush forests of the world.[5]

Beyond the blessing of the Palm Sunday foliage, the Romano-Germanic Pontifical attests to its aspersion with holy water and to its incensation with fragrant organic substances, two practices that can be traced to the tenth century.[6] The celebrant then distributed the branches to the clergy and faithful at the altar of the extramural church. The palm procession, which some-times included a crucifix adorned with flowers, began immediately thereafter. As the procession approached city gates, choirboys stationed at the top of the gates or on the church porch would sing the hymn *Gloria, laus, et honor* before spreading textiles, flowers, and branches before the crucifix or blessed sacrament.[7] The Romano-Germanic Pontifical also describes the liturgical actions at the stations of the cross, which included casting palms or branches before the crucifix in a ritual reenactment of Matthew 21:8 ("Others cut boughs from the trees, and strewed them in the way"). According to Durandus, the "green branches are thrust before the cross and on the cross to indicate that we have all the freshness of the virtues from the Crucified; for Christ was the green branch, having in himself and us by him all the freshness of the virtues."[8] The collec-tive homage of palms ended with the prostration of the celebrant, clergy, and people before the crucifix:

> And then all the people strew flowers or leafy branches on each side, the clergy singing the anti-
> phon: With the angels and the children let us be found faithful, crying out to the Conqueror of
> death: Hosanna in the highest. These things having been finished accordingly, the bishop or priest
> should come before the cross, and having prostrated himself on the ground with all the people, he
> adores the crucifix.[9]

The ritualized use of botanical elements was not restricted to Palm Sunday. The ashes for Ash Wednesday, for example, derived from the fronds or branches used in the palm procession from the preceding year. In some parts of Europe, the *Mandatum* rite, or custom of foot-washing on Holy Thursday, involved the use of a cleansing mixture of "hot water and fragrant herbs" and water infused with "flowers and fragrant herbs." A 1487 missal from Amiens specifies that palm branches be used for the Holy Thursday altar-cleansing rite.[10] Similarly, the Jáen missal of 1499 prescribes the casting down of "green foliage beneath the feet of him bearing or bringing the Body of the Lord" during the Holy Thursday Eucharistic reposition.[11] Rose garlands were also used across Europe for the feast of the Corpus Christi, which was celebrated on Holy Thursday.[12] In 1392, for instance, youths from Senlis went out on the vigil of Corpus Christi to "the gardens of the town to pick roses to make headdresses for the feast, as was customary for young men from the town."[13]

The use of vegetation in churches extended far beyond Lent. During the church consecration rite, the altar was sprinkled seven times with holy water and hyssop, a "lowly" herb emblematic of "the humility and inextinguishable love of Christ."[14] The embellishment of altars and build-ings with flowers, moreover, began early in the history of the church. In the fourth century, Paulinus of Nola recommended spreading flowers on the ground and dressing the threshold of

his church with garlands during the feast of Saint Felix.[15] Around the same period, Saint Jerome praised bishop Nepotian of Altino for decorating churches and chapels with diverse flowers and tree branches (*diversi floribus et arborum comis*).[16] As early as the seventh century, priests crowned the newly baptized with foliage after communion.[17] Furthermore, John Chrysostom (d. 407) reveals that living crowns featured prominently in marriage ceremonies: "Garlands are wont to be worn on the heads of bridegrooms, as a symbol of victory, betokening that they approach the marriage bed unconquered by pleasure."[18] Foliate crowns continued to be used in the high Middle Ages, as I noted in my discussion of the annual feast of Saint Firmin at Amiens Cathedral.

Documents from late medieval churches in England reveal that plants were a common and recurring cost for clerical communities. Expenses from 1479 from the church of Saint-Mary-at-Hill in London include 4s.7d. for "flags, garlands, and torches."[19] The accounts from 1487 show that the same community spent 8½d. for two and a half dozen rose garlands to celebrate Saint Barnabas Day, 3d. on birch boughs for Midsummer Day, and 8d. on palms, flowers, a box, and obleyes (offerings) for Palm Sunday. The expenses for 1490 and 1493 include woodruff garlands for Corpus Christi and rushes "for the new pews." In 1519–1520, the wardens purchased three dozen garlands for the Corpus Christi procession, two dozen green garlands, garlands for the three crosses, a branch of three flowers to place "before the Trinity," and a branch of hawthorn to adorn the tabernacle of Our Lady of the Assumption.[20]

The pungent flowers and verdant leaves bedecking liturgical furnishings, portals, chapels, seats, and floors, as well as the clergy and the faithful, contributed to the headiness of the church experience from its beginnings. The developments that transpired in France over the course of the twelfth century, however, saw nature play a more prominent role in the church than ever before. With the marked increase in monumental flora in exterior and interior architectural design, the organic world not only became a more conspicuous, but also a more permanent fixture of the church. Amid this everlasting vegetation, the foliate frieze stands as an unusually pervasive and resonant motif, operating in tandem with figural sculptures, other botanical imagery, the liturgy, real plants, and the knowledge, memories, and expectations of viewers to inflect the stratified spaces of the church in myriad ways. Given the importance of the seasons, the climate, and agriculture to their lifeworld, medieval beholders could not have failed to notice the rapid encroachment of natural forms in and on their churches. Recognizing the centrality of nature in medieval life lets nature reassert its presence in the medieval church, allowing us marvel, like our predecessors, at the splendor of the garden within.

Notes

INTRODUCTION

1. Key texts on the symbolism of the medieval church include Stookey, "Gothic Cathedral"; von Simson, *Gothic Cathedral*; Bandmann, *Mittelalterliche Architektur*; Panofsky and Panofsky-Soergel, eds., *Abbot Suger*; and Sauer, *Symbolik des Kirchengebäudes*. Sedlmayr's interpretation of the Gothic cathedral as a literal representation of the Heavenly Jerusalem in *Entstehung der Kathedrale*, while problematic, will be addressed in Chapter 2.
2. Although Reims Cathedral does not have an interior frieze, fragments discovered during excavations reveal that a foliate band probably adorned the mid-twelfth-century sections of the building, which were added to the Carolingian structure. See Prache, *Saint-Rémi*, 96; and Reinhardt, *Cathédrale de Reims*, 56–60.
3. Carruthers, *Experience of Beauty*, esp. Chapters 5 and 6.
4. Foliate friezes are mentioned briefly in Jalabert, *Flore sculptée*, and "Flore gothique"; Behling, *Pflanzenwelt*; and Lasteyrie, *L'architecture religieuse*, 593–604. Although Lambin (*Flore gothique*) makes no mention of foliate friezes, he does attend to depictions of grapevines in twelfth-century French architecture and traces the stylistic development of the motif.
5. Jalabert presented the thirteenth-century emergence of naturalistic foliage as a French phenomenon that began in the Île-de-France and later spread to other areas. More recently, scholars have contextualized Jalabert's findings by associating the development of naturalistic foliage in mid-thirteenth-century French architecture with contemporary scientific writings, notably those of Albertus Magnus. See Cohen and Dectot, *Paris*, 70–83.
6. Schlink, *Cluny und Clairvaux*, 59; Sandron, *Amiens*, 52–53.
7. On the last issue, see Givens, *Observation*, 5.
8. I am drawing specifically on Pierre Bourdieu's definition of the habitus as sets of dispositions (durable and acquired schemes of perception, thought, and action) determined in large part by upbringing and education, which is more inclusive than Marcel Mauss' definition, which focuses primarily on actions and the body. See Bourdieu, *Distinction*, 169–75.
9. Murray, *Notre-Dame, Cathedral of Amiens*, 8, 29, 46–47, 115, 197, note 22. Murray repeated his thesis in subsequent publications, such as *Gothic Sermon*, 43–44, and *Plotting Gothic*, 148.
10. Murray broadened his interpretation of natural forms in architectural contexts in a later study, suggesting that "forms of nature were put into the cathedral for a range of reasons: to refer both to Eden and to Paradise and to the living cross upon which Christ died; to convey legitimacy; to induce a sense of becoming or transformation; to create a sense of local identity, of the passage of

time, of hereness and nowness as well as the sublime." His interpretation of the band of foliage at Amiens Cathedral, however, remained unchanged. See Murray, *Plotting Gothic*, 148.

11. Foot, "Plenty, Portents and Plague."
12. Duby, *L'économie rurale*; Slicher van Bath, *Agrarian History*; Bloch, *Les caractères*.
13. Evans-Pritchard, *Nuer*. Also see Gell, *Anthropology of Time*, 17; and Trachtenberg, *Building-in-Time*, 25–40.
14. Henisch, *Medieval Calendar*.
15. That is not to say, of course, that these kinds of images were transparent, unproblematic representations of rural life. On the ideological functions of calendar scenes, see Alexander, "*Labeur* and *Paresse*"; and Camille, "Très Riches Heures."
16. Ambrosoli, *The Wild and the Sown*; Oschinsky, *Walter of Henley*; Calkins, "Piero de' Crescenzi"; Richter, "Überlieferung"; and Alfonsi, *Pier de' Crescenzi*.
17. The themes of nature, fertility, procreation, and love appear in many medieval texts, including the *Roman de la Rose*, Bernardus Silvestris *Cosmographia*, and Alan of Lille's *De planctu naturae*, all of which will be discussed in Chapter 2. On nature, science, and herbals, see Givens, "Reading and Writing"; Collins, *Medieval Herbals*; and Anderson, *Illustrated History*.
18. On the changing cultural and historical meanings of the word "nature," see Cronon, ed., *Uncommon Ground*; and Collingwood, *Idea of Nature*. On the medieval conception of nature as part of the "order of creation," see Ritchey, "Discovery of Nature," 225.
19. This issue will be discussed in greater detail in the Afterword.
20. On the history of the Corinthian order, see Onians, *Bearers of Meaning*.
21. Chenu, "L'homme et la nature"; Epstein, *Medieval Discovery*. For other recent perspectives on the matter, see Speer, "Discovery of Nature," and *Die entdeckte Natur*.
22. For a critique of Chenu's thesis, see Ritchey, "Discovery of Nature."
23. *Astwerk* was one of two main trends in fifteenth-century European architecture. The other was the move towards greater geometric clarity and regularization. See Nussbaum, *Deutsche Kirchenbaukunst*, esp. 287ff.
24. For an orientation to this architecture in the north, see Kavaler, *Renaissance Gothic*, esp. 211–220, and "Nature and the Chapel Vaults." Also see Günther, "Astwerk." For recent studies of *Astwerk* outside Northern Europe, see Hamon, "Le naturalisme"; and Pereda, "Shelter." Other key studies of Late Gothic architecture include Büchner, "Ast-, Laub- und Masswerkgewölbe"; Braun-Reichenbacher, *Ast- und Laubwerk*; and Oettinger, "Laube, Garten und Wald."
25. Crossley argued that fourteenth-century French court art provides the closest parallels for the Late Gothic churches of Germany, citing the bedroom of Pope Clement VI in the papal palace in Avignon (1342–52) and the arbor gallery in Charles V's now destroyed Hôtel de Saint-Pol in Paris (begun 1361) to support his claim. See Crossley, "Return to the Forest," 71. Others have traced the origins of the trend to early-fifteenth-century French buildings (most of them secular). See, for instance, Braun-Reichenbacher, *Ast- und Laubwerk*, 3–17.
26. Kavaler recognized the importance of foliage in high medieval French church design, but he argued that its confinement to specific fields made it fundamentally different from the foliage in Late Gothic buildings. See Kavaler, "Nature," 236–37.
27. On the controversies surrounding the identity of the Pseudo-Raphael, see Vogel, *Bramante und Raffael*. The full report is published in Golzio, *Raffaello*. Also see Frankl, *The Gothic*, 272–74.
28. Goethe, "Deutscher Baukunst," 93–104.
29. My translation. Châteaubriand, *Génie*, 293.
30. My translation. Châteaubriand, *Génie*, 293–94.
31. Schlegel, "Grundzüge der gotischen Baukunst," 260ff.
32. For a succinct analysis of the various approaches to Gothic architecture, see Trachtenberg, "Desedimenting Time," 19ff. For a formalist perspective, see Bony, *French Gothic Architecture*, 17–21.
33. Crossley, "Return to the Forest," 71; Frankl, *Gothic Architecture*, 163.
34. Crossley, "Return to the Forest," 71.
35. For a recent summary of the scholarship, see Givens, *Observation*, 5–36.
36. See note 1 above.

37. Eusebius, *Life of Constantine*, 3.38. Suger compared the twelve columns in the choir to apostles and the twelve ambulatory supports to minor prophets. See Panofsky, *Abbot Suger*, 104–105.
38. Durandus, *Rationale*, 1.15–27.
39. Bandmann, *Mittelalterliche Architektur*.
40. Crossley, "Medieval Architecture and Meaning." The emphasis on the role of the patron in medieval architectural design is notably apparent in Panofsky's analysis of Suger and Saint-Denis. See Panofsky, *Abbot Suger*. For a rebuttal of Panofsky's argument, see Kidson, "Panofsky."
41. Crossley, "Medieval Architecture and Meaning," 117.
42. Krautheimer, "Introduction," and "Carolingian Revival."
43. Krautheimer, "Introduction," 21–33.
44. Krautheimer, "Introduction," 1969, 149. Unless otherwise noted, all citations will refer to the 1942 article.
45. Many scholars have employed Krautheimer's approach. See, for instance, Trachtenberg, "Architecture and Music"; Flood, "Umayyad Survivals"; and Gem, "Towards an Iconography." On the intellectual milieu out of which Krautheimer's theory emerged, see McCurrach, "Renovatio."
46. See note 24 above. I was unable to consult the unpublished dissertation by Bryda, *Tree, Vine, Herb*, which focuses on the symbolism and real-life referents of Late Gothic *Astwerk* in architecture and altarpieces.
47. Crossley, "Return to the Forest," 72; and Kavaler, "Nature," 211–220.
48. Fehr, "Architektur," 202–16. Also see Feuchtmüller and Ulm, "Architektur," 217–34.
49. Binski, *Becket's Crown*, 87–101.
50. For example, the *Liber Eliensis*, which extends the earliest hagiography of Etheldreda by the Venerable Bede, recounts a miraculous event in the life of the saint involving a flowering staff. See Binski, *Becket's Crown*, 93.
51. Flood, *Great Mosque*, and "Umayyad Survivals."
52. I am grateful to Marvin Trachtenberg for relaying this information, which Flood originally communicated to him via email.
53. Flood, "Umayyad Survivals."
54. *Encyclopedia of World Art*, vol. 10, 831. Also quoted in Grabar, *Mediation*, 25.
55. Sankovitch, "Structure/Ornament."
56. Grabar, *Mediation*, esp. Chapter 1.
57. Dale, *Relics*, esp. Chapter 8, and "Vers une iconologie." Also see Castriota, *Ara Pacis*; Robinson, "Towers"; Mackie, "Abstract and Vegetal Design"; and Folda, "Problems," 15–18.
58. Jones in *The Grammar of Ornament*, 33 defined ornament as "meaningless, purely decorative, never representational."
59. Travis, "Iconography," 240.
60. Kitzinger, "Interlace and icons," 3.
61. Ambrose, *Nave Sculpture*, 65.
62. Riegl, *Problems*; Bonne, "De l'ornement à l'ornementalité," "Les ornements," and "De l'ornement dans l'art médiéval." Also see Crowther, "More than Ornament"; Schneider, "Les signes"; Grünbaum and Shephard, "Interlace Patterns"; Trilling, *Ornament* and *The Language of Ornament*; and Kavaler, "Renaissance Gothic in the Netherlands," and *Renaissance Gothic*, 47–113.
63. Gombrich, *Sense of Order*, and *Art and Illusion*.
64. Quoted in Webb and Walker, trans., *St. Bernard*, 42. *Quidquid in Scripturis valet, quidquid in eis spiritualiter sentit, maxime in silvis et in agris meditando et orando se confitetur accepisse et hoc nullos aliquando se magistros habuisse nisi quercos et fagos joco illo suo gratioso inter amicos dicere solet* (Migne, *PL* 185, col. 240).
65. Quoted in Bredero, *Bernard of Clairvaux*, 125. *Experto crede: aliquid amplius invenies in silvis, quam in libris. Ligna et lapides docebunt te quod a magistris audire non possis. An non putas posse te sugere mel de petra, oleumque de saxo durissimo?*

CHAPTER 1

1. "Comme une figure sur un fond." My translation from Derrida, "Parergon," 71. For more recent perspectives on frames and framing, see Wolf and Bernhart, ed., *Framing Borders*; and Lebensztejn, "Frame." On frame/field relations, also see Cavell, *The World Viewed*, 23–24.
2. To be clear, the church exterior, which includes the foliate friezes under consideration, is a literal not a metaphorical frame.
3. Rodowick, "Impure Mimesis," 104–105.
4. Focillon, *L'art des sculpteurs*; Baltrušaitis, *La stylistique ornementale*. For a critical examination of Baltrušaitis' thesis, see Schapiro, "Über den Schematismus."
5. For a recent study church architecture from a multisensory perspective, see Jessen and Sørensen, "Embodiment and the Senses."
6. Gombrich, *Sense of Order*, 156.
7. Andrieu, *Pontifical romain*, vol. 1, 176–95; Bowen, "Tropology"; Jounel, "Dedication," vol. 1, 215ff.; and Schloeder, *Architecture*, 170–73.
8. Hugh of Saint-Victor, *De sacramentis*, 2:5; Durandus, *Rationale*, 6. Also see Hayes, *Sacred Place*, 11–17; and Muncey, *Consecration*, 41–47.
9. Medieval thinkers interpreted the sacredness of the church fabric in a variety of ways. For Durandus, the act of consecration appropriated the material church to God: *consecratio . . . ipsam ecclesiam materialem Deo appropriate.* Durandus, *Rationale*, 6.9. By contrast, Bernard of Clairvaux believed that the stones were sacred because of the human presence within the buildings: "In what respect, however, were the stones able to have sanctity so that we celebrate their solemnity? They certainly have sanctity, but on account of our bodies." *Quid enim lapides isti potuerunt sanctitatis habere ut eorum solemnia celebremus? Habent utique sanctitatem, sed propter corpora vestra.* Sancti Bernardi, *In Dedicatione Ecclesiae*, sermon 1 (Migne, *PL* 183, col. 518–19).
10. The only exceptions were stones damaged by fire, which could be reused in monasteries: *Ligna ecclesiae dedicatae non debent ad aliud opus iungi, nisi ad aliam ecclesiam, uel igni conburenda, uel ad profectum in monasterio fratibus; in laicorum opera non debent admitti.* Decretum Gratiani, Distincto 1, C.38, in Gratian, *Corpus juris canonici*, 1138. A statute from 1289 specifies that stone fit into this category, as well as clerical vestments and ornaments: *Ligna seu lapides ecclesiarum in aliis usibus non ponantur, nisi in aedificatione & reparatione alterius ecclesiae, vel hospitalis, seu in claustra dormitorii, vel in c[l]austra coemeterii, seu alio honesto aedificio ad opus clericorum ecclesiis servientium deputato. In laicorum autem aedificiis seu usibus non ponantur, & idem observetur, de vestimentis, cortinis, & aliis ornamentis ecclesiasticis.* Quoted in "Statuta Synodalia Cadurcensis, Ruthenensis, et Tutelensis Ecclesiarum," in Mansi, *Sacrorum Conciliorum Nova*, vol. 24, col. 1019. Also see Hayes, *Sacred Place*, 115–16, note 60.
11. The literature on Suger and Saint-Denis is extensive. Key studies include Grant, *Abbot Suger*; Clark, "The Recollection of the Past"; Rudolph, *Artistic Change*; Blum, *Early Gothic*; Crosby, *Royal Abbey*; Lieber Gerson, ed., *Abbot Suger*; Kidson, "Panofsky"; and Panofsky, *Abbot Suger*. On the hierurgy of stone, see Crow, "Sacred Stones."
12. My emphasis. Quoted in Panofsky, *Abbot Suger*, 101.
13. For an alternative interpretation, which emphasizes Suger's desire to justify the "radical modernity" of the project, see Trachtenberg, "Suger's Miracles."
14. My emphasis. Quoted in Panofsky, *Abbot Suger*, 105.
15. Crow, "Sacred Stones," 64–65.
16. Clark, "Reading Reims."
17. Recent scholarship has challenged the notion of a strict division between the sacred and profane, a polarity advanced by Durkheim and Eliade. See, for instance, the essays in Spicer and Hamilton, eds., *Defining the Holy*. Also see the essays in Gerstel, ed., *Thresholds*.
18. Pevsner, *Leaves*, 11.
19. Pevsner, *Leaves*, 18.

20. *Nam testudo riget sursum pariesque deorsum, Non putrescibili ligno, sed perpete saxo.* Quoted in Aniel, *Maisons*, 30.

21. Gilbert, *Description historique*; Baron, *Description*; Durand, *Monographie*; Lefrançois-Pillion, *Cathédrale d'Amiens*; Erlande-Brandenburg, *Cathédrale d'Amiens*; Murray, *Notre-Dame, Cathedral of Amiens*; Egger, *Amiens*; Sandron, *Amiens*.

22. The surveys include Wilson, *Gothic Cathedral*, 92–119; Kimpel and Suckale, *Gotische Architektur*, 11–64; Grodecki, *Gothic Architecture*, 63–66; Bony, *French Gothic Architecture*, 275–81, 361–65; and Frankl, *Gothic Architecture*, 119ff. The cathedral also features in Jantzen, *High Gothic*, 44–45, 57–60, 112–13, 131–34, 146–48.

23. Murray, "Robert de Luzarches"; Murray and Addiss, "Plan and Space"; Bork, Mark, and Murray, "Openwork Flying Buttresses"; Kimpel, "Développement"; Murray, *Gothic Sermon*; Katzenellenbogen, "Prophets"; Frachon-Gielarek, *Amiens*; Sandron, "Deux chapelles"; and Doquang, "Status and the Soul."

24. The total interior length of Amiens Cathedral is 133.5 meters. The interior length of the transept is 62 meters.

25. Murray's analysis is unique in that he stressed the ability of the frieze to carry meaning. He also addressed stylistic issues, attributing the nave frieze to Robert de Luzarches, the frieze on the terminal walls and east side of the transept to Thomas de Cormont, and the choir frieze to Renaud de Cormont. Murray, *Notre-Dame, Cathedral of Amiens*, 8, 29, 46–47, 115, 197, note 22, *Gothic Sermon*, 43–44, and *Plotting Gothic*, 148. Baron and Erlande-Brandenburg each devoted a single sentence to the frieze in their monographs on the cathedral. See Baron, *Description*, 96; and Erlande-Brandenburg, *Cathédrale d'Amiens*, 16. The frieze is described briefly by Gilbert, *Description*, 109–10. While short, Lefrançois-Pillion describes the frieze in positive terms, characterizing it as a "magisterial example of Gothic flora." See Lefrançois-Pillion, *Cathédrale d'Amiens*, 11. Durand's description is longer, but consists largely of a formal analysis and a summary of Viollet-le-Duc's changing opinion of the frieze. See Durand, *Monographie*, vol. 1, 232–34. Sandron linked the frieze to the earlier foliate bands at Soissons Cathedral and Saint-Rémi at Reims. See Sandron, *Amiens*, 52–53.

26. The frieze's horizontal emphasis has been described as a remnant of Romanesque tendencies. See Viollet-le-Duc, *Dictionnaire*, 107.

27. On this cathedral, see Villes, "Cathédrale de Metz"; and Brachmann, "Saint-Étienne de Metz."

28. Davson, ed., *The Eye*.

29. On the widespread antipathy towards polychromy in France starting during the Protestant Reformation, see Pastoureau, "La Réforme." Researchers determined that the west façade sculptures were only repainted once after the original campaign, save the trumeau figures, which were painted numerous times over the centuries. On the polychromy at Amiens Cathedral, see the final four essays in Verret and Steyaert, ed., *Couleur*, 207–58. For a recent summary of the scholarship on the poychromy of Gothic churches, see Victoir, "La polychromie." Also see Vuillemard-Jenn, "La polychromie des façades gothiques," and "La polychromie des cathédrales gothiques."

30. Victoir, "Nature in Architecture," 73–75.

31. The gold leaf on the façade of Amiens lay on base layers of white lead, red ochre, and vermillion. See Zambon, Grunenwald, and Hugon, "Polychromie."

32. These buildings are Amiens Cathedral, Angers Cathedral, Bourges Cathedral, the abbey church at Charlieu, the church of Notre-Dame-du-Port in Clermont-Ferrand, the former church at Mimizan, Notre-Dame of Paris, Notre-Dame-la-Grande in Poitiers, Saint-Ayoul in Provins, Reims Cathedral, Rouen Cathedral, and Senlis Cathedral. See Pallot-Frossard, "Polychromie," 73–90.

33. Leniaud, "Sainte Chapelle," 333–59.

34. On the capital at Chalon-sur-Saône Cathedral, see Angheben, *Chapiteaux*, 474–75. On the attribution of the pair of capitals in the Musée national du Moyen Âge to the dismantled jubé at Chartres Cathedral, see Pingeot, *Sculpture décorative*, 102–106; and Baron, "Tombeau de Charles V," 253–56. On the capital from the north transept of Notre-Dame, see Erlande-Brandenburg and Thibaudat, *Sculptures de Notre-Dame*, n. 265; and Erlande-Brandenburg and Kimpel, "Statuaire de Notre-Dame," 230.

35. On the painted frieze at Autun Cathedral, see Rollier-Hanselmann and Castandet, "Couleurs et Dorures," 245–46.
36. Michler, "Farbfassung," 29–64; Egger, *Amiens*, 131; and Sandron, *Amiens*, 86–88. Restorers working under the Services de l'État en charge des monuments historiques of France have recreated the grey and white scheme at Chartres Cathedral. Several Romanesque churches in Burgundy, including the priory church at Paray-le-Monial, have also been restored in this manner. For a critique of this aggressive restoration approach, see Armi, "Destruction," 300–27.
37. Kimpel and Suckale stressed the geometric treatment of the vegetation at Amiens Cathedral. Despite the abstraction, the frieze differs significantly from the lucid geometric forms that dominate the interior of the building. See Kimpel and Suckale, *Gotische Architektur*, 59.
38. Jalabert (*Flore sculptée*, 100) identified the species as watercress, but the fruit clusters invalidate this argument. Murray accepted Jalabert's thesis, but noted that the fruit bunches resemble grapes. See Murray, *Notre-Dame, Cathedral of Amiens*, 8, 46.
39. There is only one exception: a seam bisects a grape cluster on the east side of the north transept. The other half of this cluster is missing.
40. This observation was made by Murray, *Notre-Dame, Cathedral of Amiens*, 46–47, 115; and repeated by Givens, *Observation*, 113–14.
41. Mussat, *Cathédrale du Mans*, 138.
42. Camille, *Image on the Edge*. The literature on marginalia is extensive. Key contributions include Freeman Sandler, "Bawdy Betrothal," 154–59, and "Hybrids," 51–65; Randall, *Images in the Margins*, "Gothic Marginal Warfare," and "Exempla."
43. On the stylistic development of sculpted foliage in medieval France, see Viollet-le-Duc, *Dictionnaire*, vol. 5, 485–524; Lambin; *Flore des grandes cathédrales*, and *Flore gothique*; Jalabert, *Flore sculptée*, and "La flore gothique." For a pan-European perspective, see Behling, *Pflanzenwelt*. For a summary of the scholarship on naturalism in Gothic art, see Givens, *Observation*, 5–36.
44. A number of twelfth-century buildings in the area had foliate friezes. Fragments of a frieze were discovered during excavations of the Gothic cathedral of Reims, which likely belonged to the earlier building on the site. A frieze also adorned the Romanesque abbey church of Saint-Thierry located a few kilometers north of Reims. See Reinhardt, *Cathédrale*, 56–60; and Prache, *Saint-Rémi*, 96. Also see Prache, "Saint-Rémi de Reims," 104–21, and *Notre-Dame-en-Vaux*; Corsepius, *Notre-Dame-en-Vaux*; and Clark, "Original Design," 67–75.
45. On the date of the choir of Langres Cathedral, see Schlink, *Cluny und Clairvaux*, 70–75.
46. The choir and transept friezes of Le Mans Cathedral differ stylistically. The thirteenth-century choir frieze is rigid and schematized, whereas the frieze in the transept, built in the 1470s, is clearly a grapevine. The Romanesque nave does not have a foliate frieze. See Bouttier, "Chevet de la cathédrale du Mans," and *Cathédrale du Mans*; Salet, "Cathédrale du Mans"; Fleury, *Cathédrale du Mans*; and Mussat, *Cathédrale du Mans*.
47. Pevsner, *Leaves*, 18–20.
48. Some craftsmen may have based their foliate designs on direct observation, while others may have worked from artistic models. See Givens, *Observation*, 134ff. A third and likely alternative is that craftsmen combined direct observation with artistry. See Jung, "Review," 327.
49. The church of Notre-Dame at Moret-sur-Loing has a complex building history. A foliate frieze appears in the nave, which dates to the second half of the thirteenth century. See Tribhout, *Moret-sur-Loing*; and Bellanger, *Moret-sur-Loing*. On Saint-Rémi at Reims and Notre-Dame-en-Vaux at Châlons-en-Champagne, see note 44 above. The choir of the church of Notre-Dame-Saint-Laurent at Eu, which has three foliate friezes, was originally built between 1186 and 1226. Major changes were made to the choir after a fire in 1426. On this building, see Coutan, "Notre-Dame-et-Saint-Laurent: Eu"; and Legris, *L'Église d'Eu*. The choir of Saint-Jacques at Dieppe, which has two foliate friezes, was originally built in the first half of the thirteenth century, but it was renovated in the second half of the fifteenth century. The nave has a single frieze at the level of the clerestory. See Bottineau-Fuchs, *Haute-Normandie*, 126–39; Cochet, *Dieppe*; Deshoulières, *Dieppe*; and Legris, *Saint-Jacques de Dieppe*. The nave of Saint-Maclou in Rouen has two foliate friezes, whereas the choir has three. See Neagley, *Disciplined Exuberance*. On

the friezes in the Norman churches, also see Grant, *Architecture and Society*, 82–84, 168–74, 186–92.

50. For a gendered reading of church spaces, see Schleif, "Men on the Right."

51. On the foliage at Langres Cathedral, see Schlink, *Cluny und Clairvaux*, 53–63.

52. Kimpel and Suckale outlined their theory in the opening chapter of their book, which focuses on Amiens Cathedral. Their interpretation departs from earlier explanatory models, which presented the differences between the eastern and western sections of the building as the outcome of stylistic evolution or as evidence of personnel changes. See Kimpel and Suckale, *Gotische Architektur*, 11–64.

53. On the dating of the building, see Caviness, *Royal Abbeys*, 65–97, and "Saint-Yved." Also see Steger, "Braine."

54. The church was used briefly as a parish church after the monastery was dissolved during the Revolution. An engraving by Adrien Dauzats (after a drawing by Jean-Lubin Vauzelle) reveals that the nave was in ruins by ca. 1830. The materials were used as fill in 1832. See Caviness, "Saint-Yved," 525–26, note 4, 528, note 15, 542. Also see Lefèvre-Pontalis, *Saint-Yved*, who provides the destruction date of 1832.

55. On this portal, see McClain, "Saint-Yved."

56. The building was restored by Viollet-le-Duc. Pre-restoration engravings of the friezes are published in King and Hill, *Études pratiques*, vol. 1, pl. IV, figs. 9, 9b, 10.

57. Caviness, "Saint-Yved," 542–43.

58. Among the properties under Saint-Yved's control were lands donated in 1158 by the count and countess of Dreux, Robert and Agnes, as well as fourteen *séterées* of arable land and a vineyard at nearby Couvrelles. The latter two were gifted to the abbey by the dean of the chapter of Saint-Pierre-au-Parvis in Soissons between 1190 and 1203, just as Saint-Yved was nearing completion. On the gifts by the count and countess of Dreux, see Paris, AN, LL 1583, n. 49, pp. 88–89, and n. 112, p. 143. The original charter of 1158 is in Laon, Archives départementales de l'Aisne, H 1017. On the lands given to the abbey by the dean of the chapter of Saint-Pierre-au-Parvis in Soissons, see Paris, AN, LL 1583, n. C, p. 129. Also see Guyotjeannin, ed., *Chartrier*, 240.

59. Recent studies of this building include Clark, *Laon Cathedral*; and Saint-Denis, *Laon*.

60. No documents related to the fourteenth-century work on the south transept façade survive. It is possible that a lightening strike in 1343 spurred the reconstruction. See Schlicht, *Rouen vers 1300*, 125, note 66.

61. The association of Christ with the portal stems from John 10:9: "I am the door: by me if any man enter in, he shall be saved."

62. Similarities with the Cluny III choir capitals suggest that the Anzy-le-Duc façade sculptures date to the early twelfth century. Most of the archivolt foliage dates to the 1941–1944 restoration campaigns. The files pertaining to this work have been lost, but pre-restoration photographs confirm that the modern design replicates the medieval one. See Stamatis Pendergast, "Anzy-le-Duc," 141, note 3.

63. Olson, *Ornamental Colonnettes*, 99–107.

64. On this portal, see Erlande-Brandenburg, "Porte du cimetière."

65. The third portal, which opened onto the north tower, was lost when the tower collapsed in 1633. The façade was heavily restored between 1833 and 1835. See Stürmer, *Saint-Lazare zu Avallon*; Recht, "Saint-Lazare d'Avallon"; Vallery-Radot, "L'iconographie"; and Baudoin, "Monographie."

66. The façade was probably built between 1225 and 1240. See Murray, *Notre-Dame, Cathedral of Amiens*, 87–102. For an alternative account, which dates the beginning of construction to ca. 1236, see Erlande-Brandenburg, "La façade."

67. On the west façade sculptures, see Sauerländer, "Antiqui et Moderni"; Feldmann, *Bamberg und Reims*; Kurmann, *Façade de la cathédrale de Reims*; Hinkle, *Portal of the Saints*; and Lefrançois-Pillion, *Sculpteurs de Reims*. On the use of textiles in churches during Lent and their possible meanings, see Dale, *Relics, Prayer, and Politics*, Chapter 7.

68. For a recent study of the retrofaçade foliage, see Sadler, *Reverse Façade*, 171–73.

69. Randall, *Images in the Margins*, 8.

70. The Rutland Psalter of ca. 1260 has been cited as one of the earliest fully developed examples of marginalia. See Camille, *Image on the Edge*, 22.
71. Randall, *Images in the Margins*, 9–10.
72. Camille, *Image on the Edge*, Chapters 2 and 3.
73. Alexander, "Iconography and Ideology," 4–5.
74. Alexander, "Iconography and Ideology," 5.
75. Bonne, "Les ornements."
76. Bonne, "Les ornements," 49, and "De l'ornement à l'ornementalité," 104.
77. On the dismantling of Cluny III between 1809 and 1823, see Marguery-Melin, *Destruction de l'abbaye*.
78. The bibliography on the architecture of Cluny III is vast. For an orientation to the building, see Stratford, ed., *Cluny, 910–2010*; Baud, *Cluny*; Armi, *Masons and Sculptors*, 22–23 and Appendix 4; Salet, "Cluny III"; Conant, *Églises et la maison du chef d'ordre*, and *Carolingian and Romanesque Architecture*, 107–25; and Evans, *Romanesque Architecture*. On the documents related to Cluny III, see Stratford, "Documentary Evidence."
79. Stratford, "Grand portail," 15–18.
80. The dating of the narthex of Cluny III has been controversial. In an early publication, Conant dated the inception of work between 1118 and 1125. He further posited that the narthex was completed by around 1147. See Conant, "The Third Church," vol. 2, 332–33. In a later publication, Conant provided a more specific date, suggesting that work began ca. 1122 with the two easternmost bays, but that the remaining bays were not completed until 1220–1225. See Conant, *Carolingian and Romanesque Architecture*, 122. Branner argued that the narthex was initially designed around 1125. This early design was partially executed in the eastern bays of the narthex, which has a tripartite elevation similar to the nave. The fourth part of the elevation was created when the rib vaults were built around 1170. According to Branner, the westernmost nave bays were constructed around 1180–1185. See Branner, *Burgundian Gothic*, 130. Branner's conclusions were largely accepted by Schlink, *Cluny und Clairvaux*, 97.
81. On Autun Cathedral, see Sapin and Berry, *Naissance*; Seidel, *Legends in Limestone*; and Terret, *Saint-Lazare d'Autun*. Work began on the priory church of Paray-le-Monial around 1120 with the construction of the choir. See Armi, "Context of the Nave Elevation," 323, and *Masons and Sculptors*, 171–76. Also see Minott Kerr, *Cluniac Priory Church*, 130–44. For an alternative account, which dates the beginning of work to ca. 1100, see Sapin et al., *Bourgogne romane*, 30; and Barnoud et al., *Paray-le-Monial*, 137–42, 146. Work on the church of Notre-Dame at La-Charité-sur-Loire began ca. 1059, about three decades before Abbot Hugh initiated work on Cluny III. The east end of the building predates Cluny III, but the nave, begun around the same time as Cluny III, reflects the influence of the motherhouse. See Suter-Raeber, *La Charité-sur-Loire*; Hilberry, "La Charité-sur-Loire"; Anfray, *L'architecture religieuse*, 62–98; Beaussart, *La Charité-sur-Loire*, 13–31; Serbat, "La Charité-sur-Loire." Other Cluny-related buildings include the cathedrals of Langres and Chalon-sur-Saône and the churches at Beaune, Saulieu, and Semur-en-Brionnais. On the so-called Cluny School of architecture, see Conant, *Carolingian and Romanesque Architecture*, 107–25; Schlink, *Cluny und Clairvaux*; and Minott Kerr, *Cluniac Priory Church*, 150–56.
82. For a recent study of the design of the nave of Cluny III, see Armi, "Context of the Nave Elevation." On the foliate capitals of the south transept, see Armi, *Masons and Sculptors*, 165–66.
83. Minott Kerr characterized the pattern as egg-and-dart, but the orientation of the "egg" is incorrect and the lines are too sinuous to support this theory. See Minott Kerr, *Former Cluniac Priory Church*, 131.
84. Stratford, "Grand portail," 15–18; Rollier, "Fouilles archéologiques," 16–20.
85. Armi, "Context of the Nave Elevation," 321
86. Armi, "Context of the Nave Elevation," 338–39.
87. On the links between Cluny, Old Saint Peter's, and the city of Rome, see Constable, *Abbey of Cluny*, 19–41; Stalley, *Early Medieval Architecture*, 169–70; and Baud, *Cluny*, 172. On the intolerant Cluniac worldview as the third church was under construction, see Iogna-Prat, *Order and Exclusion*.

88. The vision appears in Gilo, *Vita sancti Hugonis abbatis*, which was written by Gilo shortly after Hugh's death. On this episode in the history of Cluny, see Carty, "Gunzo's Dream," 113–23.

89. Galterius, *Vita sancti Anastasii* (Migne, *PL* 149, col. 425–32). Baudot and Chaussin, *Vies des saints*, vol. 10, 519–23; Bruel and Bernard, *Chartes de l'abbaye de Cluny*, vol. 4, 123–24, n. 2922, 254, n. 3071. Also see Constable, *Abbey of Cluny*, 198–200, and "Three Lives of Odo Arpinus," 191–92.

90. On the relationship between Cluny and Jerusalem, see Constable, *Abbey of Cluny*, 30.

91. Demus, *Byzantine Art*, 112–18.

92. Constable, *Abbey of Cluny*, 197.

93. Quoted in Conant, *Carolingian and Romanesque Architecture*, 116.

94. The extent of Cluny's influence on the architecture of its subject houses has been called into question, but objections focus primarily on the plans of the buildings, not on their elevations. See Lyman, "Politics of Selective Eclecticism."

95. The popularity of the rosette in Cluniac churches was noted by Armi, *Masons and Sculptors*, 65, n. 32. The motif appears not just in churches, but also in domestic settings, which speaks to shared workshop practices across religious and secular contexts.

96. La Madeleine at Vézelay was rebuilt after a fire damaged the existing church on 21 July 1120, during the abbacy of Renaud de Semur. Seminal studies of the building include Kingsley Porter, *Romanesque Sculpture*; Salet, *Cluny et Vézelay, La Madeleine de Vézelay*, and *La Madeleine de Vézelay et ses dates de construction*. Also see Evans, *Cluniac Art*; Conant, "Cluniac Building"; Armi, *Masons and Sculptors*, 177–90; and Angheben, ed., *Patrimoine de la basilique de Vézelay*. On the Gothic choir, see Branner, *Burgundian Gothic*, 192–94; and Timbert, *Vézelay*. On the restoration of the building in the nineteenth century, which was largely faithful to the medieval design, see Timbert, ed., *Viollet-le-Duc*; and Murphy, *Memory and Modernity*.

97. It has been suggested that the diverse vegetal borders at Vézelay promoted interactive viewing. See Ambrose, *Nave Sculpture*, 66

98. On Autun Cathedral, see note 81 above. Seidel challenged the connection between the cathedral of Autun and Cluny III, arguing that their similarities are based on "the appropriation of widely available, even ubiquitous, architectural elements." See Seidel, *Legends in Limestone*, 92. However, it is not the individual elements, but rather the manner in which they were combined and the distinctive relationships between them that speaks in favor of a connection between the two buildings.

99. Vergnolle et al., *Notre-Dame-de Beaune*, and "L'ancienne collégiale," 179–201.

100. For a history of the rinceau, see Hamlin, "Evolution of Decorative Motives," 29–32, 51–53. For a recent account of rinceaux in Byzantine and Islamic contexts, see Mietke, "Vine Rinceaux," 175–76.

101. The gate was incorporated into the medieval city wall. It was sealed in the sixteenth century. See Prangey, "Langres. Porte gallo-romaine," 1–11.

102. Unwin, *Wine and the Vine*, 178.

CHAPTER 2

1. *Paradysi dei speciem floribus variis vernantem, gramine foliisque virentem.* My translation from Theophilus, *De diversis artibus*, 204–205. Some scholars have identified Theophilus as the Benedictine monk Roger of Helmarshausen, but acceptance of this theory is far from universal.

2. *Si respicit laquearia, vernant quasi pallia; si considerat parietes, est paradysi species; si luminis abundantiam ex fenestris intuetur, inestimabilem vitri decorem et operis pretiosissimi varietatem miratur.* My translation from Theophilus, *De diversis artibus*, 204–207.

3. Kavaler, "Nature," 239–43.

4. Crossley, "Return to the Forest," 72.

5. Bucher, "Fifteenth-Century German Architecture," 409–16.

6. Crossley, "Return to the Forest," 72.

7. Both texts were available in Europe in the fifteenth century. See Krinsky, "Vitruvius Manuscripts," 36–70; and Anderson, ed., *Cornelii Taciti*, LXII.

8. Sedlmayr, *Entstehung der Kathedrale*, 95ff.

9. Frankl, *The Gothic*, 759. Also see the anonymous review in the *Times Literary Supplement* from 4 January 1952; Grodecki, "L'interprétation de l'art gothique," 847–57; and the review by Gall in *Kunstchronik*, 14–21.

10. Schlink, "Gothic Cathedral," 285. Although more generous than previous scholars, Murray (*Plotting Gothic*, 165–70) is ultimately critical of Sedlmayr's study.

11. The garden is also mentioned or alluded to in Isa. 5:3, Ezek. 28:13, 31:9, and Joel 2:3.

12. Gen. 2:9.

13. Augustine, *De Genesi ad Litteram*, 8.7.

14. Augustine, *De Genesi ad Litteram*, 8.4. Also see Delumeau, *History of Paradise*, 18–19.

15. Bede, *On Genesis*, 2.8. Also see Meyvaert, "Medieval Monastic Garden," 50–51, note 104.

16. Delumeau, *History of Paradise*, 19–21.

17. Scafi, *Maps of Paradise*.

18. Clark, *Origenist Controversy*.

19. Aquinas, *In II Sent.*, dist. 17, q. 2, a. 2, solutio, in *Opera omnia*, vol. 6, 538–39.

20. Grosseteste, *Hexaëmeron*, VIII.30.1.

21. Patton, "Creation, Fall and Salvation,"19–44.

22. Ambrose, *De paradiso*, 3.12.

23. Minnis, *From Eden to Eternity*, 83.

24. Gen. 1:1–18.

25. 2 Kings 2:11.

26. For a concise summary of medieval conceptions of the cosmos, see Binski, *Medieval Death*, 166–81.

27. Isa. 14:12; 2 Pet. 2:4; Acts 1:9–11.

28. Ezek. 28; Dan. 12.

29. Luke 23:43.

30. Ezek. 28:13, 36:35.

31. Delumeau, *History of Paradise*, 4.

32. On the development of the Heavenly Jerusalem as compensation for the destruction of the Temple, see Josephus, *Jewish War*, 5; Bar. 4:1–6, and 4 Ezra; and Kühnel, *Earthly to the Heavenly Jerusalem*, 34–48.

33. Rev. 21:10–19.

34. The formal links between the Heavenly Jerusalem and church architecture will be addressed below.

35. Rom. 5:12–21.

36. The current apse mosaic, which was commissioned by Pope Nicholas IV, recalls the church's earlier apse, as well as the mosaics in the Lateran baptistery and San Clemente. See Kessler and Zacharias, *Rome 1300*, 142–46; Gardner, "Pope Nicholas IV," 1–50; and Henkels, "Remarks," 128–49.

37. Rev. 22:2.

38. Gervase of Canterbury, *Historical Works*, vol. 1, 6. Translated in Frisch, *Gothic Art*, 16.

39. My translation. Honorius of Autun, *Gemma anima* 1, Chapter 149 (Migne, *PL* 172, col. 590B and C). Also see Meyvaert, "Medieval Monastic Garden," 51.

40. My translation. *Historia Selebiensis Monasterii*, 11. For a complete English translation of the text, see *Historia Selebiensis Monasterii: The History of the Monastery of Selby*, 33. Also see Constable, "Renewal and Reform," 37–67.

41. Quoted in Picard, "Paradisus-Parvis," 161, note 2. Also see Davis, *Lives*, 66.

42. My translation from Picard, "Paradisus-Parvis," 162, note 3. Also see Paul the Deacon, *History of Lombards*, 5.31.

43. Rossi, *Inscriptiones Christianae urbis*, 148.

44. Rossi, *Inscriptiones Christianae urbis*, 220.

45. Schlee, "Ikonographie der Paradiesflüsse," 133–46.

46. Rossi, *Roma sotterranea cristiana*, vol. 3, 430.

47. Picard, "Paradisus-Parvis," 174–84.

48. My translation from Picard, "Paradisus-Parvis," 169–70, note 6.

49. On the origins and development of the cloister, see Horn, "Origins of the Medieval Cloister," 13–52. Also see the essays in the "Architecture" section of Klein, ed., *Mittelalterliche Kreuzgang*, 37–102.

50. On the varied activities that took place in medieval cloisters, see Meyvaert, "Medieval Monastic Claustrum," 53–59. On the cloister as a place of "meditational memory work," see Carruthers, *Craft of Thought*, 272–76.

51. On cloister plants and their uses, see Bayard, *Sweet Herbs and Sundry Flowers*.

52. Prache and Plouvier, *Noyon Cathedral*, 30–32.

53. *Historia monachorum in Aegypto*, Chapter 17 (Migne, *PL* 21, col. 439C). Also see Meyvaert, "Medieval Monastic Garden," 27.

54. Hugh of Fouilloy, *De claustro animae*, 29 (Migne, *PL* 176, col. 1167C). On this work, see Grégoire, "De claustro animae," 193–95.

55. Durandus, *Rationale*, 1:42.

56. Quoted in Meyvaert, *Medieval Monastic Garden*, 46.

57. Barnet and Wu, *Cloisters*, 58–60; Kletke, *St.-Guilhem-le-Désert*.

58. An inscription (now lost) recorded in the seventeenth century reveals that the cloister was completed by 1228. See Huynes, *Histoire générale de l'abbaye*, 181. Texts documenting the achievements of Raoul des Iles (abbot of Mont-Saint-Michel until 1228) corroborate the epigraphic evidence. See Martène and Durand, *Thesaurus novus anecdotorum*, vol. 1, 956–57. Also see Grant, "Gothic Architecture in Southern England," 113–26.

59. Stookey, "Gothic Cathedral," 35–36; Sedlmayr, *Entstehung der Kathedrale*, 124, 142; von Simson, *Gothic Cathedral*, 113.

60. Stookey, "Gothic Cathedral," 36.

61. Stookey, "Gothic Cathedral," 36.

62. Von Simson, "Design and meaning," 6.

63. Paulinus of Nola, *Epistula* 32, quoted in Kendall, *Allegory*, 41. Also see Goldschmidt trans., *Paulinus' Churches at Nola*, 40.

64. This comparison is ubiquitous in general studies of medieval art and specialized studies of stained glass. See, for instance, Kibler and Zinn, eds., *Medieval France*, 1682. Also see Camille, *Gothic Art*, 41–42; and Marks, *Stained Glass in England*, 74.

65. The height of the nave of Amiens Cathedral is 144.23 Roman feet. See Murray, *Notre-Dame Cathedral of Amiens*, 158–63. The interior height of Beauvais Cathedral is 144.3 French royal feet, a unit of measure that is slightly longer than the Roman foot. Its exterior width is also close to 144 French royal feet. Murray, *Beauvais Cathedral*, 110–11. Also see Murray, "Reconciling the Feet," 169–81. It warrants mention that Schlink ("Gothic Cathedral," 275) has expressed skepticism at Murray's conclusions.

66. The module used to layout Saint-Ouen is a square whose sides measure 39 meters, or 120 royal feet. A document dated 12 December 1321, which states that the church of Saint-Ouen was to be made in the image of the celestial Jerusalem, reinforces the building's connection to biblical models. See Davis and Neagley, "Mechanics and Meaning," 161–82.

67. On the Creation sculptures at Chartres, see Didron, "Iconographie des cathédrales," 45ff., and *Iconographie chrétienne*, 157–60.

68. Grandclément, "Andlau," 15–20; Baum, "Porch of Andlau," 492–505. On the reuse of the *Traditio Legis* sculptures, see Elliott, *Regnum et sacerdotium*, 134–35.

69. Will, "Recherches iconographiques," 29–79.

70. The theme of paradise at Andlau is reiterated in the fruit-bearing grapevines of the porch capitals. For an interpretation of the Andlau porch as a whole in paradisiacal terms, see Förster, *Vorhalle als Paradies*, esp. 156–66.

71. Gen. 1–2.

72. *Quippe Deus sibi visio certa* [. . .] *Lux erit aurea*. Bernard of Cluny, *De contemptu mundi*, 1. On the figuration of heaven in the poem, see Pepin, "Heaven in Bernard of Cluny's *De contemptu mundi*," 101–118.

73. On the Ark, the Tabernacle, and the Temple as vessels of divine presence, see Flood, *Great Mosque*, 89–100; and Kühnel, *Earthly to the Heavenly Jerusalem*, 18–19.

74. Andrieu, *Ordines*, 336. Also see Meyer, *Medieval Allegory*, 85.
75. Benedict, *Saint Benedict's Rule* 19.1–2 (Migne, *PL* 103, col. 915D).
76. Thomas Aquinas, *Summa Theologiae, vol. 6, The Trinity (1a.27–32)*. For a concise account of the notion of God as architect, see Lilley, *City and Cosmos*, 36–40.
77. Ohly, "Deus Geometra," 1–42; Zahlten, *Creatio mundi*; Friedman, "The Architect's Compass," 419–29; and Heimann, "Three Illustrations," 39–59.
78. The tomb of Hugues Libergier is currently located in the north transept of the cathedral of Reims. On the tools of the master mason, see Wu, "Hugues Libergier"; Gimpel, *Cathedral Builders*, 89–121; and Shelby, "Medieval Masons' Tools II," 236–48. On Hugues Libergier and the church of Saint-Nicaise at Reims, see Bideault and Lautier, "Saint-Nicaise de Reims," 295–330; and Givelet, *Abbaye de Saint-Nicaise*, 95–96, 110.
79. On the structural and theological significance of straight walls in medieval church architecture, see Tallon, "Architecture of Perfection," 530–54.
80. See, for instance, Augustine, *The City of God*, XVIII: 18.
81. *Glossa in Timaeum*, ad. 28a. Quoted in Chenu, *Nature, Man and Society*, 41.
82. Quoted in Winkworth, trans., *Theologia Germanica*, 2. Also see Kavaler, *Renaissance Gothic*, 208.
83. Shimoff, "Gardens: From Eden to Jerusalem,"151–52; Baumgarten, "Qumran Sabbath Shirot," 208; Ameisenowa and Mainland, "The Tree of Life," 326–45; and Flood, *Great Mosque*, 92.
84. The conception of the Tree of Life as an olive tree is best attested in apocalyptic texts, such as the *Vita Adae et Evae* 36. On the Tree of Life as a palm, see Gąsiorowski, "Motiv des Lebensbaumes," 319–26.
85. Ameisenowa and Mainland, "The Tree of Life," 331; Lanfer, *Remembering Eden*, 33–66.
86. The manuscript was formerly catalogued as Frankfurt-am-Main, Stadtbibliothek, Ausst. 4. For a discussion of the manuscript and an image of the Tree of Life folio, see Ameisenowa and Mainland, "The Tree of Life," 340–41, Pl. 57d.
87. Mann, "Artistic Culture of Prague Jewry," 83–89.
88. On Tertullian and the other patristic authors, see Kuntz and Leathers Kuntz, "The Symbol of the Tree," 319–34; Armstrong, "Cross," 17–38; and Reno, *Sacred Tree*.
89. Bonaventure, *Lignum vitae*, prologue 2. Also see Hatfield, "Tree of Life," 132–59.
90. The bibliography on the apse mosaic of San Clemente is vast. Key studies include Riccioni, *Il mosaico absidale*; Stroll, *Symbols as Power*, 118–31; and Schulte Nordholt, "Der Baum des Lebens," 17–30. Also see Ladner, "Medieval and Modern," 223–56; and Bonne, "De l'ornement à l'ornementalité."
91. Quoted in Kendall, *Allegory*, 30. Also see Kessler and Zacharias, *Rome 1300*, 82.
92. For a detailed description of the pavement and an analysis of the underlying geometry, see Pajares-Ayuela, *Cosmatesque Ornament*, 247–70.
93. Ezek. 47:12.
94. Mather, *Voice*, 6. I borrow the concept of "intervisuality" from Camille, "Gothic Signs and the Surplus," 151.
95. For a detailed analysis of the correspondences between the *hortus conclusus* and the Garden of Eden, see Landy, "Song of Songs," 513–28.
96. On these commentaries, which were written between the sixth and fifteenth centuries, see Mather, *Voice*.
97. John of Damascus, *Sermon 1*, 160.
98. *Hodie Eden novi Adam paradisum suscipit animatum, in quo soluta est condemnatio, in quo plantatum est lignum vitae, in quo operta fuit nostra nuditas.* John of Damascus, *In Assumptione S. Mariae Virginis*, 448.
99. Chatel, *Culte de la Vierge*.
100. This issue is addressed in Thunø, *Image and Relic*, 86–87.
101. Ambrosius Autpertus, *Expositionis in Apocalypsin* 5. On this development in the eighth and ninth centuries, see Scheffczyk, *Mariengeheimnis in Frömmigkeit*, 390–428; Cunningham, "Relationship between Mary and the Church," 52–78; Coathalem, *Parallélisme*, 57–71.
102. Daley, "Closed Garden," 253–78; and Astell, *Song of Songs*, 43–44. Also see Stokstad, "Gardens in Medieval Art," 19–35.

103. Ohly, *Hohelied-Studien*, 126.
104. On the originality of Rupert's text, see Ohly, *Hohelied-Studien*, 306. The relevant passages of Rupert's text appear in Daley, "Closed Garden," 264.
105. On representations of botanical forms in the work of Schongauer, see Koreny, "Coloured Flower Study," 588–97; and Oettinger, "Laube, Garten und Wald," 208.
106. There are over forty extant or documented French choir tapestries, all of which date to the fifteenth century or later. However, textual sources confirm that textiles were used in churches in Rome and Constantinople in the Early Christian period. Moreover, churches across Western Europe seem to have maintained textile collections throughout the Middle Ages. See Weigert, *Weaving Sacred Stories*, 2–4, 121–69.
107. Oettinger, *Laube, Garten und Wald*, 216–21; Büchner, "Ast-, Laub- und Masswerkgewölbe," 292–94.
108. Vetter, *Maria im Rosenhag*, 14ff; Swarzenski, *Lateinischen illuminierten Handschriften*, fig. 795; and Daley, "Closed Garden," 267–73.
109. It has been suggested that developments in pleasure gardens and "popular" religion in the fifteenth century helped spark the trend. See Daley, "Closed Garden," 278–79.
110. On the role of time as an enabling and intrinsic aspect of pre-modern architecture, see Trachtenberg, *Building-in-Time*. Also see Camerlenghi, "Longue Durée," 11–20.
111. John 20–21.
112. On the sensory aspects of the subject, see Baert, " 'An Odour. A Taste. A Touch," 109–51, and "Noli me tangere," 323–50.
113. Flood, *Representations of Eve*, 16.
114. Iogna-Prat, "La Madeleine," 37–79, and "Bienheureuse polysémie," 21–31.
115. Baert, "An Odour. A Taste, A Touch," 132.
116. On the iconography of the portal, see Gallistl, "Porta di bronzo," 107–21, and "Tür des Bischofs Bernward," 145–81. Also see Weinryb, "The Bronze Object," 69–77.
117. Quoted in Folda, "Jerusalem and the Holy Sepulchre," 158.
118. Key studies of the Holy Sepulcher include Corbo, *Santo Sepolcro di Gerusalemme*; and Abel and Vincent, *Jérusalem*. For the state of the scholarship until 1989, see Ousterhout, "Rebuilding the Temple," 66–78. Also see Ousterhout, "The Temple," 44–53; Pringle, *Churches of the Crusader Kingdom*, 6–72; and Folda, "Jerusalem and the Holy Sepulchre," 158.
119. For recent studies of the changes made to the church in the eleventh and twelfth centuries, see Ousterhout, "Rebuilding the Temple"; and Pringle, *Churches of the Crusader Kingdom*, 13–72.
120. Folda, "Jerusalem and the Holy Sepulchre," 159–61.
121. Chareyron, *Pilgrims to Jerusalem*, 93–94.
122. Chareyron, *Pilgrims to Jerusalem*, 94–95.
123. Pringle, *Churches of the Crusader Kingdom*, 19.
124. Pringle, *Churches of the Crusader Kingdom*, 29.
125. This lost mosaic may have resembled the roughly contemporary mosaic in the north transept of Monreale Cathedral.
126. Morris, *Sepulchre of Christ*; Ousterhout, "Loca Sancta," 108–24; Bresc-Bautier, "Imitations du Saint-Sépulcre," 319–42; and Krautheimer, "Introduction." Specialized studies include Bodner, "Baptistery of Pisa," 96–105; Ousterhout, "Church of Santo Stefano," 311–21; Smith, *Baptistery of Pisa*, 214–32; Seidel, "Dombau," 340–69; and Boeck, "Baptisterium zu Pisa," 146–56.
127. On this issue, see Konrad, "Himmlische und das irdische Jerusalem," 523–40; and Kühnel, *Earthly to the Heavenly Jerusalem*.
128. Krautheimer, "Introduction"; Crossley, "Medieval Architecture and Meaning"; Davis, "Sic et Non," 414–23.
129. Crossley, "Return to the Forest," 72; Kavaler, *Renaissance Gothic*, 211–20, and "Nature and the Chapel Vaults," 243–45.
130. Augustine, *Enchiridion*, 12.
131. Saunders, *Medieval Romance*; Classen, *Medieval German Literature*.
132. Bernardus Silvestris, *Cosmographia*, 14.

133. Alan of Lille, *The Plaint of Nature*, 8.
134. The body of scholarship on the Roman de la Rose is vast. Useful general studies include Bel and Braet, *De la Rose*; Huot, *Romance of the Rose*; Brownlee and Huot, eds., *Rethinking the Romance of the Rose*; and Fleming, *Roman de la Rose*. On the connections between walled gardens and erotic pursuits, see Deluz, "Jardin médiévale," 97–107.
135. Minnis, *Magister Amoris*, 177–78.
136. For recent perspectives on medieval herbals and medicine, see Givens, Reeds, and Touwaide, eds., *Visualizing Medieval Medicine*; and Collins, *Medieval Herbals*.
137. On the possible functions of marginalia in church settings, see Camille, *Image on the Edge*, 77–98.
138. Quoted in Hamburger, Marx, and Marti, "The Time of the Orders," 59–60.
139. Belting, *Hieronymus Bosch*.
140. Braun-Reichenbacher, *Das Ast- und Laubwerk*, 70–71, 88–89; Kavaler, *Renaissance Gothic*, 213.
141. On the use of choir screens for preaching, see Jung, "Beyond the Barrier," 628–29, and *Gothic Screen*, 191–98.

CHAPTER 3

1. Weitzmann, *Miniatures of the Sacra Parallela*, 182, pls. 106, 479; Thunø, *Image and Relic*, 53–78. Another possible representation of Christ's discourse on the true vine is a fourth-century fresco in the catacomb of San Gennaro in Naples, though this identification remains uncertain. See Garrucci, *Storia della arte Cristiana*, pl. 97, 2.
2. An early study dated the lamp to 50–70 and identified it as the Holy Grail. See Eisen, *Great Chalice of Antioch*. This theory has since been challenged. See, for instance, Rorimer, "Authenticity," 161–68; Arnason, "History of the Chalice," 49–64; and Jerphanion, *Calice d'Antioche*. It warrants mention that some scholars believe that the lamp comes from the Syrian village of Kaper Koraon (modern Kurin), rather than Antioch.
3. Little, "Art of Gothic Ivories," 25–27. The association of the rose and the Virgin appears in Ecclesiasticus 24:18: "I was exalted like a palm tree in Cades, and as a rose plant in Jericho."
4. See Toubert, *Art dirigé*.
5. Tronzo, "Frames and Framing Devices," 1108–1109. Other studies of frames in Italian mural programs tend to focus on the antique sources for specific motifs and on the relationship between fictive and real frames. See Rebold Benton, "Antique Survival and Revival," 129–45; and Peroni, "Acanthe remployée et acanthe imitée," 313–26.
6. I have in mind here the broad theoretical perspective of Gumbrecht, *Production of Presence*.
7. Binski, *Gothic Wonder*, esp. 161–85; Jaeger, *Enchantment*, 134–61. Also see Carruthers, *Experience of Beauty*, esp. Chapters 5 and 6.
8. John 15:5.
9. John 2:1–11.
10. Matt. 26:26–29; Mark 14:22–25; Luke 22:14–20.
11. Elowsky, *Ancient Christian Commentary on Scripture*.
12. *Ipse est uitis, ipse uua: uitis ligno adhaerens, uua, quia lancea militis apertum latus emisit aquam et sanguinem.* Ambrose, *De patriarchis*, 4.24.
13. Ps. 80: 9–16; Isa. 5:1–7; Ezek. 15:1–8; Augustine, *Homilies on John*, 80; and Thunø, *Image and Relic*, 94–96.
14. Gaudentius of Brescia, *Tractatvs*, CSEL 68, 30–32.
15. Schiller, *Iconography of Christian Art*, 228.
16. Clement of Alexandria, *Christ the Educator*, 44; Theophilus of Alexandria, *Homilia in mysticam coenam* (Migne, *PG* 77, col. 1016–29). Also see Elowsky, *Ancient Christian Commentary*, 160.
17. Ephraem Syrus, *Hymns*, 18:21–22.
18. Peter the Venerable, *De miraculis libri duo*, I.9.
19. Adam of Saint Victor, *Liturgical Poetry*, Poem 14, 87.

20. Adam de Perseigne, *Lettres*, 97 (Migne, *PL* 209, col. 639B and C); Aquinas, *Commentary on the Gospel of John*, ch. 15. Also see Mikuž, *Le sang et le lait*, 66ff.

21. Walker Bynum, *Wonderful Blood*.

22. It warrants mentions that the attribution to Bonaventure has been called into question, with some scholars claiming that the *Vitis mystica* is an expansion of Bonaventure's sermon on John 15:1, rather than having been authored solely by Bonaventure. See Hammond, Hellmann, and Goff, eds., *Companion to Bonaventure*, 45.

23. "*Vitis mystica*," 3–4.

24. "*Vitis mystica*," 5–7.

25. "*Vitis mystica*," 7–12.

26. Aelred of Rievaulx, *De institutione inclusarum*; Bonaventure, *Holiness of Life*. Also see Bestul, *Texts of the Passion*, 8–9.

27. *Sanguis tibi in vinum vertitur ut inebrieris.* Aelred of Rievaulx, *De institutione inclusarum*, 31, p. 671.

28. [*T*]e sanctissimo corpore suo cibavit, pretiosissimo sanguine suo potavit. Bonaventure, *Holiness of Life*, V, p. 51.

29. Rubin, *Corpus Christi*, 228.

30. Braun, *Christliche Altar*, 752.

31. On the north transept sculptures, see Morganstern, *High Gothic Sculpture at Chartres*, 73–104; Büchsel, *Skulptur des Querhauses*; Sauerländer, *Gothic Sculpture in France*, 430ff; van der Meulen, "Sculpture and Its Architectural Context," 509–39; Schlag, "Die Skulpturen," 115–64; and Abdul-Hak, *Sculpture des porches*. Also see Williamson, *Gothic Sculpture*, 37–47. For a recent interpretation of the portal sculptures at Chartres in relation to stained glass, the liturgy, and the visitor's experience, see Crossley, "*Ductus and memoria*."

32. Foundational studies of the iconography of west façade sculptures at Chartres include van der Meulen, *West Portals of Chartres*; Katzenellenbogen, *Sculptural Programs of Chartres*; and Kidson, *Sculpture at Chartres*. For a concise summary of the dates of the sculptures, see Sauerländer, *Gothic Sculpture*, 384–86.

33. Fassler, "Liturgy and Sacred History," 512. Also see Fassler, *Virgin of Chartres*, 223–41.

34. Fassler, "Liturgy and Sacred History," 512.

35. Fassler, "Liturgy and Sacred History," 513.

36. The feast is celebrated annually on February 2. See Fassler, "Liturgy and Sacred History," 512.

37. Olson, *Ornamental Colonnettes*, 116.

38. Olson, *Ornamental Colonnettes*, 107–108.

39. Gomez-Géraud and Sartorius, *Joie toute simple*; and Durand and Grave, *Chronique de Mantes*, 254–55.

40. Moulin and Posot, "Chapelle de la Vierge," 49–55; Sandron and Lorentz, *Atlas de Paris*, 122; and Cohen, *Sainte-Chapelle*, 34ff.

41. The monastery was sacked in 1567, 1595, and 1629, and was largely destroyed during the French Revolution. Most of what remained of the complex was sold in 1797. The portal seems to have been removed from its original setting in the 1920s. It was acquired by the Metropolitan Museum in 1932. See Forsyth, "Gothic Doorway," 35–37.

42. Forsyth, "Gothic Doorway," 45.

43. Forsyth interpreted the disk in Christ's hand as an orb, comparing it to a *mappa mundi* and suggesting that it symbolized Christ's power over the world. Forsyth, "Gothic Doorway," 51–52.

44. Crossley, "*Ductus and memoria*," 214ff.

45. For the most complete study of this sculpture, see Schlink, *Beau-Dieu von Amiens*. More recent studies of the central portal include Murray, *Gothic Sermon*, 37–41; Williamson, *Gothic Sculpture*, 141–47.

46. Schlink, *Beau-Dieu von Amiens*. It has been suggested that the program was devised by Jean d'Abbéville, dean of the chapter when work began on Amiens Cathedral around 1220. See Murray, *Gothic Sermon*, 156, note 7.

47. The Nahum and Jonah quatrefoils to the left and right of the central portal also portray vegetation, but not grapevines.

48. Mic. 5:2; Matt. 2:6.

49. The many images of Saint Firmin at the cathedral attests to his importance, as does the new office instituted between 1304 and 1306 to emphasize the feast of the invention of his relics.

50. On the processions and their relationship to the south transept portal, see Gaposchkin, "Portals," 217–42.

51. The discovery of the relics is recounted in the anonymous seventh-century life of Saint Firmin. See Stiltingo et al., *Acta sanctorum septembris*, vol. 7, 34–57.

52. For a recent study of these portal sculptures, see Gaposchkin, "Portals," 225–29; and Murray, *Gothic Sermon*, 41–45.

53. Garnier, "Inventaires," 361–66.

54. Murray, *Notre-Dame, Cathedral of Amiens*, 109.

55. Green Man imagery was particular common in marginal zones of buildings. For a broad study of the motif, see Basford, *Green Man*.

56. Low-relief floral patterns cover the sides of the trumeau and splayed leaves decorate the outer archivolts.

57. This interpretation stands in contrast to that of Murray, Camille, and Givens, who read the interior frieze in relation to the legend of Saint Firmin and the liturgy of the Green Man. See Camille, *Gothic Art*, 135–36; Givens, *Observation*, 113–15; and Introduction, note 8.

58. Jung, *Gothic Screen*, 160–61, and "Beyond the Barrier," 638–39; Little, "Monumental Gothic Sculpture," 243–53; Baron, "Mort et résurrection," 28–41; Gillerman, "Arrest of Christ," 67–90.

59. Baron, "Mort et résurrection," 32.

60. My focus is on the Christological aspects of the design, but the use of foliate decoration on this portal also accords with a miracle in the life of Saint Honoré, to whom the portal is dedicated. According to his *vita*, the saint transformed a baker's peel into a flowering mulberry tree, an episode depicted on the right-hand side of the tympanum's lowest register. On this portal, see Gaposchkin, "Portals," 225–29; Kimpel and Suckale, "Skulpturenwerkstatt der Vierge Dorée," 217–65; Katzenellenbogen, "Tympanum and Archivolts," 280–91; and Jourdain and Duval, *Portail Saint-Honoré*.

61. Murray, *Notre-Dame, Cathedral of Amiens*, 118.

62. On the saint's legend, see Corblet, *Hagiographie*, 38–77.

63. The heavily restored Crucifixion also relates to a miracle in the life of Saint Honoré: a rood in a neighboring church reportedly inclined its head toward the chasse containing the saint's relics during a procession through the building. See Katzenellenbogen, "Tympanum and Archivolts," 282; and Jourdain and Duval, *Portail Saint-Honoré*, 29–30.

64. On the Jesse Tree, see Böcher, "Ikonographie der Wurzel Jesse," 153–68; and Watson, *Early Iconography*.

65. *Et egredietur virga de radice Iesse et flos de radice eius ascendet.*

66. *Virga ex radice Maria ex David flos ex virga filius Mariae.* Tertullian, *De carne Christi liber*, 21.

67. Mary was seen as the rod (*virga*) that issued from David. On the association of *virga* and *virgo*, see Watson, *Early Iconography*, 1, 4–5. On the link between the Virgin Mary and the *virga* in patristic texts, see Livius, *Blessed Virgin*, 107–13.

68. Watson, *Early Iconography*, 89; and Holcomb and Bessette, *Pen and Parchment*, 17–18.

69. The figure of Jesse is unfinished and was probably supposed to be painted. See Holcomb and Bessette, *Pen and Parchment*, 18.

70. Among the best-studied Jesse Tree windows in France are those at Saint-Denis (ca. 1140–1144), the cathedrals of Chartres (1150s), Troyes (twelfth century), and Le Mans (ca. 1235), the Sainte-Chapelle of Paris (1239–1248), the church of Sainte-Madeleine in Troyes (1518), and the church of Saint-Étienne in Beauvais (1522).

71. On the restoration of the west façade sculptures by Geoffroy Dechaume, see Claussen, *Chartres-Studien*, 41–61.

72. For a recent study of the iconography of the west façade sculptures, see Kasarska and Sandron, *Sculpture de la façade*. Other important studies include Thérel, "Portail de la vierge-mère," 273–87; Lapeyre, *Façades occidentales*; and Lambert, "Portails sculptés," 83–98. Also see Sauerländer; *Gothic Sculpture*, 425–28; and Williamson, *Gothic Sculpture*, 35–36.

73. Perrot, "Verrières du XIIᵉ siècle," 39–51; Johnson, "Tree of Jesse Window," 1–22.

74. Rickard, "Iconography of the Virgin Portal," 147–57.

75. The Jesse Tree replaced a thirteenth-century tympanum dedicated to Saint Romain. On the sixteenth-century sculptures and their later restoration, see Carment-Lanfry and Le Maho, *Cathédrale Notre-Dame de Rouen*, 231–32; Delsalle, *Rouen à la Renaissance*, 591.

76. That is not to say, of course, that pre-sixteenth-century depictions of the Jesse Tree were uniform. The subject was treated in diverse ways, especially in manuscripts. The Jesse Tree in the Lambeth Bible (ca. 1150–1170), for instance, shows standing figures (including prophets, Ecclesia, and Synagoga) framed by branches flanking the central stalk, to which the Virgin Mary is affixed. A bust-length image of Christ appears at the top of the composition. See Watson, *Early Iconography*, 99.

77. Kavaler, *Renaissance Gothic*, 218.

78. Baudoin, *Sculpture flamboyante*, 118–20.

79. On the iconography of the gallery of kings, see Joubert, *Sculpture gothique*, 129ff; Hohenzollern, *Königsgalerie*; and Mâle, *Religious Art in France*, 171–77. On the gallery of kings at Chartres, see Lautier, "Deux galleries." For recent observations about the gallery of kings at Reims Cathedral, see Sadler, *Reading the Reverse Façade*, 50–52; and Sauerländer, "Observations," 465–66.

80. Each king measured approximately 3.5 meters and had to be broken into pieces in order to be removed from the façade. See Erlande-Brandenburg, *Sculptures de Notre-Dame*, 9.

81. Erlande-Brandenburg, *Sculptures de Notre-Dame*, 12.

82. On the coronation ceremony, see Demouy, ed., *Reims, La cathédrale*, 103–109; and Sadler, *Reading the Reverse Façade*, 119–21.

83. Gaposchkin, "King of France," 65–66.

84. The thick leaves on the arcade framing the statues are part of Violet-le-Duc's restoration.

85. Gen. 9:20.

86. Hamlin, "Evolution of Decorative Motives," 29.

87. Amy and Gros, *Maison Carrée*.

88. Key studies of this monument include Zanker, *Power of Images*, 120–25; and Simon, *Ara Pacis Augustae*. Also see Castriota (*Ara Pacis*), who stressed the monument's vegetal ornamentation and argued that the appropriation of Greek models conveyed notions of *renovatio* and prosperity under Augustus.

89. Elsner, "Cult and Sculpture," 54.

90. For a political interpretation of the foliage, see Zanker, *Power of Images*, 179–83. On the symbolism of the vine, see l'Orange, "Ara Pacis Augustae," 7–16. For a detailed study of the style and sources of the Ara Pacis foliage, see Kraus, *Ranken der Ara Pacis*.

91. Unwin, *Wine and the Vine*, Chapter 4.

92. On the history of wine and its associations with Dionysus, see Stanislawski, "Dionysus Westward," 427–444.

93. Apollodorus of Athens, *The Library*, 3.5.1.

94. Hölderlin, *Brot und Wein*. Hengel found connections between the Dionysian mystery religion, Judaism, and Christianity, all of which had a strong presence in the Eastern Mediterranean. See Hengel, *Studies in Early Christology*, 331ff. Powell saw the consumption of the Eucharist as deriving from the cult of Dionysus. See Powell, *Classical Myth*, 274–76. Wick argued that the shared symbolism of wine was intended to demonstrate Christ's superiority over Dionysus. See Wick, "Jesus gegen Dionysos?" 179–98.

95. Hayward, "Vine," 9–18; Mildenberg, *Coinage of the Bar-Kokhba War*, 46–47.

96. Wulkan, "Grape," 369–77.

97. Kendall, *Allegory*, 33–48.

98. Canadé Sautman, *La religion du quotidien*, 96.

CHAPTER 4

1. *Aedificandi si est affectio, habes fabricam mundi, mensuras arcae, ambitum tabernaculi, fastigium templi Salomonis ipsiusque per mundum membra ecclesiae quam illa omnia figurabant.* Quodvultdeus, *De Gloria Regnoque Sanctorum*, 17, in *Opera*, 221. My translation. I would like to thank Meredith Cohen for bringing this passage to my attention.

2. Krautheimer, "Introduction," 14.

3. The notion that the architectural copy was not just a citation, but a recreation that duplicated the power of the original is discussed in Nagel and Wood, *Anachronic Renaissance*, 29–36, 51–64.

4. 1 Kings 6–7; 1 Chron. 21–22; 2 Sam. 24. The only biblical source to conflate the identity of the Temple Mount and Mount Moriah is 2 Chron. 3:1.

5. The Ark is described in Exod. 25:10–15 and 31:1–11. 1 Kings 8:9 specifies that it only held the two Tablets of the Law, but other scriptural sources, namely Exod. 16:33–34 and Num. 17:10, reveal that it also contained the flowering rod of Aaron, a jar of manna, and the first Torah scroll written by Moses.

6. On the spatial structuring of the Temple, see Branham,"Penetrating the Sacred," esp. 10–24.

7. Exod. 26:31–36.

8. Binski, *Gothic Wonder*, 201–202.

9. Luke 21:5–6; Matt. 24:1–2.

10. Josephus, *Antiquities* 8.3 and 15.11, and *Jewish War* 5.4. Herod's Temple is described in tractates Shekalim, Sukkah, Yoma, and Middot. See Danby, ed., *Mishnah*, 152–81, 589–97. On the accessibility of the Mishnah in twelfth- and thirteenth-century France, see Madigan, *Medieval Christianity*, 360–61.

11. Ammianus Marcellinus, *Roman History* 23.1.2–3; Tyrannius Rufinus, *Ecclesiastical History* 10.38–39.

12. Eusebius does not mention the buildings on the Temple Mount, nor do any Early Christian pilgrims, which suggests that the site lay undeveloped in the fourth century. See Krinsky, "Representations," 3.

13. For an orientation to the Dome of the Rock, see Grabar, *Dome of the Rock, Formation of Islamic Art*, esp. 48–67, and "The Umayyad Dome," 33–62.

14. Cahn, "Solomonic Elements," 49.

15. Ousterhout, "The Temple"; Kühnel, *Earthly to the Heavenly Jerusalem*, 140.

16. For an introduction to the architectural heritage of the Temple, see Rosenau, *Vision of the Temple*. Pictorial representations of the Temple did not typically rely on biblical descriptions. On this issue, see Krinsky, "Representations," 7. Descriptions of the Temple appear in Josephus, *Antiquities of the Jews* 8.3 and 15.11, and *Jewish War* 5.4. On the visionary Temple described in Ezek. 40–48, see Cahn, "Architecture and Exegesis," 53–68, and "Architectural Draftsmanship," 247–54. Patristic sources for the Temple include Gregory the Great's homilies on Ezekiel and Jerome's Ezekiel commentary. See *Sancti Gregorii Magni Homiliae*, 208ff; and Lubac, *Exégèse médiévale*, 388ff. Twelfth-century commentaries on the Temple include Richard of Saint-Victor's *Commentary on Ezekiel*, Andrew of Saint Victor's *Expositio hystorica in Librum Regum*, and Peter Comestor's *Historia scholastica*. On the twelfth-century Parisian sources, see Van Liefferinge, *Choir of Notre-Dame*, Appendix B.

17. On the importance of pilgrims' verbal accounts in the process of deconstructing a model and transmitting select features, see Moore, "Seeing through text," esp. 411. On the use of portable objects in disseminating medieval monumental forms synecdochically across the eastern Mediterranean, see Redford, "Portable Palaces," 84–114.

18. Other important biblical events that occurred on Mount Moriah include the Stoning of Zechariah and the Annunciation to Zacharias.

19. Eusebius, *Ecclesiastical History*, 10.4; Ferber, "Temple of Solomon," 22–23; Augustine, *Expositions of the Psalms,* Ps. 126.2; Durandus, *Rationale* 1.5.

20. Gregory the Great, *Homiliae* 39 (Migne, *PL* 76, col. 1293–4).

21. Bede makes the connection between the Tabernacle, Temple, and Church numerous times in *De tabernaculo* and *De templo*. See Hurst, ed., *Bedae Venerabilis Opera*, CCSL, 119A.
22. Haussherr, "Templum Salomonis," 101–21.
23. Stookey, "Gothic Cathedral," 35–41; and Schein, *Gateway to the Heavenly City*, 95.
24. Von Simson, *Gothic Cathedral*.
25. For a broad study of church builders linked to Solomon's Temple or Ezekiel's Temple, see Naredi-Rainer, *Salomos Tempel*, 116–39.
26. Eusebius, *Ecclesiastical History*, 10.4.2–3. Also see Smith, "Christian Rhetoric," 226–47.
27. On this issue, see Ferber, "Temple of Solomon, 21–22; Ousterhout, "The Temple," and "New Temples," 223–53. It has been suggested that the Temple had a concrete impact on the design of Early Christian churches. For example, many Early Christian basilicas adopted the 1:3 proportional system of the Temple. See Wilkinson, "Paulinus' Temple at Tyre," 553–61.
28. Eusebius, *Life of Constantine*, 3.33.1–2; Ousterhout, "The Temple," 44, and "New Temples," 232–33.
29. A fragmentary copy of the letter, called the *Itinerarium Egeriae*, is preserved in the eleventh-century Codex Aretinus from Monte Cassino. For the full Latin text, see Franceschini and Weber, eds., *Itinerarium Egeriae*. For the English translation of the relevant passage, see Wilkinson, *Egeria's Travels*, 146.
30. Grégoire and Collombet, eds., *Oeuvres*, 382–85; Kendall, *Allegory*, 34–35.
31. Onians, *Bearers of Meaning*, 76, notes 11, 12.
32. Quoted in Panofsky, *Abbot Suger*, 90–91.
33. The letter is published in full in Lalore, *Documents*, 113–16. Relevant excerpts appear in Davis and Neagley, "Mechanics and Meaning," 165.
34. The charter is reproduced in full in Davis and Neagley, "Mechanics and Meaning," 178–80.
35. Archaeologists described the façade of this church in the nineteenth century. It comprised a single portal with an inscription on the inner archivolt. Reliefs of two local bishops standing on a lion and a bull relate to the second part of the inscription: *Sic est istius in medio bovis atque leonis.* This is a direct reference to the brass basins adorned with oxen and lions at the entrance to Solomon's Temple. See Kendall, *Allegory*, 99–100; and Cahn et al., *Romanesque Sculpture*, 184–87. I would like to thank Kristine Tanton for bringing this inscription to my attention.
36. Fassler, *Virgin of Chartres*, 176; Meyer, *Medieval Allegory*, 83–91; Kenaan-Kedar, "Symbolic Meaning," 109–17; and Von Simson, *Gothic Cathedral*, 38.
37. Fassler, *Virgin of Chartres*, 173.
38. Fassler, *Virgin of Chartres*, 173; and Meyer, *Medieval Allegory*, 83–84.
39. On the sources for the Temple vine, see Patrich, "Golden Vine," 56–61; and Ugolino, *Thesaurus Antiquitatum Sacrarum*, 1111–1132.
40. The 171 extant Latin versions of Josephus' *Antiquities* attest to the popularity of the text. See Feldman, "Selective Critical Bibliography," 445–47. Also see Schreckenberg and Schubert, *Jewish Historiography*.
41. Kletter, "Christian Reception of Josephus," 368–81; Schreckenberg, *Flavius-Josephus-Tradition*.
42. For a survey of the scholarship on Josephus and his influence, see Feldman, *Josephus and Modern Scholarship*; Schreckenberg, *Bibliographie zu Flavius Josephus: Supplementband*, and *Bibliographie zu Flavius Josephus*.
43. Josephus, *Antiquities of the Jews* 15.11. The description of the vine appears only in Latin versions of *Antiquities*. See Patrich, "Golden Vine," 56–57.
44. Josephus, *Jewish War* 5.4.
45. Mishnah Middot 3:8.
46. The golden vine of Herod's Temple is also mentioned, but not described, in Tacitus, *Histories* 5:5; and Florus, *Epitome of Roman History* 1:40.
47. Josephus, *Antiquities of the Jews* 14.3. Offering golden foliage as a diplomatic gift seems to have been common at the Hasmonean court. See Löw, *Flora der Juden*, 182.
48. Flood, *Great Mosque*, 81–82.
49. Mishnah Yoma 39b.
50. Flood, *Great Mosque*, 86.

51. In contrast to earlier scholars, who emphasized the religious aspects of the Dome of the Rock, Rabbat interpreted the building as "a monument to the Umayyad Islamic rule, built by the one caliph who is rightfully credited with its consolidation." See Rabbat, "Meaning of the Umayyad Dome," 18.

52. Goldziher, *Muhammedanische Studien*. Also see Grabar, "Umayyad Dome," 35–36.

53. Koran, Sura 17.

54. Krinsky, "Representations," 4.

55. Quoted in Krinsky, "Representations," 4.

56. Eutychii, *Contextio gemmarum, sive, Eutychii*, 287–88.

57. For an alternative interpretation, which emphasizes the conflation of the Dome of the Rock and the Solomonic Temple as early as the Carolingian period, see Berger, *Crescent on the Temple*, 56–73. Many of the visual examples of the Temple she provides, however, are too generic to connect to the Dome of the Rock.

58. Fleck, "Linking Jerusalem and Rome," 430–52; Kühnel, *Earthly to the Heavenly Jerusalem*, 166; and Krautheimer, "Introduction," 20.

59. Cahn, "Solomonic Elements," 45.

60. Fleck, "Linking Jerusalem and Rome," 433; Berger, *Crescent on the Temple*, 93–121.

61. The imagined Roman history of the Baptistery was first recorded in the fourteenth century by Giovanni Villani, *Nuova Cronica*, 1.42.

62. The conflation of al-Aqsa and the Temple of Solomon appears in the following textual sources: "Qualiter sita est civitas Ierusalem," in Tobler and Molinier, eds., *Itinera Hierosolymitana*, vol. 1, 347–49; d'Avezac, ed., *Relation des voyages de Saewulf*, 32; and Sanutus, "*Liber fidelium crucis*," vol. 2 of *Gesta Dei per Francos*, 257. On the Aqsa Mosque as the building, palace, and porch of Solomon, see the description by Abbot Daniel in Petrovna Khitrovo, *Itinéraires russes*, 20–21; John of Würzburg, "Descriptio Terrae Sanctae," 125; Burchard of Mount Sion, "Descriptio terrae sanctae," 67; Stewart, ed., *Ludolph von Suchem's Description of the Holy Land*, 98; and Paulus Waltherus, *Fratris Pauli*, 271. Also see Krinsky, "Representations," 5, note 19.

63. On the Christianization of the Islamic buildings on the Temple Mount, see Berger, *Crescent on the Temple*, 75–92.

64. John of Würzburg, "Descriptio Terrae Sanctae," 129–30; Theoderic, "Libellus de locis sanctis," 142–97; Steward trans., *PPTS*, vol. 5, 1–82; and Krinsky, "Representations," 6, notes 27, 28.

65. The term *Templum Domini* appears in the following sources: *Qualiter sita est civitas Ierusalem*, 348; a tract written by the so-called Fetellus published in Vogué, *Églises de la Terre Sainte*, 412; William of Tyre, "*Historia rerum in partibus transmarinis gestarum*," 747–48; Burchard of Mount Sion, *Descriptio terrae sanctae*, 65; Stewart, ed., *Ludolph von Suchem's Description of the Holy Land*, 99; and Pernoud, ed., *Guide du pélerin*, 25. Also see Krinsky, "Representations," 5–6, notes 19, 22.

66. Krinsky, 6, note 23.

67. Cahn, "Solomonic Elements," 46–47; Levy-Rubin, "Crusader maps," 231–37; Meuwese, "Representations of Jerusalem," 139–48.

68. Berger, *Crescent on the Temple*, 93–148; Weiss, "Hec Est Domus Domini," 210–17, and "Three Solomon Portraits," 15–38.

69. Van Liefferinge, *Choir of Notre-Dame*, 49–54, 126–27.

70. Davis, "Cathedral, Palace, Hôtel," 32.

71. 1 Kings 6:20; Ezek. 41:4. The relevant passages in Guillebert's text appear in Le Roux de Lincy and Tisserand, *Paris et ses historiens*, 152–53.

72. The three zones of Saint-Denis correspond to the Temple courtyard, *hekhal*, and Holy of Holies. See Frank and Clark, "Abbot Suger."

73. Fassler, *Virgin of Chartres*, 177. A similar argument was made in relation to the stucco reliefs of palms in the Chapel of the Savior at Germigny-des-Prés (ca. 806), whose apse is decorated with a mosaic of the Ark of the Covenant. See Onians, *Bearers of Meaning*, 76.

74. On the relationship between the Heavenly Jerusalem, Saint-Ouen in Rouen, Amiens Cathedral, and Beauvais Cathedral, see Chapter 2. Each side of the crossing square at Amiens Cathedral measures 50 Roman feet. This may allude to Noah's Ark, which is described in Gen. 6:15 as being

50 cubits wide. See Murray, "Reconciling the Feet," 172. The Sainte-Chapelle of Paris measures 100 by 50 royal feet, which mirrors the dimensions of Solomon's Palace as described in 1 Kings 7. See Murray, "Architectural Envelope," 21–25.

75. Ousterhout, "Church of Santo Stefano"; Cahn, "Solomonic Elements," 51–56; and Binski, *Gothic Wonder*, 187–229.

76. Flood, *Great Mosque*, 87–88.

77. The *isnād* of this hadith terminates with al-Walīd ibn Muhammād, who stated: "When Solomon the son of David, peace be on them both, completed the building of the Temple (Bayt al-Maqdis), God, may He be extolled and exalted, caused two trees to grow close to the Gate of Mercy. One of them brought forth leaves of gold and the other, leaves of silver. Every day it was his custom to pluck from each tree 200 *ratl* of gold and silver and the Mosque [the entire Haram area] was inlaid with gold and silver. When Nebuchadnezzar came, he destroyed the Mosque and took away from it eight wagon-loads of gold and silver and placed them in al-Rūmiyya [Rūmiyyat al-Madā'in in Iraq]." See Elad, *Medieval Jerusalem*, 106; and Flood, *Great Mosque*, 87.

78. This observation was first made by Jairazbhoy, *Outline of Islamic Architecture*, 32. Also see Flood, *Great Mosque*, 88–89.

79. Elad, "Historical Value," 56, and *Medieval Jerusalem*, 55. Also see Flood, *Great Mosque*, 98.

80. On the Temple curtain, see Pelletier, "Grand rideau."

81. Creswell, *Early Muslim Architecture*, vol. 1, 121–22.

82. Soucek concluded that the associations of holiness in the early Islamic period were attached not to the memory of the Solomonic Temple, but to the site itself. Soucek, "Temple of Solomon," 110.

83. The bibliography on Hagia Sophia is expansive. Key studies of the architecture include Mainstone, *Hagia Sophia*; Mango, *Hagia Sophia*; and Mathews, *Early Churches of Constantinople*, 105–80.

84. Remnants of a sixth-century rinceau were also found in the narthex. See Hawkins, "Plaster and Stucco Cornices," 131–35; Flood, *Great Mosque*, 74–75.

85. Paul the Silentiary, *Descriptio S. Sophiae*, 647, in Mango, ed., *Art of the Byzantine Empire*, 86.

86. Lethaby and Swainson, *Church of Sancta Sophia*, 36.

87. Procopius, *Buildings*, 1.1.54, 61–62.

88. Procopius, *Buildings* 1.1.29–30.

89. Ousterhout, "New Temples," 241.

90. Dagron, *Constantinople imaginaire*, 293–309.

91. Scheja, "Hagia Sophia," 54.

92. Romanos Melodus, *Hymnes*, vol. 5, 470–99; Romanus Melodus, *Kontakia*, 247; Topping, "Earthquakes and Fires," 22–35; and Ousterhout, "New Temples," 241–42.

93. Corippus, *In laudem Iustini*, 283.

94. Procopius, *History of the Wars*, 4.9.5–9. Also see Harrison, "Jerusalem," 239–48; Flood, *Great Mosque*, 78; and Ousterhout, "New Temples," 248.

95. Majeska, "St. Sophia," 71–87; Dagron, *Constantinople imaginaire*, 301–303; Ousterhout, "New Temples," 243.

96. On the date and patronage of Saint-Polyeuktos, see Harrison, *Temple for Byzantium*, and "The Church of St. Polyeuktos," 276–79. For an alternative account, which dates the bricks of the substructures of Saint-Polyeuktos to 508/9–511/12 and those of the superstructure to 517/18–521/22, see Bardill, *Brickstamps of Constantinople*, vol. 1, 62–64, 111–16.

97. Several sculptural fragments from Saint-Polyeuktos were reused in the Monastery of Christ Pantokrator (now the Zeyrek Mosque) in the first half of the twelfth century. See Ousterhout, Ahunbay, and Ahunbay, "Study and Restoration," 265–70. The *Pilastri Acritani* in Venice were taken from Saint-Polyeuktos during the Fourth Crusade. See Nelson, "History of Legends," 63–90; Deichmann, *Rom, Ravenna, Konstantinopel*, 649–63, and "I Pilastri Acritani," 75–89.

98. The main excavation took place between 1964 and 1969 under the direction of Nezih Firatli and R. M. Harrison.

99. Given the size and arrangement of the foundations, Harrison envisioned a domed basilica with an eastern apse and western narthex. See Harrison, *Temple for Byzantium*, 127ff. By contrast,

Mainstone suggested that a square tower surmounted the church. See Mainstone, *Hagia Sophia*, 160. More recently, Bardill argued in favor of a wooden coffered ceiling. See Bardill, "New Temple," 345–60. Ousterhout supported Bardill's conclusions. See Ousterhout, "New Temples," 246.

100. Flood, *Great Mosque*, 77–87.

101. Flood, *Great Mosque*, 57–113; Harrison, "Church of St. Polyeuktos," 278.

102. The poem is preserved in the *Greek Anthology* as AP 1.10. For recent analyses, see Whitby, "St Polyeuktos Epigram," 159–88; and Conner, "Epigram."

103. The building measured 51.45 m × 51.9 m. See Harrison, *Temple for Byzantium*, 137, and "Church of St. Polyeuktos," 277. Both Bardill and Milner emphasized a connection to the visionary temple of Ezekiel rather than to Solomon's Temple, an argument that is difficult to maintain given that the dedicatory inscription specifically mentions Solomon. See Bardill, "New Temple," 342–45; and Milner, "Image of the Rightful Ruler," 73–81.

104. Dagron, *Emperor and Priest*, 50.

105. Ousterhout, "New Temples," 248.

106. Quoted in Dagron, *Emperor and Priest*, 147.

107. Maguire, "Davidic Virtue"; and Spain Alexander, "Heraclius." Also see Ousterhout, "New Temples," 248.

108. *Versus Iohannis Scotti ad Karolum Regem*, 45–49, in *MGH AA*, vol. 3, 551; Krautheimer, "Introduction," 9–10.

109. Flood, *Great Mosque*, 57–113, and "Umayyad Survivals."

110. Flood, "Umayyad Survivals," 58.

111. Flood, "Umayyad Survivals," 58.

112. Flood, "Umayyad Survivals," 58. Also see Brinner trans. *Chronicle of Damascus*, vol. 1, 161, vol. 2, 120.

113. Flood, *Great Mosque*, 57–68.

114. My translation. [U]*ne frise de rinceaux de marbre blanc et doré se découpant sur un fond de marbre foncé*. Quoted in Saladin, *Manuel d'art musulman*, 84. The gilding is also visible in a painting of the prayer niche by Lord Frederick of Leighton, which dates to 1873–1875. It is reproduced in the exhibition catalog, *Visions of the Ottoman Empire*, pl. 23.

115. Flood, *Great Mosque*, 65, and "Umayyad Survivals," 59.

116. Flood, *Great Mosque*, 66, 101.

117. Sauvaget, *Mosquée omeyyade de Médine*, 80.

118. Flood, "Umayyad Survivals," 60–61.

119. Flood, "Umayyad Survivals," 61–64.

120. Flood, "Umayyad Survivals," 65.

121. Pevsner, *Leaves*, 18; Givens, *Observation*, 134ff.

122. On the polychromy of the frieze at Autun Cathedral, see Rollier-Hanselmann and Castandet, "Couleurs et Dorures," 245–46.

123. Rollier-Hanselmann and Castandet, "Couleurs et Dorures," 245–46.

124. Pallot-Frossard, "Polychromie," 90.

125. Bernard of Clairvaux, *Apologia*, in Holt, *Documentary History of Art*, vol., 20. Bernard mentions the Cluniacs twice in his *Apologia*, but his criticisms likely applied to all traditional Benedictines. See Rudolph, "Bernard of Clairvaux's *Apologia*."

126. Weigert, *Weaving Sacred Stories*, 2–4, 121–69; and Dale, *Relics, Prayer, and Politics*, Chapter 7.

127. Josephus, *Antiquities of the Jews* 15.11.

128. Frank and Clark, "Abbot Suger," 110.

129. Frank and Clark, "Abbot Suger," 121–23. On the Saint-Denis copy of *Antiquities*, which is now in the Biblioteca Ambrosiana in Milan, see Nebbiai-Dalla Guarda, *Bibliothèque*, 61.

130. Bede emphasized the symbolism of the pillars: *Et statuit duas columnas in porticu templi. Cum statuisset columnam dexteram, vocavit eam nomine Jachin, id est, firmitas. Similiter erexit secundam columnan, et vocavit nomen ejus Booz, id est, in robore. Dextera columna, ut supra diximus, exprimit figuram doctorum qui primitivam in Hierosolymis instituerunt Ecclesiam; secunda eorum qui ad praedicandum gentibus destinati sunt. Vel certe dextera columna eos significat qui*

venturum in carne Dominum prophetando praedixerant; secunda, illos, qui hunc jam venisse, et mundum suo sanguine redemisse, testantur (Migne, *PL* 91, col. 786A and B). Rabanus' treatment of the Temple pillars appears in his broad discussion of columns, whose mystical significance stems from their reference to Jachin and Booz. On this issue, see Onians, *Bearers of Meaning*, 75–76.

131. Onians, *Bearers of Meaning*, 88–89.

132. The statues were removed from the façade in 1771. They are known from fragments, drawings by Antoine Benoist (1725–1728), and engravings made after Benoist's drawings published by Bernard de Montfaucon (1729). See Little, "Monumental Sculpture at Saint-Denis," 26–27.

133. Cahn, *Solomonic Elements*, 55.

134. The columns are now in the baptismal chapel at the end of the south aisle. The style of the carving and epigraphy suggest that they were made in the second quarter of the thirteenth century. See Cahn, *Solomonic Elements*, 50–56; and Rosenau, *Vision of the Temple*, 34–35. Two Corinthian capitals at the entrance to the choir of the twelfth-century church of Sainte-Croix at Champeix (Auvergne) are inscribed with the words CIACHIN and BOOT. These capitals sit atop fluted pilaster piers, which attests to the flexibility with which builders used biblical models. On the capitals at Champeix, see Baudoin, *Auvergne*, 43; Świechowski, *Sculpture romane*, 33–35; and Cahn, *Solomonic Elements*, 63, note 14. On the Solomonic aspects of columns and capitals in Romanesque churches in Auvergne, see Heyman, *"That Old Pride of the Men of Auvergne,"* 49–73.

135. *Domine, dilexi decorem domus tuae, et locum habitationis gloriae tuae. Decorantur ecclesiae caelaturis, picturis et tornatilibus sculpturis, quae a tabernaculo Moysis, vel templo Salomonis, formam accipiunt* (Migne, *PL* 213, col. 40). My translation.

136. Krautheimer, "Introduction," 5.

137. Armi, *Design and Construction*.

138. Heitz, "Galilées bourguignonnes," 253–722. I am grateful to Kristine Tanton for alerting me to this issue.

139. It warrants mention that the church of Saint-Polyeuktos had been dismantled by the twelfth century and could not have served as a model for French builders.

140. Chareyron, *Pilgrims to Jerusalem*, 81.

141. Panofsky, *Abbot Suger*, 64–65.

142. For example, Ibn Jubayr (d. 1217), who traveled from his native al-Andalus to Egypt in 1182–1183, reveals that Saladin (d. 1193) used Frankish prisoners of war to build a fortress called the Citadel in Cairo. The Christian prisoners were reportedly so numerous that free workmen were deemed unnecessary for the actualization of Saladin's other architectural projects. Ibn Jubayr's report was embellished by the Egyptian historian al-Maqrizi (d. 1442), who stated that Saladin employed 50,000 prisoners of war to build the Citadel. See Lev, "Prisoners of War." On the forced labor of Latin prisoners in the building projects of fourteenth-century Cairo, see Loiseau, "Frankish Captives." I would like to thank Finbarr Barry Flood for bringing this issue to my attention.

143. There are several documented examples of the exchange or ransoming of prisoners. For instance, the Crusaders released the Fatimid emir Shawar in 1116–1117 in exchange for Christian prisoners held by the Fatimids. In 1158–1159, the Fatimids captured Crusaders of high military rank. These prisoners were subsequently released and sent to Byzantium. See Lev, "Prisoners of War," 19–27.

AFTERWORD

1. For recent perspectives on the senses, in particular the non-ocular senses, see the essays in Jørgensen, Laugerud, and Skinnebach, eds., *Saturated Sensorium*.

2. Monti, *Sense of the Sacred*, 279.

3. Monti, *Sense of the Sacred*, 279.

4. Monti, *Sense of the Sacred*, 281.

5. Monti, *Sense of the Sacred*, 281.

6. Monti, *Sense of the Sacred*, 283.
7. Monti, *Week of Salvation*, 44.
8. Quoted in Monti, *Sense of the Sacred*, 287.
9. Foliage also featured in the prayer following the prostration, which stressed the symbolism of the palm and olive branches. Monti, *Sense of the Sacred*, 289.
10. *Missale Ambianense*; Monti, *Sense of the Sacred*, 746.
11. Monti, *Sense of the Sacred*, 329.
12. Rubin, *Corpus Christi*, 249.
13. *Ès jardins de ladicte ville pour ceuillir des roses pour faire des chapeaux pour ladicte fete comme les jeunes hommes de ladicte ville ont acoustumé de fere.* My translation. Rubin, *Corpus Christi*, 249. Also see Vaultier, *Folklore*, 120.
14. Durandus, *Rationale*, 7.20.
15. Paulinus of Nola, "De S. Felice natalitium carmen," III, *Poema* 14, v.110–12. Also see Goody, *Culture of Flowers*, 122.
16. Jerome, *Epistola* LX, "Ad heliodorum epitaphium nepotiani" (Migne, *PL* 22, col. 597). Also see Goody, *Culture of Flowers*, 122.
17. This practice appears in Severus' description of the Alexandrine ritual. See Herbermann et al., *Catholic Encyclopedia*, vol. 6, 385.
18. John Chrysostom, *Homily IX, 1 Timothy*, in Schaff, ed., *Nicene and Post-Nicene Fathers*, vol. 13, 437.
19. McLean, *Medieval English Gardens*, 69.
20. McLean, *Medieval English Gardens*, 69–70.

Bibliography

Abdul-Hak, Selim. *La sculpture des porches du transept de la cathédrale de Chartres: étude iconographique et stylistique des sources du classicisme gothique*. Paris: E. de Boccard, 1942.

Abel, Louis Félix-Marie, and Hugues Vincent. *Jérusalem. Recherches de topographie, d'archéologie et d'histoire. T. 2. Jérusalem Nouvelle*. Paris: J. Gabalda, 1914.

Adam de Perseigne. *Lettres*. Translated by Jean Bouvet. Vol. 1. Paris: Éditions du Cerf, 1960.

Adam of Saint Victor. *The Liturgical Poetry of Adam of St. Victor*. Translated by Digby S. Wrangham. Vol. 1. London: Kegan Paul, Trench & Co., 1881.

Aelred of Rievaulx. *De institutione inclusarum*. Edited by Anselm Hoste and C. H. Talbot. Turnhout: Brepols, 1971.

Alan of Lille. *The Plaint of Nature*. Translated by James J. Sheridan. Toronto: Pontifical Institute of Mediaeval Studies, 1980.

Alexander, Jonathan J. G. "Iconography and Ideology: Uncovering Social Meanings in Western Medieval Christian Art." *Studies in Iconography* 15 (1993): 1–44.

Alexander, Jonathan J. G. "*Labeur* and *Paresse*: Ideological Representations of Medieval Peasant Labor." *Art Bulletin* 72 (1990): 436–52.

Alfonsi, Tommaso. *Pier de' Crescenzi (1233–1321): Studi e documenti*. Bologna: Licinio Cappelli Editore, 1933.

Ambrose. *De paradiso*. Translated by John J. Savage. *Saint Ambrose: Hexameron, Paradise, and Cain and Abel*. New York: Fathers of the Church, 1961.

Ambrose. *De patriarchis*. Edited by Karl Schenkl. *Sancti Ambrosii Opera*. Vol. 2. Vindobonae: F. Tempsky, 1897.

Ambrose, Kirk. *The Nave Sculpture of Vézelay: The Art of Monastic Viewing*. Toronto: Pontifical Institute of Mediaeval Studies, 2006.

Ambrosius Autpertus. *Expositionis in Apocalypsin*. Edited by Robert Weber, CCCM 27–27A. Turnhout: Brepols, 1975.

Ambrosoli, Mauro. *The Wild and the Sown: Botany and Agriculture in Western Europe, 1350–1850*. Cambridge: Cambridge University Press, 1997.

Ameisenowa, Zofja, and W. F. Mainland. "The Tree of Life in Jewish Iconography." *Journal of the Warburg Institute* 2 (1939): 326–45.

Ammianus Marcellinus. *The Roman History*. Translated by Charles D. Yonge. London: G. Bell, 1894.

Amy, Robert, and Pierre Gros. *La Maison Carrée de Nîmes*. Paris: Éditions du CNRS, 1979.

Anderson, Frank J. *An Illustrated History of the Herbals*. New York: Columbia University Press, 1977.

Anderson, J. G. C., ed. *Cornelii Taciti—de Origine et Situ Germanorum*. Oxford: Clarendon Press, 1938.

Andrieu, Michel. *Le pontifical romain du Moyen-Âge*. 4 vols. Vatican City: Biblioteca apostolica vaticana, 1938.

Andrieu, Michel. *Les ordines romani du haut moyen âge, IV, Les textes: Ordines XXXV–XLIX*. Louvain: Spicilegium sacrum lovaniense bureaux, 1956.

Anfray, Marcel. *L'architecture religieuse du Nivernais au moyen âge: les églises romanes*. Paris: Picard, 1951.

Angheben, Marcel, ed. *Le patrimoine de la basilique de Vézelay*. Charenton-le-Pont: Flohic, 1999.

Angheben, Marcello. *Les chapiteaux romans de Bourgogne: thèmes et programmes*. Turnhout: Brepols, 2003.

Aniel, Jean-Pierre. *Les maisons des Chartreux: des origines à la Chartreuse de Pavie*. Bibliothèque de la Société française d'archéologie, 16. Genève: Droz, 1983.

Apollodorus of Athens. *The Library*. Translated by James George Frazer. Vol. 1. Cambridge, MA: Harvard University Press, 1921.

Armi, C. Edson. "The Context of the Nave Elevation at Cluny III." *JSAH* 69 (2010): 320–51.

Armi, C. Edson. *Design and Construction in Romanesque Architecture: First Romanesque Architecture and the Pointed Arch in Burgundy and Northern Italy*. Cambridge: Cambridge University Press, 2004.

Armi, C. Edson. *Masons and Sculptors in Romanesque Burgundy: The New Aesthetic of Cluny III*. University Park: The Pennsylvania State University Press, 1983.

Armi, C. Edson. "Report on the Destruction of Romanesque Architecture in Burgundy." *JSAH* 55 (1996): 300–27.

Armstrong, Gregory T. "The Cross in the Old Testament: According to Athanasius, Cyril of Jerusalem and the Cappadocian Fathers." In *Theologia Crucis-Signum Crucis: Festschrift für Erich Dinkler zum 70. Geburtstag*, edited by Erich Dinkler, Carl Andresen, and Günter Klein, 17–38. Tübingen: Mohr, 1979.

Arnason, H. Harvard. "The History of the Chalice of Antioch." *The Biblical Archaeologist* 4 (1941): 49–64.

Astell, Ann W. *The Song of Songs in the Middle Ages*. Ithaca, NY: Cornell University Press, 1990.

Augustine. *The City of God*. Translated by Marcus Dods. New York: Modern Library, 2000.

Augustine. *De Genesi ad Litteram*. Translated by John Hammond Taylor. *The Literal Meaning of Genesis*. Vol. 2. New York: Newman Press, 1982.

Augustine. *The Enchiridion on Faith, Hope, and Love*, edited by Thomas S. Hibbs. Washington, DC: Regnery Gateway, 1996.

Augustine. *Expositions of the Psalms*. Translated by Maria Boulding. Hyde Park, NY: New City Press, 2004.

Augustine. *Homilies on the Gospel according to S. John: And His First Epistle*. Vol. 11. London: W. Smith, 1883–1884.

Baert, Barbara. "'An Odour. A Taste. A Touch. Impossible to Describe': *Noli me tangere* and the Senses." In *Religion and the Senses in Early Modern Europe*, edited by Wietse de Boer and Christine Göttler, 109–51. Leiden: Brill, 2012.

Baert, Barbara. "Noli me tangere: Narrative and Iconic Space." In *Jerusalem as Narrative Space: Erzählraum Jerusalem*, edited by Annette Hoffmann and Gerhard Wolf, 323–50. Leiden: Brill, 2012.

Baltrušaitis, Jurgis. *La stylistique ornementale dans la sculpture romane*. Paris: E. Leroux, 1931.

Bandmann, Günter. *Mittelalterliche Architektur als Bedeutungsträger*. Berlin: Mann, 1951.

Bardill, Jonathan. *Brickstamps of Constantinople*. 2 vols. Oxford: Oxford University Press, 2004.

Bardill, Jonathan. "A New Temple for Byzantium: Anicia Juliana, King Solomon, and the Gilded Ceiling of the Church of St. Polyeuktos in Constantinople." In *Social and Political Life in Late Antiquity*, edited by William Bowden et al., 339–70. Leiden: Brill, 2006.

Barnes, Carl F., Jr. "The Cathedral of Chartres and the Architect of Soissons." *JSAH* 22 (1963): 63–74.

Barnes, Carl F., Jr. "The Twelfth-Century Transept of Soissons: The Missing Source for Chartres?" *JSAH* 28 (1969): 9–25.

Barnet, Peter, and Nancy Y. Wu. *The Cloisters: Medieval Art and Architecture*. New York: The Metropolitan Museum of Art; New Haven: Yale University Press, 2005.

Barnoud, Jean-Noël, et al. *Paray-le-Monial*. Paris: Éditions Zodiaque, 2004.

Baron, Françoise. "Le tombeau de Charles V au musée des Monuments français." *Bulletin de la Société nationale des antiquaires de France* (1986): 253–56.

Baron, Françoise. "Mort et résurrection du jubé de la cathédrale d'Amiens." *Revue de l'Art* 87 (1990): 29–41.

Baron, Jean. *Description de l'église cathédrale Notre-Dame d'Amiens*. Amiens: Yvert et Tellier, 1900.

Basford, Kathleen. *The Green Man*. Ipswich: D. S. Brewer, 1978.

Baud, Anne. *Cluny, un grand chantier médiéval au cœur de l'Europe*. Paris: Picard, 2003.

Baudoin, Jacques. *Auvergne: terre romane*. Cournon: Éditions de Borée, 1993.

Baudoin, Jacques. *La sculpture flamboyante en Normandie et Ile-de-France*. Nonette: CRÉER, 1992.

Baudoin, Paul-Médéric. "Monographie de l'église Saint-Lazare d'Avallon." *Bulletin de la Société d'études d'Avallon* 20 (1879): 5–27.

Baudot, Jules, and Léon Chaussin. *Vies des saints et des bienheureux selon l'ordre du calendrier avec l'historique des fêtes*. 12 vols. Paris: Librairie Letouzey et Ané, 1935–1959.

Baum, Julius. "The Porch of Andlau Abbey." *Art Bulletin* 17 (1935): 492–505.

Baumgarten, Joseph. "The Qumran Sabbath Shirot and Rabbinic Merkabah Traditions." *Revue de Qumran* 13 (1988): 199–213.

Bayard, Tania. *Sweet Herbs and Sundry Flowers: Medieval Gardens and the Gardens of the Cloisters*. New York: The Metropolitan Museum of Art, 1985.

Beaussart, Pierre. *L'église bénédictine de La Charité-sur-Loire, Fille aînée de Cluny*. La Charité-sur-Loire: A Delayance, 1929.

Bede. *On Genesis*. Translated by Calvin B. Kendall. Liverpool: Liverpool University Press, 2008.

Behling, Lottlisa. *Die Pflanzenwelt der mittelalterlichen Kathedralen*. Cologne: Böhlau, 1964.

Bel, Catherine, and Herman Braet. *De la Rose: texte, image, fortune*. Louvain: Peeters, 2006.

Bellanger, H. *Guide-illustré de Moret-sur-Loing*. Moret-sur-Loing: Imprimerie de H. Bellanger, 1908.

Belting, Hans. *Hieronymus Bosch: Garden of Earthly Delights*. Munich and New York: Prestel, 2005.

Benedict. *Saint Benedict's Rule*. Translated by Patrick Barry. Mahwah, NJ: Hidden Spring, 2004.

Berger, Pamela. *The Crescent on the Temple: The Dome of the Rock as Image of the Ancient Jewish Sanctuary*. Leiden and Boston: Brill, 2012.

Bernard of Cluny. *Scorn for the World: Bernard of Cluny's De contemptu mundi: The Latin Text with English Translation and an Introduction*. Translated by Ronald E. Pepin. East Lansing, MI: Colleagues Press, 1991.

Bernardus Silvestris. *The Cosmographia of Bernardus Silvestris*. Translated by Winthrop Wetherbee. New York: Columbia University Press, 1990.

Bestul, Thomas H. *Texts of the Passion: Latin Devotional Literature and Medieval Society*. Philadelphia: University of Pennsylvania Press, 1996.

Bideault, Maryse, and Claudine Lautier. "Saint-Nicaise de Reims: chronologie et nouvelles remarques sur l'architecture." *Bulletin monumental* 135 (1977): 295–330.

Binski, Paul. *Becket's Crown: Art and Imagination in Gothic England, 1170–1300*. New Haven: Yale University Press, 2005.

Binski, Paul. *Gothic Wonder: Art, Artifice and the Decorated Style 1290–1350*. New Haven: Yale University Press, 2014.

Binski, Paul. *Medieval Death: Ritual and Representation*. Ithaca, NY: Cornell University Press, 1996.

Bloch, Marc. *Les caractères originaux de l'histoire rurale française*. Paris: A. Colin, 1955–56.

Blum, Pamela Z. *Early Gothic Saint-Denis: Restorations and Survivals*. Berkeley: University of California Press, 1992.

Böcher, Otto. "Zur jüngeren Ikonographie der Wurzel Jesse." *Mainzer Zeitschrift* 67–68 (1972–1973): 153–68.

Bodner, Neta. "The Baptistery of Pisa and the Rotunda of the Holy Sepulchre: A Reconsideration." In *Visual Constructs of Jerusalem*, edited by Bianca Kühnel, Galit Noga-Banai, and Hanna Vorholt, 95–105. Turnhout: Brepols, 2014.

Boeck, Urs. "Das Baptisterium zu Pisa und die Jerusalemer Anastasis." *Bonner Jahrbücher* 164 (1964): 146–56.

Bonaventure. *Holiness of Life: Being St. Bonaventure's Treatise De perfectione vitae ad sorores*. Translated by Laurence Costello. St. Louis: Herder, 1928.

Bonaventure. *Lignum vitae*. Translated by José de Vinck. *The Works of Bonaventure. 1, Mystical opuscula: Cardinal, Seraphic Doctor, and Saint*. Paterson, NJ: St. Anthony Guild Press, 1960.

Bonne, Jean-Claude. "De l'ornement à l'ornementalité: la mosaïque absidiale de San Clemente de Rome." In *Le rôle de l'ornement dans la peinture murale du Moyen Âge: actes du colloque international tenu à Saint-Lizier du 1er au 4 juin 1995, Poitiers, centre d'études supérieures de civilisation médiévale*, edited by John Ottaway, 103–19. Vol. 4. Poitiers: Université de Poitiers, CNRS, 1997.

Bonne, Jean-Claude. "De l'ornement dans l'art médiéval (VIIᵉ–XIIᵉ siècle). Le modèle insulaire." In *L'image: fonctions et usages des images dans l'Occident médiéval; actes du 6ᵉ 'International Workshop on Medieval Societies,' Centre Ettore Majorana (Erice, Sicile, 17–23 octobre 1992)*, edited by Jérôme Baschet and Jean-Claude Schmitt, 207–49. Paris: Léopard d'Or, 1996.

Bonne, Jean-Claude. "Les ornements de l'histoire (à propos de l'ivoire carolingien de saint Rémi)." *Annales. Histoire, Sciences Sociales* 51 (1996): 37–70.

Bony, Jean. *French Gothic Architecture of the 12th and 13th Centuries*. Berkeley: University of California Press, 1983.

Bork, Robert, Robert Mark, and Stephen Murray. "The Openwork Flying Buttresses of Amiens Cathedral: 'Postmodern Gothic' and the Limits of Structural Rationalism." *JSAH* 56 (1997): 478–93.

Bottineau-Fuchs, Yves. *Haute-Normandie Gothique*. Paris: Picard, 2001.

Bourdieu, Pierre. *Distinction: A Social Critique of the Judgment of Taste*. Translated by Richard Nice. Cambridge: Harvard University Press, 1984.

Bouttier, Michel. *La cathédrale du Mans*. Le Mans: Éditions de la Reinette, 2000.

Bouttier, Michel. "Le chevet de la cathédrale du Mans: recherches sur le premier projet." *Bulletin monumental* 161 (2003): 291–306.

Bowen, Lee. "The Tropology of Mediaeval Dedication Rites." *Speculum* 16 (1941): 469–79.

Brachmann, Christoph. "La construction de la cathédrale Saint-Étienne de Metz et de l'église collégiale Notre-Dame-la-Ronde pendant le deuxième tiers du XIIIᵉ siècle." *Congrès archéologique de France* 149 (1991): 447–75.

Branham, Joan R. "Penetrating the Sacred: Breaches and Barriers in the Jerusalem Temple." *Thresholds of the Sacred: Architectural, Art Historical, Liturgical, and Theological Perspectives on Religious Screens, East and West*, edited by Sharon Gerstel, 6–24. Washington, DC: Dumbarton Oaks Research Library Collection, 2006.

Branner, Robert. *Burgundian Gothic Architecture*. London: A. Zwemmer, 1960.

Braun, Joseph. *Der christliche Altar in seiner geschichtlichen Entwicklung (Band 1): Arten, Bestandteile, Altargrab, Weihe, Symbolik*. München: Alte Meister Guenther Koch, 1924.

Braun-Reichenbacher, Margot. *Das Ast- und Laubwerk: Entwicklung, Merkmale und Bedeutung einer spätgotischen Ornamentform*, Erlanger Beiträge zur Sprach- und Kunstwissenschaft, 24. Nürnberg: Hans Carl, 1966.

Bredero, Adriaan H. *Bernard of Clairvaux: Between Cult and History*. Grand Rapids, MI: W. B. Eerdmans, 1996.

Bresc-Bautier, Geneviève. "Les imitations du Saint-Sépulcre de Jérusalem (IXᵉ–XVᵉ siècles): archéologie d'une dévotion." *Revue d'histoire de la spiritualité* 50 (1974): 319–42.

Brinner, William M., ed. *A Chronicle of Damascus 1389–1397 by Muhammad ibn Muhammad ibn Saṣrā*. 2 vols. Berkeley: University of California, 1963.

Brown, Elizabeth A. R. "The Chapels and Cult of Saint Louis at Saint-Denis." *Mediaevalia* 10 (1988): 279–331.

Brownlee, Kevin, and Sylvia Huot, eds. *Rethinking the Romance of the Rose: Text, Image, Reception*. Philadelphia: University of Pennsylvania Press, 1992.

Bruel, Alexandre, and Auguste Bernard. *Recueil des chartes de l'abbaye de Cluny*. 6 vols. Paris: Imprimerie nationale, 1876–1903.

Bryda, Gregory. *Tree, Vine, and Herb: Vegetal Themes and Media in Late Gothic Germany*. PhD dissertation, Yale, 2016.

Bucher, François. "Fifteenth-Century German Architecture. Architects in Transition." In *Artistes, artisans et production artistique au Moyen Age*, edited by Xavier Barral i Altet, 409–16. Vol. 2. Paris: Picard 1987.

Büchner, Joachim. "Ast-, Laub- und Masswerkgewölbe der endenden Spätgotik: Zum Verhältnis von Architektur, dekorativer Malerei und Bauplastik." In *Festschrift Karl Oettinger: zum 60. Geburtstag am 4. März 1966*, edited by Karl Oettinger, Hans Sedlmayr, and Wilhelm Messerer, 265–301. Erlangen: Universitätsbund Erlangen-Nürnberg, 1967.

Büchsel, Martin. *Skulptur des Querhauses der Kathedrale von Chartres*. Berlin: Mann, 1995.

Bugslag, James. "Contrefais al vif': Nature, Ideas and Representation in the Lion Drawings of Villard de Honnecourt." *Word and Image* 17 (2001): 360–78.

Burchard of Mount Sion, "Descriptio terrae sanctae." In *Peregrinatores Medii Aevi Quatuor*, edited by J. C. M. Laurent. Leipzig: J. C. Hinrichs, 1864.

Cahn, Walter. "Architectural Draftsmanship in Twelfth-Century Paris: The Illustrations of Richard of Saint-Victor's Commentary on Ezekiel's Temple Vision." *Gesta* 15 (1976): 247–54.

Cahn, Walter. "Architecture and Exegesis: Richard of St.-Victor's Ezekiel Commentary and Its Illustrations." *Art Bulletin* 76 (1994): 53–68.

Cahn, Walter. "Solomonic Elements in Romanesque Art." In *The Temple of Solomon*, edited by Joseph Gutmann, 45–72. Missoula, MT: Scholars Press, 1976.

Cahn, Walter, et al. *Romanesque Sculpture in American Collections: II. New York and New Jersey, Middle and South Atlantic States, the Midwest, Western and Pacific States*. Turnhout: Brepols, 1999.

Calkins, Robert G. "Piero de' Crescenzi and the Medieval Garden." In *Medieval Gardens*, edited by Elisabeth B. MacDougall, 155–73. Washington, DC: Dumbarton Oaks Research Library and Collection, 1986.

Camerlenghi, Nicola. "The Longue Durée and the Life of Buildings." In *New Approaches to Medieval Architecture*, edited by Robert Bork, William W. Clark, and Abby McGehee, 11–20. Farnham: Ashgate, 2011.

Camille, Michael. *Gothic Art: Visions and Revelations of the Medieval World*. London: Weidenfeld and Nicolson, 1996.

Camille, Michael. "Gothic Signs and the Surplus: The Kiss on the Cathedral." *Yale French Studies*, Special Issue: Contexts: Style and Values in Medieval Art and Literature (1991): 151–70.

Camille, Michael. *Image on the Edge: The Margins of Medieval Art*. London: Reaktion Books, 1992.

Camille, Michael. "The Très Riches Heures: An Illuminated Manuscript in the Age of Mechanical Reproduction." *Critical Inquiry* 17 (1990): 72–107.

Canadé Sautman, Francesca. *La religion du quotidien: rites et croyances populaires de la fin du Moyen Âge*. Firenze: Leo S. Olshcki Editore, 1995.

Carment-Lanfry, Anne-Marie. *La cathédrale Notre-Dame de Rouen*. Rouen: Imprimerie T.A.G., 1989.

Carruthers, Mary. *The Craft of Thought: Meditation, Rhetoric, and the Making of Images, 400–1200*. Cambridge: Cambridge University Press, 1998.

Carruthers, Mary. *The Experience of Beauty in the Middle Ages*. Oxford: Oxford University Press, 2013.

Carty, Carolyn M. "The Role of Gunzo's Dream in the Building of Cluny III." *Gesta* 27 (1988): 113–23.

Carver McCurrach, Catherine. "'Renovatio' Reconsidered: Richard Krautheimer and the Iconography of Architecture." *Gesta* 50 (2011): 41–69.

Castriota, David. *The Ara Pacis Augustae and the Imagery of Abundance in Later Greek and Early Roman Imperial Art*. Princeton: Princeton University Press, 1995.

Cavell, Stanley. *The World Viewed*. 1971. Reprint, Cambridge: Harvard University Press, 1979.

Caviness, Madeline H. "Saint-Yved of Braine: The Primary Sources for Dating the Gothic Church." *Speculum* 59 (1984): 524–48.

Caviness, Madeline H. *Sumptuous Arts and the Royal Abbeys in Reims and Braine: Ornatus Elegantiae, Varietate Stupendes*. Princeton: Princeton University Press, 1990.

Chaline, Jean-Pierre, ed. *La cathédrale de Rouen: seize siècles d'histoire*. Rouen: Société de l'histoire de Normandie, 1996.

Chareyron, Nicole. *Pilgrims to Jerusalem in the Middle Ages*. Translated by W. Donald Wilson. New York: Columbia University Press, 2005.

Châteaubriand, François-Réné de. *Génie du Christianisme*. 2 vols. Paris: Louis Vivès, 1878.

Chatel, Marie Louise. *Le culte de la Vierge en France du Vᵉ au XIIᵉ siècle*. PhD dissertation, Université Paris IV Sorbonne, 1945.

Chenu, Marie-Dominique. "L'homme et la nature. Perspectives sur la Renaissance du XIIᵉ siècle." *Archives d'Histoire Doctrinale et Littéraire du Moyen Âge* 27 (1952): 39–66.

Chenu, Marie-Dominique. *Nature, Man, and Society in the Twelfth Century: Essays on New Theological Perspectives in the Latin West*. Toronto: University of Toronto Press, 1998.

Chéruel, Adolphe. *Histoire de Rouen pendant l'époque communale, 1150–1328, suivie de pièces justificatives*. 2 vols. Rouen: Périaux, 1843–1844.

Clark, Elizabeth A. *The Origenist Controversy: The Cultural Construction of an Early Christian Debate*. Princeton: Princeton University Press, 1992.

Clark, William W. *Laon Cathedral*. 2 vols. London: Harvey Miller, 1983.

Clark, William W. "Notes on the Original Design of the Choir and Chevet of Saint-Rémi at Reims." In *Pierre, Lumière, Couleur: Étude d'histoire de l'art du moyen âge en l'honneur d'Anne Prache*, edited by Anne Prache, Fabienne Joubert, and Dany Sandron, 67–75. Paris: Presses de l'Université de Paris-Sorbonne, 1999.

Clark, William W. "Reading Reims, I. The Sculptures on the Chapel Buttresses." *Gesta* 39 (2000): 135–45.

Clark, William W. "'The Recollection of the Past Is the Promise of the Future.' Continuity and Contextuality: Saint-Denis, Merovingians, Capetians, and Paris." In *Artistic Integration in Gothic Buildings*, edited by Virginia Chieffo Raguin, Kathryn Brush, and Peter Draper, 92–113. Toronto: University of Toronto Press, 1995.

Classen, Albrecht. *The Forest in Medieval German Literature: Ecocritical Readings from a Historical Perspective*. New York and London: Lexington Books, 2015.

Claussen, Peter C. *Chartres-Studien: zu Vorgeschichte, Funktion und Skulptur der Vorhallen*. Wiesbaden: Franz Steiner, 1975.

Clement of Alexandria. *Christ the Educator*. Translated by Simon P. Wood. 1954. Reprint, Washington, DC: Catholic University of America Press, 2008.

Coathalem, Hervé. *Le parallélisme entre la sainte Vierge et l'église dans la tradition latine jusqu'à la fin du XIIᵉ siècle*. Romae: Apud aedes Universitatis Gregorianae, 1954.

Cochet, Jean-Benoît. *Les églises de l'arrondissement de Dieppe*. Paris: Derache, Dumoulin, 1850.

Cohen, Meredith. *The Sainte-Chapelle of Paris and the Construction of Sacral Monarchy: Royal Architecture in Thirteenth-Century Paris*. Cambridge: Cambridge University Press, 2015.

Cohen, Meredith, and Xavier Dectot. *Paris ville rayonnante: Musée de Cluny 10 février-24 mai 2010*. Paris: Réunion des musées nationaux, 2010.

Collingwood, R. G. *The Idea of Nature*. Oxford: Clarendon Press, 1945.

Collins, Minta. *Medieval Herbals: The Illustrative Traditions*. Toronto and Buffalo: University of Toronto Press, 2000.

Conant, Kenneth J. *Carolingian and Romanesque Architecture, 800–1200*. Harmondsworth: Penguin Books, 1959.

Conant, Kenneth J. "Cluniac Building during the Abbacy of Peter the Venerable." In *Petrus Venerabilis 1156–1956: Studies and Texts Commemorating the Eighth Centenary of his Death*, edited by Gilles Constable and James Kritzeck, 121–27. Rome: Herder, 1956.

Conant, Kenneth J. *Les églises et la maison du chef d'ordre*. Mâcon: Imprimerie Protat Frères, 1968.

Conant, Kenneth J. "The Third Church at Cluny." In *Medieval Studies in Memory of A. Kingsley Porter*, edited by W. Koehler, 327–58. Vol. 2. Cambridge, MA: Harvard University Press, 1939.

Conner, Carolyn L. "The Epigram in the Church of Hagios Polyeuktos in Constantinople and Its Byzantine Response." *Byzantion* 69 (1999): 479–527.

Constable, Giles. *The Abbey of Cluny: A Collection of Essays to Mark the Eleven-Hundredth Anniversary of Its Foundation*. Berlin: Lit, 2010.

Constable, Giles. "Renewal and Reform in Religious Life: Concepts and Realities." In *Renaissance and Renewal in the Twelfth Century*, edited by Robert L. Benson, Giles Constable, and Carol D. Lanham, 37–67. Toronto: University of Toronto Press, 1991.

Constable, Giles. "The Three Lives of Odo Arpinus: Viscount of Bourges, Crusader, Monk of Cluny." In *Religion, Text, and Society in Medieval Spain and Northern Europe: Essays in Honor of J. N. Hillgarth*, edited by Thomas E. Burman et al., 183–99. Toronto: Pontifical Institute of Mediaeval Studies, 2002.

Corblet, Jules. *Hagiographie du diocèse d'Amiens*. Vol. 3. Paris: J.-B. Dumoulin, 1873.

Corbo, Virgilio. *Il Santo Sepolcro di Gerusalemme: aspetti archeologici dalle origini al periodo crociato*. 3 vols. Jerusalem: Franciscan Printing Press, 1981.

Corippus. *In laudem Iustini Augusti minoris, Libri IV*. Translated by Averil Cameron. London: The Athlone Press, 1976.

Corroyer, Édouard J. *Guide descriptif du Mont Saint-Michel*. Paris: André Daly, 1886.

Corsepius, Katharina. *Notre-Dame-en-Vaux: Studien zur Baugeschichte des 12. Jahrhunderts in Châlons-sur-Marne*. Stuttgart: F. Steiner, 1997.

Coutan, Ferdinand. "Église Notre-Dame-et-Saint-Laurent: Eu." *Congrès archéologique de France* 99 (1936): 388–412.

Creswell, Keppel A. C. *Early Muslim Architecture*. 2 vols. 1932–1940. Reprint, Oxford: Clarendon Press, 1969.

Cronon, William, ed. *Uncommon Ground: Toward Reinventing Nature.* New York: Norton, 1995.

Crosby, Sumner Knight. *The Royal Abbey of Saint-Denis: From Its Beginnings to the Death of Suger, 475–1151.* New Haven: Yale University Press, 1987.

Crossley, Paul. "*Ductus and memoria*: Chartres Cathedral and the Workings of Rhetoric." In *Rhetoric beyond Words: Delight and Persuasion in the Arts of the Middle Ages*, edited by Mary Carruthers, 214–49. Cambridge: Cambridge University Press, 2010.

Crossley, Paul. "Medieval Architecture and Meaning: The Limits of Iconography." *Burlington Magazine* 130 (1988): 116–21.

Crossley, Paul. "The Return to the Forest: Natural Architecture and the German Past in the Age of Dürer." In *Künstlerischer Austausch Artistic Exchange: Akten des XXVIII. Internationalen Kongresses für Kunstgeschichte*, edited by Thomas W. Gerhtgens, 71–80. Vol. 2. Berlin: Akademie Verlag, 1993.

Crow, Jason. "The Sacred Stones of Saint-Denis." In *Chora 6: Intervals in the Philosophy of Architecture*, edited by Alberto Pérez-Gómez and Stephen Parcell, 55–74. Montreal: McGill-Queens University Press, 2011.

Crowther, Paul. "More than Ornament: The Significance of Riegl." *Art History* 17 (1994): 482–94.

Cunningham, Francis L. B. "The Relationship between Mary and the Church in Medieval Thought." *Marian Studies* 9 (1958): 52–78.

Dagron, Gilbert. *Constantinople imaginaire: études sur le Recueil des "Patria."* Paris: Presses universitaires de France, 1984.

Dagron, Gilbert. *Emperor and Priest: The Imperial Office in Byzantium.* Cambridge: Cambridge University Press, 2003.

Dale, Thomas E. A. *Relics, Prayer, and Politics in Medieval Venetia: Romanesque Painting in the Crypt of Aquileia Cathedral.* Princeton: Princeton University Press, 1997.

Dale, Thomas E. A. "Vers une iconologie de l'ornement dans la peinture murale romane: le sens allégorique des tentures feintes de la crypte de la basilique patriarchale d'Aquilée." In *Le rôle d'l'ornement dans la peinture murale du Moyen Âge, actes du colloque tenu à Saint-Lizier du 1er au 4 juin 1995, Poitiers, centre d'études supérieures de civilisation médiévale* 4, edited by John Ottaway, 139–48. Poitiers: Université de Poitiers, CNRS, 1997.

Daley, Brian E. "The 'Closed Garden' and 'Sealed Fountain': Song of Songs 4:12 in the Late Medieval Iconography of Mary." In *Medieval Gardens*, edited by Elisabeth Blair Macdougall, 253–78. Washington, DC: Dumbarton Oaks Research Library and Collection, 1986.

Danby, Herbert, ed. *The Mishnah.* Peabody, MA: Hendrickson Publishers, 2011.

Darmon, Jean-Pierre. "Dionysos chez les Lingons: le pur classicisme de la mosaïque de Langres." In *Imago Antiquitatis: religions et iconographie du monde romain*, edited by Nicole Blanc and André Turcan, 197–204. Paris: De Boccard, 1999.

Darmon, Jean-Pierre. "La mosaïque de Bacchus." In *Le nouveau musée de Langres: état des lieux*, 89–95. Langres: Musée de Langres, 1996.

D'Avezac, M., ed. *Relation des voyages de Saewulf à Jerusalem et en Terre-Sainte.* Paris: Bourgogne et Martinet, 1839.

Davis, Michael T. "Cathedral, Palace, Hôtel: Architectural Emblems of an Ideal Society." In *Arts of the Medieval Cathedrals: Studies on Architecture, Stained Glass and Sculpture in Honor of Anne Prache*, edited by Kathleen Nolan and Dany Sandron, 27–45. Farnham Surrey, England; Burlington, VT: Ashgate, 2015.

Davis, Michael T. "*Sic et Non.* Recent Trends in the Study of Gothic Ecclesiastical Architecture." *JSAH* 58 (1999): 414–23.

Davis, Michael T., and Linda Elaine Neagley. "Mechanics and Meaning: Plan Design at Saint-Urbain, Troyes and Saint-Ouen, Rouen." *Gesta* 39 (2000): 161–82.

Davis, Raymond. *The Lives of the Eighth-Century Popes (Liber Pontificalis). The Ancient Biographies of Nine Popes from AD 715 to AD 817*. Liverpool: Liverpool University Press, 1992.

Davson, Hugh, ed. *The Eye*. New York: Academic Press, 1962.

Dehio, Georg, and Gustav von Bezold. *Die Kirchliche Baukunst des Abendlandes*. Stuttgart: J. G. Cotta, 1884–1901.

Deichmann, Friedrich W. "I Pilastri Acritani." *Atti della Pontifica Accademia Romana di archeologia* 50 (1977–1978): 75–89.

Deichmann, Friedrich W. *Rom, Ravenna, Konstantinopel, Naher Osten*. Wiesbaden: Steiner, 1982.

Delsalle, Lucien-René. *Rouen à la Renaissance: Sur les pas de Jacques le Lieur*. Rouen: L'Armitière, 2007.

Delumeau, Jean. *History of Paradise: The Garden of Eden in Myth and Tradition*. New York: Continuum, 1995.

Deluz, Christiane. "Le jardin médiévale, lieu d'intimité." In *Vergers et jardins dans l'univers médiéval: Sénéfiance*, no. 28, 97–107. Aix-en-Provence: Publications de CUER MA, 1990.

Demouy, Patrick, ed. *Reims, La cathédrale*. Saint-Léger-Vauban: Zodiaque, 2000.

Demus, Otto. *Byzantine Art and the West*. London: Weidenfeld and Nicholson, 1970.

Derrida, Jacques. *Of Grammatology*. Translated by Gayatri Chakravorty Spivak. Baltimore: Johns Hopkins University Press, 1998.

Derrida, Jacques. *La vérité en peinture*. Paris: Éditions Flammarion, 1978.

Deshoulières, François. *Dieppe*. Paris: Henri Laurens, 1929.

Didron, Adolphe-Napoléon. *Iconographie chrétienne: histoire de Dieu*. Paris: Imprimerie royale, 1843.

Didron, Adolphe-Napoléon. "Iconographie des cathédrales." *Annales archéologiques* 9 (1849): 41–56.

Doquang, Mailan S. "The Lateral Chapels of Notre-Dame in Context." *Gesta* 50 (2011): 137–61.

Doquang, Mailan S. *Rayonnant Chantry Chapels in Context*. PhD dissertation, Institute of Fine Arts, NYU, 2009.

Doquang, Mailan S. "Status and the Soul: Commemoration and Intercession in the Rayonnant Chapels of Northern France in the Thirteenth and Fourteenth Centuries." In *Memory and Commemoration in Medieval Culture*, edited by Elma Brenner, Mary Franklin-Brown, and Meredith Cohen, 93–118. Farnham, UK: Ashgate, 2013.

Duby, George. *L'économie rurale et la vie des campagnes dans l'occident médiévale: France, Angleterre, Empire, XI–XV siècles*. Paris: Aubier, 1962.

Duby, Georges. *Medieval Art. Europe of the Cathedrals, 1140–1280*. Geneva: Editions d'Art Albert Skira, 1995.

Durand, Alphonse, and Eugène Grave. *La chronique de Mantes: ou histoire de Mantes depuis le IX^e siècle jusqu'à la Révolution*. Mantes: G. Gillot, 1883.

Durand, Georges. *Monographie de l'église Notre-Dame, cathédrale d'Amiens*. 3 vols. Paris: Picard, 1901–1903.

Durandus, William. *The Symbolism of Churches and Church Ornaments: A Translation of the First Book of the Rationale divinorum officiorum*. Translated by John M. Neale and Benjamin Webb. Leeds: TW Green, 1843.

Durkheim, Émile. *Les formes élémentaires de la vie religieuse*. 5th ed. Paris: Presses universitaires de France, 1968.

Egger, Anne. *Amiens: la cathédrale peinte*. Paris: Perrin, 2000.

Eisen, Gustavus A. *The Great Chalice of Antioch: On Which Are Depicted in Sculpture the Earliest Known Portraits of Christ, Apostles and Evangelists*. 2 vols. New York: Kouchakji Frères, 1923.

Elad, Amikam. "The Historical Value of *Fadā'il al-Quds* Literature—a Reconsideration." *Jerusalem Studies in Arabic and Islam* 14 (1991): 41–70.

Elad, Amikam. *Medieval Jerusalem and Islamic Worship: Holy Places, Ceremonies, Pilgrimage.* Leiden: Brill, 1995.

Eliade, Mircea. *The Sacred and the Profane: The Nature of Religion.* Translated by Willard R. Trask. New York: Harcourt Brace, 1959.

Elliott, Gillian. *Regnum et sacerdotium in Alsatian Romanesque Sculpture: Hohenstaufen Politics in the Aftermath of the Investiture Controversy (1130–1235).* PhD dissertation, The University of Texas at Austin, 2005.

Elowsky, Joel C. *Ancient Christian Commentary on Scripture: The New Testament, IVb, John 11–21.* Downers Grove, IL: InterVarsity Press, 2007.

Elsner, John. "Cult and Sculpture: Sacrifice in the Ara Pacis Augustae." *JRS* 81 (1991): 50–61.

Ephraem Syrus. *Ephrem the Syrian: Hymns.* Translated by Kathleen E. McVey. New York: Paulist Press, 1989.

Epstein, Steven A. *The Medieval Discovery of Nature.* Cambridge: Cambridge University Press, 2012.

Erlande-Brandenburg, Alain. *La cathédrale d'Amiens.* Paris: Caisse nationale des monuments historiques et des sites, 1982.

Erlande-Brandenburg, Alain. "La façade de la cathédrale d'Amiens." *Bulletin monumental* 135 (1977): 253–93.

Erlande-Brandenburg, Alain. "La porte du cimetière à l'abbatiale de Saint-Denis dite 'Porte des Valois'. Emplacement originel, déplacement, datation." *Comptes rendus des séances de l'Académie des Inscriptions et Belles-Lettres* 143 (1999): 189–217.

Erlande-Brandenburg, Alain, and Dieter Kimpel. "La statuaire de Notre-Dame de Paris avant les destructions révolutionnaires." *Bulletin monumental* 136 (1978): 213–66.

Erlande-Brandenburg, Alain, and Dominique Thibaudat. *Les Sculptures de Notre-Dame de Paris au musée de Cluny.* Paris: Éditions de la Réunion des musées nationaux, 1982.

Eusebius. *Ecclesiastical History.* Translated by John E. L. Oulton. London: W. Heinemann, 1949.

Eusebius. *Life of Constantine.* Translated by Averil Cameron and Stuart G. Hall. Oxford: Oxford University Press, 1999.

Eutychii. *Contextio gemmarum, sive, Eutychii, Patriarchae Alexandrini, Annales.* Translated by Edward Pococke and John Selden. Oxoniae: Impensis Humphredi Robinson: 1658.

Evans, Joan. *Cluniac Art of the Romanesque Period.* Cambridge: Cambridge University Press, 1950.

Evans, Joan. *The Romanesque Architecture of the Order of Cluny.* Cambridge: Cambridge University Press, 1938.

Evans-Pritchard, E. E. *The Nuer: A Description of the Modes of Livelihood and Political Institutions of a Nilotic People.* Oxford: Clarendon Press, 1940.

Fassler, Margot E. "Liturgy and Sacred History in the Twelfth-Century Tympana at Chartres." *Art Bulletin* 75 (1993): 499–520.

Fassler, Margot E. *The Virgin of Chartres: Making History through Liturgy and the Arts.* New Haven: Yale University Press, 2010.

Fehr, Götz. "Architektur." In *Die Kunst der Donauschule 1490–1540: Ausstellung des Landes Oberösterreich,* edited by Otto Wutzel, 202–16. Linz: OÖ Landesverlag, 1965.

Feldman, Louis H. *Josephus and Modern Scholarship* (1937–1980). Berlin: W. de Gruyter, 1984.

Feldman, Louis H. "A Selective Critical Bibliography of Josephus." In *Josephus, the Bible, and History,* edited by Louis H. Feldman and Gōhei Hata, 330–58. Leiden, Brill, 1989.

Feldmann, Hans-Christian. *Bamberg und Reims, Die Skulpturen 1220–1250: zur Entwicklung von Stil und Bedeutung der Skulpturen in dem unter Bischof Ekbert (1203–1237).* Ammersbek bei Hamburg: Verlag an der Lottbek, 1992.

Ferber, Stanley. "The Temple of Solomon in Early Christian and Byzantine Art." In *The Temple of Solomon*, edited by Joseph Gutmann, 21–43. Missoula, MT: Scholars Press, 1976.

Feuchtmüller, Rupert, and Benno Ulm. "Architektur des Donaustiles im Raum von Wien, Steyr und Admont." In *Die Kunst der Donauschule 1490–1540: Ausstellung des Landes Oberösterreich*, edited by Otto Wutzel, 217–34. Linz: OÖ Landesverlag, 1965.

Flavius Josephus. *The New Complete Works of Josephus*. Translated by William Whiston. Grand Rapids, MI: Kregel Publishers, 1999.

Fleck, Cathleen A. "Linking Jerusalem and Rome in the Fourteenth Century: Images of Jerusalem and the Temple in the Italian Bible of Anti-Pope Clement VII." In *Real and Ideal Jerusalem in Jewish, Christian and Islamic Art*, edited by Bianca Kühnel, 430–52. Jerusalem: The Hebrew University of Jerusalem, 1998.

Fleming, John V. *The Roman de la Rose: A Study in Allegory and Iconography*. Princeton: Princeton University Press, 1969.

Fleury, Gabriel. *La cathédrale du Mans*. Paris: Henri Laurens, 1910.

Flood, Finbarr Barry. *The Great Mosque of Damascus: Studies on the Makings of an Umayyad Visual Culture*. Leiden: Brill, 2001.

Flood, Finbarr Barry. "Umayyad Survivals and Mamluk Revivals: Qalawunid Architecture and the Great Mosque of Damascus." *Muqarnas* 14 (1997): 57–79.

Flood, John. *Representations of Eve in Antiquity and the English Middle Ages*. New York: Routledge, 2011.

Florus. *Epitome of Roman History*, edited by Edward S. Foster and John C. Rolfe. Cambridge, MA: Harvard University Press, 1929.

Focillon, Henri. *L'art des sculpteurs romans: recherches sur l'histoire des formes*. Paris: E. Leroux, 1931.

Folda, Jaroslav. "Jerusalem and the Holy Sepulchre through the Eyes of Crusader Pilgrims." *Jewish Art* 23/24 (1997/1998): 158–64.

Folda, Jaroslav. "Problems in the Iconography of the Art of the Crusaders in the Holy Land: 1098–1291/1917–1997." In *Image and Belief: Studies in Celebration of the Eightieth Anniversary of the Index of Christian Art*, edited by Colum Hourihane, 11–24. Princeton: Princeton University Press, 1999.

Foot, Sarah. "Plenty, Portents and Plague: Ecclesiastical Readings of the Natural World in Early Medieval Europe." In *God's Bounty? The Churches and the Natural World*, edited by Peter Clarke and Tony Claydon, 15–41. Woodbridge, Suffolk: Ecclesiastical History Society; Rochester, NY: Boydell and Brewer, 2010.

Förster, Christian. *Die Vorhalle als Paradies: Ikonographische Studien zur Bauskulptur der ehemaligen Frauenstiftskirche in Andlau*. Weimar: Verlag und Datenbank für Geisteswissenschaften, 2010.

Forsyth, William H. "A Gothic Doorway from Moutiers-Saint-Jean." *Metropolitan Museum Journal* 13 (1978): 33–74.

Fossey, Jules. *Monographie de la cathédrale d'Évreux*. Évreux: Imprimerie de l'Eure, 1898.

Frachon-Gielarek, Nathalie. *Amiens: les verrières de la cathédrale*. Amiens: Association pour la généralisation de l'inventaire régional en Picardie, 2003.

Franceschini, Ezio, and Robert Weber, ed. *Itinerarium Egeriae*. Turnhout: Brepols, 1958.

Frank, Jacqueline, and William W. Clark. "Abbot Suger and the Temple in Jerusalem: A New Interpretation of the Sacred Environment in the Royal Abbey of Saint-Denis." In *The Built Surface. Volume 1: Architecture and the Pictorial Arts from Antiquity to the Enlightenment*, edited by Christy Anderson and Karen Koehler, 109–29. Aldershot: Ashgate, 2002.

Frankl, Paul. "The Evolution of Gothic Architecture." Review of *Die Entstehung der Kathedrale* by Hans Sedlmayr. *Times Literary Review*, January 2, 1952.

Frankl, Paul. *Gothic Architecture*. Revised by Paul Crossley. New Haven: Yale University Press, 2000.

Frankl, Paul. *The Gothic: Literary Sources and Interpretations through Eight Centuries*. Princeton: Princeton University Press, 1960.

Freeman Sandler, Lucy. "A Bawdy Betrothal in the Ormesby Psalter." In *Tribute to Lotte Brand Philip: Art Historian and Detective*, edited by William W. Clark et al., 154–59. New York: Abaris Books, 1985.

Freeman Sandler, Lucy. "Reflections on the Construction of Hybrids in English Gothic Marginal Illustration." In *Art, the Ape of Nature, Studies in Honor of H. W. Janson*, edited by Moshe Barasch and Lucy Freeman Sandler, 51–65. New York: H. Abrams, 1981.

Friedman, John B. "The Architect's Compass in Creation Miniatures of the Later Middle Ages." *Traditio* 30 (1974): 419–29.

Frisch, Teresa G. *Gothic Art 1140–c. 1450. Sources and Documents*. Toronto: University of Toronto Press, 1987.

Gall, Ernst. Review of *Die Entstehung der Kathedrale*, by Hans Sedlmayr. *Kunstchronik* 4 (1951): 14–21.

Gallistl, Bernhard. "La porta di bronzo di Bernward da Hildesheim: iconografia e iconologia." In *La porta di Bonanno nel Duomo di Pisa e le porte bronzee medioevali europee: arte e tecnologia*, edited by Ottavio Banti, 107–21. Pontedera: Bandecchi & Vivaldi, 1999.

Gallistl, Bernhard. "Die Tür des Bischofs Bernward und ihr ikonographisches Programm." In *Le porte di bronze dall'antichità al secolo XIII*, edited by Salvatorino Salomi, 145–81. Rome: Istituto della Enciclopedia Italiana, 1990.

Gaposchkin, M. Cecilia. "Portals, Processions, Pilgrimage, and Piety: Saints Firmin and Honoré at Amiens." In *Art and Architecture of Late Medieval Pilgrimage in Northern Europe and the British Isles*, edited by Sarah Blick and Rita Tekippe, 217–42. Leiden: Brill, 2005.

Gardner, Julian. "Pope Nicholas IV and the Decoration of Santa Maria Maggiore." *Zeitschrift für Kunstgeschichte* 36 (1973): 1–50.

Garnier, Jacques. "Inventaires du trésor de la cathédrale d'Amiens." *Mémoires de la société des antiquaires de Picardie* 10 (1850): 229–391.

Garrucci, Raffaele. *Storia della arte Cristiana nei primi otto secoli della chiesa: Vol. 2. Pitture cimiteriali*. Prato: G. Guasti, 1873.

Gąsiorowski, Stanislaw Jan. "Das Motiv des Lebensbaumes und die sog. Kandelabermotive in der antiken Ornamentik: Eine typologische Studie." In *Pisma Wybrane*, edited by Kazimierz Majewski and Maria Nowicka, 319–26. Wroclaw: Zaklad Narodowy im. Ossolińskich, 1969.

Gaudentius of Brescia. *S. Gavdentii episcopi brixiensis tractatvs*. Edited by Ambrosius Glück and Anton Polaschek. Vindobonae: Hoelder-Pichler-Tempsky, 1936.

Gell, Alfred. *The Anthropology of Time: Culture Constructions of Temporal Maps and Images*. Oxford: Berg, 1992.

Gem, Richard. "Towards an Iconography of Anglo-Saxon Architecture." *JWCI* 46 (1983): 1–18.

Gennep, Arnold van. *The Rites of Passage*. Translated by Monika B. Vizedom et al. Chicago: University of Chicago Press, 1960.

Gerson, Paula Lieber, ed. *Abbot Suger and Saint-Denis: A Symposium*. New York: Metropolitan Museum of Art, 1986.

Gerstel, Sharon E., ed. *Thresholds of the Sacred: Architectural, Art Historical, Liturgical and Theological Perspectives on Religious Screens, East and West*. Washington, DC: Dumbarton Oaks Research Library Collection, 2006.

Gervase of Canterbury. *The Historical Works of Gervase of Canterbury*. Vol. 1, edited by William Stubbs. London: Longman & Co., 1879.

Gilbert, Antoine P. M. *Description historique de l'église cathédrale de Notre-Dame d'Amiens*. Amiens: Caron-Vitet, 1833.

Gillerman, Dorothy. "The Arrest of Christ: A Gothic Relief in The Metropolitan Museum of Art." *Metropolitan Museum Journal* 15 (1980): 67–90.

Gimpel, Jean. *The Cathedral Builders*. Translated by Teresa Waugh. New York: Grove Press, 1983.

Giovanni Villani. *Nuova Cronica*, edited by Giuseppe Porta. 3 vols. Parma: Fondazione Pietro Bembo, 1990–1991.

Givelet, Charles. *L'église et l'abbaye de Saint-Nicaise de Reims: notice historique et archéologique*. Reims: F. Michaud, 1897.

Givens, Jean A. *Observation and Image-Making in Gothic Art*. Cambridge: Cambridge University Press, 2005.

Givens, Jean A. "Reading and Writing the Illustrated *Tractatus de herbis*, 1280–1526." In *Visualizing Medieval Medicine and Natural History, 1200–1550*, edited by Jean A. Givens, Karen M. Reeds, and Alain Touwaide, 115–45. Aldershot: Ashgate, 2006.

Givens, Jean A., Karen M. Reeds, and Alain Touwaide, eds. *Visualizing Medieval Medicine and Natural History, 1200–1550*. Aldershot: Ashgate, 2006.

Goethe, Johann Wolfgang von. "Von Deutscher Baukunst." In *Von deutscher Art und Kunst*, edited by Johann Gottfried von Herder and Hans D. Irmscher, 93–104. 1773. Reprint, Stuttgart: Reclam, 1995.

Goldschmidt, R. C., trans. *Paulinus' Churches at Nola: Texts, Translations and Commentary*. Amsterdam: Noord-Hollandsche Uitgevers Maatschappij, 1940.

Goldziher, Ignác. *Muhammedanische Studien*. 2 vols. Halle: Niemeyer, 1889–1890.

Golzio, Vincenzo. *Raffaello nei documenti nelle testimonianze dei contemporanei e nella letteratura del suo secolo*. Farnborough, Hants: Gregg, 1971.

Gombrich, Ernst H. *Art and Illusion: A Study in the Psychology of Pictorial Representation*. New York: Pantheon Books, 1960.

Gombrich, Ernst H. *The Sense of Order: A Study of the Psychology of Decorative Art*. Ithaca, NY: Cornell University Press, 1979.

Gomez-Géraud, Marie-Christine, and Amaury Sartorius. *Une joie toute simple: méditation sur le portail du Christ en gloire de la collégiale de Mantes-la-Jolie*. Mantes-la-Jolie: Paraclet, 1997.

Goody, Jack. *The Culture of Flowers*. Cambridge: Cambridge University Press, 1993.

Gosse-Kischinewski, Annick, and Françoise Gatouillat. *La cathédrale d'Évreux*. Évreux: Imprimerie Hérissey, 1997.

Grabar, Oleg. *The Dome of the Rock*. Cambridge, MA: Belknap Press of Harvard University Press, 2006.

Grabar, Oleg. *Formation of Islamic Art*. New Haven: Yale University Press, 1973.

Grabar, Oleg. *The Mediation of Ornament*. Princeton: Princeton University Press, 1992.

Grabar, Oleg. "The Umayyad Dome of the Rock in Jerusalem." *Ars Orientalis* 3 (1959): 33–62.

Grandclément, Oriane. "Andlau, église des Saints-Pierre-et-Paul: la sculpture du portail et de la façade occidentale." *Congrès archéologique de France* 162 (2006): 15–20.

Grant, Lindy. *Abbot Suger of St.-Denis: Church and State in Early-Twelfth-Century France*. London; New York: Longman, 1998.

Grant, Lindy. *Architecture and Society in Normandy, 1200–1270*. New Haven: Yale University Press, 2005.

Grant, Lindy. "Gothic Architecture in Southern England and the French Connection in the Early Thirteenth Century." In *Thirteenth Century England III: Proceedings of the Newcastle-upon-Tyne Conference 1989*, edited by Peter R. Coss and S. D. Lloyd, 113–26. Woodbridge: Boydell Press, 1991.

Gratian. *Corpus juris canonici*, edited by Aemilius Ludwig Richter. Lipsiae: Tachnitz, 1839.

Grégoire, J. F., and F. Z. Collombet, eds. *Oeuvres de C. Sollius Apollinaris Sidonius*. Lyon: Rusand, 1836.

Grégoire, Reginald. "Le 'De claustro animae', est-il d'un clunisien?" *Studia monastica* 4 (1962): 193–95.

Gregory the Great. *Sancti Gregorii Magni Homiliae in Hiezechielem prophetam*, CCSL 142, edited by Marcus Adriaen. Turnhout: Brepols, 1971.

Grodecki, Louis. "L'interprétation de l'art gothique: Hans Sedlmayr, *Die Entstehung der Kathedrale*." *Critique* 8 (1952): 847–57.

Grünbaum, Branko, and G. C. Shephard. "Interlace Patterns in Islamic and Moorish Art." *Leonardo* 25 (1992): 331–39.

Günther, Hubertus. "Das Astwerk und die Theorie der Renaissance von der Entstehung der Architektur." In *Théorie des arts et création artistique dans l'Europe du Nord du XVIᵉ siècle au début du XVIIIᵉ siècle*, edited by Michèle-Caroline Heck, Frédérique Lemerle and Yves Pauwels, 13–32. Lille: Villeneuve-d'Ascq, 2002.

Guyotjeannin, Olivier, ed. *Le chartrier de l'abbaye prémontrée de Saint-Yved de Braine (1134–1250)*. Paris: École nationale des Chartes, 2000.

Hamburger, Jeffrey F., Petra Marx, and Susan Marti. "The Time of the Orders, 1200–1500. An Introduction." In *Crown and Veil: Female Monasticism from the Fifth to the Fifteenth Centuries*, edited by Jeffrey F. Hamburger and Susan Marti, 41–75. New York: Columbia University Press, 2008.

Hamlin, Alfred. "The Evolution of Decorative Motives." *American Architect* (1901): 29–32, 51–53.

Hammond, Jay M., Wayne Hellmann, and Jared Goff, eds. *A Companion to Bonaventure*. Leiden: Brill, 2013.

Harrison, R. M. "The Church of St. Polyeuktos in Istanbul and the Temple of Solomon." In *Okeanos: Essays Presented to Ihor Sevcenko*, Harvard Ukrainian Studies 7, 276–79. Cambridge, MA: Harvard University Press, 1983.

Harrison, R. M. "From Jerusalem and Back Again: The Fate of the Treasures of Solomon." In *Churches Built in Ancient Times: Recent Studies in Early Christian Archaeology*, edited by Kenneth Painter, 239–48. London: Society of Antiquaries of London, 1994.

Harrison, R. M. *A Temple for Byzantium: The Discovery and Excavation of Anicia Juliana's Palace-Church in Istanbul*. Austin: University of Texas Press, 1989.

Hatfield, Rab. "The Tree of Life and the Holy Cross: Franciscan Spirituality in the Trecento and the Quattrocento." In *Christianity and the Renaissance: Image and Religious Imagination in the Quattrocento*, edited by Timothy Verdon and John Henderson, 132–60. Syracuse, NY: Syracuse University Press, 1990.

Haussherr, Reiner. "Templum Salomonis und Ecclesia Christi: Zu einem Bildvergleich der Bible moralisée." *Zeitschrift für Kunstgeschichte* 31 (1968): 101–21.

Hawkins, E. J. W. "Plaster and Stucco Cornices in Hagia Sophia, Istanbul." *Actes du XIIᵉ congrès international des études byzantines* 3 (1964): 131–35.

Hayes, Dawn Marie. *Body and Sacred Place in Medieval Europe, 1100–1389*. New York: Routledge, 2003.

Hayward, Robert. "The Vine and Its Products as Theological Symbols in First-Century Palestinian Judaism." *Durham University Journal* 82 (1990): 9–18.

Heimann, Adelheid. "Three Illustrations from the Bury St. Edmunds Psalter and Their Prototypes: Notes on the Iconography of Some Anglo-Saxon Drawings." *JWCI* 29 (1966): 39–59.

Heitz, Carol. "À propos de quelques 'Galilées' bourguignonnes." In *Saint-Philibert de Tournus: histoire, archéologie, art*, edited by Jacques Thirion, 253–722. Tournus: Centre international d'études Romanes, 1995.

Hengel, Martin. *Studies in Early Christology*. Edinburgh: T&T Clark, 1995.

Henisch, Bridget Ann. *The Medieval Calendar Year*. University Park: The Pennsylvania State University Press, 1999.

Henkels, H. "Remarks on the Late 13th-Century Apse Decoration in S. Maria Maggiore." *Simiolus: Netherlands Quarterly for the History of Art* 4 (1971): 128–49.

Herbermann Charles G., et al. *Catholic Encyclopedia*. Vol. 6. New York: The Encyclopedia Press, 1913.

Heyman, Avital. *"That Old Pride of the Men of Auvergne": Laity and Church in Auvergnat Romanesque Sculpture*. London: Pindar Press, 2005.

Hilberry, Harry H. "La Charité-sur-Loire Priory Church." *Speculum* 30 (1955): 1–14.

Hinkle, William M. *The Portal of the Saints of Reims Cathedral: A Study in Mediaeval Iconography*. New York: College Art Association of America in conjunction with the Art Bulletin, 1965.

Historia Selebiensis Monasterii: The History of the Monastery of Selby. Translated by Janet Burton and Lynda Lockyer. Oxford: Clarendon Press, 2013.

Historia Selebiensis Monasterii. In *The Coucher Book of Selby*. Vol. 1, edited by Joseph T. Fowler. Durham: Yorkshire Archaeological and Topographical Association, 1891.

Hohenzollern, Johann G. Prinz von. *Die Königsgalerie der französischen Kathedrale: Herkunft, Bedeutung, Nachfolge*. Munich: W. Fink, 1965.

Holcomb, Melanie, and Lisa Bessette. *Pen and Parchment: Drawing in the Middle Ages*. New York: The Metropolitan Museum of Art, 2009.

Hölderlin, Friedrich. *Brot und Wein*. Neu-Isenburg: Tiessen, 1980.

Holt, Elizabeth G., ed. *A Documentary History of Art*. 2 vols. Garden City, NY: Doubleday, 1957.

Horn, Walter. "On the Origins of the Medieval Cloister." *Gesta* 12 (1973): 13–52.

Hugh of Saint-Victor, *On the Sacraments of the Christian Faith (De sacramentis)*. Translated by Roy J. Deferrari. Cambridge, Mass.: The Medieval Academy of America, 1951.

Hull Stookey, Laurence. "The Gothic Cathedral as the Heavenly Jerusalem: Liturgical and Theological Sources." *Gesta* 8 (1969): 35–41.

Huot, Sylvia. *The Romance of the Rose and Its Medieval Readers: Interpretation, Reception, Manuscript Transmission*. Cambridge: Cambridge University Press, 1993.

Hurst, David, ed. *Bedae Venerabilis Opera*. Turnhout: Brepols, 1969.

Huynes, Jean. *Histoire générale de l'abbaye de Mont-Saint-Michel au péril de la mer*. Rouen: A. Le Brument, 1872.

Iogna-Prat, Dominique. "'Bienheureuse polysémie.' La Madeleine du *Sermo in veneratione Sanctae Mariae Magdalenae* attribué à Odon de Cluny (X^e siècle)." In *Marie Madeleine dans la mystique, les arts et les lettres*, edited by Eve Duperray et al., 21–31. Paris: Beauchesne, 1989.

Iogna-Prat, Dominique. "La Madeleine du 'Sermo in veneratione sanctae Mariae Magdalenae' attribué à Odon de Cluny." *Mélanges de l'école française de Rome. Moyen Âge* 104 (1992): 37–70.

Iogna-Prat, Dominique. *Order and Exclusion: Cluny and Christendom Face Heresy, Judaism, and Islam, 1000–1150*. Ithaca, NY: Cornell University Press, 2002.

Jacobus de Voragine. *The Golden Legend: Readings on the Saints*. 2 vols. Translated by William Granger Ryan. Princeton: Princeton University Press, 1993.

Jaeger, C. Stephen. *Enchantment: On Charisma and the Sublime in the Arts of the West*. Philadelphia: University of Pennsylvania Press, 2012.

Jairazbhoy, Rafique A. *An Outline of Islamic Architecture*. New York: Asia Publishing House, 1972.

Jalabert, Denise. "La flore gothique, ses origines, son évolution du XII^e au XV^e siècle." *Bulletin monumental* 91 (1932): 181–246.

Jalabert, Denise. *La flore sculptée des monuments du moyen âge en France. Recherches sur les origines de l'art français*. Paris: Picard, 1965.

Jantzen, Hans. *High Gothic: The Classic Cathedrals of Chartres, Reims, Amiens*. Princeton: Princeton University Press, 1984.

Jerphanion, Guillaume de. *Le calice d'Antioche: les théories du dr. Eisen et la date probable du calice*. Roma: Pontificium institutum orientalium studiorum, 1926.

Jessen, Mads Dengsø, and Tim Flohr Sørensen. "Embodiment and the Senses in Eleventh- to Thirteenth-Century Churches in Southern Scandinavia." In *The Saturated Sensorium: Principles of Perception and Mediation in the Middle Ages*, edited by Hans Henrik Lohfert Jørgensen, Henning Laugerund, and Laura Katrine Skinnebach, 207–25. Aarhus: Aarhus University Press, 2015.

John of Damascus. "*In Assumptione S. Mariae Virginis*." In *Breviarium Parisiense*, 445–96. Parisiis: Apud Francisum-Hubertum Muguet, 1714.

John of Damascus. *Sermon 1*. Translated by Mary H. Allies. *St. John Damascene on Holy Images: Followed by Three Sermons on the Assumption*. London: Thomas Baker, 1898.

John of Würzburg. "Descriptio Terrae Sanctae." In *Descriptiones Terrae Sanctae*, edited by Titus Tobler. Leipzig: J. C. Hinrichs, 1874.

Johnson, James R. "The Tree of Jesse Window of Chartres: *Laudes Regiae*." *Speculum* 36 (1961): 1–22.

Jones, Owen. *The Grammar of Ornament*. London: Day and Sons Limited, 1856.

Jørgensen, Hans Henrik Lohfert, Henning Laugerud, and Laura Katrine Skinnebach, eds. *The Saturated Sensorium: Principles of Perception and Mediation in the Middle Ages*. Aarhus: Aarhus University Press, 2015.

Jounel, Pierre. "The Dedication of Churches." In *Principles of the Liturgy*, edited by Irénée Henri Dalmais et al., 215–27. Vol. 1. Collegeville, MN: Liturgical Press, 1987.

Jourdain, Louis, and Antoine Théophile Duval. *Le portail Saint-Honoré, dit de la Vierge Dorée de la cathédrale d'Amiens*. Amiens: Duval et Herment Imprimeurs, 1844.

Jung, Jacqueline E. "Beyond the Barrier: The Unifying Role of the Choir Screen in Gothic Churches." *Art Bulletin* 82 (2000): 622–57.

Jung, Jacqueline E. *The Gothic Screen: Space, Sculpture, and Community in the Cathedrals of France and Germany, ca. 1200–1400*. Cambridge: Cambridge University Press, 2012.

Jung, Jacqueline E. "Review of *Observation and Image-Making in Gothic Art*, by Jean A. Givens." *Journal of Religion* 87 (2007): 325–27.

Kane, Tina. *The Troyes Mémoire: The Making of a Medieval Tapestry*. Woodbridge: Boydell Press, 2010.

Kant, Immanuel. *The Critique of Judgment*. New York: Hafner Press, 1951.

Kasarska, Iliana, and Dany Sandron. *La sculpture de la façade de la cathédrale de Laon: Eschatologie et humanisme*. Paris: Picard, 2008.

Katzenellenbogen, Adolf. "The Prophets on the West Façade of the Cathedral of Amiens." *Gazette des Beaux-Arts* 40 (1952): 241–60.

Katzenellenbogen, Adolf. *The Sculptural Programs of Chartres Cathedral: Christ, Mary, Ecclesia*. Baltimore: Johns Hopkins Press, 1959

Katzenellenbogen, Adolf. "Tympanum and Archivolts on the Portal of St. Honoré at Amiens." In *De artibus opuscula XL: Essays in Honor of Erwin Panofsky*, edited by Millard Meiss, 280–91. New York: New York University, 1961.

Kavaler, Ethan Matt. "Nature and the Chapel Vaults at Ingolstadt: Structuralist and Other Perspectives." *Art Bulletin* 87 (2005): 230–48.

Kavaler, Ethan Matt. *Renaissance Gothic: Architecture and the Arts in Northern Europe, 1470–1540*. New Haven: Yale University Press, 2012.

Kavaler, Ethan Matt. "Renaissance Gothic in the Netherlands: The Uses of Ornament." *Art Bulletin* 82 (2000): 226–51.

Kenaan-Kedar, Nurith. "Symbolic Meaning in Crusader Architecture. The Twelfth-Century Dome of the Holy Sepulcher Church in Jerusalem." *Cahiers archéologiques* 34 (1986): 109–17.

Kendall, Calvin B. *The Allegory of the Church: Romanesque Portals and Their Verse Inscriptions*. Toronto: University of Toronto Press, 1998.

Kessler, Herbert L., and Johanna Zacharias. *Rome 1300: On the Path of the Pilgrim*. New Haven: Yale University Press, 2000.

Kibler, William W., and Grover A. Zinn, eds. *Medieval France: An Encyclopedia*. New York: Garland, 1995.

Kidson, Peter. "Panofsky, Suger and St. Denis." *JWCI* 50 (1987): 1–17.

Kidson, Peter. *Sculpture at Chartres*. London: A. Tiranti, 1958.

Kimpel, Dieter. "Le développement de la taille en série dans l'architecture médiévale et son rôle dans l'histoire économique." *Bulletin monumental* 135 (1977): 195–222.

Kimpel, Dieter, and Robert Suckale. *Die gotische Architektur in Frankreich, 1130–1270*. München: Hirmer Verlag, 1985.

Kimpel, Dieter, and Robert Suckale. "Die Skulpturenwerkstatt der Vierge Dorée am Honoratusportal der Kathedrale von Amiens." *Zeitschrift für Kunstgeschichte* 36 (1973): 217–65.

King, Thomas H., and George T. Hill. *Études pratiques tirées de l'architecture du moyen âge en Europe*. 2 vols. Bruges: n.p., 1857.

Kingsley Porter, Arthur. *Romanesque Sculpture of the Pilgrimage Roads*. Boston: Marshall Jones Company, 1923.

Kitzinger, Ernst. "Interlace and Icons: Form and Function in Early Insular Art." In *The Age of Migrating Ideas: Early Medieval Art in Northern Britain and Ireland—Proceedings of the Second International Conference on Insular Art,* edited by Michael Spearman and John Higgitt, 3–15. Edinburgh: National Museums of Scotland, 1993.

Kitzinger, Ernst. *The Mosaics of Monreale*. Palermo: Flaccovio, 1963.

Klein, Peter K., ed. *Der mittelalterliche Kreuzgang—The Medieval Cloister—Le cloître au Moyen Âge: Architektur, Funktion, und Programm*. Regensburg: Schnell & Steiner, 2004.

Kletke, Daniel. *The Cloister of St.-Guilhem-le-Désert at The Cloisters in New York City*. Berlin: Köster, 1997.

Kletter, Karen M. "The Christian Reception of Josephus in Late Antiquity and the Middle Ages." In *A Companion to Josephus*, edited by Honora Howell Chapman and Zuleika Rodgers, 368–81. Malden, MA: John Wiley & Sons, Inc., 2016.

Konrad, Robert. "Das himmlische und das irdische Jerusalem im mittelalterlichen Denken." In *Speculum historiale: Geschichte im Spiegel von Geschichtsschreibung und Geschichtsdeutung*, edited by Clemens Bauer et al., 523–40. Freiburg and München: Alber, 1965.

Koreny, Fritz. "A Coloured Flower Study by Martin Schongauer and the Development of the Depiction of Nature from van der Weyden to Dürer." *Burlington Magazine* 133 (1991): 588–97.

Kraus, Theodor. *Die Ranken der Ara Pacis: Ein Beitrag zur Entwicklungsgeschichte der augusteischen Ornamentik*. Berlin: Mann, 1953.

Krautheimer, Richard. "Carolingian Revival of Early Christian Architecture." *Art Bulletin* 24 (1942): 1–38.

Krautheimer, Richard. "Introduction to an 'Iconography of Mediaeval Architecture.'" In *Studies in Early Christian, Medieval, and Renaissance Art*, 115–50. New York: New York University Press, 1969.

Krautheimer, Richard. "Introduction to an 'Iconography of Mediaeval Architecture.'" *JWCI* 5 (1942): 1–33.

Krinsky, Carol H. "Representations of the Temple of Jerusalem before 1500." *JWCI* 33 (1970): 1–19.

Krinsky, Carol H. "Seventy-eight Vitruvius Manuscripts." *JWCI* 30 (1967): 36–70.

Kühnel, Bianca. *From the Earthly to the Heavenly Jerusalem: Representations of the Holy City in Christian Art of the First Millennium*. Rome: Herder, 1987.

Kuntz, Paul G., and Marion Leathers Kuntz. "The Symbol of the Tree Interpreted in the Context of Other Symbols of Hierarchical Order, the Great Chain of Being and Jacob's Ladder." In *Jacob's Ladder and the Tree of Life: Concepts of Hierarchy and the Great Chain of Being*, edited by Marion Leathers Kuntz and Paul Kuntz, 319–34. New York: P. Lang, 1987.

Kurmann, Peter. *La façade de la cathédrale de Reims: Architecture et sculpture des portails: étude archéologique et stylistique*. Paris and Lausanne: Editions du CNRS; Payot, 1987.

Ladner, Gerhart B. "Medieval and Modern Understanding of Symbolism: A Comparison." *Speculum* 54 (1979): 223–56.

Lalore, Charles. *Documents sur l'abbaye de Notre-Dame-aux-Nonnains de Troyes*. Troyes: Imprimerie et Lithographie Dufour-Bouquot, 1874.

Lambin, Émile. *La flore des grandes cathédrales de France*. Paris: Aux bureaux de la Semaine des constructeurs, 1897.

Lambin, Émile. *La flore gothique*. Paris: André Daly fils, 1893.

Lambert, Élie. "Les portails sculptés de la cathédrale de Laon." *Gazette des beaux-arts* 17 (1937): 83–98.

Landy, Francis. "The Song of Songs and the Garden of Eden." *Journal of Biblical Literature* 98 (1979): 513–28.

Lanfer, Peter Thacher. *Remembering Eden: The Reception History of Genesis 3:22–24*. New York and Oxford: Oxford University Press, 2012.

Lapeyre, André. *Des façades occidentales de Saint-Denis et de Chartres aux portails de Laon: études sur la sculpture monumentale dans l'Ile-de-France et les régions voisines au XIIᵉ siècle*. Mâcon: Protat, 1960.

Lasteyrie, Robert de. *L'architecture religieuse en France à l'époque romane: ses origines, son développement*. Paris: Picard, 1912.

Laurent, J. C. M., ed. *Peregrinatores Medii Aevi Quatuor*. Leipzig: J. C. Hinrichs, 1864.

Lautier, Claudine. "Les deux galeries des rois de la cathédrale de Chartres." *Bulletin monumental* 169 (2011): 41–64.

Leach, Edmund. *Culture and Communication: The Logic by Which Symbols Are Connected*. Cambridge: Cambridge University Press, 1976.

Lebensztejn, Jean-Claude. "Starting Out from the Frame (Vignettes)." In *Deconstruction and the Visual Arts: Art, Media, Architecture*, edited by Peter Brunette and David Wills, 118–40. Cambridge: Cambridge University Press, 1994.

Lefèvre-Pontalis, Eugène. "Saint-Yved de Braine." *Congrès archéologique de France* 78 (1911): 428–40.

Lefrançois-Pillion, Louise. *La cathédrale d'Amiens*. Paris: Plon, 1937.

Lefrançois-Pillion, Louise. *Les Sculpteurs de Reims*. Paris: Rieder, 1928.

Legris, Albert. *L'église d'Eu et la chapelle du collège. Notice historique et descriptive*. Paris: Champion, 1913.

Legris, Albert. *L'église de Saint-Jacques de Dieppe: notice historique et descriptive*. Dieppe: G. Letremble, 1918.

Le Maho, Jacques. *La cathédrale Notre-Dame de Rouen*. Mont-Saint-Aignan: Publications des universités de Rouen et du Havre, 2010.

Leniaud, Jean-Michel. "La restauration du décor peint de la Sainte Chapelle haute par Duban, Lassus, et Boeswillwald, 1839–ca. 1881." In *Die Denkmalpflege vor der Denkmalpflege*, edited by Volker Hoffmann, Jürg Schweizer, and Wolfgang Wolters, 333–59. Bern; New York: P. Lang, 2005.

Le Roux de Lincy, Antoine, and L. M. Tisserand. *Paris et ses historiens aux XIVᵉ et XVᵉ siècles*. Paris: Imprimeries Impériale, 1867.

Lethaby, W. R., and Harold Swainson. *The Church of Sancta Sophia Constantinople: A Study of Byzantine Building*. New York: Macmillan & Co., 1894.

Lev, Yaacov. "Prisoners of War during the Fatimid-Ayyubid Wars with the Crusaders." In *Tolerance and Intolerance: Social Conflict in the Age of the Crusades*, edited by Michael Gervers and James M. Powell, 11–27. Syracuse: Syracuse University Press, 2001.

Levy-Rubin, Milka. "The Crusader Maps of Jerusalem." In *Knights of the Holy Land. The Crusader Kingdom of Jerusalem*, edited by Silvia Rozenberg, 231–37. Jerusalem: Israel Museum, 1999.

Lilley, Keith D. *City and Cosmos: The Medieval World in Urban Form*. London: Reaktion Books, 2009.

Little, Charles T. "The Art of Gothic Ivories: Studies at the Crossroads." *The Sculpture Journal* 23 (2014): 13–30.

Little, Charles T. "Monumental Gothic Sculpture from Amiens in American Collections." In *Pierre, Lumière, Couleur: Étude d'histoire de l'art du moyen âge en l'honneur d'Anne Prache*, edited by Anne Prache, Fabienne Joubert, and Dany Sandron, 243–53. Paris: Presses de l'Université de Paris-Sorbonne, 1999.

Little, Charles T. "Monumental Sculpture at Saint-Denis under the Patronage of Abbot Suger: The West Façade and the Cloister." In *The Royal Abbey of Saint-Denis in the Time of Abbot Suger (1122–1151)*, edited by Sumner McKnight Crosby et al., 25–31. New York: The Metropolitan Museum of Art, 1981.

Livius, Thomas. *The Blessed Virgin in the Fathers of the First Six Centuries*. London: Burns and Oates Ltd., 1893.

Loiseau, Julien. "Frankish Captives in Mamluk Cairo." *Al Masaq: Islam and the Medieval Mediterranean* 23 (2011): 37–52.

L'Orange, Hans Peter. "Ara Pacis Augustae: La zona floreale." *Acta ad archaeologiam et artium historiam pertinentia* 1 (1962): 7–16.

Löw, Immanuel. *Die Flora der Juden*. 4 vols. Wien: Löwit, 1924–1934.

Lubac, Henri de. *Exégèse médiévale: les quatre sens de l'Écriture*. 2 vols. Paris: Aubier, 1961.

Lyman, Thomas W. "The Politics of Selective Eclecticism: Monastic Architecture, Pilgrimage Churches, and 'Resistance to Cluny.'" *Gesta* 27 (1988): 83–92.

Mackie, Gillian. "Abstract and Vegetal Design in the San Zeno Chapel, Rome: The Ornamental Setting of an Early Medieval Funerary Programme." *Papers of the British School at Rome* 63 (1995): 159–82.

Macy, Gary. "The Dogma of Transubstantiation in the Middle Ages." *Journal of Ecclesiastical History* 45 (1994): 11–41.

Madigan, Kevin. *Medieval Christianity: A New History*. New Haven: Yale University Press, 2015.

Maguire, Henry. "Davidic Virtue: The Crown of Constantine Monomachos and Its Images." In *The Real and Ideal Jerusalem in Jewish, Christian and Islamic Art*, edited by Bianca Kühnel, 117–23. Jerusalem: The Hebrew University of Jerusalem, 1998.

Mainstone, Rowland J. *Hagia Sophia: Architecture, Structure and Liturgy of Justinian's Great Church*. New York: Thames and Hudson, 1988.

Majeska, George. "St. Sophia: The Relics." *DOP* 27 (1973): 71–87.

Mâle, Emile. *Religious Art in France. The Thirteenth Century: A Study of Medieval Iconography and Its Sources*. Princeton: Princeton University Press, 1984.

Mango, Cyril A. *Hagia Sophia: A Vision for Empires*. Istanbul: Ertuğ & Kocabıyık, 1997.

Mango, Cyril A., ed. *The Art of the Byzantine Empire, 312–1453: Sources and Documents*. Toronto: University of Toronto Press, 1986.

Mann, Vivian B. "The Artistic Culture of Prague Jewry." In *Prague: The Crown of Bohemia, 1347–1437*, edited by Barbara Drake Boehm and Jiří Fajt, 83–89. New York and New Haven: The Metropolitan Museum of Art and Yale University Press, 2005.

Mansi, Giovan Domenico. *Sacrorum Conciliorum Nova et Amplissima Collectio*. Vol. 24. Parisiis: Expensis H. Welter, 1901–27.

Marguery-Melin, Bruno. *La destruction de l'abbaye de Cluny, 1789–1823*. Cluny: Bulletin du Centre d'études clunisiennes, 1985.

Marin, Louis. "The Frame of Representation and Some of Its Figures." In *On Representation*. Translated by Catherine Portet, 352–72. Stanford: Stanford University Press, 2001.

Marinus Sanutus. "*Liber fidelium crucis super Terrae Sanctae recuperatione et conservation.*" Vol. 2 of *Gesta Dei per Francos*, edited by Jacques Bongars. Hanoviae: typis Wechelianis, apud heredes I. Aubrii, 1611.

Marks, Richard. *Stained Glass in England in the Middle Ages.* Toronto: University of Toronto Press, 1993.

Martène, Edmond, and Ursin Durand. *Thesaurus novus anecdotorum.* Vol. 1. Paris: F. Delaulne, 1717.

Mather, E. Ann. *The Voice of My Beloved: The Song of Songs in Western Medieval Christianity.* Philadelphia: University of Pennsylvania Press, 1992.

Mathews, Thomas F. *The Early Churches of Constantinople: Architecture and Liturgy.* University Park: Pennsylvania State University Press, 1971.

Mauss, Marcel. "Notion de technique du corps." *Journal de Psychologie* 32 (1936): 5–23.

McClain, Jeoraldean. "A Modern Reconstruction of the West Portals of Saint-Yved at Braine." *Gesta* 24 (1985): 105–19.

McCue, James F. "The Doctrine of Transubstantiation from Berengar through Trent: The Point at Issue." *Harvard Theological Review* 61 (1968): 385–430.

McGee Morganstern, Anne. *High Gothic Sculpture at Chartres Cathedral: The Tomb of the Count of Joigny, and the Master of the Warrior Saints.* University Park: The Pennsylvania State University Press, 2011.

McLean, Teresa. *Medieval English Gardens.* Mineola, NY: Dover Publication, 2014.

Meulen, Jan van der. "Sculpture and Its Architectural Context at Chartres around 1200." In *The Year 1200: A Symposium*, edited by François Avril, 509–39. New York: The Metropolitan Museum of Art, 1975.

Meulen, Jan van der. *The West Portals of Chartres Cathedral.* Washington, DC: University Press of America, 1981.

Meuwese, Martine. "Representations of Jerusalem on Medieval Maps and Miniatures." *Eastern Christian Art* 2 (2005): 139–48.

Meyer, Ann R. *Medieval Allegory and the Building of the New Jerusalem.* Woodbridge, Suffolk, UK; Rochester, NY: D. S. Brewer, 2003.

Meyvaert, Paul. "The Medieval Monastic Claustrum." *Gesta* 12 (1973): 53–59.

Meyvaert, Paul. "The Medieval Monastic Garden." In *Medieval Gardens*, edited by Elisabeth Blair Macdougall, 25–53. Washington, DC: Dumbarton Oaks Research Library and Collection, 1986.

Myers, Bernard S. *Encyclopedia of World Art.* Vol. 10. New York: McGraw-Hill, 1959–1987.

Michler, Jürgen. "Über die Farbfassung hochgotischer Sakralräume." *Wallraf-Richartz-Jahrbuch* 39 (1977): 29–64.

Mietke, Gabriele. "Vine Rinceaux." In *Byzantium and Islam: Age of Transition, 7th–9th Century*, edited by Helen C. Evans and Brandie Ratliff, 175–76. New Haven: Yale University Press, 2012.

Migne, Jacques-Paul. *Patrologia Latina.* Paris: Migne, 1844–1864.

Migne, Jacques-Paul. *Patrologiae Graecae.* Paris: Migne, 1857–1889.

Mikuž, Jure. *Le sang et le lait dans l'imaginaire médiéval.* Ljubljana: Založba ZRC, 2013.

Mildenberg, Leo. *The Coinage of the Bar-Kokhba War.* Frankfurt: Verlag Sauerländer, 1984.

Milner, Christine. "The Image of the Rightful Ruler: Anicia Juliana's Constantine Mosaic in the Church of Hagios Polyeuktos." In *New Constantines: The Rhythm of Imperial Renewal in Byzantium, 4th–13th Centuries*, edited by Paul Magdalino, 73–81. Aldershot: Ashgate, 1994.

Minnis, Alastair. *From Eden to Eternity: Creations of Paradise in the Later Middle Ages.* Philadelphia: University of Pennsylvania Press, 2016.

Minnis, Alastair. *Magister Amoris: The Roman de la Rose and Vernacular Hermeneutics.* Oxford: Oxford University Press, 2001.

Minott Kerr, J. *The Former Cluniac Priory Church at Paray-le-Monial: A Study of Its Eleventh- and Twelfth-Century Architecture and Sculpture*. PhD dissertation, Yale University, 1994.

Monti, James. *A Sense of the Sacred: Roman Catholic Worship in the Middle Ages*. San Francisco: Ignatius Press, 2012.

Monti, James. *The Week of Salvation: History and Traditions of Holy Week*. Huntington, IN: Our Sunday Visitor, 1993.

Monumenta Germaniae Historica. 8 vols. Berlin: Weidmann, 1887–1939.

Moore, Kathryn B. "Seeing through Text: The Visualization of Holy Land Architecture in Niccolò da Poggibonsi's *Libro d'oltromare*, 14th–15th Centuries." *Word & Image: A Journal of Verbal/Visual Enquiry* 25 (2009): 402–15.

Morris, Colin. *The Sepulchre of Christ and the Medieval West: From the Beginning to 1600*. Oxford: Oxford University Press, 2005.

Moulin, Jacques, and Patrick Posot. "La chapelle de la Vierge à l'abbaye Saint-Germain-des-Prés." *Archéologia* 140 (1980): 49–55.

Muncey, R. W. *A History of the Consecration of Churches and Churchyards*. Cambridge: W. Heffer & Sons, 1930.

Murphy, Kevin D. *Memory and Modernity: Viollet-le-Duc at Vézelay*. University Park: The Pennsylvania State University Press, 2000.

Murray, Stephen. "The Architectural Envelope of the Sainte-Chapelle. Form and Meaning." *AVISTA Forum Journal* 10 (1997): 21–25.

Murray, Stephen. *Beauvais Cathedral: Architecture of Transcendence*. Princeton: Princeton University Press, 1989.

Murray, Stephen. *A Gothic Sermon. Making a Contract with the Mother of God, Saint Mary of Amiens*. Berkeley: University of California Press, 2004.

Murray, Stephen. "Looking for Robert de Luzarches: The Early Work at Amiens Cathedral." *Gesta* 29 (1990): 111–31.

Murray, Stephen. *Notre-Dame, Cathedral of Amiens: The Power of Change in Gothic*. Cambridge and New York: Cambridge University Press, 1996.

Murray, Stephen. "Notre-Dame of Paris and the Anticipation of Gothic." *Art Bulletin* 80 (1998): 229–53.

Murray, Stephen. *Plotting Gothic*. Chicago: University of Chicago Press, 2015.

Murray, Stephen. "Reconciling the Feet at Beauvais and Amiens Cathedrals." In *Ad Quadratum: The Practical Application of Geometry in Medieval Architecture*, edited by Nancy Y. Wu, 169–81. Aldershot: Ashgate, 2002.

Murray, Stephen, and James Addiss. "Plan and Space at Amiens Cathedral: With a New Plan Drawn by James Addiss." *JSAH* 49 (1990): 44–66.

Mussat, André. *La cathédrale du Mans*. Paris: Berger-Levrault, 1981.

Nagel, Alexander, and Christopher Wood. *Anachronic Renaissance*. New York: Zone Books, 2010.

Naredi-Rainer, Paul von. *Salomos Tempel und das Abendland. Monumentale Folgen historischer Irrtümer*. Köln: Dumont Buchverlag, 1994.

Neagley, Linda. *Disciplined Exuberance: The Parish Church of Saint-Maclou and Late Gothic Architecture in Rouen*. University Park: The Pennsylvania State University Press, 1998.

Nebbiai-Dalla Guarda, Donatella. *La bibliothèque de l'abbaye de Saint-Denis en France du IX^e au XVIII^e siècle*. Paris: Éditions du CNRS, 1985.

Nelson, Robert S. "The History of Legends and the Legends of History: The Pilastri Acritani in Venice." In *San Marco, Byzantium, and the Myths of Venice*, edited by Henry Maguire and Robert S. Nelson, 63–90. Washington, DC: Dumbarton Oaks Research Library and Collection, 2010.

Nussbaum, Norbert. *Deutsche Kirchenbaukunst der Gotik.* Darmstadt: Wissenschaftliche Buchgesellschaft, 1994.

Oettinger, Karl. "Laube, Garten und Wald: Zu einer Theorie der süddeutschen Sakralkunst 1470–1520." In *Festschrift für Hans Sedlmayr*, edited by Karl Oettinger and Hans Sedlmayr, 201–28. Munich: C. H. Beck, 1962.

Ohly, Friedrich. "Deus Geometra: Skizzen zur Geschichte einer Vorstellung von Gott." In *Tradition als historische Kraft: Interdisziplinäre Forschungen zur Geschichte des früheren Mittelalters*, edited by Norbert Kamp and Joachim Wollasch, 1–42. Berlin and New York: Gruyter, 1982.

Ohly, Friedrich. *Hohelied-Studien: Grundzüge einer Geschichte der Hoheliedauslegung des Abendlandes bis um 1200.* Wiesbaden: F. Steiner, 1958.

Olson, Vibeke. *The Ornamental Colonnettes of the Royal Portal of Chartres: Architecture and Sculpture in the Context of Design and Labor.* PhD dissertation, University of California, Santa Barbara, 2001.

Onians, John. *Bearers of Meaning: The Classical Orders in Antiquity, the Middle Ages, and the Renaissance.* Princeton: Princeton University Press, 1988.

Oschinsky, Dorothea. *Walter of Henley and Other Treatises on Estate Management and Accounting.* Oxford: Clarendon Press, 1971.

Ousterhout, Robert. "The Church of Santo Stefano: A 'Jerusalem' in Bologna." *Gesta* 20 (1981): 311–21.

Ousterhout, Robert. "Loca Sancta and the Architectural Response to Pilgrimage." In *The Blessings of Pilgrimage*, edited by Robert Ousterhout, 108–24. Urbana: University of Illinois Press, 1990.

Ousterhout, Robert. "New Temples and New Solomons: The Rhetoric of Byzantine Architecture." In *The Old Testament in Byzantium*, edited by Paul Magdalino and Robert Nelson, 223–53. Washington DC: Dumbarton Oaks Research Library Collection, 2010.

Ousterhout, Robert. "Rebuilding the Temple: Constantine Monomachus and the Holy Sepulchre." *JSAH* 48 (1989): 66–78.

Ousterhout, Robert. "The Temple, the Sepulchre, and the Martyrion of the Savior." *Gesta* 29 (1990): 44–53.

Ousterhout, Robert, Zeynep Ahunbay, and Metin Ahunbay. "Study and Restoration of the Zeyrek Camii in Istanbul: Second Report, 1997–98." *DOP* 54 (2000): 265–70.

Pajares-Ayuela, Paloma. *Cosmatesque Ornament: Flat Polychrome Geometric Patterns in Architecture.* New York: Norton, 2001.

Pallot-Frossard, Isabelle. "Polychromie des portails sculptés médiévaux en France: Contributions et limites des analyses scientifiques." In *La couleur et la pierre: polychromie des portails gothiques*, edited by Denis Verret and Delphine Steyaert, 73–90. Paris: Picard, 2002.

Panofsky, Erwin, and Gerda Panofsky-Soergel, ed. *Abbot Suger on the Abbey Church of St.-Denis and Its Art Treasures.* 2nd ed. 1946. Reprint, Princeton: Princeton University Press, 1973.

Pastoureau, Michel. "La Réforme et la couleur." *Bulletin de la Société du protestantisme français* 138 (1992): 323–42.

Patrich, Joseph. "The Golden Vine, the Sanctuary Portal, and Its Depiction on the Bar-Kokhba Coins." *Jewish Art* 19/20 (1993/94): 56–61.

Patton, Corrine. "Creation, Fall and Salvation: Lyra's Commentary on Genesis 1–3." In *Nicholas of Lyra: The Senses of Scripture*, edited by Philip D. W. Krey and Lesley Smith, 19–43. Leiden: Brill, 2000.

Paul the Deacon. *History of Lombards.* Translated by William Dudley Foulke. Philadelphia: University of Pennsylvania Press, 2003.

Paulinus of Nola. "De S. Felice natalitium carmen." In *S. Pontii Meropii Paulini Nolani Opera*, edited by William Hartel. Vienna: F. Tempsky, G. Freytag, 1894.

Pelletier, André. "Le grand rideau du vestibule du temple de Jérusalem." *Syria* 35 (1958): 218–26.

Pepin, Ronald E. "Heaven in Bernard of Cluny's *De contemptu mundi.*" In *Imagining Heaven in the Middle Ages: A Book of Essays*, edited by Jan S. Emerson and Hugh Feiss, 101–118. New York: Garland Publishing, 2000.

Pereda, Felipe. "The Shelter of the Savage: 'From Valladolid to the New World." *Medieval Encounters* 16 (2010): 268–359.

Pernoud, Régine, ed. *Un guide du pélerin de Terre Sainte au XV^e siècle.* Mantes: Imprimerie du Petit Mantais, 1940.

Peroni, Adriano. "Acanthe remployée et acanthe imitée dans les cathédrales de Modène, Ferrare, et Pise." In *L'acanthe dans la sculpture monumentale de l'Antiquité à la Renaissance*, edited by Léon Pressouyre, 313–26. Paris: Éditions du Comité des travaux historiques et scientifiques; Publications de la Sorbonne, 1993.

Perrot, Françoise. "Les verrières du XII^e siècle de la façade occidentale, étude archéologique." *Monuments historiques de la France* 1 (1977): 39–51.

Persinger, Cynthia L. *The Politics of Style: Meyer Schapiro and the Crisis of Meaning in Art History.* PhD dissertation, University of Pittsburg, 2007.

Peter the Venerable. *De miraculis libri duo.* Edited by Denise Bouthillier. Turnhout: Brepols, 1988.

Petrovna Khitrovo, Sofiia. *Itinéraires russes en Orient.* Geneva: Fick, 1889.

Pevsner, Nikolaus. *The Leaves of Southwell.* London and New York: Penguin, 1945.

Picard, Jean-Charles. "Les origines du mot Paradisus-Parvis." *Mélanges de l'école française de Rome. Moyen-Age, Temps modernes* 83 (1971): 159–86.

Pingeot, Anne. *La sculpture décorative sur pierre de 1137 à 1314 déposée au musée de Cluny.* PhD dissertation, École du Louvre, 1974.

Powell, Barry B. *Classical Myth.* 2nd ed. Upper Saddle River: Prentice Hall, 1998.

Prache, Anne. *Notre-Dame-en-Vaux de Châlons-sur-Marne. Campagnes de construction.* Châlons-sur-Marne: s.n., 1966.

Prache, Anne. "Saint-Rémi de Reims." *Congrès archéologique de France* 135 (1977): 109–21.

Prache, Anne. *Saint-Rémi de Reims: l'oeuvre de Pierre de Celle et sa place dans l'architecture gothique.* Genève: Droz, 1978.

Prache, Anne, and Martine Plouvier. *Noyon Cathedral: Oise.* Translated by Pamela Hargreaves. Amiens: Association pour la généralisation de l'inventaire régional en Picardie, 1998.

Prangey, Girault de. "Langres. Porte gallo-romaine." *Mémoires de la Société historique et archéologique de Langres* 1 (1847): 1–11.

Prangey, Girault de. "Monuments Gallo-Romains." *Mémoires de la Société historique et archéologique de Langres* 1 (1847): X–XIV.

Pringle, Denys. *The Churches of the Crusader Kingdom of Jerusalem: A Corpus, Volume 3, The City of Jerusalem.* Cambridge: Cambridge University Press, 2007.

Procopius. *Buildings.* Translated by Henry B. Dewing. Cambridge, MA: Harvard University Press, 1940.

Procopius. *History of the Wars.* Translated by Henry B. Dewing. London: Heinemann; New York: Putnam, 1916.

Quodvultdeus. *Opera Quodvultdeo Carthaginiensi episcopo tributa*, edited by René Braun. Turnhout: Brepols, 1976.

Rabbat, Nasser. "The Meaning of the Umayyad Dome of the Rock." *Muqarnas* 6 (1989): 12–21.

Randall, Lilian M. C. "Exempla as a Source of Gothic Marginal Illustration." *Art Bulletin* 39 (1957): 25–38.

Randall, Lilian M. C. *Images in the Margins of Gothic Manuscripts.* Berkeley and Los Angeles: University of California Press, 1966.

Randall, Lilian M. C. "The Snail in Gothic Marginal Warfare." *Speculum* 37 (1962): 358–67.

Rebold Benton, Janetta. "Antique Survival and Revival in the Middle Ages: Architectural Framing in Late Duecento Murals." *Arte medievale* 7 (1993): 129–45.

Recht, Roland. "Sculptures découvertes à Saint-Lazare d'Avallon." *Bulletin monumental* 141 (1983): 149–63.

Redford, Scott. "Portable Palaces: On the Circulation of Objects and Ideas about Architecture in Medieval Anatolia and Mesopotamia." In *Mechanisms of Exchange: Transmission in Medieval Art and Architecture of the Mediterranean, ca. 1000–1500*, edited by Heather E. Grossman and Alicia Walker, 84–114. Leiden: Brill, 2013.

Reinhardt, Hans. *La cathédrale de Reims: son histoire, son architecture, sa sculpture, ses vitraux.* Paris: Presses universitaires de France, 1963.

Reno, Stephen J. *The Sacred Tree as an Early Christian Literary Symbol: A Phenomenological Study.* Saarbrücken: Homo et Religio, 1978.

Riccioni, Stefano. *Il mosaico absidale di S. Clemente a Roma: "Exemplum" della chiesa riformata.* Spoleto: Fondazione Centro Italiano di Studi sull'Alto Medioevo, 2006.

Rickard, Marcia R. "The Iconography of the Virgin Portal at Amiens." *Gesta* 22 (1983): 147–57.

Riegl, Alois. *The Problems of Style: Foundations for a History of Ornament.* Translated by Evelyn M. Kain. Princeton: Princeton University Press, 1992.

Ritchey, Sara. *Holy Matter: Changing Perceptions of the Material World in Late Medieval Christianity.* Ithaca, NY: Cornell University Press, 2014.

Ritchey, Sara. "Rethinking the Twelfth-Century Discovery of Nature." *Journal of Medieval and Early Modern Studies* 39 (2009): 225–55.

Richter, Will. "Die Überlieferung der 'Ruralia commoda' des Petrus de Crescentiis im 14. Jahrhundert." *Mittellateinisches Jahrbuch* 16 (1981): 223–75.

Robert Grosseteste. *Hexaëmeron.* Edited by Richard C. Dales and Servus Gieben. London: Oxford University Press, 1982.

Robinson, Cynthia. "Towers, Birds, and Divine Light: The Contested Territory of Nasrid and 'Mudéjar' Ornament." In *Confronting the Borders of Medieval Art*, edited by Jill Caskey, Adam S. Cohen, and Linda Safran, 27–79. Leiden: Brill, 2011.

Rodowick, D. N. "Impure Mimesis, or the Ends of the Aesthetic." In *The Art of Art History: A Critical Anthology*, edited by Donald Preziosi, 89–108. Oxford: Oxford University Press, 2009.

Rollier, Gilles. "Les fouilles archéologiques de l'avant-nef." *Cahiers du Musée d'art et d'archéologie de Cluny* 1 (1996): 16–20.

Rollier-Hanselmann, Juliette, and Stéphanie Castandet. "Couleurs et dorures du portail roman de Cluny III. Restitution en 3D d'une oeuvre disparue," *Bulletin du Centre d'études médiévales d'Auxerre* 14 (2010): 235–50.

Romanus Melodus. *Hymnes.* Translated by José Grosdidier de Matons. Paris: Éditions du Cerf, 1981.

Romanus Melodus. *Kontakia of Romanos, Byzantine Melodist, 2, On Christian Life.* Translated by Marjorie Carpenter. Columbia: University of Missouri Press, 1973

Rorimer, James J. "The Authenticity of the Chalice of Antioch." In *Studies in Art and Literature for Belle da Costa Greene*, edited by Dorothy E. Miner, 161–68. Princeton: Princeton University Press, 1954,

Rosenau, Helen. *Vision of the Temple: The Image of the Temple of Jerusalem in Judaism and Christianity.* London: Oresko Books, 1979.

Rossi, Giovanni Battista de. *Inscriptiones Christianae urbis Romae septimo saeculo antiquiores.* Vol. 2. Romae: Ex Officina Libraria Pontificia, 1888.

Rossi, Giovanni Battista de. *La Roma sotterranea cristiana.* Vol. 3. Roma, Cromo-litografia pontificia, 1877.

Rubin, Miri. *Corpus Christi: The Eucharist in Late Medieval Culture*. Cambridge: Cambridge University Press, 1991.

Rudolph, Conrad. *Artistic Change at St-Denis: Abbot Suger's Program and the Early-Twelfth Century Controversy over Art*. Princeton: Princeton University Press, 1990.

Rudolph, Conrad. "Bernard of Clairvaux's *Apologia* as a Description of Cluny, and the Controversy over Monastic Art." *Gesta* 27 (1988): 125–32.

Sadler, Donna L. *Reading the Reverse Façade of Reims Cathedral: Royalty and Ritual in Thirteenth-Century France*. Farnham, UK: Ashgate Publishing, 2012.

Saint-Denis, Alain. *Laon, la cathédrale*. Paris: Éditions Zodiaque, 2002.

Saladin, Henri. *Manuel d'art musulman I: l'architecture*. Paris: Picard, 1907.

Salet, Francis. "La cathédrale du Mans." *Congrès archéologique de France* 119 (1961): 18–58.

Salet, Francis. *Cluny et Vézelay: l'oeuvre des sculpteurs*. Paris: Société française d'archéologie, 1995.

Salet, Francis. "Cluny III." *Bulletin monumental* 126 (1968): 235–92.

Salet, Francis. *La Madeleine de Vézelay: Étude iconographique*. Melun: Librarie d'Argences, 1948.

Salet, Francis. *La Madeleine de Vézelay et ses dates de construction*. Paris: Imprimerie de Daupeley-Gouverneur, 1936.

Sandron, Dany. *Amiens: la cathédrale*. Paris: Éditions Zodiaque, 2004.

Sandron, Dany. "La fondation par le cardinal Jean de la Grange de deux chapelles à la cathédrale d'Amiens: une tradition épiscopale devenue manifeste politique à la gloire du roi Charles V." In *L'Artiste et le clerc. Commandes artistiques des grands ecclésiastiques à la fin du Moyen Âge (XIVᵉ–XVIᵉ siècles)*, edited by Fabienne Joubert, 155–70. Paris: Presses de l'Université Paris-Sorbonne, 2006.

Sandron, Dany, and Philippe Lorentz. *Atlas de Paris au Moyen Âge: Espace urbain, habitat, société, religion, lieux de pouvoir*. Paris: Parigramme, 2006.

Sankovitch, Anne-Marie. "Intercession, Commemoration, and Display: The Parish Church as Archive in Late Medieval Paris." In *Demeures d'éternité. Églises et chapelles funéraires au XVᵉ et XVIᵉ siècles. Actes du colloque tenu à Tours du 11 au 14 juin 1996*, edited by Jean Guillaume, 247–67. Paris: Picard, 2005.

Sankovitch, Anne-Marie. "Structure/Ornament and the Modern Figuration of Architecture." *Art Bulletin* 80 (1998): 687–717.

Sapin, Christian, et al. *Bourgogne romane*. Dijon: Faton, 2006.

Sapin, Christian, and Walter Berry. *Naissance d'un îlot urbain: les abords de la cathédrale Saint-Lazare d'Autun du IXᵉ au XVIIIᵉ siècle. L'apport des recherches à la connaissance de l'îlot urbain et du quartier canonical*. Auxerre: CEM, 1999.

Sars, Maxime de. "Les chapelles de la cathédrale de Laon." *Bulletin de la Société historique de Haute-Picardie* 13 (1935): 15–29.

Sauer, Joseph. *Symbolik des Kirchengebäudes und seiner Ausstattung in der Auffassung des Mittelalters*. Freiburg: Herdersche Verlagshandlung, 1924.

Sauerländer, Willibald. "Antiqui et Moderni at Reims." *Gesta* 42 (2003): 19–37.

Sauerländer, Willibald. *Gothic Sculpture in France, 1140–1270*. Translated by Janet Sondheimer. New York: H. N. Abrams, 1972.

Sauerländer, Willibald. "Observations sur la topographie et l'iconologie de la cathédrale du sacre." *Académie des inscriptions et belles-lettres* 136 (1992): 463–79.

Saunders, Corrine J. *The Forest of Medieval Romance: Avernus, Broceliande, Arden*. Cambridge: D. S. Brewer, 1993.

Sauvaget, Jean. *La mosquée omeyyade de Médine: étude sur les origines architecturales de la mosquée et de la basilique*. Paris: Vanoest, 1947.

Scafi, Alessandro. *Maps of Paradise*. Chicago: University of Chicago Press, 2013.

Schaff, Philip, ed. *Nicene and Post-Nicene Fathers. First Series.* Vol. 13. New York: Cosimo Classics, 2007.

Schapiro, Meyer. "On Some Problems in the Semiotics of Visual Art: Field and Vehicle in Image-Signs." *Simiolus: Netherlands Quarterly for the History of Art* 6 (1972): 9–19.

Schapiro, Meyer. "Über den Schematismus in der romanischen Kunst." *Kritische Berichte zur kunstge-schichtlichen Literatur* 5 (1932–1933): 1–21.

Scheffczyk, Leo. *Das Mariengeheimnis in Frömmigkeit und Lehre der Karolingerzeit.* Leipzig: St. Benno Verlag, 1959.

Schein, Sylvia. *Gateway to the Heavenly City: Crusader Jerusalem and the Catholic West (1099–1187).* Aldershot: Ashgate, 2005.

Scheja, Georg. "Hagia Sophia und Templum Salomonis." *Istanbuler Mitteilungen* 12 (1962): 44–58.

Schiller, Gertrud. *Iconography of Christian Art. 2. The Passion of Jesus Christ.* Greenwich, CT: New York Graphic Society, 1972.

Schlag, Gottfried. "Die Skulpturen des Querhauses der Kathedrale von Chartres." *Wallraf-Richartz-Jahrbuch* 12–13 (1943): 115–64.

Schlee, Ernst. "Die Ikonographie der Paradiesflüsse." *Studien über christliche Denkmäler* 24 (1937): 133–46.

Schlegel, Friedrich von. *Sämtliche Werke.* Vienna: Mayer, 1823.

Schleif, Corine. "Men on the Right—Women on the Left: (A)Symmetrical Spaces and Gendered Places." In *Women's Space: Patronage, Place and Gender in the Medieval Church*, edited by Virginia Chieffo Raguin and Sarah Stanbury, 207–49. Albany: State University of New York, 2005.

Schlicht, Markus. *La cathédrale de Rouen vers 1300. Portail des Libraires, portail de la Calende, chapelle de la Vierge.* Caen: Société des antiquaires de Normandie, 2005.

Schlink, Wilhelm. *Der Beau-Dieu von Amiens: Das Christusbild der gotischen Kathedrale.* Frankfurt am Main: Insel Verlag, 1991.

Schlink, Wilhelm. "The Gothic Cathedral as the Heavenly Jerusalem: A Fiction in German Art History." In *The Real and Ideal Jerusalem in Jewish, Christian and Islamic Art*, edited by Bianca Kühnel, 275–85. Jerusalem: The Hebrew University of Jerusalem, 1998.

Schlink, Wilhelm. *Zwischen Cluny und Clairvaux: Die Kathedrale von Langres und die burgundische Architektur des 12. Jahrhunderts.* Berlin: De Gruyter, 1970.

Schloeder, Steven J. *Architecture in Communion: Implementing the Second Vatican Council through Liturgy and Architecture.* San Francisco: Ignatius Press, 1998.

Schneider, Lambert. "Les signes du pouvoir: structure du langage iconique des Thrâces." *Revue archéologique* 2 (1989): 227–51.

Schreckenberg, Heinz. *Bibliographie zu Flavius Josephus.* Leiden: Brill, 1968.

Schreckenberg, Heinz. *Bibliographie zu Flavius Josephus: Supplementband mit Gesamtregister.* Leiden: Brill, 1979.

Schreckenberg, Heinz. *Die Flavius-Josephus-Tradition in Antike und Mittelalter.* Leiden: Brill, 1972.

Schrenkenberg, Heinz, and Kurt Schubert. *Jewish Historiography and Iconography in Early and Medieval Christianity.* Assen: Van Gorcum, 1992.

Schulte Nordholt, Hendrik. "Der Baum des Lebens. Eine Analyse des Mosaiks in der Apsiskalotte von S. Clemente in Rom." *Römische historischer Mitteilungen* 28 (1986): 17–30.

Sedlmayr, Hans. *Die Entstehung der Kathedrale.* Zurich: Atlantis Verlag, 1950.

Seidel, Linda. *Legends in Limestone: Lazarus, Gislebertus, and the Cathedral of Autun.* Chicago: University of Chicago Press, 1999.

Seidel, Max. "Dombau, Kreuzzugsidee und Expansionspolitik. Zur Ikonographie der Pisaner Kathedralbauten." *Frühmittelalterliche Studien* 11 (1977): 340–69.

Serbat, Louis. "La Charité-sur-Loire." *Congrès archéologique de France* 80 (1913): 374–400.

Shelby, Lon R. "Medieval Masons' Tools II: Compass and Square." *Technology and Culture* 6 (1965): 236–48.

Shimoff, Sandra R. "Gardens: From Eden to Jerusalem." *Journal for the Study of Judaism* 26 (1995): 145–55.

Sicardi Cremonensis episcopi mitrale: Sive de Officiis Ecclesiasticis Summa, edited by J.-P. Migne. Paris: Migne, 1855.

Simon, Erika. *Ara Pacis Augustae*. Tübingen: Wasmuth, 1967.

Simson, Otto von. "The Gothic Cathedral: Design and Meaning." *JSAH* 11 (1952): 6–16.

Simson, Otto von. *The Gothic Cathedral: Origins of Gothic Architecture and the Medieval Concept of Order*. New York: Pantheon, 1956.

Slicher van Bath, Bernard H. *The Agrarian History of Western Europe: ad 500–1850*. Translated by Oliver Ordish. London: Arnold, 1963.

Smith, Christine. *The Baptistery of Pisa*. New York: Garland, 1978.

Smith, Christine. "Christian Rhetoric in Eusebius' Panegyric at Tyre." *Vigiliae Christianae* 43 (1989): 226–47.

Soucek, Priscilla. "The Temple of Solomon in Islamic Legend and Art." In *The Temple of Solomon*, edited by Joseph Gutmann, 73–123. Missoula, MT: Scholars Press, 1976.

Spain Alexander, Suzanne. "Heraclius, Byzantine Imperial Ideology, and the David Plates." *Speculum* 52 (1977): 217–37.

Speer, Andreas. "The Discovery of Nature: The Contribution of the Chartrians to Twelfth Century Attempts to Found a *Scientia Naturalis*." *Traditio* 52 (1997): 135–51.

Speer, Andreas. *Die entdeckte Natur: Untersuchungen zu Begründungsversuchen einer "scientia naturalis" im 12. Jahrhundert*. Leiden: Brill, 1995.

Spicer, Andrew, and Sarah Hamilton, eds. *Defining the Holy: Sacred Space in Medieval and Early Modern Europe*. Aldershot: Ashgate, 2005.

Stalley, Roger. *Early Medieval Architecture*. Oxford: Oxford University Press, 1999.

Stamatis Pendergast, Carol. "The Lintel of the West Portal at Anzy-le-Duc." *Gesta* 15 (1976): 135–42.

Stanislawski, Dan. "Dionysus Westward: Early Religion and the Economic Geography of Wine." *Geographical Review* 65 (1975): 427–44.

Steger, Michelle. "L'abbaye de Braine." In *Agriculture et économie chez les Prémontrés*, edited by Martine Plouvier, 106–23. Amiens: Centre d'études et de recherches prémontrées, 1989.

Stewart, Aubrey, ed. *Ludolph von Suchem's Description of the Holy Land and of the Way Thither*. Cambridge: Cambridge University Press, 2013.

Stiltingo, Joanne, et al. *Acta sanctorum septembris*. Vol. 7. Antuerpiae: Apud Bernardum Alb. Vander Plassche, 1760.

Stokstad, Marilyn. "Gardens in Medieval Art." In *Gardens of the Middle Ages*, edited by Marilyn Stokstad and Jerry Stannard, 19–35. Lawrence: Spencer Museum of Art, University of Kansas, 1983.

Stratford, Neil. "À propos du grand portail de la nef de Cluny III." Translated by Éliane Vergnolle. *Bulletin monumental* 170 (2012): 15–30.

Stratford, Neil. "The Documentary Evidence for the building of Cluny III." In *Le gouvernement d'Hugues de Semur à Cluny: Actes du Colloque scientifiques international: Cluny, septembre 1988*, 283–312. Cluny: Musée Ochier, 1990.

Stratford, Neil, ed. *Cluny, 910–2010: Onze siècles de rayonnement*. Paris: Éditions du Patrimoine, Centre des monuments nationaux, 2010.

Stroll, Mary. *Symbols as Power: The Papacy following the Investiture Contest*. Leiden: Brill, 1991.

Stürmer, Andreas. *Ehemalige Kollegiatskirche Saint-Lazare zu Avallon*. Köln: Vertrieb, Abt. Architektur des Kunsthistorischen Instituts, 1984.

Suter-Raeber, Regula. *La Charité-sur-Loire*. Bern: Francke Verlag, 1964.

Swarzenski, Hanns. *Die lateinischen illuminierten Handschriften des 13. Jahrhunderts in den Ländern am Rhein, Main, Donau*. Berlin: Deutscher Verein für Kunstwissenschaft, 1936.

Świechowski, Zygmunt. *Sculpture romane d'Auvergne*. Clermont-Ferrand: G. de Bussac, 1973.

Tacitus. The Histories, the Annals. Translated by Clifford H. Moore and John Jackson. Cambridge, MA: Harvard University Press, 1931.

Tallon, Andrew. "An Architecture of Perfection." *JSAH* 72 (2013): 530–54.

Terret, Victor. *La cathédrale Saint-Lazare d'Autun*. Autun: Imprimerie de Dejussieu et Xavier, 1919.

Tertullian. *De carne Christi liber*. Edited by Ernest Evans. London: SPCK, 1956.

Theoderic. "Libellus de locis sanctis." In *Peregrinationes tres*, CCCM139, edited by Robert B. C. Huygens, 142–97. Turnhout: Brepols, 1994.

Theophilus. *Theophili, qui et Rugerus, presbyteri et monachi, libri III. de diversis artibus: seu, Diversarum artium schedula*. Translated by Robert Hendrie. London: J. Murray, 1847.

Thérel, Marie-Louise. "Le portail de la vierge-mère de la cathédrale de Laon: Étude iconographique de la troisième voussure." In *Actes du 95e Congrès national des sociétés savantes. Sections d'archéologie et d'histoire de l'art: Reims*, 273–87. Paris: Bibliothèque nationale, 1973.

Thomas Aquinas. *Commentary on the Gospel of John: Chapters 13–21*. Translated by Fabian R. Larcher and James A. Weisheipl. Washington, DC: Catholic University of America Press, 2010.

Thomas Aquinas, *Opera omnia*. Vol. 6, edited by Roberto Busa. Stuttgart-Bad Cannstatt: Frommann-Holzboog, 1980.

Thomas Aquinas. *Summa Theologiae, vol. 6, The Trinity (1a.27–32)*. Translated by Ceslaus Velecky. Cambridge: Cambridge University Press, 2006.

Thunø, Erik. *Image and Relic: Mediating the Sacred in Early Medieval Rome*. Rome: L'Erma di Bretschneider, 2002.

Timbert, Arnaud. *Vézelay: le chevet de la Madeleine et le premier gothique bourguignon*. Rennes: Presses Universitaires de Rennes, 2009.

Timbert, Arnaud, ed. *Viollet-le-Duc: le chantier de restoration de La Madeleine de Vézelay: correspondance, 1840–1841*. Auxerre: Monuments historique de l'Yonne, 2005.

Tobler, Titus, and August Molinier, eds. *Itinera Hierosolymitana et Descriptiones Terrae Sanctae*. 2 vols. Geneva: Fick, 1879.

Topping, Eva C. "On Earthquakes and Fires: Romanos' Encomium to Justinian." *Byzantinische Zeitschrift* 71 (1978): 22–35.

Toubert, Hélène. *Un art dirigé: Réforme grégorienne et iconographie*. Paris: Éditions du Cerf, 1990.

Trachtenberg, Marvin. "Architecture and Music Reunited: A New Reading of Dufay's 'Nuper Rosarum Flores' and the Cathedral of Florence." *Renaissance Quarterly* 54 (2001): 740–75.

Trachtenberg, Marvin. *Building-in-Time from Giotto to Alberti and Modern Oblivion*. New Haven: Yale University Press, 2010.

Trachtenberg, Marvin. "Desedimenting Time: Gothic Column/Paradigm Shifter." *RES: Anthropology and Aesthetics* 40 (2001): 5–28.

Trachtenberg, Marvin. "Gothic/Italian 'Gothic': Toward a Redefinition." *JSAH* 50 (1991): 22–37.

Trachtenberg, Marvin. "Suger's Miracles, Branner's Bourges: Reflections on 'Gothic Architecture' as Medieval Modernism." *Gesta* 39 (2000): 183–205.

Travis, William J. "The Iconography of the Choir Capitals at Saint-Lazare of Autun and the Anagogical Way in Romanesque Sculpture." *Konsthistorisk Tidskrift* 68 (1999): 220–49.

Tribhout, André. *Moret-sur-Loing: son église*. Moret-sur-Loing: s.n., 1970.

Trilling, James. *The Language of Ornament*. London: Thames and Hudson, 2001.

Trilling, James. *Ornament: A Modern Perspective*. Seattle: University of Washington Press, 2003.

Tronzo, William. "On the Role of Antiquity in Medieval Art: Frames and Framing Devices." In *Ideologie e pratiche del reimpiego nell'alto Medioevo: 16–21 aprile 1998*, 1085–1114. Vol. 1. Spoleto: Centro Italiano di studi sull'alto medioevo, 1999.

Turner, Victor. "Betwixt and Between: The Liminal Period in *Rites de Passage*." In *The Forest of Symbols. Aspects of Ndembu Ritual*, 93–111. Ithaca, NY: Cornell University Press, 1970.

Tyrannius Rufinus. *Ecclesiastical History*. Translated by Philip R. Amidon. Oxford: Oxford University Press, 1997.

Ugolino, Blasius. *Thesaurus Antiquitatum Sacrarum*. Venetiis: Herthz, 1750.

Unwin, Tim. *Wine and the Vine: An Historical Geography of Viticulture and the Wine Trade*. London: Routledge, 1991.

Vallery-Radot, Jean. "L'iconographie et le style des trois portails de Saint-Lazare d'Avallon." *Gazette des Beaux-Arts* 52 (1958): 23–34.

Van Liefferinge, Stefaan. *The Choir of Notre-Dame of Paris: An Inquiry into Twelfth-Century Mathematics and Early Gothic Architecture*. PhD dissertation, Columbia University, 2006.

Vaultier, Roger. *Le folklore pendant la guerre de Cent Ans d'après les Lettres de rémission du Trésor des chartes*. Paris: Librairie Guénégaud, 1965.

Vergnolle, Éliane, et al. "L'ancienne collégiale Notre-Dame de Beaune: les campagnes des XIIe et XIIIe siècles." *Congrès archéologique de France* 152 (1997): 179–201.

Vergnolle, Éliane, et al. *La collégiale Notre-Dame-de Beaune. Côte-d'Or*. Paris: Éditions du patrimoine, 1997.

Verret, Denis, and Delphine Steyaert, ed. *La couleur et la pierre: polychromie des portails gothiques*. Paris: Picard, 2002.

Vetter, Ewald M. *Maria im Rosenhag*. Düsseldorf: L. Schwann, 1956.

Victoir, Géraldine. "Nature in Architecture: The Vegetal World and Architectural Polychromy in Northern France from the Mid-Twelfth to Mid-Fourteenth Century." In *Art and Nature: Studies in Medieval Art and Architecture*, edited by Laura Cleaver, Kathryn Gerry, and Jim Harris, 69–79. London: Courtauld Institute of Art, 2009.

Victoir, Géraldine. "La polychromie et l'apport de son étude à la connaissance de l'architecture gothique." In *Architecture et sculpture gothiques: renouvellement des méthodes et des regards: actes du IIe colloque international de Noyon, 19–20 juin 2009/sous la direction de Stéphanie Diane Daussy et Arnaud Timbert*, 121–35. Rennes: Presses Universitaires de Rennes, 2012.

Villes, Alain. "Remarques sur les campagnes de construction de la cathédrale de Metz au XIIIe siècle." *Bulletin monumental* 162 (2004): 243–72.

Viollet-le-Duc, Eugène-Emmanuel. *Dictionnaire raisonné de l'architecture française du XIe au XVIe siècle*. 10 vols. Paris: B. Bance, 1854–1868.

Visions of the Ottoman Empire. Edinburgh: Trustees of the National Galleries of Scotland, 1994.

"Vitis mystica," or the True Vine: A Treatise on the Passion of Our Lord. Translated by William B. Brownlow. London: R. Washbourne, 1873.

Vogel, Julius. *Bramante und Raffael: Ein Beitrag zur Geschichte der Renaissance in Rom*. Leipzig: Klinkhardt & Biermann, 1910.

Vogüé, Melchior de. *Les églises de la Terre Sainte*. Paris: Victor Didron, 1860.

Vuillemard-Jenn, Anne. "La polychromie des cathédrales gothiques." In *20 siècles en cathédrales, catalogue de l'exposition du palais du Tau, Reims*, 219–28. Paris: Editions du Patrimoine, 2001.

Vuillemard-Jenn, Anne. "La polychromie des façades gothiques et sa place au sein d'un dispositif visuel." *Histoire de l'art* 72 (2013): 43–56.

Walker Bynum, Caroline. *Holy Feast and Holy Fast: The Religious Significance of Food to Medieval Women*. Berkeley: University of California Press, 1987.

Walker Bynum, Caroline. *Wonderful Blood. Theology and Practice in Late Medieval Northern Germany and Beyond*. Philadelphia: University of Pennsylvania Press, 2007.

Waltherus, Paulus. *Fratris Pauli Waltheri Guglingensis Itinerarium in Terram Sanctam et ad Sanctam Catherinam*, edited by M. Sollweck. Tübingen: Stuttgart, 1892.

Watson, Arthur. *The Early Iconography of the Tree of Jesse*. Oxford: Oxford University Press, 1934.

Webb, Geoffrey, and Adrian Walker, trans. *St. Bernard of Clairvaux: The Story of His Life as Recorded in the Vita Prima Bernardi by Certain of His Contemporaries, William of St. Thierry, Arnold of Bonnevaux, Geoffrey and Philip of Clairvaux, and Odo of Deuil*. Westminster, MD: Newman Press, 1960.

Weigert, Laura. *Weaving Sacred Stories: French Choir Tapestries and the Performance of Clerical Identity*. Ithaca, NY: Cornell University Press, 2004.

Weinryb, Ittai. "The Bronze Object in the Middle Ages." In *Bronze*, edited by David Ekserdjian, 69–77. London: Royal Academy of Arts, 2012.

Weinryb, Ittai. "Living Matter: Materiality, Maker, and Ornament in the Middle Ages." *Gesta* 52 (2013): 113–32.

Weiss, Daniel. "Hec Est Domus Domini Firmiter Edificata: The Image of the Temple in Crusader Art." *Jewish Art* 23/24 (1997/98): 210–17.

Weiss, Daniel. "The Three Solomon Portraits in the Arsenal Old Testament and the Construction of Meaning in Crusader Painting." *Arte medievale* 6 (1992): 15–38.

Weitzmann, Kurt. *The Miniatures of the Sacra Parallela: Parisinus Graecus 923*. Princeton: Princeton University Press, 1979.

Whitby, Mary. "The St Polyeuktos Epigram (*AP* 1.10): A Literary Perspective." In *Greek Literature in Late Antiquity: Dynamism, Didacticism, Classicism*, edited by Scott Fitzgerald Johnson, 159–88. Aldershot: Ashgate, 2006.

Wick, Peter. "Jesus gegen Dionysos? Ein Beitrag zur Kontextualisierung des Johannesevangeliums." *Biblica* 85 (2004): 179–98.

Wilkinson, John. *Egeria's Travels to the Holy Land*. Warminster: Aris & Phillips, 1981.

Wilkinson, John. "Paulinus' Temple at Tyre." *Jahrbuch der Österreichischen Byzantinistik* 32 (1982): 553–61.

Will, Robert. "Recherches iconographiques sur la sculpture romane en Alsace: Les représentations du Paradis." *Cahiers techniques de l'art* 1 (1948): 29–80.

William of Tyre. "Historia rerum in partibus transmarinis gestarum." In *Gesta Dei per Francos*, edited by Jacques Bongars. Vol. 1. Hanoviae: typis Wechelianis, apud heredes I. Aubrii, 1611.

Wilson, Christopher. *The Gothic Cathedral: The Architecture of the Great Church, 1130–1530*. London and New York: Thames and Hudson, 1990.

Winkworth, Susanna, trans. *Theologia Germanica*. London: Macmillan and Co., 1937.

Wolf, Werner, and Walter Bernhart, eds. *Framing Borders in Literature and Other Media*. Amsterdam: Editions Rodopi, 2006.

Wu, Nancy. "Hugues Libergier and His Instruments." *Nexus Network Journal* 2 (2000). http://www.nexusjournal.com/Wu.html.

Wulkan, Reba. "The Grape and the Vine: A Motif in Contemporary Jewish Textiles." In *Creating Textiles: Makers, Methods and Markets*, edited by Madelyn Shaw, 369–77. Earleville: Textile Society of America, 1998.

Zahlten, Johannes. *Creatio mundi: Darstellungen der sechs Schöpfungstage und naturwissenschaftliches Weltbild im Mittelalter*. Stuttgart: Klett-Cotta, 1979.

Zambon, Liliana, Dominique Grunenwald, and Paulette Hugon. "La polychromie du portail central de la cathédrale d'Amiens: conservation, restauration, et investigations scientifiques." In *La couleur et la pierre: polychromie des portails gothiques*, edited by Denis Verret and Delphine Steyaert, 233–47. Paris: Picard, 2002.

Zanker, Paul. *The Power of Images in the Age of Augustus*. Translated by Alan Shapiro. Ann Arbor: University of Michigan Press, 1990.

Index

Note: Page numbers in italics refer to illustrations

Aachen, Palatine Chapel, 162
abaci, 60, 84, 134, 141, 184
'Abd al-Malik ibn Marwan, 161, 165, 171, 177
Abelard, Peter, 163
Abraham, sacrificing Isaac, 117, 124
Abu 'Ali al-Mansur al-Hakim, 104
Abu Bakr al-Wāsitī, 170
acanthus, 9, 49, 60, 69, 95, 150, 170, 177, 185
Adam and Eve, 75, 124
 Creation, 88–89
 Expulsion, 20, *72*, 76, 89, 106
Adam of Perseigne, 116
Adam of Saint-Victor, 116
adaptation, in ocular physiology, 28
Aelia Capitolina, 161
Aelred of Rievaulx, 116
agriculture, 1, 8–9, 71, 191
agricultural treatises, 9, 107
Alan of Lille, 11, 97, 107
Alberti, Leon Battista, 74
Alcuin, 162
Alexander the Great, 69
Alexander, Jonathan J. G., 59, 194n15
altars, 25, 37, 53, 60, 117, 120–121, 124, 128–129, 132–134, 160, 190
al-Walīd ibn 'Abd al-Malik, 177
Ambrose, Kirk, 19, 201n97
Ambrose, Saint, 76, 97, 102, 115
Amiens Cathedral, 168, 191
 choir screen, 133–134, 139
 elevation, 1, 28, *29*, 34

foliate friezes, 1, 27–35, 49, 53–57, 125, *126–127*, 132, 134, *135–138*, 141, 147, *149*, 179 (*see also under* foliate friezes, at Amiens Cathedral)
 gallery of kings, 147, *149*
 labyrinth, 28
 measurements, 88, 197n24, 203n65, 212n74
 polychromy, 29–30, 34, 179, 197n29, 197n31
 Saint Firmin feast, 28, 128–129, 191
 south transept, 30, 134, *135–138*
 west façade, central portal, 49, 53, *54–57*, 79, *80*, 125–129, 132, 134, 140–141, *142*
 west façade, north portal, 53, *130–133*
 west façade, south portal, 53, 132, 143, *144*
Amiens, Musée de Picardie, 60, *61*
Amsterdam, Rijksmuseum, *109*
Anastasius, 67
Andlau Abbey, 88–89, *90–91*, 94
Andrew of Saint-Victor, 161, 163
angels, 26, *27*, 36, 44, 76–78, 98, 102, 117, 121–122, 124, 126, 128, 132, 134, 139, 173, 190
Angers Cathedral, 179
Anicia Juliana, 175–176
animals, 8, 35, 47, 59, 64, 79, 96, 107–108
Anne, Saint, 117, 120
Antioch Chalice, *112*, 113, 206n2
antiquity, 9, 71, 94, 114–115, 150, 152, 159
Anzy-le-Duc, La Trinité, 44, *47*, 121
apses, 9, 17, 41, *79*, 95–96, 126
Aquinas, Saint Thomas, 75, 92, 102, 107, 116
Archangel Michael, 126

archetypes, biblical, 18, 81, 88, 157, 159, 163, 168, 185, 186. *See also* prototypes, architectural
Aristobulus II, 164
Ark of the Covenant, 20, 91, 157, 159, 160, 162–163, 174
Armi, C. Edson, 67
Ash Wednesday, 190
asp, 128
aspersions, 25, 190
astragals, 60, 134
Astwerk, 11, 13, 17, 73–74, 99
atriums, 81, 103
Augustine of Hippo, Saint, 75, 97, 102, 107, 115, 157, 161
Augustus, 152
Autpert Ambrose, 97
Autun Cathedral, 19, 30, *34*, 44, 46, 62, 69, 121, 179, 186
Auvray, Pierre-Laurent, 62
Avallon, Saint-Lazare, 49, *52–53*, 184

Baalbek, Temple of Bacchus, 150
Bacchus, 150, *153*. *See also* Dionysus
Baltrušaitis, Jurgis, 23, 196n4
Bamberg Psalter (Bamberg Staatsbibliothek, Msc. Bibl.48), 99–100, *101*
Bandmann, Günter, 17
baptism, 9, 115
baptism of Clovis, 60
baptismal chapels, 215n134
baptismal fonts, 80
Baron, Jean, 28
basilicas, 81, 84, 103, 168
basilisk, 128
Beau Dieu, 53, 126, *127*, 128, 141. *See also under* Amiens Cathedral, west façade, central portal
Beaune, Notre-Dame, 69, *70*, 186
Beauvais Cathedral, *22*, 88, 145, *146*, 168
Bede, the Venerable, 75, 161, 180
Benoist, Antoine, *183*
Bernard of Clairvaux, 21, 26, 97, 180
Bernard of Cluny, *De contemptu mundi*, 91
Bernard (monk), 165
Bernard Silvestris, 9, 107
Bernward, bishop, 102
Berzé-la-Ville, Cluniac chapel, *24*
Bethlehem, 128
Bezalel and Oholiab, 159, 162
Binski, Paul, 18
birds, 35, 47, 57, 59, 64, *65*, 79, 84, 96
Bologna, Santo Stefano, 168
Bonaventure, Saint, 95, 107, 116

Bonne, Jean-Claude, 19, 60, 62, 114
Bonnefont Cloister, *188*
bosses, 7, 34, 36, 60
Bourges Cathedral, 179
Braine, Saint-Yved, 40–42
Braun-Reichenbacher, Margot, 17, 73, 108
bread, as corpus of Christ, 53, 121, 124
Brescia, San Salvatore, 67
Bucher, François, 74
Büchner, Joachim, 17, 73
Burgundy, 1, 7, 27, 35, 62, 69, 71
Byzantine architecture, 18, 67, 159, 162, 171–177, 179, 185
Byzantium, 67, 71, 174, 176, 186

Caen, La Trinité, 42, *45–46*
Cahn, Walter, 161
Cairo, tomb of Nur al-Din, 178
Calcidius, 92
Camille, Michael, 36
Canterbury Cathedral, 80
capital friezes, *56*, 57, 141
capitals, 7, 9, 13, 19, 30, 34, 36, 49, 57, 60, 62, 69, 84, 95, 122, 124, 132, 134, *150*, 159, 175–176, 184
Carolingian
 architecture, 17, 67, 81, 162
 ivories, 60, 95
 scholars, 97, 162–163
Castriota, David, 19
censers, 117, 121, 124, 134
chalices, *112*, 113, 117, 120, 124, 134
Chalon-sur-Saône Cathedral, 30, 62, *64*
Châlons-en-Champagne, Notre-Dame-en-Vaux, 35–37, 71
Champagne, 1, 35
Champagné-Saint-Hilaire, Notre-Dame des Moreaux, 163
Chantilly, Musée Condé, *10*, *72*
Charlemagne, 162
Charles VI, king, 36
Charlieu, abbey church, 179
Chartres Cathedral, 1, 42, 100, 121, 125, 163
 buttresses, *44*
 Feast of the Purification, 121
 gallery of kings, 147
 jubé, 30
 north transept, 88–89, 94, 117, *118*, 120, 143, *144*
 west façade (Royal Portal), 47, *50*, *120*, 168
Chartres, school of, 47
Châteaubriand, François-Réné de, 13
Chenu, Marie-Dominique, 9, 11

choir, as place of divine presence, 91
Chrétien de Troyes, 107
Christ
 Arrest, 134
 as corner stone, 26
 Ascension, 128
 Betrayal, 102, 134
 blood of, 115–117, 121
 Crucifixion, 77, 95, 102, 113, 115, 117, 161
 Descent into Limbo, 134
 disputation with the doctors, 166
 entry into Jerusalem, 132, 134, 189
 expulsion of the moneychangers, 166
 as gardener, 102, 106
 Incarnation, 97, 100, 116, 139, 141
 Lamentation, 113
 Last Supper, 115
 in Majesty, 117, 121
 miracles of, 115
 Nativity, 120–121
 as New Adam, 79, 102, 124
 Noli me tangere, 102, *103–104*, 106
 Passion, 95, 102–103, 105–106, *114*, 116–117,
 126, 134
 Presentation in the Temple, 120, 161, 166
 Resurrection, 20, 77, 94, 97, 99, 102, 186
 tomb of, 20, 102–103, 105–106, 121, 162 (*see
 also* Holy Sepulcher)
Chronicon monasterii Casinensis, 81
church, symbolism of, 17, 73–74, 110, 214n130
Cistercians, 21, 44, 116, 139
Cîteaux, monastery, 139, *140–141*
Clarembald of Arras, 92
Clark, William W., 168, 180
Clement of Alexandria, 115
Clermont-Ferrand, Notre-Dame-du-Port, 180
cloisters, 81–82, *83*, 84, *85*, 86, *87*, 88, 107,
 124, *188*
Clovis, king, 60
Cluny III, 20, 27, 30, 62–67, 69, 71, 179,
 185–186
Cluny, Musée d'art et d'archéologie, *63*, *64*, *65*
Colmar, Saint-Martin, 98
columns, symbolism of, 17
consecration of churches, 25–26, 71, 74, 86, 157,
 162, 190
Constable, Giles, 67
Constantine the Great, 103, 106, 161, 166, 176
Constantine Monomachus, 104
Constantinople, 67, 162, 171, 174–176. *See also*
 Istanbul
copies, architectural, 157, 177–178, 185, 210n3
Corinthian, 60, 62, 69, 150

Corippus, 174
Corpus Christi feast, 190–191
Creation, 75, 84, 88–89, 92, 106–108, 117, 190
crockets, 18, 42, 49, 76, 99
cross of the Crucifixion, 95–96, 102, 115,
 117, 134
 as *arbor vitae*, 95
 as winepress, 115
Crossley, Paul, 13, 15, 17–18, 73–74, 106, 125
Crowther, Paul, 19
Crusades, 21, 103–104, 159, 161, 166, 186

Dagron, Gilbert, 176
Dale, Thomas E. A., 19
Damascus
 Great Mosque, 18, 165, 177–179, 185
 māristān of Nur al-Din, 178
 tomb of Baybars I, 178
Danube School, 18, 108
David, king, 123, 139–141, 159, 163, 174,
 176–177
debir. See Holy of Holies
Depaule, Jean Charles, 19
Desiderius, abbot, 81
Diegesis, 174
Dieppe, Saint-Jacques, 37
Dijon, Bibliothèque municipal, *140–141*
Dionysus, 152. *See also* Bacchus
Donus, pope, 81
doves, 36, 139, 189
dragons, 36, 122, 128
ductus, 125
Durand, Georges, 28

Easter, 116
Eden. *See* Garden of Eden
Egeria (nun), 162
Egger, Anne, 28
Eliezer ben Rabbi Zadok (Rabbi), 164
Elijah, 77, 124, 174
Elsner, Jaś, 152
Ely Cathedral, 18
Ephrem, Saint, 116
Epstein, Steven, 9
Erlande-Brandenburg, Alain, 28
Etheldreda, Saint, 18
Eu, Notre-Dame-Saint-Laurent, 37
Eucharist, 1, 20, 115, 117, 120–121, 124–125, 134,
 154, 190
Eusebius of Caesarea, 17, 74, 161–162
Eutychius of Alexandria, 166
Ezekiel, prophetic vision, 77, 96, 100, 161,
 168, 176

Fassler, Margot, 120–121, 168
Fehr, Götz, 18
Felix, Saint, 191
field-frame relationship, 20, 23–27, 44, 59–62, 114–115
Filarete, Antonio, 74
Firmin, Saint, 8, 28, 53, 128–129, 132, 191
Flood, Finbarr Barry, 18, 165, 168, 177
Florence Baptistery, 166
flying buttresses, 23
Focillon, Henri, 23
foliate crowns, 129, 132, 191
foliate friezes
 at Amiens Cathedral, 1, 27–35, 49, 53–57, 125, *126–127*, 132, 134, *135–138*, 141, 147, *149*, 179
 at Andlau Abbey, 88–89, *90–91*
 at Autun Cathedral, 30, *34*, 44, *46*, 69, 121, 179, 186
 as bearers of meaning, 8, 17–21
 at Beaune Cathedral, 69, *70*, 186
 inside churches, 35–40
 outside churches, 1, 40–42
 at Chalon-sur-Saône Cathedral, 62, *64*
 at Chartres Cathedral, 42, *44*, 47, 88, *89*, 117, 120–121
 on church portals, 7, 42–49
 at Cluny III, 62–67, 71, 179, 185–186
 as framing devices, 20, 23, 26
 at La Madeleine, Vézelay, 67, *68–69*, 186
 at La Trinité, Anzy-le-Duc, 44, *47*, 121
 at Langres Cathedral, 8, 37, *38–39*, 69–71, 185
 at Laon Cathedral, 42, *43–44*
 at Le Mans Cathedral, 36, *39*, 179
 at Metz Cathedral, 28, *31*, 57, 180
 at Notre-Dame, Poissy, *5*, 37
 at Notre-Dame-en-Vaux, Châlons-en-Champagne, 35–36, 71
 at Reims Cathedral, 6–8, 57, 180
 at Rouen Cathedral, *51*
 at Saint-Denis, 47, *51*
 at Saint-Germain-des-Prés, *14–15*, 121, 124
 at Saint-Lazare, Avallon, 49, 52–53, 184
 at Saint-Maclou, Rouen, 37, *48–49*, 57, *58*, 59
 at Saint-Rémi, Reims, *3*, 8, 36–37, 71
 at Saint-Yved, Braine, 40–42
 on small-scale objects, 59–62
 at Soissons Cathedral, *4*, 8, 71
forest theory, 13
Forsyth, William, 124
Fountain of Life, 76, 108
Francesco di Giorgio, 74
François I, king, 147

Frank, Jacqueline, 168, 180
Frankl, Paul, 13, 74
frescoes, 9, 67
fruit, 1, 21, 28, 34–37, 41, 53, 64, 75–76, 80, 84, 94–97, 102, 108, 113, 115–116, 121, 125, 128–129, 133, 140, 164–165, 168, 170, 176, 179

Galilee, as architectural term, 186
Galilee earthquake, 161
gallery of kings, 147, *149*
Garden of Eden, 20, 75–77, 79–81, 84, 88–89, 91–92, 94–97, 106–108, 124, 190. *See also under* paradise, earthly
Garden of Gethsemane, 102
Garden of Joseph of Arimathea, 20, 102, 105
garlands, 35, 150, 180, 190–191
Gaudentius of Brescia, 115
généralizée (style), 7
Gervase of Canterbury, 80
Gilbert, Antoine, 28
gilding, 30, 160, 168, 170, 178–180. *See also* gold
Givens, Jean, 37
Gloria, laus, et honor, 190
God, as architect, 92, *93*
Goethe, Johann Wolfgang von, 13
gold, 29–30, 78–79, 86, 96, 100, 105, 160, 164–165, 170, 173, 177, 179–180. *See also* gilding
Golden Vine, 1, 18, 21, 95, 157–159, 163–165, 168, 170, 173–175, 177, 179–180, 184–186
goldfinches, 99
Goldziher, Ignác, 165
Gombrich, Ernst, 19–20, 24
Gothic, 1, 13, 15, *16*, 28, 30, 37, 74–76, 133
 Early, 100
 High, 7, 28
 Late, 11, 13, 17–18, 20, 73, 99, 113
Grabar, Oleg, 19
grapevines. *See also* vines
 in ancient architecture, 150, 152
 cultivation of, 15, 150
 depictions of, 20, 37, 49, 53, 57, 89, 102, 113–117, 121, 123–126, 128, 132–134, 140–141, 147, 153–154, 179
 in Jewish contexts, 152–153
 as symbol of Christ, 113–117, 126, 128, 132–134
 as Tree of Life, 94–95
Green Man, 129, 132
Gregory IX, pope, 162
Gregory the Great, Saint, 115, 161–162
Grünbaum, Barbara, 19
Guillebert de Metz, 168

Gunzo (monk), 67
Guy of Geneva, 67

Hadrian, 161
The Hague, Koninklijke Bibliotheek, *167*
Haram al-Sharif, *160*, 161, 170. *See also under*
 Jerusalem, Temple Mount
Harrison, Martin, 176
Hawkins, Ernest S. W., 172–173
heaven. *See* paradise
Heavenly Jerusalem, 74–75, *78*, 79, 84, 86, 88,
 96, 106, 162, 168, 177, 189. *See also under*
 paradise, celestial
hekhal, 21, 160, 163–165
Helena, Saint, 166, 176
hell, 77, 108
Hengel, Martin, 152
Henry of Avranches, 27
Henry Murdach, 21
Hermann von Minden, 107
Herod's Temple, 160–161, 163–166. *See also*
 under Jerusalem, Temple
hierarchy, of church spaces, 37, 40
Hieronymus Bosch, *Garden of Earthly Delights*,
 107–108
Hildesheim, Saint-Michael, bronze doors,
 102, *104*
Hippolytus of Rome, 102
Hiram of Tyre, 162
Historia monachorum, 84
Historia Selebiensis Monasterii, 81
Hölderlin, Friedrich, 152
Holy of Holies, 20, 91, 160, 162, 165, 168, 176
Holy Land, 67, 103, 105, 162, 186. *See also*
 Jerusalem
Holy Sepulcher, 102–103, 105–106. *See also*
 under Christ, tomb of
Holy Thursday, 190
Holy water, 25, 190
Holy Week, 9, 189
Honoré, Saint, 134
Honorius of Autun, 75, 80, 97, 161, 190
hortus conclusus, 17, 20, 97–100, 102, 107
Hugh of Fouilloy, 80, 84
Hugh of Saint-Victor, 25
Hugh of Semur, 62
Hugues Libergier, 92, *94*
Hunt for the Unicorn, 99
hyssop, 25, 190

Ibn 'Asakir, 177
Ibn al-Murajjā, 170
Île-de-France, 1, 35

Ingolstadt, Our Lady, *12*
inscriptions, 44, 81, 88, 139, 154
Insular art, 19
Isabelle of France, 116
Isidore, abbot, 84
Isidore of Seville, 75, 161
Islamic architecture, 18–19, 159, 161, 165–166,
 170, 177–179, 186
Istanbul. *See also* Constantinople
 Archaeological Museum, *176*
 Hagia Sophia, 18, 67, 162, 171–175, 177, 179,
 185–186
 Saint-Polyeuktos, 18, 162, 171,
 175–176, 185
ivories, 114, 145
 Carolingian, 60, 95
 Late Gothic, 113, *114*
ivy, 30, 122, 150

Jachin and Booz, 159, 180, 184
Jacob, Dream of the Ladder, 77, 161
Jáen missal, 190
Jalabert, Denise, 7
jambs, 6, 47, 49, *50–51*, 53, 59, 88–89, 95, *136*,
 138, 141, 147, 184
 capitals, 49, 57, 122, 124
 columns, 47, 49, 121, 168, 180, *182*
 statues, 57, 117, 120, 122, 134, 180, *183*
Jerome, Saint, 139, *140–141*, 191
Jerusalem
 Aqsa Mosque, 161, 166
 Christian conquest and occupation of, 103,
 158, 166, 186
 Church of the Holy Sepulcher, 17, 103,
 104–105, 106, 161–162, 166
 Dome of the Rock, 18, 21, 67, *156*, 158–159,
 161, 165–166, 168, 170–171, 173, 175,
 177–180, 185–186
 Gate of Mercy, 170, 213n77
 Golden Gate, 170
 guides to, 170
 maps of, 166, *167*
 palace of Solomon, 166, 168, 212n74
 porch of Solomon, 166
 Roman sack of, 77
 stables of Solomon, 166
 Temple, 1, 18, 20–21, 57, 77, 91, 94, 120–121,
 124, 140, 153, 157–166, 168, 170–171,
 173–177, 179–180, 184–186, 189
 (*see also* Herod's Temple; Solomon's Temple;
 Zerubbabel's Temple)
 Temple Mount, 157, 159, 160–161, 165–166
 (*see also* Haram al-Sharif)

Jesse Tree
　in manuscripts, 139, *140*, 145
　in sculpture, 53, 117, 139–143, 145,
　　147, 180
　in stained glass, 145
Johannes Scotus Erigena, 177
John I, pope, 81
John the Baptist, 120
John Chrysostom, 191
John of Damascus, 97, 113
Jones, Owen, 19
Josephus, Flavius, 21, 94, 158, 160–161, 163–164,
　　168, 170–171, 180, 186
Justinian I, 166, 171, 174–176

karma, 18, 165, 177–178, 185
Kavaler, Ethan Matt, 18–19, 73, 106
Kimpel, Dieter, 37
kinetics, 115. See also *ductus*; movement
kings, of Judea, 140, 147
Kitzinger, Ernst, 19
Kodesh Hakodashim. See Holy of Holies
Krautheimer, Richard, 17–18, 157, 185
Krinsky, Carol Herselle, 165–166

labors of the months, 8, 92, 107, 121
La-Charité-sur-Loire, Notre-Dame, 62
Lallemand, Jean-Baptiste, 62
lamb of God, 120
Langres
　Cathedral, 8, 37, *38*, 69, 71, 185
　Roman gate, 69, *70*
Laon Cathedral, 42, *43–44*, 100, 141,
　　142, 143
Last Judgment
　at Amiens Cathedral, 79, 125–126, 132,
　　134, 140
　at Autun Cathedral, 44, 121
　at Laon Cathedral, 141
Lavanttal, Saint-Leonhard, *103*
Lefrançois-Pillion, Louise, 28
Le Mans Cathedral, 30, 36–37, *39*, 179
Lent, 57, 190
Leo X, pope, 13
Levant, contact with, 67, 71, 158, 166, 186
Liber Pontificalis, 81
Liberal Arts, 121
Liessies Abbey, 84
Life of St. Sylvester, 176
Limbourg Brothers
　Belles Heures of Jean de France, 60
　Très Riches Heures du Duc de Berry, *10, 72*, 76
Lincoln Cathedral, 18

lintels, 44, 47, 49, 53, *55*, 57, 59, 88–89, 117,
　　120–122, 125–126, 129, *131*, 134, 140–141,
　　145, 147, 163, 170, 180
lions, 69, 128
liturgy, 8–9, 20–21, 49, 57, 67, 73, 86, 115, 121,
　　125, 129, 139, 163, 189, 191
Loire, 1, 35
London, Saint-Mary-at-Hill, 191
Lorris, Guillaume de and Jean de Meun, *Roman
　　de la Rose*, 107
Louis IX, king, 30, 117
Louis of Blois, 84
Lucas Cranach, 108, *109*

Madrid, Museo del Prado, *108*
Mamluk architecture, 18, 177–179, 185
Manar al-Athar, *170–171*
Mandatum, 190
maniera tedesca, 13
Mantes-la-Jolie, Notre-Dame, 47, 121, *122*
manuscripts, 36, 59, 67, 78, 95, 98, 139, 145, 163
mappae mundi, 75, *76*
Mapping Gothic France, Columbia University,
　　*31–32, 35–36, 38–39, 42, 45–46, 122,
　　148, 169*
Marcus Agrippa, 150
marginalia, 59, 139
marriage, 9, 115, 191
Martin Schongauer, 98
Martino Ferrabosco, *82*
Mary Magdalene, 102, 106
Mass, 25, 53, 110, 115, 117, 121, 124, 128,
　　133–134, 139, 163
Master Thietmar, 186
Mather, E. Ann, 97
Medina, Mosque of the Prophet, 178
Melchizedek, 117, 120, 124
memory, 20, 125
metalwork, 73
Metz Cathedral, 28, *31*, 57, 180
Micah, 128, *129*
Michler, Jürgen, 30
Milan, San Simpliciano, 67
Mimizan, priory church, 179
Minnis, Alastair, 76, 107
Mishnah, 158, 160–161, 164–165, 180, 186
Mont-Saint-Michel, 86, *87*
Montecassino, abbey church, 81
Montfaucon, Bernard de, *183*
Monti, James, 190
Moret-sur-Loing, Notre-Dame, 37
mosaics, 9, 105, 171, 178
Moses, 120, 159, 174, 185

Mount Moriah, 159. *See also under* Jerusalem, Temple Mount
Mount of Olives, 102
Moutiers-Saint-Jean, abbey church, 122–124
movement of beholder, 125, 128, 133–134. See also *ductus*; kinetics
Muhammad (prophet), 165
Muhammad ibn Muhammad ibn Saṣrā, 177
Murray, Stephen, 8, 28

narthex, 62, 64, *65–66*, 67, 69, 174, 179, 185–186
Natura, 107
naturalism, 11, 26
naturaliste (style), 7
Nebuchadnezzar, 92, 160, 170
Nepotian of Altino, 191
New Law, 120, 157
New York, The Metropolitan Museum of Art, *16*, *60*, *82*, *85*, *103*, *112*, *114*, *123*, 134, *153*, *188*, 207n41
Nicholas of Lyre, 75
Nicodemus, 102
Night Journey, 165
Nîmes, Maison Carrée, 150
Noah, 150
Noah's Ark, 168, 189, 212n74
Nola, church of the Apostles, 88
Normandy, 1, 35
Notker the Stammerer, 162
Noyon Cathedral, cloister, 82, *83*

oak, 21, 57
Obsequiale Brixinense, 189
Odo of Cluny, 102
Odo of Metz, 162
Odo of Tournai, 80
Oettinger, Karl, 17, 73
Ohly, Friedrich, 97
Old Law, 96, 120, 157
olive trees and branches, 94, 152, 189, 204n84
Olson, Vibeke, 47, 121
Onians, John, 180
opus sectile, 96
ordo creationis, 9
Origen, 75
ornament, theories of, 18–20, 60, 62, 114

Pallot-Frossard, Isabelle, 30
palmettes, 41–42, 49, 60, 184
Palm procession, 190
Palm Sunday, 189–191
palms, 84, 94, 160, 165, 176, 189–191

panegyrics, 162, 177
paradise, 73–75, 89, 91–92, 96–97, 102, 106–108, 110, 165, 170
 as architectural term, 80–81
 association with churches, 88
 association with cloisters, 81–82, 84, 86, 88
 celestial, 20, 77–81, 84, 88–89, 102, 106, 190 (*see also* Heavenly Jerusalem)
 earthly, 20, *72*, 75–77, 81, 106, 152 (*see also* Garden of Eden)
Paray-le-Monial, abbey church, 62, 198n36, 200n81
Paris
 Bibliothèque nationale de France (BnF), 64, 66, *76*, *183*
 Musée national du moyen âge, *14*, *33*, 122, *149*, *182*
 Notre-Dame, 30, *33*, 116, 147, *148–149*, 168
 royal palace, 147
 Saint-Germain-des-Prés, Virgin Chapel, *14*, 121, 124
 Sainte-Chapelle, 30, *32–33*, 168
 Tour Jean-sans-Peur, *12*
Paul the Deacon, 81
Paul I, pope, 81
Paul, Saint, 67, 88
Paul the Silentiary, 172–173
Paulinus of Nola, 88, 190
Paulinus of Tyre, 162
peacock, symbolism of, 79
Peter of Blois, 80
Peter Comestor, 161, 163, 168
Peter Damian, 80
Peter Lombard, 75
Peter, Saint, 67, 81, 88, 117
Peter the Venerable, 67, 116
Petrus Chrysologus, 102
Pevsner, Nikolaus, 26
Philo of Alexandria, 94
Picard, Jean-Charles, 81
Picardy, 1, 35
Pierre des Aubeaux, 143
Pietro de' Crescenzi, 9
Pilastri Acritani, 175
pilgrimage, 67, 103–104, 158, 165
piliers cantonnés, 28
plants, use in church decoration and ritual, 9, 189–191
plaster, *173*
Plato, *Timaeus*, 92
pointed arches, 13, 99
Poissy, Notre-Dame, *5*, 36–37
Poitiers, Notre-Dame-la-Grande, 180

polychromy of churches, 29–30, 34, 73, 96, 147, 197n29
Pompey the Great, 164
Powell, Barry, 152
Prague, Altneu synagogue, 95
Princeton University Art Museum, *65*
processions, 25, 28, 53, 110, 120–121, 128, 132, 134, 190–191
Procopius, 173–174
prototypes, architectural, 18, 67, 157, 161, 163, 177, 185
Provins, Saint-Ayoul, 180
Pseudo-Apollodorus, *Bibliotheca*, 152

Qubbat al-Sakhra, 161. *See also under* Jerusalem, Dome of the Rock
qibla, 177–178
Quodvultdeus, Saint, 157, 210n1

Rabanus Maurus, 102, 161
Raphael, 13
 Madonna della Sedia, 24, *25*
Ravenna, San Giovanni Evangelista, 67
réaliste (style), 8
reality effect, 15
Reims
 Cathedral, 1, *6–7*, 26, *27*, 57, *58*, 147, 179–180, 193n2, 198n44
 church of Saint-Nicaise, 92
 church of Saint-Rémi, *3*, 8, 36–37, 71
 tomb of Hugues Libergier, 92, *94*, 204n78
relics, 8, 25–26, 40, 128–129, 132, 166, 174
Rémi, Saint, 60, *61*
Revelation, 77–79, 86, 88, 96–97, 115, 162
Riccoldo da Monte di Croce, 105
Richard of Saint-Victor, 161, 163
Riegl, Alois, 19
rinceau, 37, 41–42, 47, 64, *65*, 69, 71, 88–89, 100, 113, 150, 177, 185–186
Robert Campin, follower of, 99
Robert Grosseteste, 9, 75
Robinson, Cynthia, 19
Romanesque, 1, 75, 166
Romano-Germanic Pontifical, 189–190
Romanos the Melodist, *Hymn 54*, 174
Romantics, 13, 15
Rome
 Ara Pacis Augustae, 150, *151*, 152
 Old Saint-Peter's, 67, 81, *82*
 San Clemente, mosaics, 95, *96*
 Santa Maria Maggiore, mosaics, 79
 Temple of Jupiter Optimus Maximus, 164
roses, 57, 98, 113, 190–191, 206n3, 216n13

rosettes, 60, 67, 69, 176, 184, 201n95
Rouen
 Cathedral, 47, *51*, 143, 145, 179
 Saint-Maclou, 37, *48–49*, 57, *58*
 Saint-Ouen, 88, 163, 168
Rubin, Miri, 117
Rule of Saint Benedict, 91
Rupert of Deutz, 97, 161

Saewulf (monk), 103
Saint-Denis, abbey church, 17, 26, 47, *51*, 91, 162–163, 168, *169*, 180, *181–183*, 185, 212n72, 215n132
Saint-Firmin-en-Castillon, 129
Saint-Gall, monastery, 162, 180
Saint-Gall plan (St. Gallen, Stiftsbibliothek, Codex Sangallensis 1092), 81, *83*
Saint-Guilhem-le-Désert, cloister, 84, *85*
Saladin, 215n142
Saladin, Henri, 177, 214n114
Samuel (prophet), 120, 152
Sandron, Dany, 8, 28
sanguis Christi, 116. *See also under* Christ, blood of
Sankovitch, Anne-Marie, 19
Sauve, bishop, 128–129
Scheja, Georg, 174
Schinkel, Karl Friedrich, *16*
Schlee, Ernst, 81
Schlegel, Friedrich von, 13
Schlink, Wilhelm, 8, 74, 128
Schneider, Lambert, 19
Sedlmayr, Hans, 74–75
Semele, 152
Semur-en-Brionnais, Saint-Hilaire, 64
Senlis Cathedral, 179
Sibt ibn al-Jawzī, 170
Sicard of Cremona, 184
Sidonius Apollinaris, 162
Simeon, priest, 120, 124
Simplicius, pope, 81
Simson, Otto von, 88
Sir Gawain and the Green Knight, 107
Soissons Cathedral, *4*, 8, 71
Solomon, king, 1, 100, 123, 139–140, 153, 159, 162–163, 165–166, 170, 174, 176–177, 180, 185
Solomon's Palace, 166, 168. *See also under* Jerusalem, palace of Solomon
Solomon's Stables, 166. *See also under* Jerusalem, stables of Solomon
Solomon's Temple, 18, 21, 157, 159–163, 165–166, 168, 171, 173–176, 184–186. *See also under* Jerusalem, Temple

Solomonic aesthetic, 160
Song of Songs, 17, 97–98, 100, 102
Soucek, Priscilla, 171
Southwell Minster, chapter house, 26
stained glass, 8, 23, 28, 71, 73, 88, 139,
 143, 145
stone
 hierurgy of, 26
 properties of, 27, 92
Stookey, Lawrence Hull, 86, 88
Strabo, 164
Strasbourg Cathedral, 13
Suckale, Robert, 37
Suger, abbot, 17, 26, 162–163, 168, 185–186
synecdoche, 121, 157

Tabernacle, 20, 91, 157, 159, 162, 185
Tacitus, 74
tapestries, 73, 180
Temple of Jerusalem. *See* Jerusalem, Temple
Temple Mount. *See* Jerusalem, Temple Mount
Temple Vine. *See* Golden Vine
Ten Commandments, 91, 159
Tertullian, 95, 139
Testamentum Domini, 37
Theodoric (monk), 105–106
Theologia Deutsch, 92
Theophilus of Alexandria, 116
Theophilus, *De diversis artibus*, 73–74, 91
Thierry of Chartres, 92
Three Marys at the Tomb, 102, 121
Throne of God, 177
Throne of Wisdom, 121. *See also* Virgin
 and Child
time
 ecological, 8
 eschatological, 20, 49, 117, 126
Titus, 161, 174
Toubert, Hélène, 114
Tournus, Saint-Philibert, *11*
Tours, Saint-Martin, 162
Trachtenberg, Marvin, *70*, *87*
Traditio Legis, 88
Travis, William, 19
Tree of Knowledge, 75, 89, 102
Tree of Life, 75, 79–80, 89, 94–97
Trilling, James, 19
Trinity College Apocalypse (Cambridge, Trinity
 College, Ms. R.16.2), *78*, 79
Tristan legends, 107
Tronzo, William, 114
Troyes, Saint-Urbain, 162

Umayyad, 18, 21, 158, 161, 165–166, 168,
 177–179, 185
Urban IV, pope, 162

Van Liefferinge, Stefaan, 168
vela, 57, 160, 170
Venice, San Marco, 175
Vézelay, La Madeleine, 19, 64, 67, *68*, 69, 186
Vienna, Österreichische Nationalbibliothek,
 Codex Vindobonensis 2554, *93*
Vierge Dorée, 30, 134. *See also under* Amiens
 Cathedral, south transept
vines, 9, 18, 21, 30, 34, 36–37, 41, 47, 49, 53,
 63–64, 79, 84, 86, 89, 94–96, 113, 115–117,
 120–122, 124, 126, 128, 132–134, 139–141,
 143, 147, 150, 152–154. *See also* Golden
 Vine; grapevine
virga, 139
Virgin and Child, 99–100, 122, 134, 145. *See also*
 Throne of Wisdom
Virgin Mary
 Annunciation, 99
 Assumption, 97, 117, 141
 cult of, 97
 Coronation, 79, 117, 122–123, 141, 143
 Death, 117, 141
 as *hortus conclusus*, 97–98, 100
 as intercessor, 97, 126
 as New Eve, 97, 124
 as queen of heaven, 97, 143
 as *typus ecclesiae*, 97
viticulture, 1, 71, 152
Vitis mystica, 116
Vitruvius, 74

Walafrid Strabo, 161
Walker Bynum, Caroline, 116
Walter of Henley, 9
Washington, D.C., National Gallery of Art, *99*
Wick, Peter, 152
William of Conches, 9, 92
William Durandus of Mende, 17, 25, 84, 161, 190
William of Malmesbury, 80
William of Saint-Thierry, 21
World Tree, 94
Würzburg Cathedral, 168, 184

Zanker, Paul, 152
Zerubbabel's Temple, 160–162, 164, 166. *See also*
 under Jerusalem, Temple
Zeus, 152
zodiac, 44, 121